INTRODUCTION TO PHOTOGRAPHY

MARVIN J. ROSEN

California State University, Fullerton

HOUGHTON MIFFLIN COMPANY • BOSTON

Dallas Geneva, Ill. Hopewell, N.J. Palo Alto London

INTRODUCTION TO PHOTOGRAPHY

A SELF-DIRECTING APPROACH SECOND EDITION

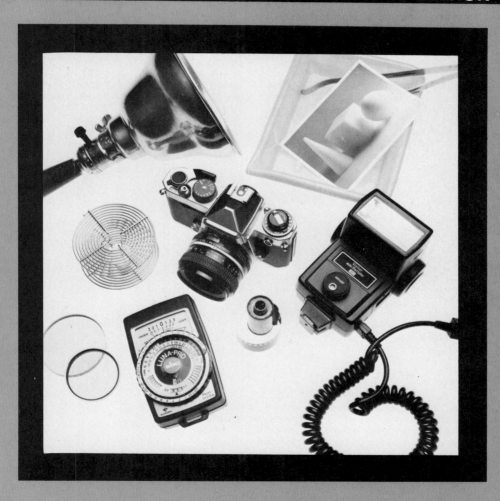

PHOTO CREDITS

Cover photo and unit-opener photos by Jerry Wilke.

Vern Anderson 11–8; Janet Argon 10–5 (right); Joan Armstrong 6–13B; Suzanne Barba 10–4 (left); James Beals 10–4 (right); James Bell 11–17E; Mark Boster 11–15; Joe Breckenridge 10–1A; Edgar Breffitt 5–17B, 6–1A; Laura Brucken 11–10A; Jim Chambers 6–6; Douglas C. Covert 10–19A, B; Evelyn Craik 10–5 (left), 11–16 (top); Clemon Crum 11–13; Michael Dalton 10–14B; Art Dillon 11–7B; Sandra Edgerton 10–16 (right); Jack Edwards 6–7C; Janet Eisenhut 10–10; Bill Fletcher 3–16; Chris Goeckner 5–22; Edward Graham 11–6B; Ron Greim 11–5; Corey Hamel 10–3A; Richard Hand 6–7B; Lonny Hardeman 9–9, 10–12A, 11–2 (top); Jim Kersikovski 6–8A; Rick Leveque 6–12A, B, 10–8; Joyce Lewis 10–16 (top); Don Marshall 6–1B, 7–5A, 11–2 (bottom); Jim Marshall 1–2, 1–19, 1–28B, C, 2–4, 4–1, 4–2A, B, C, 4–3A, B, 4–5 A, B, C, D, E, F, 4–6A, B, C, E, F, 4–7A, B, C, 4–8A, B, C, D, 4–9A, B, C, 4–10A, B, 4–11A, B, 4–12, 4–13A, B, C, 4–14, 4–15, 4–18, 5–7, 5–14, 5–23A, B, C, D, 5–25, 8–16, 9–8A, B, 10–2A, B, C, Plates 2A, 5A, 5B, 7A; Douglas Mitani 6–2B; Julie O'Neil 1–1B, 1–23A, B, 1–27D, 3–5, 3–6, 3–7, 3–8, 3–9B, C, D, 3–10 A, B, 3–19A, B, 3–20, 3–25 C, D, 3–26A, B, C, 3–27, 5–9A, B, C, D, E, F, G, H, I, 5–10 B, C, 5–12 A, B, C, 5–17A, 6–2A, 6–3A, 6–7A, 6–8B, 6–11, 6–12C, D, 6–13A, C, 6–14, 7–2A, B, C, 7–5B, 8–1B, D, 8–2B, 8–3A, B, 8–10B, 8–11B, 8–12B, 9–1A, B, C, D, 9–10, 10–1B, 10–3B, 10–6A, B, 10–7, 10–11, 10–15, 10–17A, 10–18A, B, 11–1 (top), 11–3, 11–11A, B, C, 11–12B, 11–17B, C, D, 11–19A, B, C, D Plate 7–C; Paul Paulsen 10–14A; Joseph Profita 11–6A, 11–9; Susan Ragan 11–6C; Debbie Robertson 6–9, 10–12B, 11–16 (bottom); Debora Robinson 10–13B; Marvin Rosen 1–17, 3–13, 3–14, 5–8, 5–11A, B, 5–13A, B, 5–16, 5–20A, B, 5–21 A, B, 7–4, 7–7A, B, 8–9B, 8–13 A, B, C, D, E, 8–14C, Plates 1A, 1B, 3A, 3C, 4A, 4B, 4C, 6A, 6B, 7B, 8A, 8B; Ruth Rosen Plates 2B, 3B; Richard Shimko 10–17B; Norm Silvers 10–9; Rita Smith 11–10B; Janet Spurgeon 6–3B, 6–5C, 11–7A, Plate 9; Doug Stavert 6–5A; Molly Tigner 3–25A, B; Richard Valles 3–17, 11–12A; Gary Whitehead 10–3C; Dennis Woodward 11–4; Mike Ybarra 6–4A

Printed in the U.S.A.

Library of Congress Catalog Card Number: 81-82564

ISBN: 0-395-29765-6

CONTENTS

OBJECTIVES

1 Cameras, Lenses, and Accessories

1–A Compare the eye and the camera in terms of their basic parts and functions.
1–B Identify several basic camera types and describe their similarities and differences.
1–C Describe two major characteristics of the camera lens and their effects on picture taking.
1–D Describe several common accessories used with adjustable cameras.
1–E Describe some important camera "housekeeping" practices.
1–F Describe some good habits of camera use.

2 Films

2–A Describe the composition of black-and-white negative film and draw a cross-section of a typical film, labeling the various component layers.
2–B Define some of the basic characteristics of black-and-white negative film and give examples of how these characteristics affect photographs made under various conditions.
2–C Name a commonly available black-and-white slow-speed film, medium-speed film, and fast-speed film and describe the speed, graininess, and special uses of each.
2–D Describe the characteristics, differences, and uses of three basic types of color film, and the composition of modern color film.
2–E Describe the conditions that may adversely affect your film and describe how to store and care for your films to avoid these effects.

3 Exposure

3–A Name three basic settings found on adjustable cameras and describe their functions.
3–B Define depth of field and describe the major factors that affect it.
3–C Demonstrate how to select, using an exposure guide, appropriate combinations of apertures and shutter speeds under various conditions.

3–D Given basic exposure data, describe techniques for photographing the action of moving subjects.
3–E Describe the desirable characteristics of negatives and explain how to use an exposure meter to determine proper exposure.

4 Processing Black-and-white Film and Prints

4–A Explain and demonstrate the processing of black-and-white negative film.
4–B Describe the procedures used in making black-and-white prints.
4–C Describe the materials used in making black-and-white prints from negatives.
4–D Describe the basic equipment and darkroom used in making black-and-white prints.

5 Printing and Finishing

5–A Label and explain the function of the parts of a typical enlarger.
5–B Explain three methods of making contact prints.
5–C Explain and demonstrate how to make a contact proof sheet using the enlarger method.
5–D Describe and demonstrate how to make an enlargement.
5–E Describe and demonstrate how to determine exposure using the test strip method.
5–F Describe and demonstrate how print contrast can be controlled and how to produce relatively normal prints with flat, contrasty, and normal negatives.
5–G Describe and demonstrate several printing control techniques.
5–H Describe and demonstrate the processes of print washing, drying, spotting, mounting, and describe toning and bleaching.

6 Introduction to Composition

6-A Define composition and describe its elements and purposes.

6-B Explain and demonstrate how you can achieve emphasis by controlling detail.

6-C Explain and demonstrate how details can be emphasized or subordinated through placement.

6-D Describe and demonstrate five photographic guidelines based upon principles of composition.

7 Filters

7-A State the principles on which filters are based and describe the general effect produced by using a filter when photographing a subject in black and white.

7-B Describe two forms of filter construction and state how each is attached to the camera.

7-C Define and apply the principle of filter factors to calculate exposure.

7-D Name and describe the purposes of five types of filters commonly used in black-and-white photography—with examples.

7-E Name and describe the purposes of five types of filters commonly used in color photography—with examples.

8 Basic Lighting

8-A Describe the purposes and principles of artificial lighting.

8-B Name and describe the functions of six basic lighting tools used in artificial indoor lighting.

8-C Describe and demonstrate the functions of the key (or main) light, fill light, background light, and accent lights in a basic setup.

8-D Describe and demonstrate some basic lighting techniques for portrait photography.

8-E Describe and demonstrate some common problems and techniques for lighting small objects in product photography.

9 Flash Photography

9-A Describe the principles and functions of flash photography and the major differences between flashbulbs and electronic flash units.

9-B Given a table of guide numbers, select the appropriate guide number for a specific shutter speed, synchronization, flash unit, and film speed; and given a guide number, calculate appropriate f/stop settings for subjects at various flash-to-subject distances.

9-C Explain and demonstrate several techniques for using a single flash unit for lighting a subject and explain their several purposes. Calculate flash-to-subject distance for fill-in flash.

9-D Explain and demonstrate how flash can be used to stop fast action.

9-E List several maintenance and safety recommendations for handling flash equipment.

10 More on Composition and Print Quality

10-A Describe and demonstrate how perspective controls can be used to modify apparent depth and distance in a photograph.

10-B Describe and demonstrate how lines of composition can be used to emphasize the center of interest and generate dynamism in a photograph.

10-C Describe and demonstrate how tone and contrast can be used to reveal essential details, emphasize the central idea, and contribute to the mood of a photograph.

10-D Describe and demonstrate principles of color composition related to color harmony, psychological effects of color, and effects of reflected light.

11 Applied Photography

11-A Describe some of the principles and techniques of scenic photography.

11-B Describe some of the principles and techniques of architectural photography.

11-C Describe some of the principles and techniques that can be used in photographing still-life subjects.

11-D Describe and demonstrate some common sense guidelines for photographing people.

11-E Describe real action, simulated action, and peak action and demonstrate a technique used for photographing each.

11-F Describe how successful pictures of people appeal to basic human emotions.

11-G Describe some of the principles and techniques of close-up and copy photography.

PREFACE

This edition, like the one that preceded it, is a general introduction to photography designed for those with no previous experience in the craft. The text covers the basic skills needed to make effective photographs in black and white or color and to process, print, and finish in black and white. It teaches how to use an adjustable camera, common attachments and accessories, as well as basic darkroom supplies and equipment. Because successful photography also depends on the photographer's perception and style, the book encourages students to seek out subjects that interest them and guides them in communicating their thoughts and feelings to others.

The technical content of the text as it applies to the beginning photographer has been thoroughly updated in response to the rapid development of photographic technology and to the suggestions of many colleagues and students. The treatment of camera features and accessories has been reorganized completely and includes new information of special concern to the novice photographer. An explanation of the types of automatic cameras, which now seem to dominate the popular market, is included as well as some instruction in the controlled use of their automatic features to obtain previsualized results. Additional material has been included on the use of RC papers, which continue to replace fiber-base papers as the preferred print material in introductory photography classes. The discussion of density and contrast control has been expanded in several units of this edition. Finally, a completely new section on close-up and copy photography has been added because so many students find these skills useful in preparing projects and presentations on a great variety of subjects.

The second edition retains the characteristics that make the text useful in a variety of instructional modes: a modular approach that includes statements of learning objectives, key concepts, illustrated instructional material, written exercises, field and laboratory assignments, suggested references, self-tests with explanatory answer keys, and an extended glossary of terms and concepts. Used as a conventional text, the book provides basic information, allowing instructors to supplement its content with their own demonstrations, lectures, and discussions. The self-directing features of the text allow students to instruct themselves in many basic skills and procedures, thus freeing instructors from repetitive lecturing and demonstrating and allowing them to concentrate more of their own efforts on topics of special interest to them and their students.

The text has also proven successful in programs of individualized teaching and learning. Incorporating certain principles of programmed instruction, the text serves as a guide for individual study and practice for students who can work with a minimum of supervision. Used in this way, the book allows students to learn at their own rates: those who are able and so inclined may proceed rapidly toward mastery of photographic skills; others may proceed more slowly to suit their levels of skill or interest. The instructor's role tends to be more tutorial, the student-teacher interaction more adjusted to the needs of individual students.

Independent learners will find the book especially well suited to studying photography on their own. The book is designed to serve as a tutor: it systematically introduces each new topic; provides instruction and practice in an orderly and cumulative fashion; builds complex skills on simpler ones; and provides continuous feedback to evaluate individual performance.

Throughout this edition, student photographs

have been used extensively to illustrate various principles because students can be motivated by peer examples. Students recognize that these achievements are within their grasp, that they were produced by students like themselves rather than by professional photographers. The works of professional photographers have also been used wherever they have been found to illustrate a particular point most effectively.

The book contains eleven learning units. In Units 1 through 5, students concentrate on the technical skills of operating a camera, selecting materials, developing film, and making and finishing prints. Unit 6 introduces students to composition in the "craft" sense. Controllable elements and techniques of composition that aid in communicating ideas and feelings are identified without imposing inflexible rules that may cloud vision and stunt growth. Then, in Units 7 through 9, students explore more deeply the interaction of light and film through the use of filters and supplementary lighting. Unit 10 returns to the subject of composition, elaborating on the principles of perspective, density and contrast, and color as they apply to communicating the photographer's ideas. In Unit 11, students practice applying their knowledge to scenery, architecture, still life, people, action, close-ups, and copy photography.

The contributions of many persons to this work are gratefully acknowledged—Dr. J. William Maxwell and Mrs. Barbara Machado for their encouragement and material support in the preparation of the first edition; the students and photographers whose works appear herein; and my many colleagues who provided invaluable suggestions for strengthening the second edition. Especially helpful were the reviews of Robert Detwiler, Hocking Technical College in Nelsonville, Ohio; James A. Fosdick, University of Wisconsin-Madison; and Barbara McKenzie, The University of Georgia.

I am indebted to the many students and colleagues who in various ways contributed to whatever strengths this work may possess. Their hope and mine will be amply satisfied if those who use the text find it helpful in learning this novel craft.

INTRODUCTION TO PHOTOGRAPHY

CAMERAS, LENSES, AND ACCESSORIES

U N I T 1

Eye and Camera

> **Objective 1–A** Compare the eye and the camera in terms of their basic parts and functions.
>
> **Key Concepts** lens, light sensitive surface, retina, film, camera body, shutter, aperture, iris diaphragm, seeing selectively, seeing indiscriminately

HOW TO USE THIS BOOK

Objectives and key concepts
This is the start of Unit 1: Cameras, Lenses and Accessories. Within each unit are several objectives that are numbered 1–A, 1–B, 1–C, and so forth. This first objective, 1–A, is about the eye and the camera. The objective describes what you will learn to do: "Compare the eye and the camera in terms of their basic parts and functions." Following the objective is a list of key concepts — the important terms and ideas that are included in this objective. The key concepts are italicized in the text when they are introduced or defined for the first time in each unit.

Throughout this book each of your learning objectives and all the key concepts are stated, as they are above, at the start of each new objective, to give you an advance idea about what you are expected to learn.

The human eye provides a good starting point for learning how a camera works. The lens of the eye is like the *lens* of the camera. In both instruments the lens focuses an image of the surroundings on a *light sensitive surface* — the *retina* of the eye and the *film* in the camera. In both, the light-sensitive material is protected within a light-tight container — the eyeball of the eye and the *body* of the camera. Both eye and camera have a mechanism for shutting off light passing through the lens to the interior of the container — the lid of the eye and the *shutter* of the camera. In both, the size of the lens opening, or *aperture*, is regulated by an *iris diaphragm*. Study Figure 1–1 to compare the eye and the camera.

The eye adjusts automatically to high and low light conditions. In a darkened room the iris of the eye opens wide to allow as much light as possible to enter. In bright light the iris of the eye closes down to prevent too much light from entering. Observe the pupil of your own eye in a mirror as you switch a bright light on and off and you will see the iris adjust the size of your pupil for each condition.

Most adjustable cameras do *not* adjust automatically for high and low light conditions. In most cases you must adjust your camera manually to regulate the amount of light that enters it. To help you with this manual adjustment, many cameras have built-in features that inform you of changing light conditions. Nevertheless, some cameras, even as the eye, do adjust themselves automatically for varying light conditions.

The eye also adjusts automatically to focus on the objects of interest to you. Small muscles attached to the lens of the eye alter its shape to focus now on nearby objects and then on distant objects. Most adjustable cameras do *not* adjust focus automatically; in most cases you must adjust your camera manually to focus on the objects of interest to you. To help you with this adjustment, most cameras provide built-in features that let you know which objects are in and out of focus on the film; some cameras even adjust focus automatically. Thus in many ways the camera functions much as the human eye.

One important difference between eye and camera is that the eye *sees selectively*; the camera *sees indiscriminately*. In other words, human beings tend to observe only those details that are important to them. Their minds have the ability to filter out all details except those to which they are paying attention. The camera, on the other hand, tends to see all the details

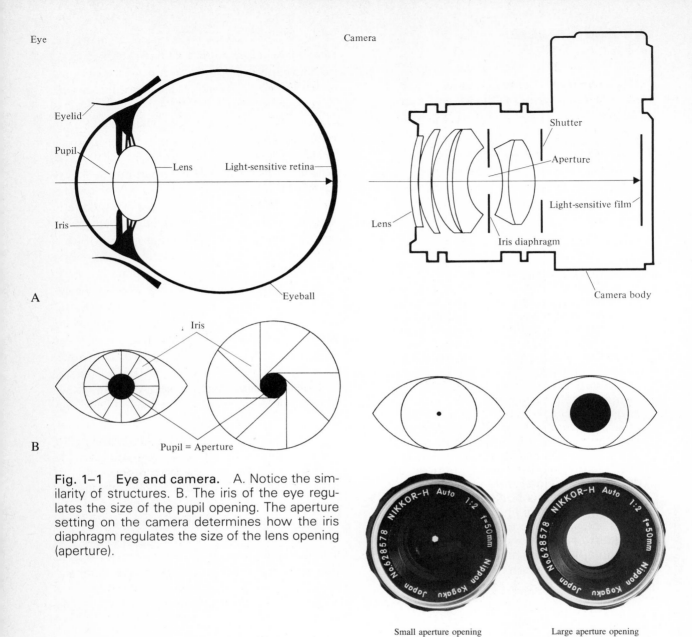

Fig. 1–1 Eye and camera. A. Notice the similarity of structures. B. The iris of the eye regulates the size of the pupil opening. The aperture setting on the camera determines how the iris diaphragm regulates the size of the lens opening (aperture).

Small aperture opening Large aperture opening

in view and to record them on the film. It has no mind of its own to help it pay attention to some details and not to others. Those who have taken pictures have had the experience of finding in some finished print a strange object which they did not notice when they snapped the picture because they had been concentrating on the subject at the time. In other words, they saw selectively only those details to which they were attending, but the camera saw indiscriminately all the details in its field of view. As a photographer you must train yourself to see what the camera sees. (See Figure 1–2.)

Fig. 1–2 Eye's view and camera's view. What did the camera see that the photographer failed to see?

HOW TO USE THIS BOOK

Exercises
At the end of the reading for each objective in this book you will be asked to do a written exercise. The exercises for all objectives in a unit are given at the end of the unit. You should try to complete an exercise immediately following the reading for an objective, while the material is fresh in your mind.

This is the end of the reading for Objective 1–A. Turn to Exercise 1–A on page 29 and complete it now, before proceeding to the reading for Objective 1–B.

Basic Camera Types

Objective 1–B Identify several basic camera types and describe their similarities and differences.

Key Concepts pinhole camera, box camera, pocket camera, folding camera, bellows, small format, 35-mm camera, half-frame camera, 110 camera, 126 camera, medium format, large format, single-lens reflex (SLR), focal plane shutter, twin-lens reflex (TLR), rangefinder (RF), manual focus, fixed focus, auto focus, parallax error, fixed exposure, manual exposure, match-needle, automatic exposure, shutter priority, aperture priority, programmed automatic, exposure override, view and studio cameras, instant camera, wide-angle camera, underwater camera, underwater housing, stereo camera, press camera

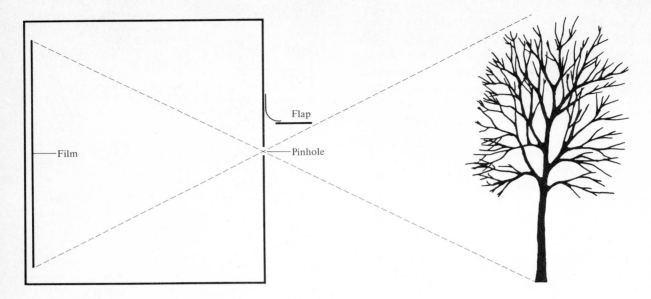

Fig. 1–3 Pinhole camera.

Camera technology has developed in many directions and cameras themselves have taken many forms. Modern cameras are classified commonly according to their body types, film sizes and image formats, viewing and focusing systems, exposure-setting systems, and special functions.

Body types

To gain an understanding of the evolution of modern cameras, we will look first at some of the earlier, simpler types of cameras.

The *pinhole camera* (Figure 1–3) is the simplest of all cameras. Basically it is a light-tight box with a pinhole in one end. At the opposite end is the film. A flap controls the light entering the pinhole. The camera has no lens; rather, the pinhole focuses the image on the film. All other cameras merely add refinements to this basic design. Two important refinements are the lens, which substitutes for the pinhole, and the spring-loaded shutter, which substitutes for the flap.

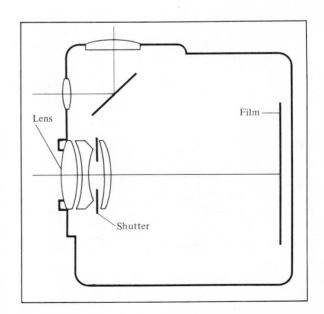

Fig. 1–4 Box camera.

The *box camera* (Figure 1–4) was an inexpensive refinement of the pinhole camera equipped with a simple lens and a shutter. Most often, the nonadjustable lens is set to focus on objects twelve feet from the camera and beyond. The nonadjustable shutter, usually placed behind the lens, is set for 1/25–1/30 sec., suitable only for shooting stationary objects under average lighting conditions. The early box cameras and their modern counterparts may take excellent photographs under these conditions, but because their adjustments are limited they cannot be used effectively under other conditions. Close-ups, action shots, and weak lighting conditions are usually beyond a box camera's capabilities.

A modernized form of the box camera is the *pocket camera* (Figure 1–5), so called because its body shape lends itself to being carried in a pocket. The shutter speeds of these cameras are generally faster than the older box cameras, usually 1/60 sec., and many pocket cameras offer adjustments and accessories to increase the range of their performance. Some pocket cameras offer supplementary lenses for close-ups and telephoto effects; some offer aperture and shutter-speed adjustments as well as flash to meet the needs of action shots and weak lighting conditions. In addition to these features, cartridge film loading and automatic exposure make the modern pocket camera an inexpensive and handy tool for the amateur photographer who shoots in a variety of circumstances.

The *folding camera* (Figure 1–6) is simply a box camera with an accordion-pleated *bellows* in place of the rigid box. The lens, diaphragm, and shutter assembly can be folded back into the camera body to make the camera smaller and easier to carry. Folding cameras can be found in many varieties, and the better ones may be equipped with superior lenses, focusing adjustments, variable-speed shutters, and aperture adjustments.

Fig. 1–5 Pocket camera. (Minolta Corporation)

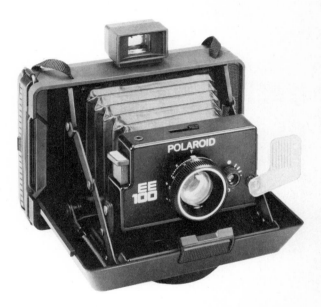

Fig. 1–6 Folding camera. (Polaroid Corporation)

Film size and image format

Many cameras are classified according to the size of the film they use or the format of the images they produce. The major types are small-, medium-, and large-format cameras.

Because a photographic image can be magnified only to a certain degree without visibly degrading its

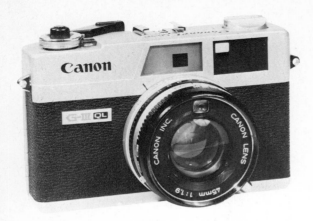

Fig. 1–7 35-mm camera. (Canon U.S.A., Inc.)

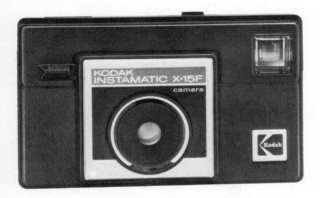

Fig. 1–8 126 camera. (Eastman Kodak Company)

quality and sharpness, film size and image format should be considered in relation to how the images will be used. The larger the recorded image, the larger will be the acceptable degree of magnification. For enlargement to album-size prints or small-room projection, small-image formats may be quite suitable; for exhibit-size enlargements, auditorium projection, or publication, larger-image formats may be required. When selecting an image format for projection, remember that most common slide projectors are designed for small-format images; projec-

tors for medium- and large-format images are less readily available and more expensive. Keep in mind too that as image size increases, cost per image also increases. Your choice of film size and image format should reflect, therefore, your expected uses of the recorded images.

One type of *small-format* camera is the *35-mm camera*, so called because it uses 35-mm film — the same as that used for making professional motion pictures. A camera of this type loads with a *magazine*, a light-tight metal container holding a strip of film sufficient for a number of images, each measuring 24 mm by 36 mm. These magazines are available in many different sizes, some sufficient for twelve exposures, some for as many as seventy-two exposures. The most common sizes are sufficient for twenty or thirty-six exposures. Some cameras of this type are designed to produce a greater number of smaller images from the same film magazines. The *half-frame* camera, for example, uses the same 35-mm film but produces an image that measures 17 mm by 24 mm, half the size of the full-frame format of the standard 35-mm camera.

The 35-mm camera is today's most popular type. It is available in many varieties, from simple, non-adjustable models suitable for use under a limited range of conditions to highly sophisticated models with interchangeable and adjustable components suited to a wide variety of photographic situations. (See Figure 1–7.)

Two other popular types of small-format cameras are the *110 cameras* and the *126 cameras*, which use sizes 110 and 126 film respectively. Both films are supplied in easy-loading, prethreaded, twin-reel cartridges. Equal in width to 16-mm motion picture film, 110 film is available in cartridges containing enough film for twelve or twenty-four images, each measuring 12 mm by 17 mm. Pocket cameras are often referred to as 110 cameras because they commonly use this size film. 126 film is the same width as 35-mm film and is supplied in cartridges containing sufficient film for twelve or twenty images, each measuring 28 mm by 28 mm. (See Figure 1–8.)

The most popular *medium-format* cameras are designed to use 120 or 220 film, which is supplied in rolls containing sufficient film for twelve or twenty-four images respectively, each measuring 2¼-in. by 2¼-in. square (6 cm by 6 cm). Some of the newer medium-format cameras using this size film are designed to produce rectangular images measuring 6 cm by 7 cm (2¼ in. by 2¾ in.), for example, or 4.5 cm by 6 cm (1¾ in. by 2¼ in.). (See Figure 1–9.)

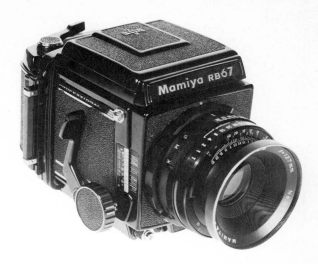

Fig. 1–9 Medium-format camera using 120 film.

HELPFUL HINT

Metrication
In the field of photography, both U.S. Customary measures (inches, quarts, pounds, degrees Fahrenheit) and metric measures (centimeters, liters, grams, degrees Celsius) are in common use. Some standard product measures may be expressed in one system, some in the other, depending on where or for what market the product is manufactured. For example, some cameras are known as 4-in. by 5-in. cameras because of their image format; other cameras are known as 6-cm by 7-cm cameras because of theirs.

In this edition we have provided metric equivalents in parentheses wherever U.S. Customary measures are in common use. Whenever metric measures are in common use, the U.S. Customary equivalent is provided in parentheses if appropriate. For example, a statement such as the following might be found: A 2¼-in. by 2¼-in. (6-cm by 6-cm) camera uses the same size film as a 6-cm by 7-cm (2¼-in. by 2¾-in.) camera. A table of metric conversions is provided in Appendix B.

many sizes and formats for both photographic and graphic arts purposes. The sizes most commonly used for photography are 2¼ in. by 3¼ in. (6 cm by 8 cm), 4 in. by 5 in. (10 cm by 13 cm), 5 in. by 7 in. (13 cm by 18 cm), and 8 in. by 10 in. (20 cm by 25 cm). Larger sizes up to 20 in. by 24 in. are produced for graphic arts and scientific purposes.

In selecting an image format, consider the trade-off between image size and camera size. In general, obtaining larger images requires the use of larger, bulkier, and usually more expensive camera equipment. To obtain the convenience of smaller, lighter, portable, and usually less expensive camera equipment, generally you will have to accept smaller image formats. Except to solve special problems and for studio uses, today's professional photographers rely heavily on small- and medium-format cameras for most purposes, particularly those using the 35-mm film and 120 or 220 film sizes. (See Figure 1–10.)

Viewing and focusing systems

The most common way of classifying cameras is by referring to their viewing and focusing systems. At least six types of viewing and focusing systems are

Large-format cameras are designed to use *sheet film*, film supplied in individual sheets to fit standard film holders. Sheet films are commercially produced in

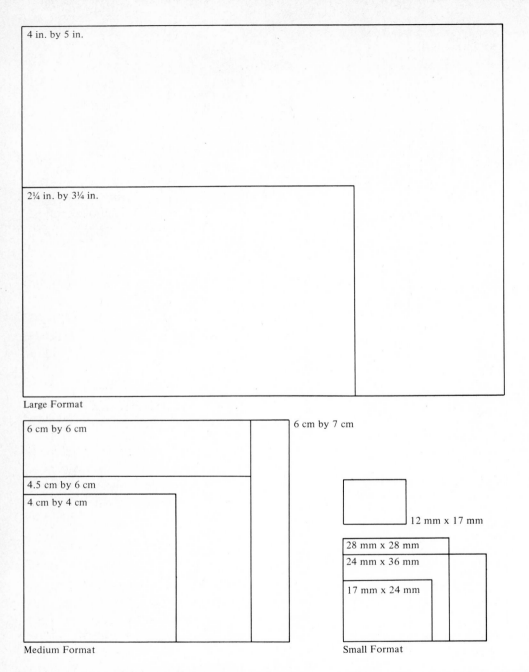

4 in. by 5 in.

2¼ in. by 3¼ in.

Large Format

6 cm by 6 cm

6 cm by 7 cm

4.5 cm by 6 cm

4 cm by 4 cm

Medium Format

12 mm x 17 mm

28 mm x 28 mm

24 mm x 36 mm

17 mm x 24 mm

Small Format

Fig. 1–10 Comparison of some image format sizes. Larger format cameras are manufactured to produce image formats of 5 in. × 7 in., 8 in. × 10 in., and 11 in. × 14 in. for special applications. (Sizes given here are those designated by National Association of Photographic Manufacturers.)

A

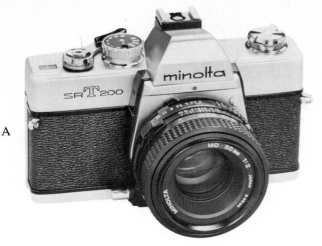

Fig. 1–11 A. Single-lens reflex (SLR) camera. (Minolta Corporation) B. Side-view cross-section of SLR camera showing focal plane shutter. Note that mirror position adjusts up and down.

B

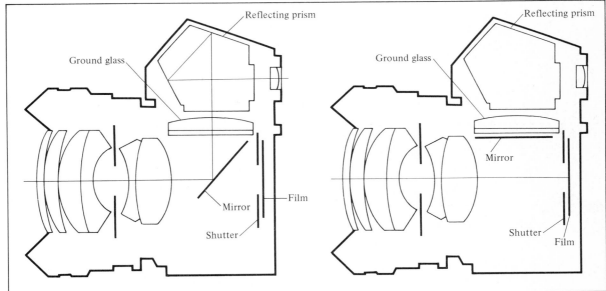

currently in common use: single-lens reflex (SLR), twin-lens reflex (TLR), rangefinder (RF), manual focus, fixed focus, and auto-focus cameras.

In the *single-lens reflex (SLR) camera,* both viewing and picture taking are performed by the camera lens. When you look through the camera's viewfinder, your vision is directed by a system of mirrors through the picture-taking lens. In this way you see exactly what the camera's lens sees and gain precise focusing and composing control.

When using an SLR camera, you view an image of the scene on a ground-glass screen. The image has been transmitted through the taking lens to the ground-glass screen by a mirror set at an angle just behind the lens. When you trip the shutter, the mirror flips up out of the way, permitting light entering the lens to be transmitted directly to the film. Figure 1–11 shows a typical SLR camera with its mirror in both viewing and taking positions. Note that normally the shutter of the SLR camera is placed behind the mirror.

Shutters of this type usually are located close to the surface of the film and operate at the camera's focal plane. Hence they are called *focal plane shutters*.

The SLR principle has been used in many types of cameras using film of many sizes and formats. Modern SLR cameras are manufactured primarily for use with 35 mm, 120, or 220 film.

The *twin-lens reflex (TLR) camera* (Figure 1–12) is distinguished by two separate but quite similar len-

Fig. 1–12 **A. Twin-lens reflex (TLR) camera.** (Bell & Howell/Mamiya Company) **B. Side-view cross-section of TLR camera.** Note that viewing and picture-taking lenses are mounted to same adjustable lens board; they focus simultaneously.

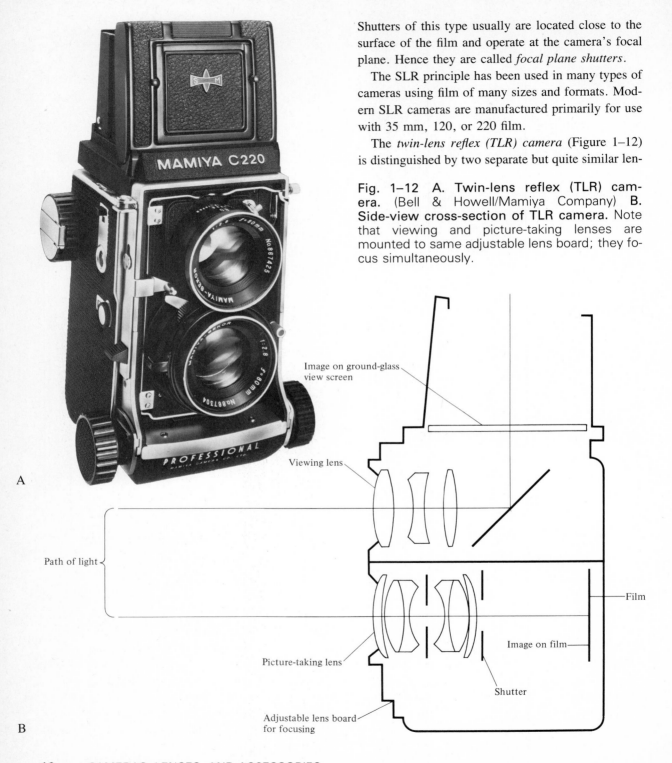

A

Image on ground-glass view screen

Viewing lens

Path of light

Picture-taking lens

Adjustable lens board for focusing

Film

Image on film

Shutter

B

ses that are mounted on the lens board at the front of the camera — one to view the scene and the other to take the picture. By using two lenses of similar optical characteristics, the viewing and taking functions can be separated while coupled to act in unison. As with the SLR camera, viewing is accomplished by means of an image focused on ground glass, which is mounted on top of the TLR camera.

Typically the upper lens of the TLR camera is for viewing, whereas the lower lens is for picture taking. The focusing adjustment moves the entire frontal lens board, including both lenses, in such a way that the images produced by both lenses are in focus at the same time. In other words, when the image on the ground glass is in focus, the image at the film plane is in focus also. TLR cameras have been produced in many sizes and formats; the most common ones available today are designed for use with 120 and 220 film. Note that unlike the SLR camera, the TLR camera normally uses a leaf-type shutter located between or just behind the lens elements.

The *rangefinder (RF) camera* (Figure 1–13) is distinguished by its separate optical system for composing and focusing. Unlike the SLR and TLR cameras that provide for viewing the image in a ground-glass screen, RF cameras provide an eye-level window that has a separate rangefinding optical system built into

it. The rangefinder system is coupled to the taking lens in such a way that adjustments in the rangefinder automatically produce adjustments in the taking lens. In this way the photographer can be certain that objects in focus in the rangefinder will be in focus in the final picture. Note that typically the rangefinder camera uses a leaf-type shutter that is located either behind the lens or between the lens element.

Fig. 1–13 A. Rangefinder camera. (E. Leitz, Inc.) B. Viewfinding and picture-taking systems.

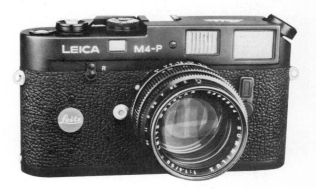

A

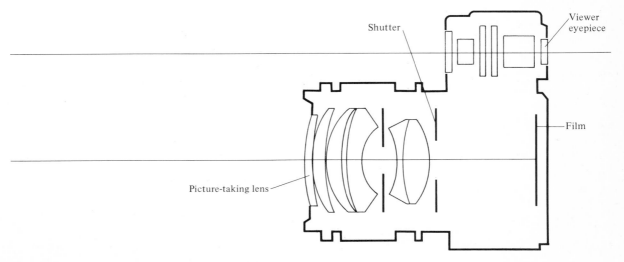

B

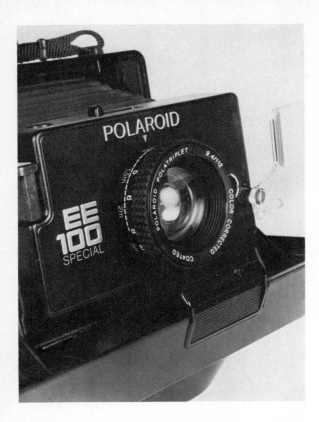

Fig. 1–14 Close-up of manual-focus camera showing focusing ring and distance scale. (Polaroid Corporation)

A *manual-focus* camera also uses an eye-level window for composing the image; however, the focusing system is separate from it. Typically, manual-focus cameras are equipped with an adjustable lens on which is inscribed a distance scale. By adjusting the focusing ring to the distance scale, the lens can be set for the estimated or measured distance between the camera and the subject. This type of viewing and focusing system is typical of simpler, inexpensive cameras that do not provide precise focusing controls. (See Figure 1–14.)

A *fixed-focus* camera also uses an eye-level window viewer for composing the image; however, it possesses no focusing system at all. With this sim-

plest of all viewing and focusing systems, fixed-focus cameras are designed to focus an image of all objects beyond some specified minimum distance from the camera.

Some manufacturers have introduced cameras equipped with automatic focusing systems. These *auto-focus cameras* emit a signal pulse of either sound or infrared light in the direction the lens is pointed. In the manner of sonar or radar, the camera's receiver translates the return reflection of the pulse into a distance reading and automatically sets the camera to focus on the reflecting object. All this occurs in a fraction of a second as the shutter is tripped to take the picture. This new technology permits focusing adjustments without the photographer having to make them.

Parallax error

The viewing system of the SLR camera provides a view of the scene that precisely matches the scene that will be recorded on the film upon release of the shutter. It does not matter if the subject is far or near because the view presented in the viewfinder is formed by the picture-taking lens. Thus, what you see in the viewfinder is what will be recorded on the film.

Other types of cameras, as we have seen, use a separate optical system for viewing and focusing, as in the case of RF and TLR cameras. When separate optical systems are used, the viewing system is displaced slightly from the optical axis of the picture-taking system. As a result, the image seen in the viewfinder may be slightly different from the image formed at the focal plane — the two systems see the subject from slightly different angles.

A separate viewfinding system is designed so that its field of view closely matches that of the picture-taking lens at average snapshot distances. However, at close-up distances, the two images may be sufficiently different as to cause a problem. This difference is what photographers call *parallax error*. Some cameras compensate for this discrepancy by providing a visual close-up frame within the viewfinder;

others correct the view by optically displacing the viewfinder image as the picture-taking lens is focused at close-up distances. Some cameras do not correct for parallax error. If your camera provides no means to correct for parallax error, you can correct for it yourself by tipping the camera slightly in the direction of the viewfinder when taking close-up pictures.

Exposure-setting systems

There are two basic settings on an adjustable camera that determine the amount of light that strikes the film — shutter speed and aperture. The length of time the shutter remains open affects the duration of the exposure; the size of the aperture affects its intensity. The simplest cameras use a *fixed exposure* system that possesses a single combination of shutter speed and aperture. Such nonadjustable cameras may be used effectively with a certain type of film under prescribed shooting conditions. Most cameras, however, are designed so that shutter speed and aperture can be adjusted to various settings, permitting use of the camera with films of various types and speeds and under many shooting conditions. Exposure-setting systems may be divided into two major classes, manual and automatic.

A *manual exposure* system requires that each of the two settings, shutter speed and aperture, be adjusted by hand. These adjustments may be made by using a published exposure guide and estimating lighting conditions. It is also possible to use an exposure meter to measure the lighting conditions and to determine exposure settings. Most photographers prefer the latter method because it is more precise. Before the 1960s, most photographers used a separate, hand-held exposure meter to determine correct exposure settings. Camera manufacturers were trying at that time to design cameras with built-in exposure meters that would simplify exposure-setting operations. The earliest built-in exposure meters required the photographer to read the meter and then set the exposure in two separate operations. Today's manual

exposure systems, using built-in microelectronics, combine the reading and setting functions into a smooth, efficient one-step operation.

As you compose the scene in the viewfinder, a meter needle or an indicator light at the edge of the viewing frame provides exposure information. Without removing your eye from the viewfinder you may adjust the shutter and/or aperture to achieve a desired exposure setting. Commonly called a *match-needle* process, this type of manual system assures simple, accurate, and consistent exposure settings. (See Figure 1–15.)

An *automatic exposure* system is designed to set the shutter speed, the aperture, or both, automatically. Since the late 1960s, camera manufacturers have designed cameras that use microelectronic and computer technologies not only to inform the photographer of lighting conditions but also to adjust the camera's exposure settings. There are three basic types of automatic exposure systems. The *shutter-priority* type requires the photographer to set the shutter speed manually while the camera sets the aperture automatically in response to lighting conditions. The *aperture-priority* type requires the photographer to set the aperture manually while the camera sets the shutter speed automatically in response to lighting con-

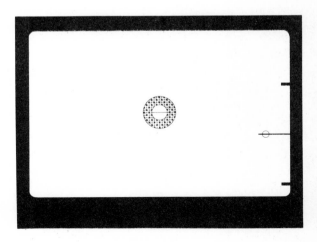

Fig. 1–15 Match-needle in viewfinder.

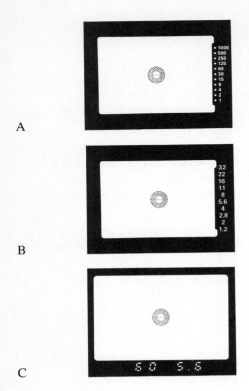

A

B

C

Fig. 1–16 Views in viewfinder. A. Shutter priority. B. Aperture priority. C. Fully automatic.

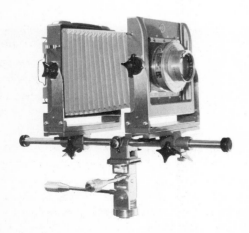

Fig. 1–17 The view or studio camera. Offers many adjustments for controlling perspective.

ditions. The *programmed automatic* type adjusts both settings automatically to a combination suitable for the lighting conditions. Better automatic exposure cameras also provide an *exposure override* control that permits the photographer to disengage the automatic functions and to adjust both settings manually. (See Figure 1–16.)

Special functions

Many cameras have been developed to meet particular needs or to perform special functions. A few of these are mentioned here to provide an idea of the variety of special-function cameras that exist today.

View and *studio cameras* are designed for work that requires precise control of perspective, depth of field, sharpness, and tone, such as in portraiture, product photography, architecture, scenic photography, and technical and scientific photography. (See Figure 1–17.) These large-format cameras load with either sheet film or 8 in. by 10 in. plates. Composing and focusing, usually time-consuming and deliberate, is accomplished through the picture-taking lens on a ground-glass screen at the back of the camera before the film is put in place. Because of their bulky size, large bellows, and many adjustments, these cameras are generally used on a tripod or other camera support.

The main advantage of the view or studio camera is its many adjustments. Lenses and shutters are completely interchangeable. In addition the lens and film can be swung and tilted in relation to each other as well as displaced from the center of the optical axis, making the camera extremely useful for correcting and controlling optical distortions and perspective effects. Interchangeable backs permit the use of roll films and instant films, as well as sheet films.

Another special type of camera is the *instant camera*. Together with its instant film, this camera produces a finished print immediately after the picture is taken without darkroom processing. The modern instant camera is designed to use a special film pack

containing a complete system of chemically treated film and paper for either black-and-white or color prints. The processing chemicals are activated within the camera and, in seconds, a finished print is produced. A major advantage of instant photography is that a finished print is immediately available. A major disadvantage is that duplicates and enlargements of the finished picture cannot usually be made easily. Although printable negatives can be obtained with a special type of instant film, duplicates and enlargements are usually available only by copying the original print. (See Figure 1–18.)

There are essentially three ways of obtaining photographic images that take in a wider angle of view than is normally seen by the human eye. One is to use what is called a wide-angle lens, which is discussed later in this unit. Another is to create a montage of several photographs, each of which has been taken from precisely the same camera position but with the camera pointed in a slightly different direction than for the adjacent photographs. These several photographs are then carefully trimmed, aligned, and mounted so as to create a single, panoramic image. The third way is to use a *wide-angle camera*. These cameras have either an external revolving lens and shutter or a special wide-angle optical system. They are especially useful for architectural work, panoramic landscapes, and large group photographs.

Circumstances that require protecting camera equipment against the intrusion of water arise more often than we think. Certainly we might like on occasion to take a camera underwater to photograph the flora, fauna, and terrain. But we may also find ourselves in a rainy climate, in snow, on a canoe trip, or exposed to ocean spray. In all of these cases an ordinary camera may not be up to the task. The *underwater camera* is a specialized piece of equipment that is designed for use when fully submersed in water down to some specified depth. In addition, some manufacturers offer *underwater housings* designed for deep-water use of their particular models. Also, some specialty manufacturers make plexiglas housings for general camera use. These, however, are not

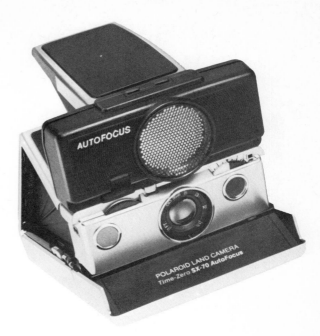

Fig. 1–18 Instant camera. (Polaroid Corporation)

generally for deep-water applications. Equipment designed for underwater use will also serve with other kinds of wet shooting conditions.

Stereo cameras are designed to take two pictures simultaneously through two separate but identical optical systems spaced a few inches apart — like human eyes. The resulting image pair may then be mounted for use in a stereo viewer to obtain a three-dimensional view of the original scene. Some camera manufacturers make stereo attachments for use with their own models.

Press cameras are often identified as special-function cameras. For many years press photographers preferred large-format cameras that could be used in a wide variety of situations — 2¼ in. by 3¼ in. or 4 in. by 5 in. for example — so that the images would not require great magnification. For a long time the Graflex camera was the standard of the industry. It was bulky, heavy, and hard to manage, but it was

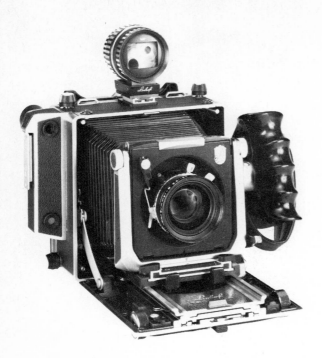

Fig. 1–19 4-in. by 5-in. (10 cm by 13 cm) sheet film camera. (HP Marketing Corp., Linhof Division)

reliable and rugged and its reflex design reduced the uncertainties of proper focusing. The Graflex was later replaced in popularity by the 4-in. by 5-in. Graphic, which along with its cousins and imitators remained in common use for many years. It used 4-in. by 5-in. sheet film, had an adjustable bellows, and certain versions had both focal plane and between-the-lens shutters, which allowed for both ground-glass and eye-level focusing. Figure 1–19 shows a modern 4-in. by 5-in. camera.

Today's press photographer, however, often uses a variety of cameras and any camera preferred by a press photographer may serve as a press camera. The availability of high-speed, fine-grain films, electronic flash units, and fast, high-resolution lenses makes possible the use of medium and small format cameras for press purposes. The press photographer often carries several lightweight cameras, supplementary len-ses, and accessories for use under various conditions and for the many purposes encountered in press work.

Summary

As you can see, many types of cameras are available to suit a variety of needs, tastes, and special purposes. Selecting a camera often can prove a confusing and frustrating task for those with little prior experience in photography. In recent times, new camera technologies have developed so rapidly that today's newest model will likely become obsolete within a few years. In fact, the economics of camera manufacture encourages rapid turnover of models so that owners will want to upgrade their equipment frequently and thereby create a constant market for new camera products.

No one camera or set of features will satisfy all needs and purposes. Each photographer develops unique working habits and becomes especially comfortable with some particular camera configuration. In the long run, only experience will reveal to you what features you are likely or unlikely to use. Only experience will reveal to you what type of camera will best serve your own picture-taking style. Obviously, there is little economic advantage to paying a premium price for features that you do not need and will not use.

The novice photographer, therefore, is usually well advised to begin with a borrowed, hand-me-down, or inexpensive camera that provides adjustable focus, aperture, and shutter speed. A little experience will improve one's judgment about what additional features will be likely to prove useful in the longer run.

Do Exercise 1–B on page 30

If you have been following directions, you will have completed Exercise 1–B on page 30 before starting Objective 1–C.

Lens Characteristics

Two major characteristics of the camera lens that affect the image are its focal length and its speed.

Focal length

The *focal length* (*F*) of a lens is the distance between the lens and the *focal point* where a sharp image of an *object at infinity* is formed. Have you ever used a magnifying glass to focus an image of the sun on a piece of paper or a leaf? The focal length of the magnifying glass is the distance between the glass and the image of the sun when it is in sharp focus. The sun, of course, is very far away and we may consider it an *object at infinity*. Practically speaking, we may consider any object more than fifty feet away from the lens an object at infinity. Figure 1–20 shows how the focal length (F) of a lens is determined.

Fig. 1–20 Focal length (F). Focal length (F) is the distance between the optical center of a lens and the plane in which the image of an object at infinity is resolved into sharpest focus. Most lenses have a fixed focal length, which is inscribed on the lens barrel. Some lenses, such as zoom lenses, have a variable focal length, the limits of which are inscribed on the lens barrel.

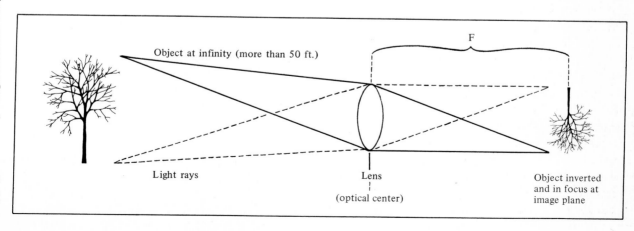

Object at infinity (more than 50 ft.)

F

Light rays

Lens
(optical center)

Object inverted and in focus at image plane

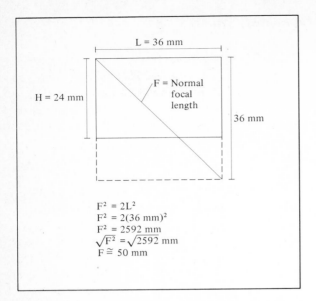

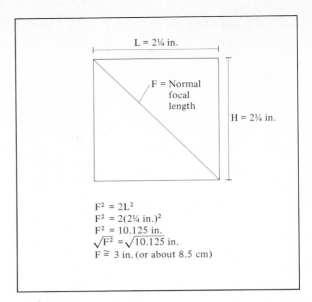

Fig. 1–21 Calculating the focal length (F) of a normal lens. F is approximately equal to the diagonal of a square whose sides are equal to the length of the negative format. Given length (L) of a negative, the normal focal length is F = $\sqrt{L^2 + L^2} = \sqrt{2L^2}$. Thus, for a standard 35-mm negative format (24 mm by 36 mm), normal F = $\sqrt{2(36^2)} = \sqrt{2592} \cong 50$ mm. The normal F for 2 ¼ in. by 2 ¼ in. (6 cm by 6 cm) is approximately 3 in. (85 mm).

You do not have to measure the focal length of a lens — the manufacturer inscribes this information on the lens barrel. The focal length of most lenses never changes because it is a characteristic of the design to which the lens is ground.

Normally a camera is fitted with a lens having a focal length approximating the diagonal of the *image format* used in that camera. Thus the *normal lens* for a camera using a 2¼-in. by 2¼-in. (6 cm by 6 cm) image format would be approximately 3 in. (85 mm). The normal lens for a 35-mm camera using a 24-mm by 36-mm format would be approximately 50 mm. Figure 1–21 shows how this was calculated using the formula for finding the diagonal of a square based on the length of the image format.

Lenses having a longer-than-normal focal length are commonly known as *telephoto lenses;* their use will increase the image size on the film. The effect is similar to looking at an object through a telescope. Lenses with shorter-than-normal focal length are known as *wide-angle* lenses; their use will reduce the image size on the film. The effect is that more peripheral details are included in the picture at any given distance. Lenses with longer or shorter focal lengths generally have differing angles of view. That is, they usually see less or more of the peripheral details in a scene than would a normal lens at the same distance. Figure 1–22 shows the different angles of view usually associated with lenses of differing focal lengths.

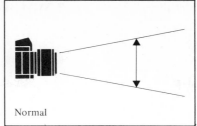
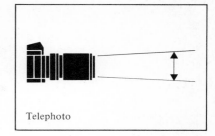

Wide angle

Normal

Telephoto

Fig. 1–22 Angles of view of various lenses used with 35-mm cameras.

A *zoom lens* possesses a variable focal length designed to be set at any point between the limits of its range. A 35-mm–70-mm zoom lens, for example, may be set to any focal length between 35 mm and 70 mm by adjusting a ring on its barrel.

Speed

A second major characteristic of a lens is its *speed*. The speed of a lens expresses how much light the lens will produce at the focal plane when it is open to its widest aperture. Just as a large window allows much light into a room, a large lens opening allows much light into the camera. Smaller windows, as smaller apertures, allow less light to pass. The speed of a lens is expressed by the symbol *f/–*, such as f/2.8 or f/2.0. The more light the lens allows to pass, the "faster" the lens.

Actually, the f/value of the lens is a precise way of expressing the relationship between the diameter (d) of the lens at its *maximum aperture* and the focal length (F) of the lens. The f/value of a lens is calculated as follows:

$$f/ = \frac{focal\ length}{diameter\ of\ lens} = \frac{F}{d}$$

For example, if the focal length were 50 mm and the diameter were 25 mm, then the speed of that lens would be

$$f/ = \frac{F}{d} = \frac{50\ mm}{25\ mm} = f/2$$

Any given f/value defines an exact relationship between the lens aperture and the area of the image format no matter what camera or lens is in use. The system of f/values provides a common standard of light measurement for all cameras under all conditions.

The manufacturer inscribes the f/value on the barrel of the lens. An f/2.0 lens has a diameter that measures one-half of its focal length; an f/4.0 lens has a diameter one-fourth of its focal length, and so on. The greater the diameter of the lens, the more light can pass through it at its widest aperture. Thus larger diameter lenses for any given focal length are faster lenses; f/2.0 is faster than f/4.0, f/4.0 is faster than f/5.6, and so on.

Mounting systems

Cameras that allow one to change lenses employ lens-mounting systems for attaching lenses to the camera body. Most such cameras employ a *bayonet-mount* system by which the lens is aligned and seated in the mount and rotated a quarter turn to lock it in place. Some older cameras use a *threaded-mount* system by which the lens is screwed into place in the camera body. Most manufacturers use their own mounting design so that one manufacturer's lenses generally will not fit directly to the camera body of another manufacturer. However, many lens makers manufacture *mounting adapters* that make it possible to mount their lenses to many popular camera bodies.

Do Exercise 1–C on page 31

Fig. 1–23 A. Lens hood. B. Lens cap.

Common Accessories

Objective 1–D Describe several common accessories used with adjustable cameras.

Key Concepts lens hood, lens cap, tripod, cable release, camera case, camera bag, exposure meter, flash unit, filters, automatic winder, motor drive, teleconverter, supplementary lenses, extension tubes, extension bellows

Hundreds of accessories are commonly available for simple as well as for complex cameras. Many are frequently, even constantly useful, while others are only rarely useful for special purposes. Some of these accessories are described briefly in the general order of their usefulness in beginning photography.

A *lens hood* is a detachable device fitted to the front of the lens to shade the lens surface from extraneous light. Use of a lens hood can improve image quality by reducing internal flare. It also protects the lens from accidental damage.

A *lens cap* is a detachable, opaque cover fitted to the front of the lens to protect it and to block the passage of light. Generally used when storing the camera, the lens cap must be removed for picture taking. Some cameras with battery-operated light meters rely on use of the lens cap between shots to reduce battery drain. (See Figure 1–23.)

A *tripod* is a portable, three-legged device used to support and stabilize the camera during lengthy setups and long exposures. When slow shutter speeds are used (as they are in weak lighting situations), the slightest movement of the camera will blur the image on the film to some degree. A tripod is useful in such situations to eliminate the unavoidable movement of the hand-held camera. For slow shutter speeds, the use of a *cable release* is also recommended. Such a

device enables the photographer to release the shutter without touching or holding any part of the camera body. (See Figure 1–24.)

Most cameras may be provided with a snug-fitting *camera case* designed to enclose and protect the camera. Referred to as ever-ready cases, they are designed so that the camera can be used quickly without removing it from the case. Most photographers, however, prefer to remove the camera case altogether while shooting, to reduce weight and to simplify camera handling and film changing. Many manufacturers also make hard-bodied, fitted camera cases for their equipment, designed to hold the camera and several accessories in neat compartments for storing and shipping.

Probably more useful in actual shooting is the soft-bodied *camera bag*, often called a gadget bag, designed to be carried from the shoulder. These are made in a great variety of sizes and shapes with various, often adjustable, interior compartments and pockets. You can choose one that suits your camera equipment and shooting style. (See Figure 1–25.)

An *exposure meter*, or light meter, is an essential accessory for an adjustable camera. It is used to measure the intensity of light in a given scene and to aid in determining exposure. Though many cameras have built-in exposure meters, photographers often carry an accessory hand-held meter as well to use when the built-in meter is inadequate. Use of the exposure meter is explained in Unit 3.

For controlling and improving lighting conditions, a *flash unit* is an essential camera accessory. The most common units today are flashcubes and electronic flash units that provide a measured burst of light synchronized with the camera's shutter. Use of flash units is explained in Unit 9.

The way the human eye perceives color does not always agree with the way film responds to the same color. To be sure that a film will render the colors of a subject the way we wish them to appear, it is often necessary to use *filters*. A filter is a detachable device fitted to the front of the lens and designed to alter the color of the light transmitted to the film. By this means,

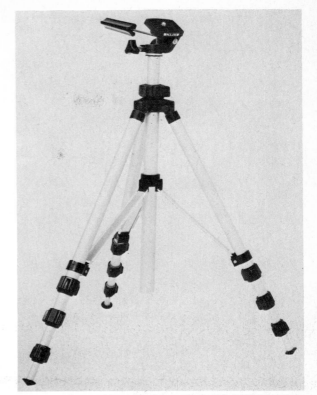

A

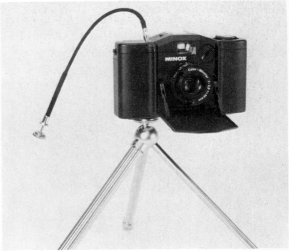

B

Fig. 1–24 A. Lightweight compact tripod. (Slik Division, Berkey Marketing Companies, Inc.) B. Camera with cable release on a tripod. (E. Leitz, Inc.)

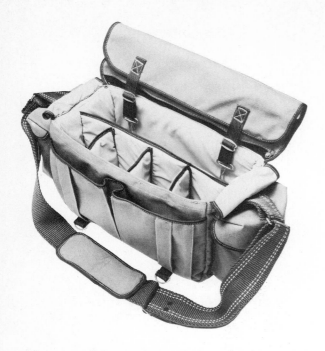

Fig. 1–25 Soft-bodied camera bag. (Smith & Son, Inc.)

Fig. 1–26 Automatic power winder. (Canon U.S.A., Inc.)

the gray-scale rendering of various colors can be controlled in black-and-white photography and color rendering can be controlled in color photography, either to obtain correct color rendition or to create special effects. Use of filters is explained in Unit 7.

Many modern cameras are available with a device for advancing the film automatically after each exposure. An *automatic winder* is useful when photographing rapid action or fast-moving events because the viewfinder need not be taken from the eye to advance the film. Some newer cameras have built-in automatic winders; however, automatic winders are more generally available as accessories. The simplest type is the power winder that advances the film at a rate of about two frames per second. The professional type is the *motor drive* that advances the film under force at a rate of about five frames per second. Automatic winders have battery-powered motors and add considerable weight when attached to the camera. (See Figure 1–26.)

Some accessories are designed to extend the uses of lenses. For example, the *teleconverter* may be used to increase the focal length of a lens. Commonly available as 2X, 3X, or 4X converters, they will double, triple, or quadruple, respectively, the focal length of any lens used with them. Thus, a 50-mm lens used with a 3X converter becomes a 150-mm lens. Though this procedure has optical disadvantages, it has the advantage of providing telephoto capability that is lighter and cheaper than an equivalent telephoto lens. Another function may be performed by a *supplementary lens,* which is used in front of the primary lens to shorten its effective focal length. The most common supplementary lenses are used for portraits, close-ups, and special effects. *Extension tubes* and *extension bellows* are used with interchangeable lenses for close-up focusing in making extreme close-ups. (See Figure 1–27.)

The accessories discussed here are the most common used in general photography, although hundreds of others are made and sold to meet a great variety of special needs and purposes.

Do Exercise 1–D on page 32

Care of the Camera

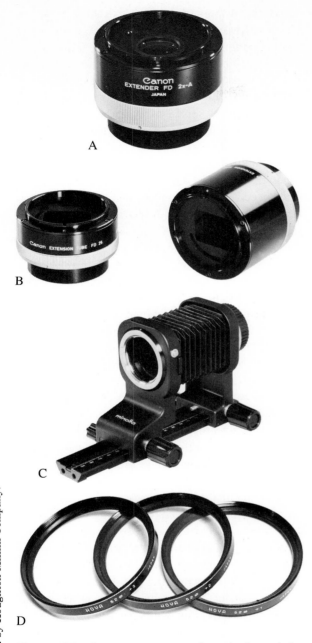

Fig. 1–27 Camera accessories designed to extend the uses of lenses. A. Teleconverter (extender). (Canon U.S.A., Inc.) B. Extension tubes. (Canon, U.S.A., Inc.) C. Extension bellows. (Minolta Corporation) D. Supplementary lenses.

> **Objective 1–E** Describe some important camera "housekeeping" practices.
>
> **Key Concepts** lens tissue, lens-cleaning solvent, lens brush, spring tension, light fog

Good housekeeping in photography begins with the camera. Proper care of the camera and the film within it are the first essentials for obtaining the best final results with your camera.

I. Keep the lens clean and protect it from chips, scratches, dampness, and heat.

The most vulnerable part of your camera is the lens. It is a precision instrument. In most cases the lens is a combination of several soft glass elements. Some are cemented together with a resin that is affected by heat or dampness.

The lens should be cleaned with a piece of soft *lens tissue* or a bit of lintless, clean linen. A soiled cloth may have dust on it, which could scratch the soft lens surface. Certain cloth fibers may be brittle and could also scratch the lens surface. Also available commercially are hand-held cannisters of compressed air made to photographic standards that may be used for cleaning lenses.

If the lens is coated too thickly with dust and grease, a drop or two of a *lens-cleaning solvent* may be needed. Lens-cleaning solvent should be applied to a lens tissue and then gently to the lens — never directly to the surface of the lens. Do not touch the glass surface with your fingers — they will deposit oils and acids harmful to your lens. Do not breathe on the lens or wipe it with a facial tissue or handkerchief from your pocket. The moisture in your breath may be as harmful to your lens as the coarse fibers in ordinary cloth and paper tissue.

When your camera is idle, keep it in a cool, dry, clean place. If your lens does not fold back into the camera body where it is protected, use a lens cap and store your camera in a case or drawer. Many photographers prefer to use an ultraviolet filter over the lens at all times to protect it from scratches.

2. Keep your camera clean and protect it from heat, shock, and dampness.

Dust sometimes seeps into the interior of a camera, where it is attracted to the smooth, soft surface of the film. Dust on the film shows up as black blemishes on your finished prints. Make it a habit to keep the inner face of the lens and inner surfaces of the camera dust-free. Use a soft *lens brush* for cleaning the interior of the camera when you change film.

Use a camera case to protect against dust and to shield the camera from casual bumps and shocks that occur in the everyday handling of the camera.

Avoid storing your camera where it will be exposed to extreme temperatures or dampness. Automobile glove compartments may seem like attractive storage places, but they become excessively hot during the summer months. Heat will affect both your film and your lens and should be avoided carefully. Boats, basements, and similarly damp places also should be avoided. Dampness will affect your film, your lens, and the metal parts of your camera.

3. Relax all mechanical tensions and remove batteries during inactive periods.

Do not leave the shutter of your camera cocked when it is to be stored for a period of time. Release all *spring tension* adjustments built into your camera before storage. Springs under tension tend to lose their strength over time and shutter speeds or other fine adjustments may become unreliable. Remove batteries from battery-powered cameras and accessories to prevent damage from leakage.

4. Load film in subdued light and store it in a cool, dry place.

Never load film in direct sunlight. The backing paper and packing provide excellent protection for films, and with reasonable care all danger of *light fog* can be eliminated. Light fog is the exposure of the film to some ambient source of light. Handling film in direct, strong sunlight may expose the edges of the film and thus damage the film.

Likewise, avoid storing the film where it may be exposed to heat. Not only should glove compartments be avoided, but also any place that has high temperatures from trapped heat during summer months. A suitcase carried on top of a car and exposed to the sun may become excessively hot during a trip. It is a poor place for film storage. When traveling buy fresh film as you need it. Many photographers refrigerate their film for maximum freshness. Refrigerated film must be brought to normal temperature before use.

5. Have your camera inspected regularly.

Have an expert inspect your camera for light leaks and internal dirt in the lens approximately once a year. The shutter and diaphragm should be tested for accuracy and the mechanism for holding the film flat during exposure should be checked. Small maladjustments in your camera can lead to major disappointments in the final photographs.

6. Never attempt to repair or service your camera yourself.

Cameras are precision instruments. Repairs and service should be performed only by a skilled, reputable technician. Resist any temptation to do this work yourself and you will save yourself needless expense and regret.

Do Exercise 1–E on page 33

Good Habits of Camera Use

> **Objective 1–F** Describe some good habits of camera use.
>
> **Key Concepts** expiration date, outdated film, film advance, viewfinder, range, focus setting, infinity setting, camera shake

1. Label your camera with the kind of film in it and the expiration date.

If your film has been in the camera for some time — and if you have misplaced the empty carton — you may forget the kind of film in the camera and its *expiration date*. Different types of film have different photographic qualities. As the film ages, its sensitivity to light may become impaired. Eventually the aging process may render the film totally useless. Never shoot with *outdated film*. Note the type of film and its expiration date on a small tab of masking tape and mount it on the camera body when you load the camera.

2. Advance the film after each exposure.

You may waste film and lose picture opportunities unless you operate the *film advance* after each exposure. Unless your habit is consistent, you may raise your camera to shoot only to find that the film has not been advanced and the camera is not ready. If your camera is the type that cocks the shutter spring as you advance the film, be sure to shoot off the last picture to release the shutter spring before putting the camera away.

3. Carry extra film with you.

Don't risk running out of film on a photographic expedition. Always carry a few extra rolls with you.

4. Use your viewfinder.

Your eyes may be dazzled by a grand scenic view — but your camera won't take in anything outside the frame of the film. The camera's *viewfinder* is designed to show exactly what details will appear in the frame of the film. Use your viewfinder to compose the photograph within that frame.

5. Correct for parallax error when shooting close-ups with a viewfinder camera.

Cameras with optical viewfinding systems that are separate from the picture-taking system may not see exactly the same image as that formed by the picture-taking lens, especially when shooting close-ups. If necessary, correct for this discrepancy by pointing the camera slightly in the direction of the viewfinder after composing your image. (See Figure 1–28.)

6. Know your camera's capabilities.

Don't try to take pictures beyond your camera's capabilities. If you need shutter speeds or lens apertures faster than your camera has, you will be disappointed in the finished photographs. Know how your camera works and what it will do so your picture taking will become automatic.

7. Get the *range*.

Your *focus setting* should be accurate for subjects at any distance, but it is especially important at shorter camera-to-subject distances. Distances less than 6 feet even may require using a tape measure if your camera has no visual focusing mechanism. For distances of 30 feet or more, your focusing has wider latitude — you need only approximate the distance. With a normal focal length lens, the *infinity setting* can be used if your camera-to-subject distance exceeds 50 feet.

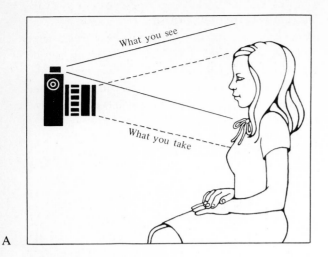

A

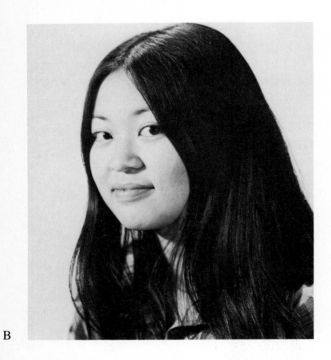

B

C

Fig. 1–28 Parallax effect. A. Image seen in viewfinder may differ from image seen by picture-taking lens. Subject may appear perfectly centered in viewfinder (B) while picture-taking lens is seeing off-center view (C). To remedy parallax effect, tip camera slightly in direction of viewfinder from picture-taking lens.

8. Avoid camera shake.

Camera shake, movement of the camera while the shutter is in motion, results in a blurred image. Learn to handle your camera so that the shutter release is operated by one finger, trigger-fashion, while the rest of your hand holds the camera steady. Stand firmly with legs apart. Give the camera support not only with your hands but also with your whole body. If you are using an eye-level viewfinder, snuggle the camera against your cheekbone. When using slow shutter speeds, hold your breath while releasing the shutter. When using very slow shutter speeds, rest the camera on a solid object or use a tripod while shooting.

9. Wait before you load up with accessories.

Don't succumb to the temptation to buy too many accessories until you know what your camera can do without them. A good camera, well used, probably will produce results that are as good as or better than those produced by a mediocre camera cluttered with extras and poorly used.

Do Exercise 1–F on page 33

Suggested references

Craven, George M. *Object and Image: An Introduction to Photography.* Englewood Cliffs, N.J.: Prentice-Hall, 1975. Chapter 3.

Davis, Phil. *Photography,* 3rd ed. Dubuque, Iowa: William C. Brown, 1979.

Jacobs, Lou, Jr. *Photography Today.* Santa Monica, Calif.: Goodyear, 1976. Chapters 2, 3, 4.

Rhode, Robert B., and F. H. McCall. *Introduction to Photography,* 4th ed. New York: Macmillan, 1981. Chapters 3, 8.

Swedlund, Charles. *Photography,* 2nd ed. New York: Holt, Rinehart and Winston, 1981. Chapters 2, 3.

Teeman, Lawrence, ed. *Photographic Equipment Test Reports Quarterly,* Skokie, Illinois: Consumer Guide.

Time-Life Books, *Life Library of Photography: The Camera.* New York: Time, Inc., 1970. Chapters 2, 3, 4.

Suggested field and laboratory assignments

1. Assemble your camera kit and supplies. A suggested starter list for completing the suggested assignments in this book is provided in Appendix A.

2. Arrange for the use of a photographic darkroom and equipment. Darkrooms and equipment are often available through schools, community centers, recreation centers, photographic retailers, and photography clubs. Try looking up "Dark Room Rentals" in your local telephone company's Yellow Pages.

HOW TO USE THIS BOOK

Practice tests
When you complete the field and laboratory assignments in each chapter, proceed to the practice test at the end of the chapter. Proceed now to Practice Test 1 on page 35.

EXERCISE 1–A

1. Label the lettered parts of the following illustrations in the spaces provided below.

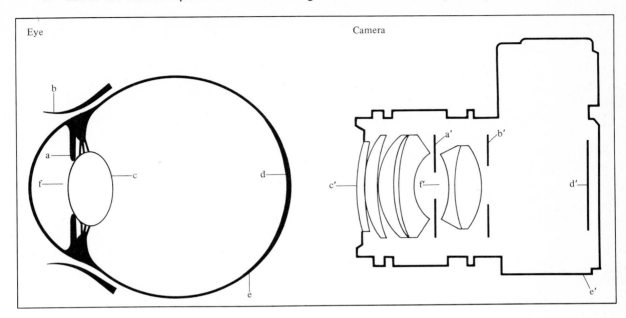

a. _____ a'. _____

b. _____ b'. _____

c. _____ c'. _____

d. _____ d'. _____

e. _____ e'. _____

f. _____ f'. _____

2. Adjusting the camera's iris diaphragm changes the size of the _____.

 This affects the light entering the camera by changing the _____

 _____.

3. You should pay special attention to background details in your viewfinder because

_____.

HOW TO USE THIS BOOK

Objectives and exercises
Notice that these exercise pages are perforated so you can remove them from the book without destroying the basic content.
 Now that you have completed Exercise 1–A, return to Objective 1–B on page 3. Note the objective and the key concepts. Then read the material.

EXERCISE 1–B

For the following cameras, list the distinguishing characteristics, such as body type, film size, location of shutter, type of viewing and focusing, exposure system, and other significant features and adjustments.

1. 120 camera: _____

2. 110 camera: _____

3. Automatic exposure camera: _____

4. 35-mm camera: _____

5. Single-lens reflex (SLR) camera: _____

6. Rangefinder camera: _____

7. Twin-lens reflex (TLR) camera: _____

8. Manual exposure camera: _____

9. Large-format camera: _____

HOW TO USE THIS BOOK

Objectives and exercises
Now that you see how the system works, return to Objective 1–C on page 17 and complete the rest of the objectives and exercises in Unit 1.

EXERCISE 1–C

1. Define focal length. _____

2. Define f/value. _____

3. The speed of your camera's lens is _____.

4. The speed of your camera's lens is (faster than, slower than, the same as) a lens with a speed of f/2.0. (Circle one.)

5. What would the focal length (F) of a normal lens be for a camera that uses a 2¼-in. by 3¼-in. film format? _____

6. A lens with a focal length shorter than normal for any given camera is called a _____ lens. It will have an angle of view (wider, narrower) than the normal lens. (Circle one.)

7. A lens with a focal length longer than normal for any given camera is called a _____ lens. It will have an angle of view (wider, narrower) than the normal lens. (Circle one.)
Return to Objective 1–D on page 20

EXERCISE 1–D

Briefly state the function of each of the following common accessories:

1. Lens hood _____

2. Lens cap _____

3. Tripod _____

4. Cable release _____

5. Exposure meter _____

6. Flash unit _____

7. Filters _____

8. Automatic winder _____

9. Teleconverter _____

10. Supplementary lenses _____

11. Extension tubes and bellows _____

Return to Objective 1–E on page 23

EXERCISE 1–E

Good housekeeping rules for cameras are only common sense. See if you can apply these common sense principles by answering "true" or "false" to the following questions.

_____ 1. A good place to store your camera is under the seat of your car.

_____ 2. If you are shooting at the beach and need to reload your camera, it would be a good idea to find someone with an umbrella or a car nearby.

_____ 3. Never clean a lens with anything but lens tissue and liquid lens cleaning solution.

_____ 4. Always keep a roll or two of film in the glove compartment of your car so you won't miss a picture opportunity.

_____ 5. If the children in your home must have a camera to play with, get them an inexpensive box camera and make your own camera out-of-bounds.

_____ 6. Always store your camera cocked and ready for action.

_____ 7. To save money, perform minor camera repairs yourself.

Return to Objective 1–F on page 25

EXERCISE 1–F

List four or more good camera habits that you will try to develop.

1. _____

2. _____

3. _____

4. _____

HOW TO USE THIS BOOK

References and assignments
Now you have completed all six objectives in Unit 1. At this point in each unit there is a list of references that may help you clarify the content of the unit or provide additional information of special interest to you.

Following the references are some field and laboratory assignments to give you practical experience. In the first assignment you are asked to assemble your basic tools. In later assignments you will begin making pictures.

Review the references and do the suggested field and laboratory assignments on page 27 now.

HOW TO USE THIS BOOK

Taking practice tests
At this point you should have com-
pleted all six objectives in Unit 1 and
your field and laboratory assignments.
 Concluding each unit is a practice
test. It is strictly to help you check your
own understanding and knowledge.
Prepare for it as you would for any test.
Study, review, and then take the test
without referring to the materials you
have studied. Make it a true test of your
knowledge.

PRACTICE TEST 1

For each of the following questions, select the one *best* answer and write its corresponding
letter in the blank preceding the question. After you have completed the test, check your
answers against the correct answers, which follow the test. If you miss any of the test items,
review the study materials suggested.

_____ 1. What part of the human eye performs the same function as the camera's film?
 A. lens
 B. retina
 C. iris
 D. eyelid
 E. pupil

_____ 2. Which of the following cameras is NOT equipped with bellows?
 A. folding
 B. twin-lens reflex
 C. 4-in. by 5-in. Graphic
 D. view
 E. all of the above are equipped with bellows

_____ 3. A camera with an f/1.0 lens has a _____.
 A. very fast lens
 B. very slow lens
 C. lens diameter equal to its focal length
 D. both A and C
 E. both B and C

_____ 4. To clean smudges from the lens surface _____.
 A. blow gently on the lens and wipe with a handkerchief
 B. wipe lightly with a damp finger and dry
 C. use lens-cleaning solvent and wipe with lens tissue
 D. breathe on the lens and wipe with lens tissue
 E. wipe gently with a dampened facial tissue

_____ 5. With a twin-lens reflex camera you can correct for parallax by _____.
 A. setting to a faster shutter speed
 B. stopping down
 C. tilting the camera slightly upward
 D. changing to a faster film
 E. setting the camera on a tripod

_____ 6. "The camera sees indiscriminately; the eye sees selectively." This statement means that _____.
 A. the eye sees color, but the black-and-white film of the camera sees only shades of black, white, and gray
 B. you should beware of lamp cords, picture frames, and telephone wires that your camera will see but you may not
 C. it is better to compose with the eye than with the camera's viewfinder
 D. the camera will record every detail of a scene, whereas you may not notice every detail
 E. both B and D

_____ 7. The common format of the modern _____ camera is 2¼ in. by 2¼ in.
 A. Graphic
 B. 35-mm
 C. view
 D. twin-lens reflex
 E. box

_____ 8. Your lens has a maximum aperture diameter of 2 in. and a focal length of 4 in. What is the speed of your lens?
 A. f/8.0
 B. f/4.0
 C. f/2.0
 D. f/1.0
 E. f/.5

_____ 9. During storage the camera should be _____.
A. placed in a clean, dry place
B. stored with the shutter uncocked
C. housed in a well-protected place
D. stored with the lens covered
E. all of the above

_____ 10. Which of the following is the recommended way to record the kind of film in your camera?
A. Always use the same kind of film.
B. Keep the film container box handy.
C. Keep the film wrapper handy.
D. Write it on a slip of paper.
E. Write it on masking tape and affix the tape to your camera.

_____ 11. The aperture of the lens is regulated by adjusting the camera's _____.
A. shutter
B. iris diaphragm
C. viewfinder
D. distortion rectifier
E. light-sensitive film

_____ 12. For maximum focusing and perspective control, portrait photographers often prefer a _____ camera.
A. box
B. folding
C. view
D. twin-lens reflex
E. 35-mm

_____ 13. A lens of shorter-than-normal focal length is a _____ lens.
A. slower-than-normal
B. zoom
C. faster-than-normal
D. wide-angle
E. telephoto

_____ 14. Which of the following may be used to clean dust from the interior of the camera?
A. soft lens brush
B. cleaning solvent
C. breath
D. facial tissue
E. dry, clean cloth

_____ 15. Good habits of camera use would suggest that you _____.
A. label your camera with the kind of film that is in it
B. never carry more film than you need
C. use your viewfinder
D. avoid splurging on accessories until you master your camera
E. all except B

_____ 16. An accessory used to support and stabilize the camera is a(n) _____.
A. teleconverter
B. cable release
C. automatic stabilizer
D. tripod
E. camera supporter

_____ 17. An accessory that helps take a rapid sequence of shots without removing your eye from the viewfinder is a(n) _____.
A. automatic winder
B. flash unit
C. extension tube
D. teleconverter
E. supplementary lens

_____ 18. An accessory that alters the color of light transmitted to the film is a(n) _____.
A. lens hood
B. teleconverter
C. supplementary lens
D. extension bellows
E. filter

ANSWERS TO PRACTICE TEST 1

1. B If you missed the answer to this question, review Figure 1–1 on page 2.
2. B The twin-lens reflex camera is the only camera not usually equipped with a bellows. See "Basic Camera Types," page 3.
3. D f/1.0 is a very fast lens with diameter equal to focal length. See "Lens Characteristics," page 17.
4. C Do not use breath or fingers to clean your lens because they contain oils and acids harmful to the lens. Do not use cloth or facial tissues because they may contain dust or abrasive fibers that may cause microscopic scratches on the lens surface. See "Care of the Camera," page 23.
5. C See Figure 1–12 on page 10 if you missed this. Remember, the viewing lens is *above* the taking lens on the twin-lens reflex camera. If you are taking a close-up, you must tilt the camera slightly upward, toward the viewing lens, so that the taking lens will see the same picture as the viewfinder.
6. E Both B and D are correct. You may not notice lamp cords, picture frames, and telephone wires because you are concentrating on your subject. But your camera may see these details and record them in your picture.
7. D Refer to "Basic Camera Types," page 3, if you missed this. Of the alternatives given, only the modern TLR commonly produces 2¼-in. by 2¼-in. negatives. It generally uses size 120 film.

8. C The f/value of a lens is calculated by dividing the focal length (F) by the diameter of the lens. In this question you divide 4 in. by 2 in. to find the maximum aperture, which tells you how fast the lens is. By the way, there is no f/.5, as you will learn in the next unit. If you divided 2 in. by 4 in. you should review "Lens Characteristics," page 17.

9. E All the alternatives are correct. E is the one *best* answer.

10. E See "Good Habits of Camera Use," page 25. Also be sure to record the film's expiration date.

11. B Remember the comparison between the eye and the camera. The iris of the eye and the iris diaphragm of the camera regulate the size of the opening that admits light. See "Eye and Camera," page 1.

12. C Although portrait photographers could use any of the cameras listed, they frequently use the view or studio camera because of the qualities described in "Basic Camera Types," on page 3.

13. D A shorter-than-normal focal length is a wide-angle lens; it reduces image size and accepts a wider angle of view. A longer-than-normal focal length increases the image size and accepts a narrower angle of view. This would be a telephoto lens. If you confused focal length (F) with lens speed (f/), restudy "Lens Characteristics," page 17.

14. A Lens tissues and lens-cleaning solvents are used for lenses. A soft brush can be used to remove dust from the surface of a lens before applying solvent and is also ideal for cleaning dust from the crevices within the camera. Facial tissues and cloth may leave more particles of dust and fiber than they remove.

15. E You should always carry extra film with you. Don't risk running out. All other alternatives were identified as good camera habits in "Good Habits of Camera Use," page 25.

16. D A portable tripod is used for these purposes during lengthy setups and long exposures. See page 20.

17. A Though they are heavy and expensive, automatic winders are useful for this purpose. See page 22.

18. E This is the filter's specific purpose. See page 21.

HOW TO USE THIS BOOK

Mastering the content

If you answered all the test items correctly, you have mastered the content of Unit 1. If you missed any, go back and review the content for those items until you understand them.

If you are using this book as part of a course, your instructor will give you instructions about turning in your exercises and assignments and taking the final unit test.

When you have successfully completed the requirements for Unit 1 you will have demonstrated your mastery of the unit objectives and will be ready for the next unit. And so you should proceed through this book — one objective at a time, one unit at a time — mastering the content as you go along. Try to set up your own schedule and stick to it; with mastery you should develop skill in communicating your ideas and feelings through photography.

FILMS

U N I T 2

2

Composition of Black-and-white Film

A young child with his or her first camera often is tempted to look at a roll of undeveloped film in full light to ''see the pictures.'' Until the film is developed, however, there is no outward clue to the pictures stored in it. Ordinary film consists of a flexible, transparent support material on which there is a smooth, cream-yellow or gray coating that can be scratched or washed off with hot water. On the back of the film is a blue, green, or red dye. But the film looks the same whether it has been exposed or not. The pictures stored in the film are totally invisible to the naked eye until the film has been chemically processed and the negative made.

Figure 2–1 shows a cross-section of a typical modern black-and-white film. It is precision manufactured according to an exact formula. The thin *top coating* layer protects the *emulsion*. The emulsion, composed of millions of microscopic crystals of *silver halides* — silver bromide and silver iodide, suspended in a thin layer of *gelatin*, gives the film its photographic properties. The silver halides are light-sensitive, registering their encounter with light by turning black during development. The whole structure of photography depends on this one fact — that silver halides exposed to light will release their metallic silver when developed. The silver halide crystals then are suspended evenly in the soft gelatin to make the light-sensitive emulsion, which is spread evenly and thinly over the surface of the support material.

The *subbing adhesive layer* helps the emulsion bond to the support material. The *support* is a transparent, firm, flexible, chemically stable, plastic base (usually cellulose-acetate or mylar) that holds the emulsion. It is insensitive to light. Supports used in the manufacture of roll films and film packs are relatively thin, whereas miniature and motion picture film supports are thicker, and sheet film supports are generally thickest.

A *second adhesive layer* helps the *antihalation backing* adhere to the support. The antihalation backing is a dyed gelatin coating on the back of the support. This backing absorbs intense light, which may penetrate all the way through the emulsion and support during exposure. If not absorbed, these light rays may reflect from the far surface of the support into

Fig. 2–1 Cross-section of black-and-white film.

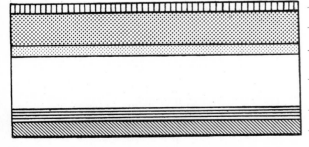

- Top coat
- Emulsion
- Subbing adhesive layer
- Support
- Second adhesive layer
- Antihalation backing

the emulsion and create halo effects around bright points in the image. You may have seen this halo effect in pictures of street lights at night. The anti-halation backing is removed completely during film processing. In addition, manufacturers add hardeners, preservatives, and other ingredients according to their own formulas to improve performance.

Do Exercise 2–A on page 59

Characteristics of Black-and-white Film

Objective 2–B Define some of the basic characteristics of black-and-white negative film and give examples of how these characteristics affect photographs made under various conditions.

Key Concepts speed, fast-speed films, slow-speed films, medium-speed films, film speed rating, ASA ratings, DIN ratings, ISO ratings, ultra fast-speed films, pushing the film, color sensitivity, panchromatic film, orthochromatic film, blue-sensitive film, infrared film, grain size, coarse-grain negative, fine-grain negative, coarse-grain film, fine-grain film, graininess, medium-grain film, contrast, inherent contrast, high-contrast film, resolving power, resolution, acutance or sharpness, latitude

Films have several varying characteristics that affect their performance under different conditions. Some of the more important characteristics are speed, color sensitivity, grain, contrast, resolving power, acutance, and exposure latitude. The potentialities of a film for achieving certain purposes often will be affected by these characteristics.

Film speed

Films vary in their *speed,* or sensitivity to light. Some films are extremely sensitive to light and do not require much exposure to record a usable image. These films are called *fast-speed films* because their emulsions are highly active and respond to low levels of illumination. Other films require much more exposure to record a usable image. They are called *slow-speed films* because their emulsions are less active and will respond only to higher levels of illumination. *Medium-speed films,* of course, fall in between.

The *film speed rating* is a numerical index that describes a film's speed. The system of film ratings in most common use in America today, the *ASA ratings,* was developed by the American Standards Association (now the United States Standards Association), from which it derives its name. The system most commonly used in Europe is the system of *DIN ratings,* which stands for Deutsches Industrie Norm (German Industry Standard). The film speed for most modern films is recorded on film packages using the *ISO rating* (International Standards Organization) that incorporates both ASA and DIN ratings. Thus a film rated ASA 200 or 24 DIN would be labeled ISO 200/24°.

We may refer to the relative speed of films in terms of the following general classes:

Slow-speed films: Ratings up to ISO 50/18°

Medium-speed films: Ratings between ISO 64/19°–160/23°

Fast-speed films: Ratings between ISO 200/24°–400/27°

Ultra fast-speed films: Ratings over ISO 400/27°

Some typical film speed ratings are reported in Table 1. One convenient feature of the ASA system is that the ratings are directly proportional to their corresponding film speeds. The speed of an ASA 64 film, for example, is twice that of an ASA 32 film and will require half the amount of light to obtain an equivalent exposure. The DIN system works differ-

Table 1 Equivalent Film Speed Ratings

ASA	DIN	ISO
12	12	12/12°
20	14	20/14°
25	15	25/15°
32	16	32/16°
40	17	40/17°
50	18	50/18°
64	19	64/19°
80	20	80/20°
100	21	100/21°
125	22	125/22°
160	23	160/23°
200	24	200/24°
400	27	400/27°
800	30	800/30°

Films may be labeled with one or more film speed ratings: the American ASA, the German DIN, or the International ISO. The ASA ratings double as the film speed doubles; the DIN ratings increase by three degrees as the film speed doubles. The ISO ratings incorporate both ASA and DIN ratings.

ently. As film speed doubles, the DIN rating increases by 3. Thus the speed of a DIN 24 film is twice that of a DIN 21 film and will require half the amount of light to make an equivalent exposure.

Bear in mind that a film's rated speed is simply a numerical index that the manufacturer recommends for obtaining optimal results under standard conditions of exposure and processing. This index allows the user to compare the relative speeds of various films and to obtain similar results when similar standard procedures are followed.

Experienced users may alter the standard conditions, however, to obtain results better suited to particular conditions. Processing with a more energetic developer, for example, requires decreased exposure and increased development time to obtain optimal results and thereby increases a film's effective speed. Similarly, processing in a fine-grain developer requires increased exposure and decreased development time to obtain optimal results and thereby decreases

a film's effective speed. This technique for altering effective film speed is used mostly with fast films to increase effective film speed and, in this case, is known as *pushing the film.*

Negatives that have been pushed possess less than optimum quality, but the technique permits photography under extremely dim lighting conditions. For example, in certain situations, a photographer may expose film rated ASA 400 as though its rated speed were ASA 3200 and obtain acceptable results by altering the standard conditions of processing to compensate for the reduced exposures.

Color sensitivity

Black-and-white films are sensitive to different colors in varying degrees. Colors are recorded as different shades of gray. Thus black-and-white film sees color simply as varying degrees of brightness. There are several types of film, each of which sees the brightness of various colors differently — that is, each film has a different *color sensitivity*. Four of these films are:

Panchromatic (pan) film
Panchromatic (pan) film is sensitive to all colors. It sees various colors in approximately the same brightness ratio as does the human eye. Pan film thus tends to produce black-and-white prints that appear similar to the way our vision would translate scenes into black and white.

Orthochromatic film
Orthochromatic films are sensitive to all colors except red. They can be developed by inspection under a red safelight. Because the film is insensitive to red, reddish objects tend to appear darker in the resulting prints than our eye would expect. This film is no longer in common use.

Blue-sensitive film

Blue-sensitive film sees only blue. It is blind to all other colors and oversensitive to blue. The film produces high-contrast negatives and prints. Thus it is well suited for black-and-white copy work of line drawings and manuscripts and it is used extensively in lithography.

Infrared film

Infrared films are sensitive primarily to the infrared and blue portions of the spectrum. They are particularly useful in certain aerial, medical, scientific, industrial, legal, documentary, and photomicrographic photography. Used with a deep orange or red filter, they may give striking and unusual effects in landscape and other photography. (See Figure 7–4D, page 236.)

Grain size

Grain size refers to the grouping or clumping together of the minute silver grains that form the film's negative image. The grain pattern of the negative affects the printed image. If a negative's silver grains are clustered in relatively large clumps, we refer to it as a *coarse-grain negative*. The enlarged print it produces may appear grainy, mottled, or sandy and may suffer a corresponding reduction in sharpness. A *fine-grain negative*, on the other hand, consists of silver grains clustered in relatively small clumps. More likely it will produce prints that appear sharp and unmottled at the same magnification.

Negative grain is related to several interacting factors:

1. Film speed. The faster films also tend to be *coarse-grain films*, as their emulsions necessarily are composed of larger, coarser grains of silver halides. The *fine-grain films* are necessarily slower. Thus to obtain greater film speed you must accept a coarser grain pattern inherent in the emulsion. If you desire finer-grain negatives, you must accept a slower film speed.

2. Exposure and processing. Overexposure and/or overdevelopment increase the density of the silver deposits in the negative, thereby increasing negative *graininess*.

3. Magnification. Although magnification of the negative image does not alter the grain pattern of the negative, it does reveal it. Normally the graininess of a coarse-grain negative will not be apparent if the size of the final print is close to the size of the negative. But if the image is enlarged for printing, the grain pattern also will be enlarged and thus tend to reveal the graininess inherent in the negative. Therefore finer-grain negatives usually are used as greater magnification is required.

Graininess is not always undesirable in a print. The coarse, mottled appearance of a grainy image may serve certain aesthetic purposes. You should strive to control graininess to serve your own purposes.

For general photographic purposes many photographers prefer to work with a medium-speed, *medium-grain film*, which strikes a compromise between their needs for both fine grain and fast speed in a variety of circumstances.

Contrast

Contrast refers to the difference in density between light objects in a scene and dark objects. Factors that affect contrast are development time, temperature, and agitation. As these increase, the contrast for any particular scene brightness will be increased in the negative. Different films may achieve the same contrast for the same scene, but may reach it in different development times. A film that reaches a given contrast more quickly is said to have higher *inherent contrast*.

The manufacturer has certain control over a film's inherent contrast at the time the emulsion is prepared. In general, slower films tend to have higher inherent contrast and achieve a given contrast in shorter development times. The faster films tend to have lower inherent contrast and achieve a given contrast in longer development times. This built-in characteristic can be increased or decreased by varying exposure, processing procedures, and printing procedures. For most photographic purposes, photographers prefer to work with medium-speed films that have medium inherent contrast and that achieve normal contrast in moderate development time.

A *high-contrast film* is a special type of film that records only black and white tones — no middle gray tones. It is used in lithography and graphic arts to reproduce line copy, to make half-tone negatives, and sometimes to impart a special effect to continuous tone images.

Resolving power

A film's ability to record distinguishable fine detail is called its *resolving power*. The test of a film's resolving power involves photographing sets of parallel lines that vary in their sizes and in their distances from one another. Then the negative image is examined under a microscope to determine the number of lines per millimeter that are recognizable as separate lines — the number beyond which the lines fuse together into an indistinguishable mass.

The resolving power of films ranges from low, which allows distinguishing no more than fifty-five lines per millimeter, to ultra-high, which allows distinguishing more than six hundred lines per millimeter.

The *resolution* evident in any given negative is very sensitive to exposure and falls off rapidly with under- or overexposure. The achievement of optimal resolution with any given film depends on correct exposure, subject contrast, as well as other factors.

Acutance

The *acutance,* or *sharpness,* of a film is its ability to record finite edges between adjacent scenic elements. The test of a film's acutance involves exposing a film to light while it is partially shaded by a sharp knife edge in contact with the emulsion. Viewing the processed negative, you may observe that the edge of the exposed portion, rather than ending abruptly at the unexposed area, bleeds somewhat into it. This bleeding is caused by the diffusion of light within the emulsion itself. Its extent is determined by the coarseness of the grain and the thickness of the emulsion and produces our impression of the sharpness of the resulting picture. To obtain the highest possible sharpness, select a film with a thin emulsion and fine grain, and avoid overexposure and overdevelopment.

Exposure latitude

A film's *latitude* is its ability to produce a full range of tones despite some degree of over- or underexposure or over- or underdevelopment. Films with wide latitude will produce a full range of tones even when exposure and/or development vary widely from the standard. Films with narrow latitude must be exposed and developed to precise standards to obtain a full range of tones. In general, the faster the film speed, the wider the exposure latitude will be; the slower the film speed, the narrower the exposure latitude will be. Thus, slow films require more accurate exposure and development to give optimal results.

Do Exercise 2–B on page 59

Black-and-white Films

Film packaging

Films are packaged in forms suitable for the cameras in which they will be used. Some cameras are designed to use a long strip of film on which successive exposures are made. Films for these cameras are packaged in rolls as *roll film, magazines,* or *cartridges*. The entire strip of film is designed to be loaded into the camera at one time. Other cameras are designed to use rectangular *sheets* of film. Films for these cameras are packaged in boxes and typically the sheets of film are preloaded by the photographer into special holders prior to use in the camera. (See Figure 2.2.)

Magazines and cartridges

Thirty-five-mm cameras were originally designed to use standard motion-picture film. For use in these cameras the film is wound onto a spool and contained within a light-tight metal magazine. A short leader of the film is left protruding from the magazine for loading onto a take-up spool within the camera. Once inside the camera the film is advanced from the magazine onto the camera's take-up spool as each exposure is made. When all exposures have been made, the film must be rewound into the magazine before removal from the camera. Some cameras are designed to use special, light-tight plastic cartridges, which contain both the film and the take-up spool. Film is advanced at each exposure entirely within the cartridge. After exposure the entire cartridge is removed without rewinding.

Roll film

For many cameras, a strip of film is rolled together with an opaque paper backing onto a spool. This roll of film is inserted into the camera and threaded onto the take-up spool. The camera is sealed and the film is advanced one exposure at a time onto the take-up spool. When exposures are completed, the take-up spool, now bearing the film and the backing paper, is removed from the camera for processing.

Sheet film

Sheet film is packaged in boxes of twenty-five sheets. The boxes may be opened only in total darkness. The film, notched near the corner to aid identification and handling, is loaded into special, light-tight film holders. Each film holder holds two sheets of film. The film holder is inserted into the camera to expose one sheet of film. It is removed, inverted, and reinserted into the camera to expose the second sheet of film. After both sheets of film have been exposed, another film holder containing fresh film must be used. In the darkroom, the exposed sheets of film are removed from the holder for processing.

Film sizes

Films sizes are internationally standardized by both camera and film manufacturers, assuring a ready market for their products and availability of materials for almost all modern cameras throughout the world. Some of the common film sizes are 35 mm magazines; 110 and 126 cartridges; 828, 120, 220, 620, 127, 616, and 116 rolls; $2\frac{1}{4}$-in. by $3\frac{1}{4}$-in., $3\frac{1}{4}$-in. by $4\frac{1}{4}$-in., 4-in. by 5-in., 5-in. by 7-in., 8-in. by 10-in., and 11-in. by 14-in. sheets.

Fig. 2–2 **Film packaging.** A. Film pack. B. 120 roll. C. 35-mm magazine. D. Box of sheet film. E. 126 cartridge.

Table 2 Commonly Available Black-and-white Films

Speed and Purpose	Manufacturer and Name		ISO
Slow-speed films (up to ISO 50/18°): Excellent in high illumination, such as at the beach or in the snow, when fine detail is needed. Full range of gray tones across wide range-of-brightness values. Little apparent graininess. Generally require quite accurate exposure settings. Most suitable for extreme enlargement.	Adox	KB-14	20/14°
		KB-17	40/17°
	Agfa	Agfapan 25	25/15°
	Ilford	Pan F	50/18°
	Kodak	Panatomic-X	32/16°
	*Polaroid	Landfilm 55-P/N	50/18°
Medium-speed films (ISO 64/19°–160/23°): Excellent under a wide range of conditions. Wide exposure latitude, allowing exposure variations of up to two stops while still producing usable prints. For general photography. Slight apparent graininess.	Adox	KB-21	100/21°
	Agfa	Agfapan 100	100/21°
	Ilford	FP-4	125/22°
	Kodak	Plus-X	125/22°
		Verichrome Pan	125/22°
		Ektapan	125/22°
	*Polaroid	Landfilm 665-P/N	80/20°
Fast-speed films (ISO 200/24°–400/27°): Wider exposure latitude. Best when light is weak or when fast shutter speeds are needed. For general photography that includes weak light and/or action. Medium apparent graininess.	Agfa	Agfapan 200	200/24°
		Agfapan 400	400/27°
	Ilford	HP-4	400/27°
		HP-5	400/27°
	Kodak	Super-XX	200/24°
		Tri-X	400/27°
		Royal Pan	400/27°
	*Polaroid	Landfilm 42	200/24°
		Landfilm 52	400/27°
Ultra fast-speed films (ISO over 400/27°): Special-purpose films used usually when other films are too slow. Especially suited to extremely low light levels and combinations of low light and fast shutter. Generally have high apparent graininess that shows up under slight enlargement.	Kodak	Royal-X Pan	1250/32°
		2475 Recording	1000/31°
	*Polaroid	Landfilm 107	3000/36°

*These films are instant films that produce a print within a minute of removal from the camera. Those designated P/N also produce a negative for making conventional prints.

Common black-and-white films

Table 2 describes some of the commonly available black-and-white films, their characteristics, and the purposes for which they may be especially useful.

Do Exercise 2–C on page 60

Color Films

> **Objective 2–D** Describe the characteristics, differences, and uses of three basic types of color film, and the composition of modern color film.
>
> **Key Concepts** primary colors, integral tripack, dye image, color reversal film, positive transparencies, duplicate transparency, color prints, internegative, color negative film, complementary colors, instant color print film, color balance, color temperature, Kelvin degrees, black body, daylight, tungsten light, Type A films, Type B films

One of the marvels of modern photography has been the development of inexpensive color materials that can be used with the same cameras and under much the same conditions as black-and-white materials. The ease with which even the beginning photographer can obtain full-color photographic images belies the long and tortuous history of color photography, which reaches back well over a century. Today color films and processing can be obtained readily at drug and grocery stores and even at drive-through photographic outlets. Some of these films even are designed for user-processing in home darkrooms by more advanced amateurs.

The products of various manufacturers differ in the details of their chemical design. Nevertheless, in many respects most modern color films are similar in construction to black-and-white films, except that they consist of three emulsions instead of one. Each emulsion is designed to record the image produced by only one of the *primary colors* of light in the scene — red, green, or blue — and to produce a corresponding colored image during processing. Because of its three emulsions, this type of film is known as an *integral tripack*.

When the film is processed, the images on the three emulsions are developed as negative silver images, as with black-and-white film. At some stage of the processing, each of the images is converted to a *dye image* that is the complement of the primary color of light that produced it. The red-produced image becomes cyan; the green-produced, magenta; and the blue-produced, yellow. The opaque silver and silver salts are then dissolved away, leaving the three dyed image layers sandwiched close together in exact registration. When white light is transmitted through them, their images combine to produce a full range of colors that corresponds in either positive or negative form to those that were present in the original scene.

Figure 2–3 shows a cross-section of a typical color film and explains the principles of its operation. Three basic types of color film are commonly available: color reversal film, color negative film, and instant color print film.

Color reversal film

Color reversal film is designed to produce *color slides — positive transparencies* that can be looked at through a viewer or projected onto a screen. The same film you expose in the camera is returned to you in the form of slides after processing. During processing the negative images are reversed to positive ones. Then each of the three positive images is converted to a dye that is the complement of the original primary color that produced it and the silver image is bleached away. When viewed, the three images combine by a subtractive process to form a positive color image of the scene. This reversal of the negative to a positive image gives the film its technical name, *color reversal film*.

The transparency also can be used to reproduce the photograph in other forms. For example, you can have a *duplicate transparency* made, virtually equivalent to the original. Among other advantages, having a duplicate protects the original from the abuses of direct handling. You also can have a *color print* made from your original transparency. A color print is an

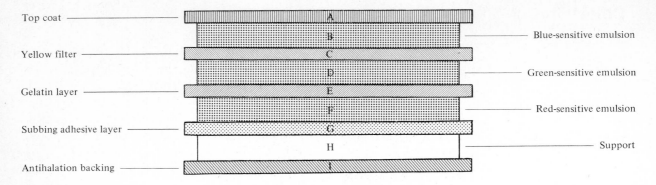

Top coat — A

Yellow filter — C

Gelatin layer — E

Subbing adhesive layer — G

Antihalation backing — I

Blue-sensitive emulsion

Green-sensitive emulsion

Red-sensitive emulsion

Support

Fig. 2–3 Cross-section of modern tripack color film. A. Top coat protects emulsion surface. B. Blue-sensitive emulsion records only the image produced by the blue light in the scene. C. Yellow filter absorbs blue light to prevent its transmission to other emulsions. D. Green-sensitive emulsion records only the image produced by the green light in the scene. (This is an orthochromatic layer. It is insensitive to red light, which passes through it to the layers beneath, and it is not exposed to blue, which has been filtered out in the layer above.) E. Gelatin layer separates green-sensitive and red-sensitive emulsions to prevent dye contamination between layers. F. Red-sensitive emulsion records only the image produced by the red light in the scene. G. Subbing aids adhesion of the emulsion to the support. H. Support, a strong, flexible plastic base, holds all layers firmly in place. I. Antihalation backing prevents back-reflection of highlights that may penetrate through all prior layers.

opaque paper- or plastic-backed print that can be viewed without mechanical aids, mounted in an album or on a display board, and handled as any other print.

There are several methods of making color prints from transparencies that differ in cost, in complexity, and in quality of the end product. Some of these methods involve direct printing on special materials using a color reversal printing process. Many of these methods are no more complex than black-and-white printing and may be performed easily in a home darkroom. Others involve making an *internegative* — copying the transparency onto a *color negative* and then using the new negative to make positive color prints. If you wish you can make an internegative using black-and-white film to produce black-and-white prints from your transparency.

Color negative film

Color negative film is designed primarily to produce color prints. It produces a transparent negative, which is then used for making the positive prints. As with a black-and-white negative, the brightness scale is reversed — bright objects appear dense in the negative, and dark objects appear thin. But the colors are reversed also — the original colors appear as their *complementary colors*. Thus blue objects will appear yellow in the negative, green will appear magenta, and red will appear cyan. The negative can be preserved, and reused as long as it is kept in good condition.

Color negative film is also of integral tripack construction. However, color negative film is not reversed in processing so that each of the three negative images is dyed the complement of its corresponding primary color. In printing, of course, both the brightness scale and the colors are reversed to correspond to the original brightness and hue in the scene.

Several end products can be made from the color negative. One of these is the color print. You also can have positive transparencies made from your color negatives, which in most respects are equivalent to the transparencies obtained with color transparency film. Black-and-white prints also can be made from your color negatives in your own darkroom. No internegatives, special equipment, papers, or chemicals are needed, although special printing papers are designed for this purpose to optimize results. The various products that can be made from both types of color film are summarized in Figure 2–4.

Instant color print film

Instant color print film operates on the same general principles as conventional film and print materials. Silver halide emulsions are the basic image-forming media and the chemical processes generally parallel those employed in color transparency films. The primary difference between instant color print films and conventional ones is that the processing and printing materials are all sandwiched together into each sheet

Fig. 2–4 Color film products.

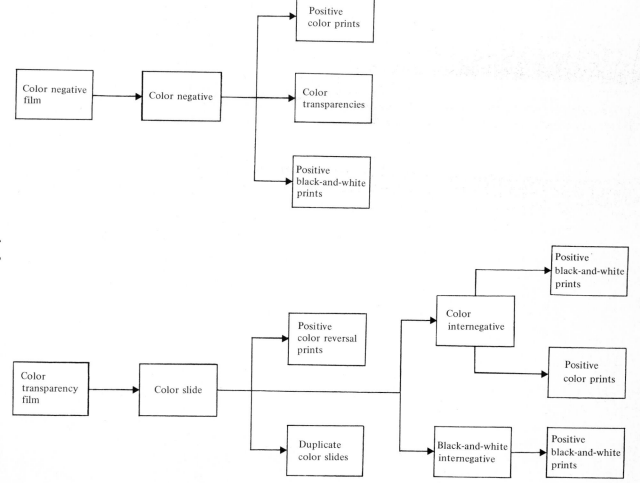

of film. The processing materials are held in an inactive state until activated following exposure. To develop the film and make the positive print, the film is squeezed between two rollers built into the camera, thus dispersing the activating chemicals throughout the emulsion. The action of this process is self-limiting and terminates automatically, leaving at last only the completely developed and stabilized print. As with all photo-chemistry, the time of development is related to the temperature of the materials and, depending upon outside temperatures, the process will take from twenty seconds to four minutes to complete.

Instant color print films are generally packaged in packs of eight or ten sheets. They may be used in cameras specially designed for their use or in special film holders designed to attach to conventional cameras. Though most commonly associated with the amateur market, instant photography has found many applications in scientific, industrial, and commercial photography, and some instant photographs have found their way into art museums and galleries.

Color balance

A film's ability to reproduce colors as the eye perceives them is known as its *color balance*. Just as the human eye may selectively ignore details in a scene that the camera records, the eye also may ignore shifts in the color of the dominant light source, which the film will record. We know, for example, that sunshine in the late afternoon is redder than at noon. The color of a white car does not appear significantly different to us at these times, but it does to color film. Because objects reflect the characteristics of the light falling upon them, they will take on the colors of the source light. If that light is dominated by the warm, reddish hues of late afternoon sunlight or ordinary incandescent light, the film will record a reddish tinge over the entire scene. Ordinarily our minds will filter out this tinge in interpreting color, yet a careful shopper knows this tinge exists and often views a new tie

or dress in daylight to see its "true" color. Under ideal conditions color film records colors as they are reflected from objects, not as the viewer may believe them to be.

The color of light, ranging from the red to the blue portions of the spectrum, is described in terms of *color temperature,* which is measured in *Kelvin degrees*. The Kelvin scale is based on the notion that an object such as a black iron rod, heated sufficiently, will eventually begin to glow. At first it will glow a deep red, but as the heat increases it will glow orange, then yellow, then white, and finally (if it does not evaporate) blue. Were we to measure the temperature of the object at various points, we would find that we could consistently associate certain temperatures with certain colors. The Kelvin scale is based on the Centigrade temperatures (corrected for absolute zero) of a theoretical *black body* associated with various colors of light found in the spectrum. Thus the lower color temperatures are associated with the red-yellow portions of the spectrum, whereas the higher color temperatures are associated with the blue-violet portions of the spectrum. Figure 2–5 reports some common light sources and their approximate color temperatures in Kelvin degrees.

Color films are balanced in manufacture for the color temperatures of source lights commonly encountered in practice. One such source is *daylight* (5,500 K) — the color of daylight on a sunny day between 10 A.M. and 2 P.M. is the standard. Another such source is *tungsten light,* which refers to artificial light produced by tungsten-filament lamps. Some color films, *Type A films,* are balanced for photoflood lights (3,400 K). Others, known as *Type B films,* are balanced for professional photo lamps (3,200 K). The most accurate color renditions are obtained when color films are used in the light for which they are balanced. If daylight film is used outdoors on a sunny day at noon, for example, a white car will appear white. Early in the morning, at sunset, or under floodlights on a showroom floor, the same film will make it appear perceptibly reddish. Using a Type A tungsten film under photoflood lights on the showroom

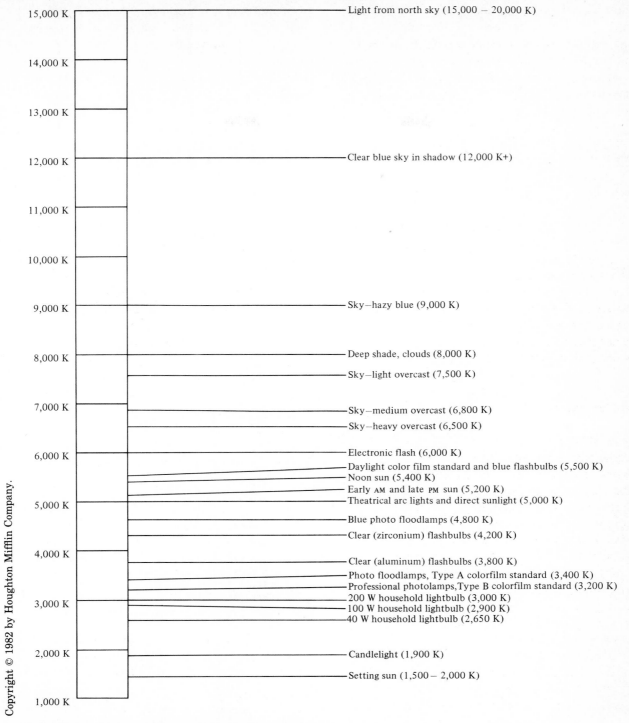

Light from north sky (15,000 – 20,000 K)

Clear blue sky in shadow (12,000 K+)

Sky—hazy blue (9,000 K)

Deep shade, clouds (8,000 K)
Sky—light overcast (7,500 K)

Sky—medium overcast (6,800 K)
Sky—heavy overcast (6,500 K)

Electronic flash (6,000 K)
Daylight color film standard and blue flashbulbs (5,500 K)
Noon sun (5,400 K)
Early AM and late PM sun (5,200 K)
Theatrical arc lights and direct sunlight (5,000 K)

Blue photo floodlamps (4,800 K)

Clear (zirconium) flashbulbs (4,200 K)

Clear (aluminum) flashbulbs (3,800 K)
Photo floodlamps, Type A colorfilm standard (3,400 K)
Professional photolamps,Type B colorfilm standard (3,200 K)
200 W household lightbulb (3,000 K)
100 W household lightbulb (2,900 K)
40 W household lightbulb (2,650 K)

Candlelight (1,900 K)

Setting sun (1,500 – 2,000 K)

Fig. 2–5 Color temperatures of various light sources.

floor, the white car again will appear white. But outdoors at noon, the tungsten film will make the car appear bluish because the film is balanced for a lower color temperature than daylight.

You often will wish to use color film under conditions that vary from its rated color balance. In Unit 7 you will learn how to control the color shifts that might occur in such circumstances by using special filters fitted to your camera.

Control of color balance at the time of shooting is critical for color transparency films. The film in your camera ends up as your slide and you have almost no

Table 3 Commonly Available Color Films

Manufacturer	Name	ISO	Color Balance
Color Reversal Films			
Agfa	Agfachrome 64	64/19°	daylight
	Agfachrome CT–18	50/18°	daylight
	Agfachrome 100 and CT–21	100/21°	daylight
Fuji	Fujichrome 100	100/21°	daylight
	Fujichrome 400	400/27°	daylight
GAF	Colorslide Film 64	64/19°	daylight
	Colorslide Film 200	200/24°	daylight
	Colorslide Film 500	500/28°	daylight
Kodak	Ektachrome 50	50/18°	tungsten-B
	Ektachrome 64	64/19°	daylight
	Ektachrome 160*	160/23°	tungsten-B
	Ektachrome 200*	200/24°	daylight
	Ektachrome 400*	400/27°	daylight
	Kodachrome 25	25/15°	daylight
	Kodachrome 40	40/17°	tungsten-A
	Kodachrome 64	64/19°	daylight
3–M	Colorslide Film 100	100/21°	daylight
	High-speed Colorslide Film	400/27°	daylight
Color Negative Films			
Agfa	Agfacolor CNS	80	daylight
Fuji	Fujicolor F–II	100	daylight
	Fujicolor F–II 400	400/27°	daylight
GAF	Colorprint Film	80/20°	daylight
Kodak	Kodacolor II	100/21°	daylight
	Kodacolor 400	400/27°	daylight
	Vericolor II Professional	100/21°	daylight/tungsten-B
	Vericolor II Commercial	80/20°	daylight
	5247 Film	100/21°	tungsten-A
3–M	Colorprint Film	100/21°	daylight
	High-speed Colorprint Film	400/27°	daylight
Instant Colorprint Films			
Kodak	Instant Print Film PR 10		daylight
Polaroid	SX-70 Land Film		daylight
	Polacolor 2 Land Film	80/20°	daylight

*Effective film speed of Ektachrome 160, 200, and 400 films can be doubled to ASA 320, 400, and 800 respectively with special processing either from the commercial processor or in the home darkroom.

opportunity to correct any color imbalances once the picture is shot. With color negative film, however, it is another story. Color imbalances in the negative may be corrected substantially during printing with compensatory filtration. It is standard practice in commercial processing laboratories to seek to balance positive prints using flesh tones or other known values as a reference. Many photographers will use a standard gray card at the start of a roll, within a scene, or in the frame preceding an important shot, to provide the printer with a standard reference for balancing color in the print.

Common color films

Table 3 describes some commonly available color films and their characteristics.

Do Exercise 2–D on page 61

Film Care and Storage

> **Objective 2–E** Describe the conditions that may adversely affect your film and describe how to store and care for your films to avoid these effects.
>
> **Key Concepts** humidity, heat, age, gases, x rays and radioactive material, static electricity

All photographic films may be affected by humidity, heat, age, gases, static electricity, x rays, or radioactive materials. Even with minimum precautions, however, you can protect your film from the adverse effects of these conditions.

1. Don't open a film package until you are ready to use the film.
Most films are provided in vapor-tight containers or packages for protection against *humidity*. No additional protection against moisture is normally required as long as this package is intact.

2. Store unexposed film in a cool, dry place or under refrigeration in its original vapor-tight package.
Film packages do not protect against *heat*. Do not leave your undeveloped film in direct sunlight or near any heat source, such as steam pipes, heat registers, or closed compartments of a car. Special care should be taken in hot seasons or regions. Films may be refrigerated or frozen as long as they are in their original vapor-tight packages. To prevent condensation, cold films should be allowed to warm to room temperature before removing them from their vapor-tight containers.

3. Expose and process film before it spoils.
Films are chemically active and change with *age*, even if unexposed to light and stored carefully. Films are given an expiration date at the time of their manufacture and with reasonable care can be guaranteed to give good results until that date. If kept in a refrigerator or freezer, they will give good results long after their expiration dates.

4. Expose and process film as soon as possible after opening its vapor-tight package. Store opened, unprocessed film in sealed, dry containers in a cool, dry place.
Once the vapor-tight package is opened, the film is subject to external conditions that will affect its condition rapidly. The camera itself is neither vapor-tight nor heat-proof, so you should avoid prolonged storage of film in the camera as well as in your equipment bag. Do not store opened packages of film in damp areas or in freezers; seal them in jars or cans and store

under mild refrigeration or in cool, dry places. You may wish to store opened packages of film with a small container of silica gel, available from most photo supply stores, to reduce the relative humidity within the storage container.

5. Avoid storing film where it may be exposed to volatile gases, x rays, or radioactive materials.

Certain *gases* may affect the chemical composition of film adversely. Motor exhaust, mildew preventives, camphor or formaldehyde vapors, and vapors from cleaners and solvents may damage film. Similarly, exposure to *x rays* and *radioactive materials* may be harmful to the film's emulsion. Special film containers should be used to ship undeveloped film through customs or other x-ray security points. If none is available, request hand inspection to avoid the film's exposure to x rays.

6. Advance and rewind film slowly and handle film carefully to avoid discharges of static electricity.

Sparks of *static electricity* at the surface of the film also can cause marks in the developed negative. Static electricity may collect at the surface of the film during dry weather when the relative humidity is very low. Just as you can build up a charge of static electricity by rubbing your feet across a carpet on a dry winter day, you can build up a static charge on the film by advancing it or rewinding it too rapidly following exposure.

7. Store negatives in a clean, dry, cool place in protective envelopes or sleeves.

The developed negatives of black-and-white film are normally very stable and require few special storage precautions. A cool, dry place will inhibit the growth of mold on the gelatin emulsion. Hydrogen sulfide and coal gas should be avoided because sulfur compounds may attack the silver in the negative image.

Negatives should be kept as clean and dust-free as possible to avoid damage to the negative image.

Do Exercise 2–E on page 62

Suggested references

Brooks, David. *Photographic Materials and Processes.* Tucson: H-P Books, 1979. Pages 1–47.

Craven, George M. *Object and Image: An Introduction to Photography.* Englewood Cliffs, N.J.: Prentice-Hall, 1975. Pages 83–90.

Davis, Phil. *Photography,* 3rd ed. Dubuque: William C. Brown, 1979.

Eastman Kodak Co. *Kodak Films: Color and Black-and-White.* Rochester, N.Y.: Eastman Kodak Company, 1978.

Jacobs, Lou Jr. *Photography Today.* Santa Monica, Calif.: Goodyear, 1976. Chapter 5.

Rhode, Robert B., and F. H. McCall. *Introduction to Photography,* 4th ed. New York: Macmillan, 1981. Chapters 6, 14, 18.

Swedlund, Charles. *Photography,* 2nd ed. New York: Holt, Rinehart and Winston, 1981. Chapter 4.

Time-Life Books. *Life Library of Photography: Color.* New York: Time, Inc., 1970. Pages 12–21.

Time-Life Books. *Life Library of Photography: Light and Film.* New York: Time, Inc., 1970. Chapter 4.

Suggested field and laboratory assignments

Obtain at least one roll each of medium-speed black-and-white film and color transparency film for use with your camera. You will use these materials to complete the field assignments in the next unit.

Do Practice Test 2 on page 63

EXERCISE 2–A

1. On page 67, draw a cross-section of a typical modern black-and-white film and label the various layers. Do not refer to the study material.

2. The chemical name for the light-sensitive crystals in the emulsion is _____

 _____.

3. The transparent, flexible acetate base that holds the emulsion is called the _____.

4. Light-sensitive crystals in the emulsion are suspended in _____.

5. A dye is coated on the back of the acetate base to prevent light from passing through the film, hitting the back of the camera, and bouncing back through the film and causing

 _____ around your brightest highlight areas. This dyed coating is called the _____.

 Return to Objective 2–B, page 44

EXERCISE 2–B

Without referring to the materials in Objective 2–B, see if you can list and describe seven of the more important variable characteristics of films.

1. _____

2. _____

3. _____

4. _____

5. _____

6. _____

7. _____

Return to Objective 2–C, page 48

EXERCISE 2–C

1. Without referring to the study materials, name one slow-speed film, one medium-speed film, and one fast-speed film available for your camera. For each, state its ASA film speed rating, its grain characteristics, and the purposes for which it would be especially useful.

	Film	ASA	Grain	Purposes
A.	_____	___	_____	_____
B.	_____	___	_____	_____
C.	_____	___	_____	_____

2. Name and describe three forms in which black-and-white films are packaged.

 A. _____

 B. _____

 C. _____

3. The film size required by your camera is _____. The form(s) of packaging available

 for your camera is (are) _____.

Return to Objective 2–D, page 51

EXERCISE 2–D

1. Without referring to the study material, draw a cross-section of a typical integral tripack color film on page 67.

2. Name and describe each of the three basic types of color film and the end products obtainable from each.

 A. _____

 B. _____

 C. _____

3. A. Explain what is meant by the color balance of a film. _____

 B. In what unit is color temperature measured? _____

 C. For what three color balances are modern color films manufactured?

 (1) _____

 (2) _____

 (3) _____

4. Name one color transparency and one color negative film that is available for your camera and name their film speed ratings.

A. _____

B. _____

Return to Objective 2–E, page 57

EXERCISE 2–E

State seven rules of film care that will help protect your fresh and developed film from adverse conditions.

1. _____

2. _____

3. _____

4. _____

5. _____

6. _____

7. _____

Review References and do Suggested field and laboratory assignments on page 58

PRACTICE TEST 2

For each of the following questions, select the one *best* answer and write its corresponding letter in the blank preceding the question. After you have completed the test, check your answers against the correct answers, which follow the test. If you miss any of the test items, review the study materials as suggested.

_____ 1. The light-sensitive crystals that turn black during development consist of _____.

 A. silver nitrate
 B. potassium bromide
 C. acetic anhydride
 D. silver halides
 E. potassium nitrate

_____ 2. Identify the layer indicated by the arrow in the following cross-section of a typical black-and-white film:

 A. subbing adhesive layer
 B. antihalation backing
 C. top coating
 D. emulsion
 E. support

_____ 3. The _____ helps the emulsion adhere to the support.
 A. top coating
 B. antihalation backing
 C. second adhesive layer
 D. subbing adhesive layer
 E. gelatin

_____ 4. Which one of the following statements is true?
A. Low ISO-index films yield minimal contrast.
B. High ISO-index films yield maximal contrast.
C. Medium ISO-index films yield maximal contrast.
D. Low ISO-index films yield maximal contrast.
E. High ISO-index films yield normal contrast.

_____ 5. Graininess in black-and-white negatives is increased most by _____.
A. underexposure and underdevelopment
B. overexposure and overdevelopment
C. underexposure and overdevelopment
D. overexposure and underdevelopment
E. none of the above — exposure and development do not affect grain

_____ 6. Which one of the following statements is true?
A. Panchromatic films render tones approximately as seen by the eye.
B. Panchromatic film can be developed under a red safelight.
C. Blue-sensitive film is well suited for portrait work.
D. Orthochromatic film is sensitive to all colors except blue.
E. Blue-sensitive film is generally low in contrast.

_____ 7. Which of the following films is fastest?
A. Agfapan 25
B. Adox KB-14
C. Kodak Panatomic-X
D. Ilford HP-5
E. The above films are all equally sensitive to light.

_____ 8. An excellent film to use when you want to make very large prints is _____.
A. Kodak Tri-X
B. Agfapan 400
C. Kodak Panatomic-X
D. Kodak 2475 recording film
E. Any film with ISO greater than 400/27°

_____ 9. You should expose and process your unopened package of film _____.
A. immediately after purchase
B. as soon as possible after purchase
C. up to one year from the date of purchase
D. before the expiration date printed on the film package
E. anytime, because the manufacturer's warranty guarantees results

Basic Camera Settings

Objective 3–A Name three basic settings found on adjustable cameras and describe their functions.

Key Concepts amount of light, sharpness, shutter speed, B and T settings, aperture, f/stop, stopping down, opening up, maximum aperture, lens speed, full stop, half-stop, focus, split-image focusing, superimposed-image focusing, ground-glass focusing

General appearance of shutter speed setting mounted on body of camera A

Shutter speed

B

Fig. 3–1 Shutter speed settings. A. Focal plane shutter. B. Leaf shutter.

There are three basic settings on an adjustable camera — shutter speed, lens opening, and focus. Shutter speed and lens opening determine the *amount of light* that strikes the film; focus determines the *sharpness* of the images that strike the film.

Shutter speed

When the shutter is closed, no light can enter the camera body and strike the film. When the shutter is open, light enters and strikes the film until the shutter closes. The length of time that the shutter remains open is known as the *shutter speed*. Simple cameras may have only a single, fixed shutter speed; adjustable cameras have a range of shutter speeds.

Shutter speeds are marked on the camera with numbers such as 30, 60, 125, 250, and 500. These numbers are actually a shorthand way of writing fractions of a second. They mean 1/30, 1/60, 1/125, 1/250, and 1/500 sec.

Because shutter speed numbers are fractions, the larger numbers represent smaller fractions. Setting your camera at 60 means that your shutter will remain open 1/60 sec. If you reset the shutter to 30, the shutter will remain open 1/30 sec. You can see that a shutter speed of 30 will let in exactly twice as much light as a shutter speed of 60, because 1/30 sec. is

twice as long as 1/60 sec. Figure 3–1 shows two types of shutter speed settings commonly found on adjustable cameras. Sometimes the setting is found on the barrel of the lens and sometimes on the body of the camera.

On most adjustable cameras the standard sequence of shutter settings is as follows:

1, 2, 4, 8, 15, 30, 60, 125, 250, 500, 1000

Note that shutter settings are arranged so that each setting is double the speed of the preceding setting. Depending on which direction you adjust the shutter

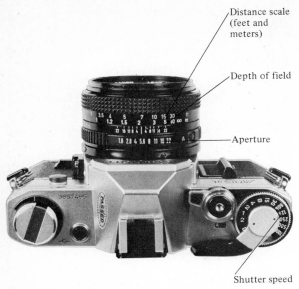

Distance scale
(feet and
meters)

Depth of field

Aperture

Shutter speed

Focal plane camera

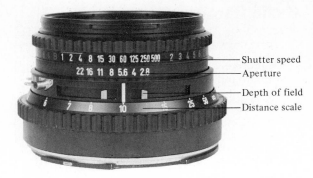

Shutter speed
Aperture
Depth of field
Distance scale

Leaf shutter camera lens barrel

Fig. 3–2 Aperture setting. Adjustments for aperture settings are usually built into the lens barrel of both the focal plane and the leaf shutter cameras.

speed, you will be doubling or halving the exposure at each successive shutter setting.

You may note that 1/15 sec. is not exactly half of 1/8 sec.; similarly, 1/125 sec. is not exactly half of 1/60 sec. These slight discrepancies appear in the sequence simply to round off the numbers. The differences are negligible and simplify our mental arithmetic. A few of the more expensive cameras also provide shutter speeds extending into the slower range, often including settings of many full seconds.

Many cameras also are equipped with *B* and/or *T settings*. Set at B, the shutter will remain open as long as the release is held in. When the release is allowed to return to its normal position, the shutter will close. Set at T, the shutter will open when the release is depressed and will remain open until the release is depressed a second time. Both B and T settings are used today for time exposures longer than those provided by the shutter.

Aperture

Light passes through the lens and into the body of the camera through an opening called the *aperture*. If the aperture is large, much light will pass through; if it is small, little light will pass through. Simple cameras may have only a single fixed aperture; adjustable cameras have a range of aperture settings.

The size of the aperture, or lens opening, is indicated by a number, called the *f/stop*. On the camera, f/stops are marked as 22, 16, 11, 8, 5.6, and so forth, and typically are found on the lens barrel. These numbers also are a shorthand way of expressing fractions. They mean 1/22, 1/16, 1/11, and so forth, and represent the ratio of the diameter of the aperture to the focal length of the lens. You never have to compute f/stops because they are calibrated by the manufacturer and engraved on the lens barrel. But usually you must set the aperture as well as the shutter speed to obtain a correct exposure.

Because these f/stops are fractions, the larger numbers represent the smaller lens openings and the

smaller numbers represent the larger lens openings. Changing the lens opening from one f/stop to the next is called adjusting the aperture "one stop." If you change stops to make the aperture smaller (for example, f/16 to f/22), this is called *stopping down* one stop. If you change stops to make the aperture larger (for example, f/16 to f/11), this is called *opening up* one stop.

The f/stops are arranged so that as you stop down, each stop allows half the amount of light to pass through as the stop before it did. When you stop down one stop — from f/16 to f/22, for example — you halve the amount of light passing through the lens. When you open up one stop — from f/16 to f/11, for example — you double the amount of light passing through. The standard sequence of f/stops is as follows:

<div align="center">

f/1.0, f/1.4, f/2, f/2.8, f/4, f/5.6, f/8, f/11, f/16, f/22, f/32

</div>

In the above sequence f/1.0 would let in the most light and f/32 would let in the least light. (Note that f/1.0 is very rarely found on modern cameras.) Figure 3–2 shows the general appearance of the aperture setting on a typical camera.

The *maximum aperture* to which a lens can be set is referred to as the *lens speed*. This f/stop is generally inscribed at the front of the lens near the focal length. For example, at the front of a lens you might see the numbers 50 mm 1:1.4. This means the focal length of the lens is 50 mm and its speed, or maximum aperture, is f/1.4.

Some cameras provide a continuously adjustable range of apertures. In other words you can set the aperture not only at these *full stops*, but also at points in between. Normally the in-between f/stops are not marked; you must approximate the setting you wish.

HELPFUL HINT

Remembering f/numbers
It may help you memorize the standard sequence to note that the f/numbers double in size at alternate stops going up in the series. But the amount of light doubles at every stop going down in the series. See Figure 3–3.

Thus, going up in the series, observe that f/2.0 is double the value of f/1.0. But the amount of light doubles at each stop in the other direction. So f/2.0 passes twice the amount of light as f/2.8. Note that f/11 is not exactly double f/5.6 as you would expect. This one discrepancy appears in the sequence to permit whole numbers in the balance of the sequence.

Fig. 3–3 Relationship between f/numbers and amount of transmitted light. Doubling f/5.6 actually equals f/11.2, but f/11 is used to simplify numbering system.

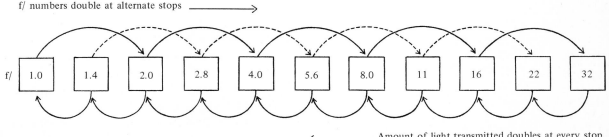

f/ numbers double at alternate stops ⎯⎯⎯⎯→

| f/ | 1.0 | 1.4 | 2.0 | 2.8 | 4.0 | 5.6 | 8.0 | 11 | 16 | 22 | 32 |

←⎯⎯⎯⎯ Amount of light transmitted doubles at every stop

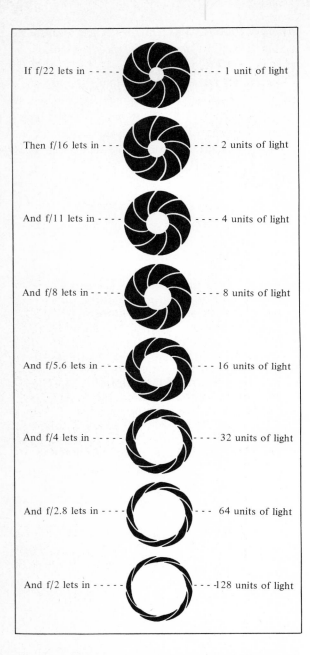

If f/22 lets in - - - - - - - - - 1 unit of light

Then f/16 lets in - - - - - - - 2 units of light

And f/11 lets in - - - - - - - - 4 units of light

And f/8 lets in - - - - - - - - 8 units of light

And f/5.6 lets in - - - - - - - 16 units of light

And f/4 lets in - - - - - - - - 32 units of light

And f/2.8 lets in - - - - - - 64 units of light

And f/2 lets in - - - - - - -128 units of light

Fig. 3–4 Relationship of f/stops to exposure.

If you want to increase the amount of light passing through to the film, but do not want to double it, you might open the aperture to a point midway between two full f/stops. This is called opening up *a half-stop*. Similarly, reducing the amount of light passing through by less than half is accomplished by stopping down a half-stop.

Figure 3–4 shows the relative size of the aperture at various f/stops and its relationship to the amount of light passing through in any fixed interval of time.

Because opening up one stop doubles the amount of light passing through, opening up two stops will increase the amount of light fourfold. Remember, the amount of light doubles at each full stop as you open up. If you open up two stops, you double the light twice, or increase the amount of light four times. Similarly, if stopping down one stop decreases the amount of light passing through by half, stopping down two stops will decrease the amount of light passing through by one-fourth. Study Figure 3–4. Note that f/22 is used as a baseline for comparing relative amounts of light at various f/stops. If we say that f/22 allows one unit of light to pass through, then opening up one stop to f/16 will allow two units of light to pass through. Opening up two stops to f/11 will allow four units of light to pass through, and so on.

Focus

The third setting on an adjustable camera is *focus*. As you move closer to or farther away from various objects in the camera's field of view, images become more or less sharp on the film. Simple cameras may have only one fixed-focus setting requiring you to position yourself at least some given minimum distance from your subject. So long as you position the camera at or beyond this distance, your subject will be in sharp focus. Should you move closer than the minimum distance, your subject will be out of focus in the picture. Adjustable cameras provide a range of focus settings, allowing you to position your camera

at various distances from the subject while retaining the image's sharpness on the film.

The simpler adjustable cameras may require you to estimate or measure the distance between the subject and the camera and then set the lens for that distance. Because this procedure is slow and imprecise, most popular adjustable cameras provide some type of focusing system to aid in setting focus correctly. Some of the common types are described below.

Split-image focusing

Split-image focusing is found most often on small format cameras. As you view your subject through the viewfinder, a portion of the image you see is split; one-half of the image is displaced somewhat from the other half. By operating the focusing ring of the lens you can bring the two halves of the image together. When the two halves of the image are joined properly, the image is in focus on the film. (See Figure 3–5.)

Superimposed-image focusing

Superimposed-image focusing also is found most often on small format cameras. As you view your subject through the viewfinder, a portion of the image you see is doubled. Two images appear, one offset slightly from the other. By operating the focusing ring of the camera you can line up the two images so they appear as one. When you have done so, the image is in focus on the film. (See Figure 3–6.)

Ground-glass focusing

Ground-glass focusing is typical of medium and large format cameras, but is sometimes found on small format cameras. This system allows you to view the image as it appears in the film plane. If the image is out of focus, it will appear fuzzy and not sharp on the ground-glass viewing screen. By operating the focusing adjustments on the camera you can sharpen the image until it appears at maximum sharpness. Whatever appears in sharp focus on the ground-glass screen will be in focus on the film. (See Figure 3–7.)

Fig. 3–5 Out-of-focus view through split-image rangefinder.

Fig. 3–6 Out-of-focus view through superimposed-image rangefinder.

Fig. 3–7 Out-of-focus view through ground-glass viewer.

Fig. 3–8 In-focus view. Whatever type of rangefinder is used, in-focus view is clear, sharp image.

Whatever the type of focusing system, a clear, sharp image in the viewfinder indicates a clear, sharp image on the film. (See Figure 3–8.)

Do Exercise 3–A on page 97

Depth of Field

Objective 3–B Define depth of field and describe the major factors that affect it.

Key Concepts depth of field, out of focus, in focus, control, maximum depth of field, shallow depth of field, infinity (∞), hyperfocal distance, hyperfocal focusing

Various objects will appear sharp or unsharp on the film depending on their distances from the camera. The distance range within which objects appear in acceptably sharp focus is called the *depth of field*. For example, suppose all objects between ten feet and twenty feet from the camera appeared in sharp focus while objects closer or farther away appeared *out of focus*. You would say that the depth of field was from ten to twenty feet, meaning that objects within that distance range appeared *in focus*.

General appearance of aperture settings

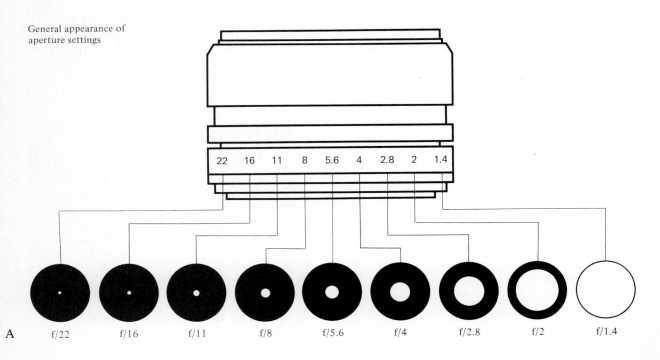

| f/22 | f/16 | f/11 | f/8 | f/5.6 | f/4 | f/2.8 | f/2 | f/1.4 |

A

B

C

Fig. 3–9 Depth of field at various apertures. A. On facing page, aperture setting affects aperture size. B. Above, depth of field at f/22. C. Above right, depth of field at f/5.6. D. Lower right, depth of field at f/1.4.

D

Depth of field is an imprecise concept. The degree of sharpness apparent in an image is only partly due to the physical characteristics of the image itself; partly it is due to the subjective judgment of the viewer — what the viewer considers acceptably sharp under the circumstances. As physical sharpness diminishes gradually from the point of maximum focus toward the boundaries of the depth of field, the judgment of the viewer will determine just where objects within the image are no longer acceptably sharp. Also, the degree of sharpness apparent in an image diminishes as the image is magnified; what appears acceptably sharp in an image of one size may become unacceptable as that image is enlarged to another size. Further, the apparent sharpness diminishes more rapidly as coarse grain films are magnified than as fine grain films are magnified. Thus, depth of field should be regarded as a useful concept rather than as a precise measuring tool.

You can use depth of field as a *control* in your pictures. That is, you can exercise control over the relative sharpness of objects at various distances from the camera. Sometimes you may wish everything in your picture from the nearest objects to the farthest to appear in acceptably sharp focus, as in a landscape. In this case you would try to achieve *maximum depth of field*. At another time you might wish only your subject to appear in sharp focus and everything before and beyond to appear out of focus, thereby concentrating the viewer's attention on the subject. In this case you would try to achieve a very *shallow depth of field*.

Aperture and depth of field

You have learned already that when you change the size of the aperture you change the amount of light passing through the lens. It is important to learn that you also change the depth of field. At small lens apertures the depth of field is greater than at large lens apertures; objects will appear in sharp focus over a greater range of distances at smaller apertures than at larger ones. When you use a large aperture you reduce the depth of field; objects will appear in sharp focus over a shorter range of distances at large apertures than at smaller ones. This principle is illustrated in Figure 3–9.

Focal length and depth of field

At any given aperture, the shorter the focal length of the lens the greater will be the depth of field. Conversely, the longer the focal length of the lens the shallower will be its depth of field. Wide-angle lenses therefore will produce greater-than-normal depth of field; telephoto lenses will produce shallower-than-normal depth of field. Figure 3–10 illustrates this principle.

Distance setting and depth of field

The focus setting of an adjustable camera is marked for various distances. Focusing on an object at any given distance from the camera assures that the object will appear in maximum sharp focus. Objects nearer or farther from the camera within the depth of field will also appear in sharp focus. The distance to which you set your focus, however, also affects the depth of field. As you set your focus on objects close to the camera you reduce the depth of field; as you set your focus on objects farther away you increase the depth of field. This principle is illustrated in Figure 3–11. Note that approximately one-third of the depth of field lies between the camera and the point of sharpest focus; approximately two-thirds lies beyond it. The maximum distance shown on your focus setting is *infinity* (∞), a theoretical distance from the camera beyond which all image-forming light rays entering the camera are approximately parallel and all objects appear to be in focus. For practical purposes, on normal focal length lenses, infinity means approximately fifty feet (fifteen meters) from the camera and beyond.

A

B

Fig. 3–10 A. Depth of field using 28-mm lens. B. Depth of field using 135-mm lens. Both photos shot at f/5.6 focused at 10 feet. Note difference in background focus.

Fig. 3–11 Distance setting affects depth of field at any given aperture.

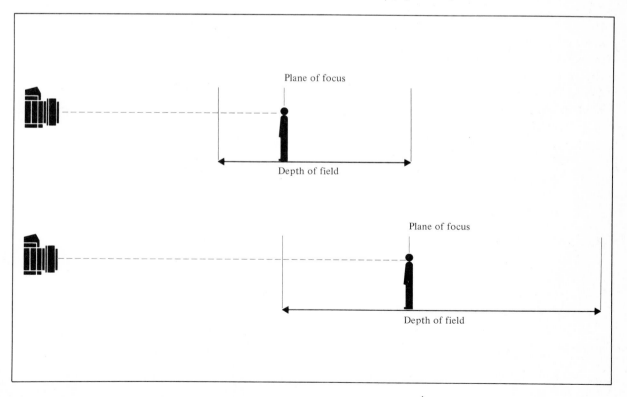

Hyperfocal focusing

At any given f/stop, with the lens focused at infinity, the distance between the camera and the nearest point of acceptable focus is called the *hyperfocal distance*. As you can see in Figure 3–12, when the lens is focused at infinity only a portion of the potential depth of field is used — that portion that lies between the camera and the point of sharpest focus. That portion of the depth of field that extends beyond the point of sharpest focus is unused because all objects to infinity will be in focus anyway, whenever the infinity setting lies within the depth of field.

To obtain maximum depth of field to infinity, the technique of *hyperfocal focusing* is used. By focusing the camera on the hyperfocal distance as in Figure 3–12 the depth of field is extended to a point closer to the camera and still reaches all the way to infinity. You can see that this technique places the infinity setting at the far limit of the depth of field and extends the near limit of the depth of field to a point half the hyperfocal distance from the camera. This technique yields the maximum depth of field possible for any given focal length and aperture setting.

Summary

Depth of field is a concept that refers generally to the distance range within which objects will appear in acceptably sharp focus in the finished image. Five

Fig. 3–12 Hyperfocal focusing.

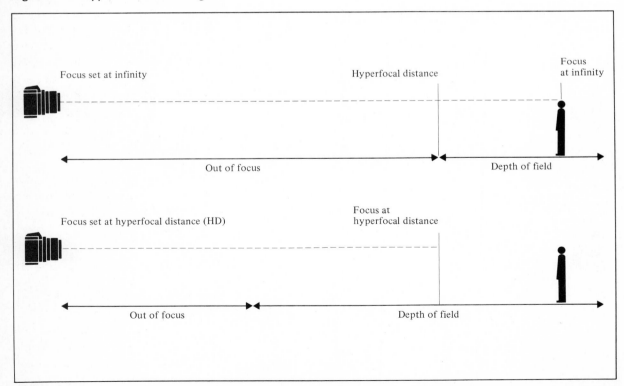

major factors operate to influence sharpness and depth of field in any given circumstances:

1. aperture
2. focal length of the lens
3. focus setting (subject-to-camera distance)
4. grain size
5. degree of magnification of finished image

To obtain the maximum range within which objects will appear acceptably sharp, use the smallest possible aperture, a lens with the shortest possible focal length, hyperfocal focusing, film and processing to produce the finest possible grain, and the least possible image enlargement. Many adjustable cameras have a depth of field scale built into the lens that indicates the distance range over which objects will appear acceptably sharp at various apertures and distance settings. Many cameras with ground-glass focusing allow direct observation of the depth of field before releasing the shutter.

Do Exercise 3–B on page 98

Aperture and Shutter Speed Combinations

Objective 3–C Demonstrate how to select, using an exposure guide, appropriate combinations of apertures and shutter speeds under various conditions.

Key Concepts exposure, intensity, time, $E = I \times T$, reciprocity law, exposure guide, equivalent exposures, camera shake, stop action, blur action, control depth of field, basic exposure rule, reciprocity failure, reciprocity failure (RF) factor

Exposure

Exposure, the amount of light acting on the film, is the product of the *intensity* of the light and the *time* during which the light acts. This relationship may be expressed as $E = I \times T$. As long as the product of the light intensity and time remains constant, the response of the film also remains constant. Thus if light intensity is doubled and time is halved, their product remains the same, as does their effect upon the film. The greater the intensity, the less the necessary time, and vice versa. This relationship has come to be known as the *reciprocity law*.

The size of your aperture, which controls the intensity of the light reaching the film, and the speed of your shutter, which controls the time, combine to determine how much light acts on your film when you trigger the shutter. Setting these two controls determines exposure.

How do you know how to set these two controls? Films of different speeds require different exposures. One simple guide is provided on the film's instruction sheet. Most films used with adjustable cameras have instructions packaged with them or printed on the backing paper at the beginning of the roll. Table 4 is a daylight *exposure guide* for film rated ASA 125. This guide tells you to use a shutter speed of 1/250 sec. and a lens opening of f/11 to photograph an average subject on a bright, sunny day with film rated at ASA 125.

Many combinations of lens openings and shutter speeds will produce the same exposure. The various combinations that produce the same amount of light are called *equivalent exposures*.

For example, suppose your exposure guide told you that you should set your camera at f/11 at 1/250 sec. You could open the lens one stop to f/8 (doubling the amount of light) and use the next faster shutter speed, 1/500 sec. (halving the amount of light), and obtain an equivalent exposure. Or, you could stop down the lens one stop to f/16 and use the next slower shutter speed, 1/125 sec. The exposure would be the same in all cases. There are four reasons why you

Table 4 Outdoor Exposure Guide for Average Subjects for Film Rated ASA 125

Shutter Speed 1/250 Sec.		Shutter Speed 1/125 Sec.		
Bright or Hazy Sun		*Cloudy Bright (No Shadows)*	*Heavy Overcast*	*Open Shade*[b]
Very light subjects f/16	Average subjects f/11[a]	f/8	f/5.6	f/5.6

[a]f/8 @ 1/125 for backlighted close-up subjects.
[b]Subject shaded from the sun but lighted by a large area of sky.

might want to select an equivalent exposure rather than the one specified in the exposure table:

1. To reduce the effect of camera movement

Camera shake with a hand-held camera during exposure is the most common cause of blurred pictures. Using a normal lens and with reasonable care, you can avoid camera shake at speeds as slow as 1/30 sec. To avoid this effect with slower speeds, you will need to use a tripod or to hold your camera steady on a firm base.

The recommended shutter speed for sunny-day picture taking is 1/250 sec. with most black-and-white films. This is a relatively fast shutter, which reduces the effect of hand-held camera movement.

2. To stop action

The image of a moving object moves across the film while the shutter remains open. Thus, a moving object will produce a blurred image if the shutter remains open too long. The recommended shutter speed of 1/250 sec. also helps to stop the blurring of moving objects. However, there are times when you may want to use a faster shutter to *stop action*, such as when you photograph the rapid action of a sporting event or a racing vehicle. In such cases you would select an equivalent exposure with a faster shutter speed.

3. To blur action

Sometimes, to enhance the impression of speed and movement, you may wish the moving object to ap-

pear blurred against its stationary background or to appear fixed against a blurred background. To accomplish this you may wish to use a slower shutter speed than recommended. Photographing a rapidly moving object with a shutter speed of 1/30 sec. or slower will visibly *blur the action* of a rapidly moving object and/or its background. In this case you would select an equivalent exposure with a slower shutter speed.

4. To control depth of field

Shooting at small apertures provides great depth of field, allowing objects both close to and far from the camera to appear in sharp focus. You may wish, however, to use a larger aperture to reduce depth of field. You may not want all the objects in your scene to appear in sharp focus, and setting the camera for an equivalent exposure with a larger aperture allows you to control *depth of field*.

In Table 5, the recommended exposure for ASA 125 film for an average subject on a bright day is circled, 1/250 sec. at f/11. If you want to stop the action of a very fast-moving object, you might prefer to use a shutter speed of 1/1000 sec. In this case you could use the equivalent exposure of 1/1000 sec. at f/5.6 to provide the same exposure with a very fast shutter — a direct application of the reciprocity law.

Suppose you want the image of a fast-moving object to appear blurred in your final picture and would like to use a slow shutter of 1/30 sec. to accomplish this. In this case you could use the equivalent exposure of 1/30 sec. at f/32. Using the reciprocity law, this combination produces the same exposure with a slow shutter.

Determining Exposure

> **Objective 3–E** Describe the desirable characteristics of negatives and explain how to use an exposure meter to determine proper exposure.
>
> **Key Concepts** density, characteristic curve, exposure, underexposed, range of density, overexposed, highlight areas, blocked up, shadow areas, latitude, exposure meter, incident-light meter, reflected-light meter, spot meter, built-in meter, averaging meter, center-weighted meter, film speed setting, exposure scale, average shade of gray, overall reading, close-up reading, highlight reading, shadow reading, range of brightness

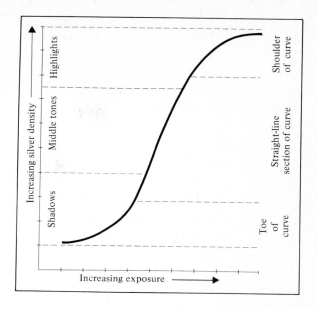

Fig. 3–18 The characteristic (H & D) curve.

Density

As the amount of light reaching the film varies, the amount of silver deposited on the film also varies. Areas of the film receiving much light will possess greater silver *density* than areas receiving little light. These variations of silver density create the image we see in the negative and later in the final print.

Each film responds to light in a unique and characteristic way. This response can be graphed to show how much the silver density will increase for any given increase in the amount of light. (See Figure 3–18.) This *characteristic curve* (also known as an H & D curve after its inventors, Hurter and Driffield) shows how a particular film's silver density will respond to varying amounts of *exposure*.

Examining the characteristic curve of any film reveals that silver density does not increase proportionally to exposure increases at all levels of brightness. At both low and high levels of exposure, the so-called toe and shoulder of the curve, great increases in brightness produce only slight increases in density. Only in the middle of the curve, the straight line section, does density increase proportionally to ex-

posure increases. That is why it is important to make exposures near the middle part of the curve — so that different brightnesses within the scene will be recorded with maximum differences in silver density.

Underexposed negatives receive too little light. Thus the entire brightness range of the scene is recorded near the low end of the curve. As a result, the darkest and brightest objects in the scene differ little in silver density and, overall, the negative appears thin and exhibits a narrow *range of density*. Tonal separation in the middle tones and shadows is weak and the negative will produce a dark print. (See Figure 3–19A.)

Overexposed negatives receive too much light. The entire brightness range of the scene is recorded near the high end of the curve. Here too the darkest and brightest objects in the scene differ little in silver density; however, overall this negative appears dense with silver and exhibits a narrow range of density. Tonal separation in the middle tones and highlights is excessively dense with silver and the negative will produce a light, grainy print. (See Figure 3–19B.)

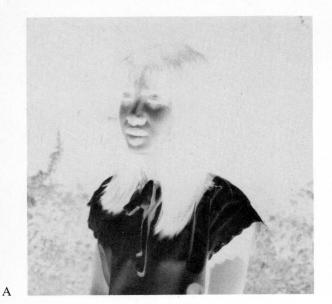

A

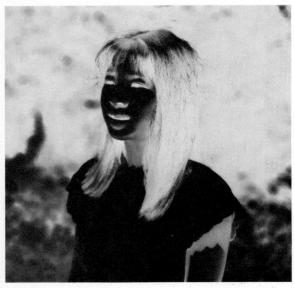

B

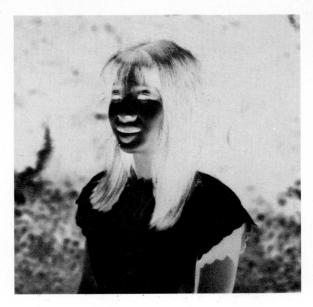

Fig. 3–20 Well-exposed negative. Details are recorded with optimal contrast throughout brightness range present in scene.

Desirable characteristics of negatives

From the above discussion you can see the importance of determining a proper exposure that will record the entire brightness range of the scene with the middle tones being recorded near the middle part of the curve. In this way, brightness differences in the scene will produce maximum differences in density on the negative and thus produce optimum tonal separations throughout the brightness range. Under most circumstances you should strive to expose for the middle of the characteristic curve in order to record the widest range of tones and the maximum tonal separations. To accomplish this you must use proper exposure. (See Figure 3–20.)

The well-exposed negative will be rich in detail. As you look into the *highlight areas* (the densest areas) of the negative, you should be able to discern many distinct details and variations in density. For

Fig. 3–19 Improper exposure of negative. A. Underexposure: detail is lost in shadows (light areas of negative). B. Overexposure: detail is lost in highlights (dark areas of negative).

example, the negative image of a white shirt in sunlight, dense on the negative, should reveal the texture of the cloth, its folds and wrinkles, and the separation of the collar against the front lapel. If these areas are too dense in the negative, these details will be *blocked up* — lost in the density of the silver deposits that record that highlight area. Blocked-up areas are difficult and often impossible to print well.

Similarly, in the *shadow areas* (the thinnest areas) of the negative, you should be able to discern distinct details and variations in density. The negative image of a black flannel suit in the shade of a tree, thin on the negative, should also reveal its texture, folds, wrinkles, and lapels. If these areas are too thin, such details will not be recorded at all. No printing techniques can replace details that are not recorded on the negative.

An important characteristic of a well-exposed negative, therefore, is its recording of detail in both highlight and shadow areas and its possession of density variations corresponding to brightness differences throughout the brightness range. Nevertheless, if the brightness range is very great, some of the darker tones will be recorded near the low end of the curve and some of the brighter tones near the high end. And even though we may see tonal differences in these shadows and highlights, even the most responsive film may not record effectively all that the eye can see. Thus, the film's *latitude* is less than that of the eye. In those cases where the range of brightness in the scene exceeds a film's latitude, it is usually preferable to favor the shadow areas by exposing toward the shoulder of the curve. This tends to preserve the shadow detail while overexposing the extreme highlights, a type of exposure that can be partially corrected. Figures 3–19A, 3–19B, and 3–20 illustrate these principles of proper exposure.

The exposure guide that comes with your film may be generally helpful in determining exposure when the range of brightness is well within the film's latitude. A modern *exposure meter*, however, provides you with a higher degree of precision. By measuring precisely the intensity of light in various parts of the

scene, the meter serves as a tool for determining an exposure that will record the scene in exactly the range of densities that you want.

Using exposure meters

There are two basic kinds of exposure meters — *incident-light meters* and *reflected-light meters*. Incident-light meters read the intensity of light reaching the scene from all sources; reflected-light meters read the intensity of light being reflected from the various objects in the scene. Incident-light meters are designed to measure the relatively brighter intensity of light sources; reflected-light meters are designed to measure the much lower intensities of reflected light. Sometimes a single meter can be adjusted for use either way. (See Figure 3–21.)

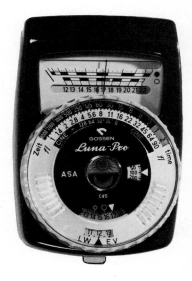

Fig. 3–21 Hand-held reflected-light meter. After setting meter to ASA index of film in use, photographer can translate measurement of light intensity into a set of equivalent exposures. (Gossen Division, Berkey Marketing Companies, Inc.)

Usually light is admitted through a small aperture or diffusion screen to a photosensitive cell. When light strikes this cell, a small current of electricity is induced proportional to the intensity of the light. This current deflects the meter's indicator needle. The brighter the light that strikes the cell, the more the needle is deflected. The needle is referenced to an exposure scale that helps the photographer determine a proper exposure.

Meters differ in design and handling. Some are designed to operate with batteries; some without. Battery-operated meters are more sensitive to low light levels and are more effective in dim lighting. Some meters are designed to be held in the hand and used separately from the camera; some attach to the camera; and some are built into the camera itself. To use a light meter effectively you must understand what it does and how to use the information it provides.

Incident-light meters
Incident-light meters are designed to measure light falling on the subject. To measure incident light, use the meter in the position of the subject and point its light-sensitive cell in the direction of the camera. Light falling on the subject then will fall on the photosensitive cell and the needle will indicate its intensity. From this reading a set of equivalent exposures is easily determined.

Use of the incident-light meter assumes that the objects in the scene have average reflectance. If the objects in the scene are predominantly light or dark, the indicated exposures must be decreased or increased accordingly. If the light falling on the subject varies in intensity, as when a pattern of shadows falls upon the scene, readings taken from both the brighter and darker light sources must be averaged to measure the average light intensity. (See Figure 3–22.)

Reflected-light meters
Reflected-light meters are designed to measure light reflected from the subject. To measure reflected light, use the meter from the position of the camera and point its light-sensitive cell in the direction of the

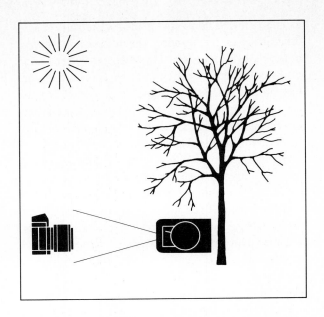

Fig. 3–22 Reading an incident-light meter to measure light falling on the subject from all sources.

subject. Light reflected from the subject toward the camera then will fall on the photosensitive cell and the needle will indicate its intensity. Various objects within a scene reflect different intensities of light; white objects, for example, reflect more light than black ones. The meter may be used to measure these various intensities separately by bringing the meter close to the various objects in the scene. A major advantage of the reflected-light meter is that it can be used to measure the light reflected from different areas of the scene and to evaluate the different effects these areas will have upon the negative image. (See Figure 3–23.)

Spot meters
The *spot meter* is a special type of reflected-light meter designed to obtain reflected-light measurements from very small areas within a scene while you stand at some distance from the subject. While you stand

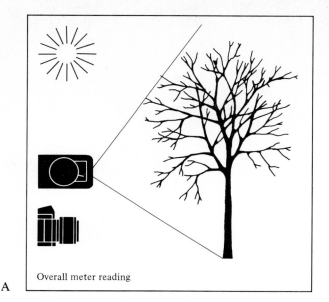

Overall meter reading

A

B

Close-up meter reading

Fig. 3–23 Reading a reflected-light meter. A. Average reading over entire scene viewed by camera may be obtained by positioning meter near camera and directing it toward a scene. B. Brightness of individual object may be read by positioning meter near object.

on the shore, for example, the spot meter allows you to obtain separate readings from the sailboats on the lake, the surface of the lake, the forest areas on the far side, the snowcapped mountains in the distance, and the sky. (See Figure 3–24.)

Built-in meters

Light meters built into the camera itself are becoming increasingly popular with both amateur and professional photographers. There are many types of *built-in meters*. Some simply report the intensity of light in the scene toward which the camera is directed and permit you to set the camera manually to an appropriate exposure. Some automatically set the camera to an appropriate exposure based upon the meter's reading. Some permit you to choose between manual and automatic operation.

Fig. 3–24 Digital auto spot light meter. (Minolta Corporation)

Among built-in light meters, the two most common types are *averaging meters* and *center-weighted meters*. The more common type is the averaging meter; it is designed to measure the average brightness reflected from all parts of the scene and to determine an appropriate setting based on this average. This works well for subjects of limited contrast and even lighting, but for scenes of high contrast care must be taken to ensure that important objects in the scene are well exposed.

The center-weighted meter assumes that the important objects in a scene usually appear near the center of the frame. The meter is designed, therefore, to base its measurement mainly on light from this center area. This works well when the important objects are near the center of the scene, but care must be taken to assure that important objects are well exposed when they occur elsewhere in the scene. See Figure 3–25.

A

B

Fig. 3–25 Built-in meters. A. Averaging meters combine measurements from two halves of the frame. If important details are not equally dominant in both halves, they may not be properly exposed. Here, bright sky in one half of frame caused important details in other half to be underexposed. B. By pointing camera so that important details dominate both halves of the frame, an exposure setting may be determined to improve exposure. C. Center-weighted meters are more sensitive to areas near the center of the frame. Here, bright sky at center causes surrounding details to be underexposed. D. By pointing camera so that important detail is at center of frame, an exposure setting may be determined to improve exposure.

C D

Using a hand-held light meter

The most common type of light meter in use today is the reflected-light meter. To determine exposure using a hand-held, reflected-light meter, you must know both the speed of your film and the intensity of light available in the scene you want to shoot. Your meter uses both kinds of information to compute appropriate exposure data. Using these data you can select a proper exposure for obtaining the particular image you want to achieve.

The meter itself measures the amount of light available in the scene. You must program the film speed into the meter by adjusting the *film speed setting.* Then, by matching the *exposure scale* to the meter reading, you can read the exposure data directly off the scale. Study Figure 3–21. Observe that this meter has been set for a film speed of ASA 100, which appears in a small window. Observe also that the indicator needle has been deflected to 17. Using this information the photographer has adjusted the outer dial of the exposure scale to place the indicator arrow in the next lower window, also at 17. The set of equivalent exposures appropriate to the scene now may be read directly from the exposure scale at the top of the dial. In this case you may observe that the set of equivalent exposures includes 1/250 sec. at f/4, 1/125 sec. at f/5.6, and so forth.

What do these indicated exposures mean? What is recorded on the film if you use one of these indicated exposures? To control the effects of exposure on your film and to select an exposure that will produce the results you want, you should understand what your meter is reporting to you. Light reflected from various areas in the scene acts on the photoelectric cell, light areas reflecting more light and dark areas reflecting less. The meter averages these light intensities and reports the average to you. The exposure scale, from which you read the exposure data, has been calibrated in manufacture to give an exposure setting that, using standard procedures, will produce a negative that will print objects of average brightness as an *average shade of gray.* Thus, using an indicated exposure,

A

Fig. 3–26 **A. Exposure set from white card light reading.** Note that white card appears gray. **B. Exposure set at gray card light reading.** The gray card appears gray. **C. Exposure set at black card light reading.** Here the black card appears gray.

objects of average brightness in the scene will be rendered an average gray, no matter how light or dark the scene is overall.

Imagine three blank walls, one black, one gray, and one white. Using your reflected-light meter you obtain a reading from the black wall and use the indicated exposure to shoot its picture. Then you do the same for each of the remaining walls, obtaining two more readings and using the indicated exposures to shoot two more pictures. Upon processing and printing the three pictures using standard procedures, what do you find? No longer black, gray, and white, all three walls appear the same average shade of gray in their respective photographs. The meter tells you

B

C

what exposure to use to make the average brightness seen by the meter an average shade of gray. If you point your meter at something you wish to appear darker or lighter than this average gray, you will have to modify the indicated exposure. (See Figure 3–26.)

Average reading

When you are photographing a large scene in which the light intensities are distributed fairly evenly — such as a landscape, seascape, or group photo under overcast skies — you can use your reflected-light meter from the camera position. Point the meter toward the scene to obtain an *overall* or *average reading* and use one of the indicated exposures. Be careful not to point the meter toward the sky; tip it slightly downward. If the meter reads too much skylight, it will inflate the average reading and lead you to underexpose shadow areas.

Close-up reading

When you are photographing a scene in which there are extreme highlight and shadow areas, an average reading may not be satisfactory. Suppose you are photographing a sunlit girl in a white dress against a background of dark, shadowed trees. At some distance the overall reading will be influenced unduly by the darkness of the trees, leading to indicated exposures that will overexpose the subject. In such cases take your meter closer to the subject to a point where subject and background are represented more equally. Such a *close-up reading* will assure you that your indicated exposure is not influenced excessively by irrelevant background details.

Using either the average or close-up method, your meter should be pointed along the axis of the camera, viewing the subject from the same angle as the camera. Figure 3–23 depicts both methods.

Range of brightness

When the scene you want to photograph has a wide range of brightness with extreme highlight and shadow areas, it is more difficult to select a proper exposure. If you base your exposure on the brightest areas in the scene, you may underexpose the darkest areas and hence fail to record details in the shadow areas. If you base your exposure on the darkest areas of the scene, you may overexpose the brightest areas so that details in the highlight areas may be too dense and blocked up to print well. To overcome these difficulties you must find an optimal exposure between the two extremes that will record the maximum detail within the full range of brightness.

One way to determine this exposure is to take your light meter to several points in the scene for close-up readings. Find the brightest important area in the scene and take a *highlight reading*. Then find the darkest important area in the scene and take a *shadow reading*. Average the two readings and select an exposure midway between the two extremes. This exposure will record light intensities midway in the brightness range as an average gray and maximize details recorded between the two extremes. This procedure is known as the *range-of-brightness* method for determining exposure. For best results with this method, obtain readings only from areas that are important to your picture. Ignore unimportant areas even though they may be more extremely light or dark. If the shadow details are of special importance, using an exposure about two-thirds of the way toward the shadow exposure will improve the overall results.

Sometimes, of course, you may not be interested in recording the entire range of detail and tone. Suppose, for example, you are shooting a sunlit portrait against a dark background of trees. In this case you want a full range of detail and tone in the face; you are not very interested in recording the detail and tone in the trees. In one approach you could take both highlight and shadow readings from the face of the subject, selecting an exposure between these extremes and ignoring the darker shadows of the background altogether.

Exposure for shadows or highlights

The latitude of most black-and-white films approximates four stops — they will record details within a range of brightness in which highlight areas are as much as sixteen times brighter than shadow areas. If the brightness range in a scene exceeds these limits, the range of brightness method may result in loss of detail in both the highlights and the shadows. One approach to solving this problem is to obey the dictum, "expose for the shadows," or, more precisely, expose for minimum shadow density. One way to use this technique is first to obtain a meter reading of the darkest important shadow area in the scene. Then reduce exposure two stops from the indicated meter reading. This renders the darkest area as thin as possible on the negative while preserving details in the shadows. Of course highlight areas may be overexposed because the exposure is not reduced enough; however, you can compensate somewhat for overexposing during processing and printing. You can never recover details that have not been recorded on the film in the first place. For this reason many photographers give priority to shadow areas when determining exposure, even when it means that highlight areas will be overexposed.

There are times, however, when highlight areas may be more important than shadows. In these cases you may prefer to give priority to the highlights, even if it means sacrificing details in the shadows. To do so, first obtain a meter reading of the brightest important highlight area in that scene. Then increase exposure two stops from the indicated meter reading. Thus the brightest areas will be rendered as dense as possible on the negative while preserving details in the highlights. The shadow areas may be underexposed and detail lost, however, because the exposure has not been increased sufficiently to record them.

These procedures for exposing for shadows or for highlights may produce more satisfying results than the other methods discussed whenever the range of brightness exceeds the latitude of your film. They are simple adaptations of the zone system, which is discussed further in Unit 10.

The 18 percent gray card

Reflected-light meters are designed to indicate exposures that will record an average light reflectance as a middle tone of gray. The industry standard for this average light level is 18 percent reflectance. This means that an object that reflects 18 percent of the light falling on it would be seen as average by your reflected-light meter. The exposures indicated by your meter would record that object as a middle tone of gray.

One way to take advantage of this feature is to meter on an object of average reflectance and then use an exposure indicated by the meter. As it is difficult to judge which objects in a scene are of average reflectance, you may substitute an 18 percent gray card for this purpose. These gray cards are easily obtained at photographic supply stores and simplify many metering situations, especially those characterized by out-of-the-ordinary lighting conditions.

Use of an 18 percent gray card will not solve the problem of a scene with a range of brightness greater than the latitude of your film. It will only assure recording the average portions of the scene as middle gray tones. If your scene has an excessively wide brightness range, both highlight and shadow details may be lost in the process. In such situations it may be better to modify the indicated exposures to expose for the shadows, as discussed earlier.

The 18 percent gray card is also useful for color printing. Because the card has standard reflectance and neutral color, it may be used to serve as a reference tone to guide the printing laboratory. Many photographers using color negative film will start each roll by shooting a frame showing an 18 percent gray card. This frame then serves as a color reference to the printer who otherwise might have difficulty determining the precise color balance of your original scene.

Most commercially made gray cards have a white surface on the opposite side of 90 percent reflectance. The white side may be used in low light levels when the gray side does not reflect enough light to obtain an accurate reading. If the white side is used, the indicated exposure must be increased by $2\frac{1}{2}$ stops to obtain the reading equivalent to 18 percent reflectance.

Simulating close-up readings

If your scene is such that you cannot get close enough to your subject to take close-up readings (and you do not have a spot meter), you can simulate the lighting situation close at hand. Consider the view across the lake, for example, with sailboats on the lake, trees on the far side, and snowcapped mountains in the distance. You can take a reading from a white sheet of paper to simulate the white sails and snow, and from a nearby tree to simulate a distant tree. The palm of your hand can be used to simulate flesh tones at a distance. You must remember, however, that these substitutes will serve only if viewed in the same type of illumination as the objects they simulate.

The use of the exposure meter to obtain previsualized tonal values is discussed in Unit 10.

To review, the stops in using a hand-held reflected-light meter are:

1. Set the meter for the speed of the film you are using.
2. Point the meter toward the subject or area of interest. Always use the meter between the camera and the subject so the meter sees the subject as the camera sees it.
3. Set the adjustable ring of the exposure scale to correspond to the needle reading.
4. Read the exposure scale.
5. Take as many readings as necessary for the method you are using.
6. Select an exposure that will record the details and tones in the scene as you want them to appear.

Using a built-in automatic meter

The built-in light meter that automatically sets your camera for a proper exposure by adjusting the aperture and/or shutter speed is designed to produce well-

Fig. 3–27 Readjusting the ASA setting of an automatic camera.

exposed negatives under average lighting conditions. However, when the subject and background are unequally illuminated, the meter may set exposure for the background lighting and under- or overexpose the subject in the foreground. The meter cannot tell the difference between your subject and its background; all it can do is to read the average intensity of light in the scene reflected from all sources. This average may be greater or lesser than the intensity of light reflected from the main subject and result in poor exposure.

To overcome this result with a built-in automatic meter, you may use one of several methods. If your camera can be set manually, you may obtain a close-up reading of the subject and manually set the camera for one of the indicated exposures. But if your camera operates only in an automatic mode, it may be necessary to fool your meter into setting a proper exposure. One simple way to achieve this is to reset the ASA setting of the camera. Double the ASA setting to reduce exposure by one stop; halve the ASA setting to increase exposure by one stop. (See Figure 3–27.)
Do Exercise 3–E on page 101

Suggested references

Brooks, David. *Photographic Materials and Processes.* Tucson: H-P Books, 1979. Pages 106–112.

Craven, George M. *Object and Image: An Introduction to Photography.* Englewood Cliffs, N.J.: Prentice-Hall, 1975. Pages 54–65.

Davis, Phil. *Photography.* 3rd ed. Dubuque: William C. Brown, 1979. Pages 79–86.

Eastman Kodak Co. *Kodak Films: Color and Black-and-White.* Rochester, N.Y.: Eastman Kodak, 1978. Pages 83–96.

Jacobs, Lou Jr. *Photography Today.* Santa Monica, Calif: Goodyear, 1976. Chapter 6.

Rhode, Robert B., and F. H. McCall. *Introduction to Photography,* 4th ed. New York: Macmillan, 1981. Chapter 4.

Swedlund, Charles. *Photography,* 2nd ed. New York: Holt, Rinehart and Winston, 1981. Chapter 5.

Time-Life Books. *Life Library of Photography: Light and Film.* New York: Time, Inc., 1970. Chapter 5.

Suggested field and laboratory assignments

Take your camera and light meter outside during daylight hours. Shoot a roll of color transparency film and a roll of black-and-white film. Shoot a variety of subjects (your choice) under a variety of lighting conditions. Be sure to include close-ups and long shots, some in bright sunlight, some in shade, some moving subjects, some stationary objects. Use your meter to determine proper exposures: Try each method of determining exposure. Keep a shooting log (see below). Record a log entry for each shot showing lighting condition, meter method, and exposure.

Have your color film commercially processed. Keep your black-and-white film for processing in the next unit.

Do Practice Test 3 on page 103

Shooting Log

Date: June 24, 1982 Roll: 1 Film: Plus-X (ASA 125)

Shot	Lighting Condition	Method	Exposure
1	Bright sunlight	Average	f/11 @ 250
2	Backlight. Face shaded	Close-up	f/5.6 @ 250
3	All in shade	Average	f/5.6 @ 250

EXERCISE 3–A

1. Describe how the basic settings are adjusted on your camera.

 A. Shutter: _____

 B. Aperture: _____

 C. Focus: _____

2. The standard sequence of shutter settings on adjustable cameras is: _____

3. Your shutter is set at 60. To double the exposure, you will set the shutter at _____.

4. The standard sequence of aperture settings on adjustable cameras is: _____

5. Your aperture is set at f/5.6. To double exposure, you will set the aperture at _____.

6. Your aperture is set at f/8. To obtain one-fourth the exposure, you will set aperture at

 _____.

7. Your shutter is set at 250. To obtain one-fourth the exposure, you will set shutter at

 _____.

8. To make a time exposure, set your shutter at _____ or _____.

9. Three types of focusing systems most common among 35-mm cameras are

 _____, _____, and _____.

10. The type of focusing viewer common in twin-lens reflex cameras is

 _____.

Return to Objective 3–B, page 74

EXERCISE 3–B

1. To obtain maximum depth of field to infinity, use the technique of _____

2. Define hyperfocal distance. _____

3. Explain how you might eliminate a busy background by controlling depth of field.

4. Explain how you would obtain maximum depth of field at any given aperture.

5. List five factors that influence sharpness and depth of field.

Return to Objective 3–C, page 79

EXERCISE 3–C

1. The film you will use for your first photo assignment is _____.

2. It has an ASA index of _____. A slower film is _____ with an ASA index of
 _____. A faster film is _____ with an ASA index of _____.

3. With an ASA 400 film you calculate a correct exposure to be f/5.6 at 1/125 sec. A correct
 exposure under the same conditions using an ASA 100 film would be f/5.6 at _____.

4. With an ASA 64 film you calculate a correct exposure to be f/11 at 1/60 sec. A correct
 exposure under the same conditions using an ASA 125 film would be _____ at 1/60 sec.

5. You calculate a correct exposure at f/5.6 at 1/125 sec. You prefer to use a shutter speed of 1/500 sec. To obtain an equivalent exposure with that shutter speed, you will set your aperture at _____. Under what circumstances might you prefer this combination?

6. In the situation above, you prefer instead to use an aperture of f/16. To obtain an equivalent exposure with that aperture, you will set your shutter at _____. Under what conditions might you prefer this combination? _____

7. Using Table 4 as a guide, determine a correct aperture setting for an outdoor average subject under bright sunlight shooting at 1/1000 sec. _____.

8. Briefly state the principle of the reciprocity law. _____

9. Explain what is meant by reciprocity failure. _____

Return to Objective 3–D, page 82

EXERCISE 3–D

1. List three variables that affect the apparent speed of a moving object.

 A. _____

 B. _____

 C. _____

2. Discuss the relationship between each of these variables and the shutter speed needed to stop the subject's action.

 A. _____

 B. _____

 C. _____

3. Describe two slow shutter techniques for photographing action and their effects on the image in the final picture.

 A. _____

 B. _____

4. Explain why it is often difficult to stop rapid action and retain good depth of field.

5. List and explain two ways you might compensate for this problem — that is, ways you might stop rapid action, retain depth of field, and make a correct exposure.

 A. _____

 B. _____

Return to Objective 3–E, page 85

EXERCISE 3–E

1. Light falling on an object is called _____ light. To measure the intensity of this

 light, you normally use the meter in the position of the _____ pointed in the

 direction of the _____.

2. The light reflected off the surface of an object is called _____ light. To measure the average intensity of all such light entering the camera, you normally use the meter

 in the position of the _____ pointed in the direction of the _____.

3. Sometimes light from the background and light from the subject differ widely in intensity. To reduce the undue influence of background lighting on our reflected-light meter

 reading, we might obtain a _____ reading with the meter in the position of the

 _____ pointing in the direction of the _____.

4. Describe the range-of-brightness method for determining exposure. _____

5. The one important bit of information you must program into the exposure meter is

 _____.

6. You obtain a close-up reading of a man in a black suit. Using the indicated exposure

 and standard procedure, the suit will appear _____ in a black-and-white print.
 You follow the same procedure with a man in a white suit. His suit will appear

 _____ in the final print.

7. If the range of brightness in a scene exceeds your film's latitude, how would you de-
 termine an exposure to maximize detail while assuring that shadow details are not lost?

8. To alter exposure with a built-in automatic meter, you may "fool" the meter by altering

 the _____ setting.

9. How might an 18 percent gray card aid you to determine exposure? _____

Review References on page 96 and do Suggested field and laboratory assignments on page 96

PRACTICE TEST 3

For each of the following questions, select the one *best* answer and write its corresponding letter in the blank preceding the question. After you have completed the test, check your answers against the correct answers, which follow the test. If you miss any of the test items, review the study materials as suggested.

_____ 1. Given a shutter setting of 1/125 sec., you would double the exposure by setting the shutter at _____.
A. 1/30 sec.
B. 1/60 sec.
C. 1/100 sec.
D. 1/250 sec.
E. 1/500 sec.

_____ 2. Which of the following shutter settings does *not* appear in the standard shutter setting system?
A. 1/250
B. 1/125
C. 1/25
D. 1/15
E. 1/8

_____ 3. Which of the following is *not* a full f/stop?
A. f/4.5
B. f/2.8
C. f/5.6
D. f/1.4
E. f/4

_____ 4. The depth of field of a given lens, focused at a given distance, will be least at _____.
A. f/4
B. f/8
C. f/11
D. f/22
E. f/32

5. For a film rated ASA 40, you find that a correct exposure is 1/250 sec. at f/5.6. If your film were rated ASA 80 under the same conditions, your correct exposure would be _____ sec. at f/5.6.
 A. 1/60
 B. 1/125
 C. 1/250
 D. 1/500
 E. 1/1000

6. A correct exposure under given conditions is 1/125 sec. at f/4. An equivalent exposure is 1/60 sec. at _____.
 A. f/2
 B. f/2.8
 C. f/5.6
 D. f/8
 E. none of these

7. While using a given roll of film, which of the following should remain constant on your light meter?
 A. ASA
 B. f/stop
 C. shutter
 D. light value
 E. both B and C

8. Your camera is set at f/11. To open up one stop, you would set the aperture at _____.
 A. f/22
 B. f/16
 C. f/8
 D. f/5.6
 E. f/4

9. The full f/stop located between f/16 and f/32 is _____.
 A. f/28
 B. f/24
 C. f/22
 D. f/20
 E. there is no full stop between f/16 and f/32

_____ 10. To increase depth of field while maintaining equivalent exposure _____.
 A. open up, expose longer
 B. open up, expose less
 C. stop down, expose longer
 D. stop down, expose less
 E. change ASA setting

_____ 11. 1/125 sec. at f/8 is the equivalent of 1/250 sec. at _____.
 A. f/16
 B. f/11
 C. f/5.6
 D. f/4
 E. f/2.8

_____ 12. To take a reflected light reading with your meter _____.
 A. stand near the subject and aim your meter at the subject
 B. stand near the subject and aim your meter at the camera
 C. stand near the camera and aim your meter at the subject
 D. stand near the light source and aim your meter at the subject
 E. A or C

_____ 13. Which of the following transmits four times as much light as f/8?
 A. f/5.6
 B. f/4
 C. f/16
 D. f/11
 E. none of these

_____ 14. You're interested in recording the distant background detail in a scenic picture as well as nearby foreground detail. You should use _____.
 A. the fastest shutter speed
 B. the slowest shutter speed
 C. the largest aperture
 D. the smallest aperture
 E. a combination of fast shutter and large aperture

_____ 15. The exposure guide packaged with your film recommends 1/125 sec. at f/8. An exposure of 1/30 sec. at f/16 _____.
 A. will produce the same exposure
 B. will produce half the exposure
 C. will produce twice the exposure
 D. will produce one-fourth the exposure
 E. will produce four times the exposure

_____ 16. To take a light reading of a strongly backlit subject, use the _____ method.
 A. overall
 B. range of brightness
 C. close-up
 D. built-in light meter
 E. B or C

_____ 17. The shutter needed to stop action of a pedestrian head-on from 25 feet is 1/125 sec. What shutter should be used for the same shot if the pedestrian is walking across your field of view?
 A. 1/250 sec.
 B. 1/125 sec.
 C. 1/60 sec.
 D. 1/30 sec.
 E. 1/15 sec.

_____ 18. You can take action pictures at slower shutter speeds if you _____.
 A. move back from the moving object
 B. wish your subject to appear blurred
 C. use panning or panoramming for your shot
 D. reduce the angle of the object moving across your camera axis until the subject is viewed more directly head-on
 E. any of the above

_____ 19. Panning or panoramming tends to produce _____.
 A. a blurred subject against a sharp background
 B. a subject caught off-balance
 C. a sharp subject against a blurred background
 D. a frozen image of the subject's action
 E. a subject and background in sharp focus

_____ 20. The indicated exposure on your light meter tells you how to set your camera if you want the average light intensity being read by the meter to appear _____ in your photograph.
 A. black
 B. full of detail
 C. white
 D. empty of detail
 E. gray

ANSWERS TO PRACTICE TEST 3

 1. B You double the exposure by letting in _more_ light, which is accomplished in this instance by allowing the shutter to remain open twice as long. If you missed this question, review "Basic Camera Settings," page 69.

2. C 1/25 sec. is an old shutter system setting. See "Basic Camera Settings," page 69.

3. A See "Basic Camera Settings," page 69.

4. A As you open the aperture you lose depth of field. Because f/4 is the widest aperture of the listed f/stops, it has the least depth of field. See "Depth of Field," page 74.

5. D An ASA 80 film is twice as fast as an ASA 40 film. Therefore you want half as much light to strike the film. The question states that the aperture remains constant at f/5.6. You must adjust the shutter to admit half as much light, to 1/500 sec. See "Aperture and Shutter Speed Combinations," page 79.

6. C You are letting in twice as much light when you adjust the shutter from 1/125 sec. to 1/60 sec. Therefore rest the aperture to reduce exposure by half. Stop down to f/5.6. This is an example of the reciprocity law in action. See "Aperture and Shutter Speed Combinations," page 79.

7. A The film's ASA is constant. Shutter speed and aperture vary from scene to scene as available light changes. See "Determining Exposure," page 85.

8. C "Open up" means let in more light. See "Basic Camera Settings," page 69.

9. C Review the sequence on page 71 if you missed this question.

10. C Small apertures increase depth of field, requiring you to stop down. As you stop down you allow less light to enter the camera. To maintain equivalent exposure, you must expose the film longer — that is, use a slower shutter. See "Aperture and Shutter Speed Combinations," page 79.

11. C In this question you have halved exposure by using a faster shutter, so you want to double exposure by opening up one stop, which is f/5.6. Remember, f/5.6 is the full stop between f/4 and 4/8.

12. E You can use a reflected light meter either close-up, as in alternative A, or from the camera position, as in alternative C. See "Determining Exposure," page 85.

13. B Opening one stop from f/8 to f/5.6 admits twice as much light. Opening another stop from f/5.6 to f/4 admits twice again as much light, or four times the amount of light as at f/8. The exposure doubles each time the aperture opens one stop.

14. D If you're interested in background and foreground detail, you want the most depth of field possible, so you'll use the smallest aperture.

15. A See the discussion in "Aperture and Shutter Speed Combinations," page 79 if you are uncertain about equivalent exposures.

16. E You might use either B or C, depending on the subject. For the discussion of meter techniques, review "Determining Exposure," page 85.

17. A See "Exposure and Action," page 82. You'll need a faster shutter because the apparent speed will be greater.

18. E These are all good techniques to remember.

19. C See "Exposure and Action," page 82.

20. E The indicated exposures on your meter are calibrated to produce a negative that will interpret the average brightness value, which the meter sees as an average gray. A black object and a white object each will appear average gray if each is shot using the indicated exposure obtained from a close-up reading of the object. See "Determining Exposure," page 85. You should use the indicated exposure as a guide in determining exposure, not as a hard-and-fast rule.

PROCESSING BLACK-AND-WHITE FILM AND PRINTS

U N I T 4

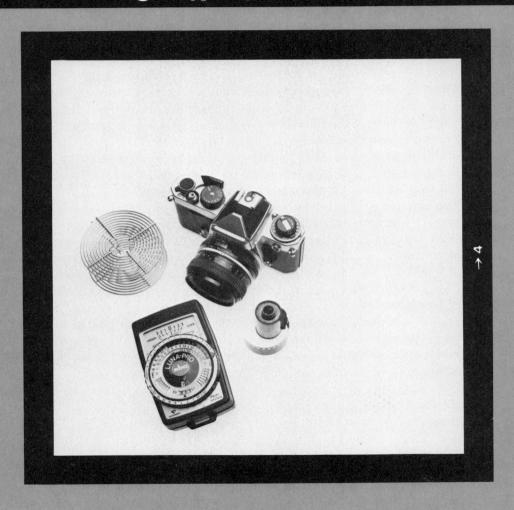

Film Processing

> **Objective 4–A** Explain and demonstrate the processing of black-and-white negative film.
>
> **Key Concepts** latent image, processing, negatives, film-processing tank, developer, silver, shortstop, fixer, wetting agent, time control, temperature control, reticulation, agitation, acetic acid, time-and-temperature chart, one-shot developer, replenisher, clearing agent

Once the film has been exposed in the camera, the photographic image is recorded in the film. Were you to look at the film at this time, however, it would appear no different from unexposed film. This recorded but invisible image on the film is called a *latent image*. To transform this latent image into a visible image it is necessary to process the film. In *processing*, the film is passed through several chemical baths in total darkness, then washed free of all active chemicals, and finally dried. When this process is complete, the exposed film has been transformed into a set of *negatives*. In the negative image, everything on the black-and-white scale has been reversed: Objects that were white in the scene are black in the negative; objects that were black in the scene are transparent in the negative. To make a positive print from the negative, you must take further steps, which will be discussed in the next unit. For now, let us study the processing of the film to produce negatives.

An overview

An overview of the entire process might be helpful before we look at each of the steps. First, it is well to keep in mind that most popular films are panchromatic — that is, they are sensitive to all visible colors of light. Therefore you cannot look at unprocessed panchromatic film under any visible light without exposing it. All handling of panchromatic film before and during processing, then, must be accomplished in total darkness. (Certain films, such as orthochromatic film, are not sensitive to all colors of light. These films can be examined before and during processing under special safelights.)

Before processing, the film is normally loaded into a special lightproof *film-processing tank*. The loading must be done in total darkness to protect the film from exposure to light. But once in the tank, with the tank properly sealed, the film can be processed under normal lighting conditions. The chemical baths can be poured into and out of the tank through special light-tight openings without exposing the film to the light outside the tank.

Once in its lightproof tank, the film is first bathed in a chemical *developer*. The exposed crystals of silver bromide, those that have been exposed to light, are attacked by the developer so that the bromine is freed, or dissociated, from the silver. The free bromine is carried off into the developer solution while the *silver* is left deposited in the emulsion. The greater the amount of exposure to light, the more silver deposited. These silver deposits are actually tangled webs of tiny grains of silver. They appear black to the naked eye and make up the dark portions

> **CAUTION**
>
> **Handling photo chemicals**
> Many photo chemicals are poisonous or caustic and should be kept beyond the reach of children. Special precautions should be taken with developers, sepia and selenium toners, and acetic acid. Also some individuals may suffer allergic skin reactions to certain photo chemicals. Plastic or rubber gloves usually will provide adequate protection to such persons.

of the negative. To stop the action of a developer, the film is immersed briefly in a clear water rinse or an acid *shortstop*.

The developer does not attack the silver bromide crystals that have not been exposed to light, however. So if you were to view the film after development you would see the black silver image embedded in a creamy white background consisting of the unexposed, undeveloped portions of the emulsion. To eliminate these still-active silver bromide crystals, another chemical bath is needed. This one is called the fixing bath and uses a chemical *fixer*. In this bath, which is also carried out within the processing tank, all the remaining undeveloped silver bromide crystals are dissolved along with the antihalation backing. In fact, all unnecessary chemicals and backings are dissolved in the fixing bath. All that remains is the metallic silver image produced by the action of the developer. This image is embedded in the gelatin emulsion that adheres throughout to the acetate backing. This is the negative that will be used to make your finished photographs.

At this point, with all the light-sensitive chemicals removed from the film, you can open the tank and view the negatives in normal light. The processing, however, is not yet complete. All traces of the processing chemicals — the developer and the fixer — must be washed from the negatives. If any traces of these chemicals remain embedded in the emulsion after processing, eventually they will dry and stain the negatives, damaging their usefulness. Following a thorough washing, the negatives must be dried properly. Keep in mind that the wet gelatin emulsion is very soft. Particles of dust or grit that lodge on it may become embedded firmly and show up as white specks on your finished photographs. Also, just as dried water spots may be unsightly on dishes and glassware, they may be disastrous on negatives. Dried water spots on the gelatin emulsion often are firmly fixed and always will show up in your finished photographs. So a *wetting agent* and correct drying procedures should be used to assure that the processed film will dry free of dust, scratches, and water spots.

All chemical processes are sensitive to both time and temperature, so it is important to exercise careful *time control* and *temperature control* during processing — just the right amount of time at a proper temperature to get the best results. Clearly the development process does not take place in an instant — were you to remove the film from the developer too soon, the process would be incomplete; were you to leave it in the developer too long, the film might become overdeveloped. Overdeveloping film tends to increase contrast and produce dense, grainy negatives, even from normally exposed film. Heat speeds up chemical processes whereas cold slows them down. If the chemical developer is too cold, it might take hours to develop the film properly; if it is too warm, it might develop so fast that you can't remove the film from the developer quickly enough to avoid overdevelopment. Furthermore if one of the solutions is very warm and another very cold, the sudden change in temperature may damage the film severely. Just as glass raised to a high temperature may crack if it is suddenly plunged into cold water, so the gelatin emulsion may react to an abrupt change of temperature. This "cracking" of the emulsion, which produces a "craze" pattern, is commonly called *reticulation*. You can see that it is important to maintain careful temperature control over all solutions used for processing the film.

Throughout the chemical processing of your film, proper *agitation* of the solutions is necessary. Were you to allow your film to remain quietly in the solution, the processing would occur very unevenly over the film surface. Small air bubbles clinging to the film's surface would not be dislodged and would show up as small undeveloped "pinholes" where chemical processing failed to take place. Further, as the chemicals acted on the heavily exposed areas, the solution in direct contact with the film would become exhausted and inactive, and the process would slow down in those areas. In less-exposed areas of the film the chemical activity would remain quite active. Thus, to assure even development over the entire film surface, you must agitate the solution to dislodge the

air bubbles and to bring fresh solution into contact with all areas of the film through the entire processing period.

Overly vigorous agitation, however, may create streaking effects and excessive contrast. Therefore, agitation too must be carried out under carefully controlled conditions. Table 7 describes some typical film developers.

The above overview may seem formidable — so many things to go wrong, so many controls to exercise. Yet the process can be mastered easily with practice. With the above general principles in mind, let us now examine the key piece of equipment used in film processing.

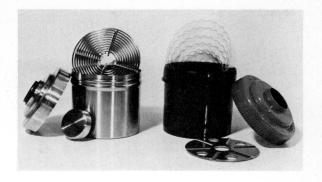

Fig. 4–1 Processing tanks and reels for roll film.

Film-processing tanks

Film-processing tanks come in several varieties. Most are made of plastic or stainless steel for use with roll films, film packs, or sheet film. All processing tanks provide some inner mechanism for holding the film so that the film emulsion will not touch anything during processing. Should the emulsion touch anything — the sides of the tank, another sheet of film, or another part of the film roll — the processing chemicals will not act properly at this point and the negatives will be damaged. Tanks for sheet films or film packs typically provide some type of cage with compartments for each separate sheet of film, or some type of hanger from which each sheet of film can be suspended separately in the solutions. Roll-film tanks typically provide a reel onto which the film can be loaded so that the film at no point touches itself. Some of these reels are rigid. Some are designed to be loaded from the center outward, whereas others are designed to be loaded from the outside toward the center. Another type uses a flexible plastic apron that is rolled up with the film, designed to hold the film so that the emulsion touches neither the apron nor other parts of the film. (See Figure 4–1.)

Whatever type of tank and loading mechanism you use, be sure that it is designed for the size and type

HELPFUL HINT

Mixing shortstop
Most photo chemicals are packaged with instructions for mixing and storage. Follow them carefully. Chemical shortstop, however, often is not explained. Shortstop is a 1 to 2 percent solution of *acetic acid.* Acetic acid can be purchased in two forms: glacial acetic acid (99 percent), which must be handled with great care, and commercial-strength acetic acid (28 percent), which is easier to store and handle. Purchase the chemical strength, but if you must purchase glacial, dilute it to commercial strength for storage. Here are the dilution formulas:

3 parts glacial + 8 parts water = 11 parts commercial strength (28 percent)
1 part commercial strength + 20 parts water = 21 parts shortstop

Using one of the many commercial stop bath preparations, while somewhat more costly, may be preferable to the slight inconvenience of the procedure just described.

Table 7 Some Typical Film Developers

Type	Manufacturer and Name	Grain	Effective Film Speed	R* or O	Comments
General Purpose Compromise formulas that strike balance among density, contrast, graininess, and resolution with general purpose films.	Agfa Rodinal	medium to very fine	normal to increased	O	finest grain with thin-emulsion films
	Beseler Ultrafin FD5	fine	normal	O	variable contrast with different dilutions
	Beseler Ultrafin FD7	fine	increased	R	moderate compensation and good shadow detail
	Edwal Super 12	fine	increased	O/R	noncompensating
	Edwal FG7	fine	increased	O/R	soft-working; long scale
	Ethol Blue	medium to fine	normal to increased	O	good shadow detail at higher EI
	Ilford Microphen	fine	increased	O/R	various dilutions give compensating effect
	Kodak HC-110	medium to fine	normal	O/R	versatile for general and special films
	Kodak D-76	medium to fine	normal	O/R	most popular; same as Ilford ID-11
Fine Grain Produce less apparent grain than general purpose developers; tend to be slow-working; afford contrast control for films with high inherent contrast.	Edwal Super 20	fine to very fine	normal	R	finest grain with slow films
	Ethol UFG	extremely fine	normal to increased	R	can use with roll or sheet film
	Ilford Perceptol	fine to extremely fine	slight decrease	O/R	gives soft tonal gradations with fast films
	Kodak Microdol-X	fine to extremely fine	slight decrease	O/R	extremely fine grain with slow films
Acutance Favor superior definition of detail and normal contrast. Work best with slow, thin-emulsion films minimally exposed for shadows.	Beseler Ultrafin FD1	fine	increased	O	for slow- to medium-speed films
	Beseler Ultrafin FD2	fine	increased	O	for medium- to fast-speed films
	Tetenal Neofin Blue	fine	increased	O	for slow- to medium-speed films
	Tetenal Neofin Red	fine	increased	O	for medium- to fast-speed films

*R (re-usable); O (one-shot); O/R (may be used either way)

Table 7 *cont.*

Type	Manufacturer and Name	Grain	Effective Film Speed	R* or O	Comments
Compensating Designed for use when high, medium, and low contrast subjects occur on same roll of film. Work best when film minimally exposed for shadows.	Edwal FG7 + B	medium to very fine	increased	R	variable contrast with various dilutions
	Edwal Minicol II	fine to very fine	increased	O	finest grain with slow films
	Ethol Tec	medium to very fine	normal	O	very fine grain with slow films
Extended Range Provide high effective film speed indexes. Tend to be soft-working. Work best when contrast normal and film not overexposed.	Acufine Acu-1	medium to ultrafine	increased	O	best when EI is double ASA
	Acufine Acufine	medium to ultrafine	increased	R	variable EI to five times ASA
	Acufine Diafine	extremely fine	increased	R	variable EI to six times ASA

of film you are developing. The reels, aprons, cages, and hangers all are designed for use with particular sizes of films. Some are adjustable, some are not. Virtually all processing tanks are designed to be loaded in complete darkness and then sealed for processing. Processing then may take place under normal lighting conditions. The manufacturer's instructions for loading the tank should be followed scrupulously. Practice loading your tank with a practice roll of unexposed film in total darkness as many times as necessary to ensure your own proficiency. *Don't load your first tank with a roll of exposed film.* Until you develop the necessary dexterity, you are likely to make a few mistakes.

Now let us describe each step in the film-processing procedure so you can try it for yourself. Remember, those steps described for total darkness must be carried out in a totally dark room. If a photographic darkroom is not available, you can usually seal a bathroom with blankets over the windows and around the doors to produce total darkness. Test your dark-

room by turning off all lights and placing a white sheet of paper before you. If after 30 seconds or so you are unable to discern the white paper, your room is dark enough for handling light-sensitive film.

Step-by-step procedure

Lights on

1. *Prepare the processing solutions.* Prepare the three chemical solutions — developer, stop bath, and fixer — according to the manufacturer's instructions and bring them to one of the recommended temperatures, say 20°C (68°F). You can do so by placing the bottles in a tray containing water at 20°C (68°F). Use a darkroom thermometer to check the temperature of the solutions, taking care to rinse the thermometer between tests so it does not contaminate the solutions. Normally a temperature variation of ± .5°C (1°F) will not alter the development time specified by

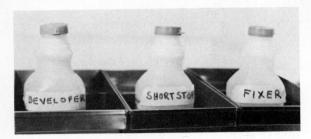

A

B

Fig. 4–2 Temperature control. A. Solution temperatures may be adjusted before use by placing storage bottles in tanks of water at correct temperature. Shortstop is the stop bath preparation used here. B. Solution temperatures may be measured with a darkroom thermometer. C. Wash water temperature may be controlled with a photographic mixing valve.

C

the manufacturer significantly. However, refer to the manufacturer's *time-and-temperature chart* for exact developing time and temperature combinations. The temperatures of the stop bath, fixer, and washing solutions should not vary more than 3°C (5°F) to avoid reticulation and excessive graininess. Most photo processing is recommended within a range of 18°–24°C (65°–75°F). Temperatures outside that range should be avoided unless specifically recommended by the manufacturer. Professional darkrooms usually maintain a constant environmental temperature so that all stored solutions are maintained at the proper temperature for immediate use. In addition, hot and cold tap water is mixed in special temperature-controlling valves so that

A

B

Fig. 4–3 Getting ready to process film. A. Check time-and-temperature chart for film/developer combination for correct developing time. B. Place small items in a dry tray in front of you so you can locate them easily in the dark.

water of the proper temperature is readily available from the water taps. The amateur may have to use more laborious procedures to maintain proper temperatures.

2. *Set up your equipment and materials.* All surfaces that the film may contact should be clean and dry. Your hands should be clean and dry; some photographers use lintless cloth gloves for film handling. Place all items on the counter before you in positions where you can find them in the dark. A small tray or box lid is useful to prevent small items from rolling off the counter. Processing chemicals should be near at hand in

a wet sink or counter. The following items should be arranged neatly before you:

Dry Counter	*Wet Counter or Sink*
film reel, cage, or hangers	processing solutions graduates
small scissors	funnel
film cassette opener or bottle opener	photo thermometer
darkroom timer	
processing tank and lid	
film to be processed	

Check the *time-and-temperature chart* provided by the developer's manufacturer. Set the darkroom timer for the developing time specified, but do not start the timer yet. Take a final look around at the items on the counter before you.

Fig. 4–4 Electromechanical darkroom timer. May be set for intervals up to 60 minutes. Signals audibly at end of interval. Luminous face and hands can be read in total darkness. Timer is set but not switched on until processing starts. (Dimco-Gray Co.: GraLab Timer)

Lights off

3. *Remove the film from its container.* For 35-mm film, use the film cassette opener or the bottle opener to pry off the end of the cassette (the end opposite the protruding film spool) and remove the film. For other roll films, tear open the seal and unwind the backing paper until you come to the film. Using the scissors, square off the leader of the 35-mm film, and for other roll films detach the film from the backing paper and trim off the tape with which it is attached. *Handle film by the edges. Do not touch the emulsion with your fingers.* Moisture and oils from your fingers, if deposited on the emulsion, will retard development and cause permanent marks on your negatives.

4. *Load the film* onto the processing reel or into the film hangers according to the tank manufacturer's instructions. Be sure to remove the tape that affixes the film to the spool.

5. *Load and seal the processing tank.* Place the loaded reel or hangers into the tank. Place the lid on the tank and seal it from light according to the manufacturer's instructions.

6. *Start developing.* Pour in sufficient developer to fill the tank, place vent cover over opening, and then start the timer. The timer should be activated immediately after each timed solution is in the tank.

7. *Begin agitation.* Agitation should conform to the film manufacturer's specifications. For roll films,

Fig. 4–5 Loading film. A. In total darkness, break open film canister, magazine, or roll. Remove film, handling it only by edges. B. Square off leading edge of film if necessary. C. Start to load film onto reel according to manufacturer's directions. D. Remove tape at end of film. E. Place reel with film in processing tank. F. Seal with light-tight cover. Once sealed, work lights may be turned on for processing.

A

B

C

D

E

F

Fig. 4–6 Processing film. A. Pour developer into tank through light-tight vent. (Handle later processing chemicals in same way.) B. Place vent cover over opening to prevent spillage of chemicals. C. Start timer. D. Agitate during development according to manufacturer's instructions. (Typically, tank is agitated continuously during first 30 sec. of development using a rotating and inverting movement; same movement is repeated for only 5 sec. in each subsequent 30-sec. interval throughout development.) E. Return developer to stock (or discard if one-shot developer is used). Pour all liquids from tank's light-tight vent. *Never open tank during processing.* F. Following development, pour water or shortstop into tank to stop developing action. Discard stop bath following use. Pour hypo into tank. Agitate occasionally during fixing. Fix according to manufacturer's instructions. Return fix to stock.

B

A

C

D

F

E

striking the bottom of the tank gently a few times on the counter or on your palm should precede the agitation process. This will dislodge any tiny air bubbles that may be clinging to the film surface. Then the film should be agitated gently according to the tank manufacturer's instructions for a full fifteen seconds. After that the tank should be agitated only intermittently for five seconds during every subsequent thirty-second period.

The agitation procedure may be different for different tanks, but usually the timing is based on the film manufacturer's requirements. Some tanks can be inverted; some cannot. Some tanks provide a device for rotating the reel within the tank. Ideally the tank will be capped, allowing it to be inverted during agitation. Proper agitation consists of inverting the tank and simultaneously rotating it. Doing so moves the developer over the film in several directions. Avoid patterned movements that may cause streaking. Follow the tank manufacturer's instructions, but establish a regular procedure. *Agitate your films precisely the same way every time you process* to reduce the possibility of variations in film development.

8. *Pour out the developer*. When the darkroom timer indicates that the development has been completed, the developer should be removed from the tank immediately. Some developers are for one-time use only and should be discarded. These *one-shot developers* can be poured down the drain. Other developers are reusable; they should be poured back into the bottles from which they came and retained for further use. Typically such developers require that a special *replenisher* solution be added to the bottle after every use. Keep track of the number of rolls of film developed with each bottle of reusable developer.

9. *Fill the tank with a clear water rinse or shortstop*. At this point you should stop the action of the developer as quickly as possible. The tank can be filled with clear water at a temperature that varies no more than ±3°C (5°F) from the developer temperature. A chemical shortstop can be used instead to stop the action of the developer. However, acid shortstops sometimes tend to form small gas bubbles under the surface of the emulsion when they are used with certain developers. These bubbles may result in small blemishes in the negatives. Nevertheless, the use of a shortstop may be advisable with fast-acting developers because the action of the developer continues at a low level if only water is used as a stop bath. When shortstop is used, a brief water rinse before the stop bath will minimize this problem. Follow the manufacturer's recommendations as to shortstop. *Do not open the tank*.

10. *Pour out the shortstop*. Water rinse is discarded; chemical shortstop may be saved after use. *Again, do not open the tank*.

11. *Fill the tank with fixer*. After the stop bath, pour enough fixer into the tank to fill it. Set the time for the fixer manufacturer's recommended fixing time. Agitate throughout the fixing cycle in the same manner described in paragraph 7. The tim-

A

Fig. 4–7 **Inspecting processed film.** A. Following fixing, open tank. B. Give film a quick water rinse and remove it from the tank. C. Inspect negatives under white light.

ing of the fixing cycle is not as critical as that of the developing cycle. Be sure that the film is fixed for the minimum recommended time, but no harm will come to your film if it is overfixed for a brief time. Extended immersion in fixer may start to bleach the negative image. Excessive fixing should be avoided, therefore, but do not be concerned if you exceed recommended fixing times by a minute or so.

12. *Pour out the fixer*. When the fixing cycle has been completed, return the fixer to its storage bottle. The typical useful life of an acid fixer is quite long, and many rolls of film can be fixed in the same, reusable solution. The manufacturer's specifications will describe how long you can expect the fixer to last and how to tell when it is becoming exhausted.

B

C

13. *Check the condition of the negatives.* When the fixing cycle has been completed you can open the processing tank and look at your film. A quick water rinse is usually advisable, and then a quick look at the negatives. Be sure that all traces of the milky white emulsion have been cleared along with the antihalation backing. You should see only the negative image against a clear background. If any traces of the opaque emulsion or antihalation backing remain, further fixing is required. Twice the clearing time is advisable for thorough fixation. When these materials have been cleared thoroughly, you can begin the washing cycle.

14. *Begin the washing cycle.* Try to wash the film in running water at a temperature as close as possible to the processing temperature. You can wash the film in its processing tank under an open tap if you take care to prevent the water

from striking the emulsion directly. The water should flow gently across the surface of the film and carry processing chemicals away. Film should be washed twenty to thirty minutes under running water. High-speed washers are available that can reduce washing time considerably. Photographic processing leaves a residue of chemicals in the emulsion that can cause the image to deteriorate rapidly if it is not removed. Washing the film for the recommended time will remove these residues, but the process can be speeded up and made more complete by the use of a chemical *clearing agent.* A clearing agent will neutralize most of the chemicals remaining in the emulsion and will speed up the washing process, thereby conserving water as well. For best results, the film should be rinsed before using the clearing agent and a record kept of the amount of film processed in it.

A

B

Fig. 4–8 Washing processed film. A. Replace film on reel and drop it in running water. (Hurricane washer, in which the water is forced upward from the inlet hose, was used here.) B. The water drains at the top as the reel settles downward. (The processed film may be washed in a developing tank by running water gently through a hose into the center of the tank. In a high-speed washer, washing is completed within 15 minutes.) C. Prepare wetting agent. D. Soak washed film in wetting agent before drying to prevent water spots.

15. *Soak the film in a wetting agent.* Following the wash cycle the film can be dried. However, you should take steps to avoid water spots drying on the emulsion surface. Most water, especially tap water, contains certain chemicals and minerals that leave solid residues when the water evaporates. To eliminate the formation of such water spots, use a wetting agent. Wetting agents reduce the surface tension of the water and inhibit the formation of water droplets on the film's surface. Photo manufacturers produce such wetting agents especially for photographic purposes.

Completely immerse your washed film, still wound on its processing reel or mounted on hangers, into the wetting bath for about a minute (or the manufacturer's suggested time). The wetting bath may be saved for further use.

16. *Hang the film to dry.* When you remove the film from the wetting bath, hold it stretched to its full length at a 45° angle for a few moments to allow the excess liquid to drain off. After this, your roll film can be hung by a film clip in a dry, dust-free place, away from any walls or objects that might scratch or mar its surface. Roll film

C D

Fig. 4–9 Drying processed film. A. Remove excess water or wetting agent from film with photographic sponge or squeegee tongs. B. Hang film in drying cabinet or other dust-free place. C. If forced-air cabinet is used as shown below, set timer according to manufacturer's instructions.

A B C

A

B

should have a film clip or clothespin attached to its bottom end as well to provide a weight so the film will hang straight and not curl as it dries. Film sheets are hung by a corner in a similar fashion.

Some photographers advise removing excess water from the surface of the film at this point, using a clean photochamois, a pair of squeegee tongs, a viscous sponge, or absorbent cotton that has been soaked and squeezed dry. Others recommend allowing the thoroughly wetted film to drip dry. If you wipe the film, you risk rubbing floating particles of dust and grit firmly into the emulsion. Drip drying risks the formation of water spots. You should try several methods under your own laboratory conditions to find the method that works best for you.

17. *Tally and replenish the developer.* If you use a reusable developer, immediately add the exact amount of replenisher specified by the manufacturer. On the lid or label of the developer bottle tally the number of rolls developed. If you follow these procedures you will know at all times that your developer is at full strength and usable for the next batch of film.

18. *File the negatives.* When your film is dry, cut and file the negatives. Roll-film negatives are cut into lengths of three to six negative frames each, depending on the film size. These strips are then stored in glassine sleeves or plastic print files for future use. Individual film sheets are stored in single frame glassine envelopes designed for that purpose. *Do not store negatives without protection. They are easily scratched and marred when stored loosely.*

Fig. 4–10 Replenishing developer. A. Following use of reusable developer, add replenisher to stock to revitalize developer's strength. B. Tally each roll developed on developer container so you will know when stock is exhausted.

A

B

Fig. 4–11 Cutting and storing negatives. A. Cut finished negatives into strips. *Do not separate individual frames.* B. Store in glassine envelopes or sleeves.

Summary

The above discussion has covered the detailed steps involved in processing your exposed film to transform the latent images into usable negatives. Let us summarize briefly the steps involved:

Prepare the processing solutions and bring them to the proper temperature.

Set up your equipment and materials neatly before you. Turn out the lights.

In total darkness, remove the film from its container and trim it. Load it onto a processing reel or hangers. Load into the processing tank and seal it. Turn on the lights.

Pour a suitable developer into the tank. Agitate. Develop for precisely the recommended time. Discard one-shot developer; return reusable developer to storage.

Pour stop bath into the tank. Use water or an acid shortstop if you prefer. Discard water; save shortstop.

Pour fixer into the tank. Agitate. Fix for recommended time. Return fixer to storage. Check negatives.

Wash the negatives to remove all traces of processing chemicals. Use a clearing agent during the washing cycle if you prefer.

Soak the negatives in a wetting agent.

Dry the film.

Tally and replenish reusable developer.

File the negatives.

Do Exercise 4–A on page 141

Making Black-and-white Prints

Objective 4–B Describe the procedures used in making black-and-white prints.

Key Concepts printing, contact printing, exposure, enlarging, enlarger, developing, stopping, fixing, clearing, washing, drying, positive print, dry area, contamination, wet area, safelights, ferrotype

Overview

Once you have processed the film into negatives, you will want to convert the negatives into pictures. The process you will use is called *printing,* and the finished products are called prints.

Basically the print processing follows the same general steps as film processing. It starts with a light-sensitive material — in this case photographic printing paper. Like film, this printing paper has a light-sensitive photographic emulsion coated on one side that must be protected from accidental exposure to light. For an image to be recorded on this printing paper, the paper first must be exposed to an image focused on its surface. To accomplish this, light is simply passed through the negative, and the negative image is recorded on the surface of the printing paper.

This exposure to the negative image can be accomplished in one of two ways. In the first method, *contact printing,* the negative is placed in direct contact with the printing paper in darkness. Then a light is turned on for a brief period to make the *exposure,* in which the light passing through the negative records the image of the negative on the light-sensitive emulsion of the printing paper. This method will produce an image exactly the same size as the negative.

In the alternate method, *enlarging,* the negative is placed in a special projector called an *enlarger;* its image is then projected onto the emulsion of the pa-

per. Enlargers are so called because they can be adjusted to make the negative image much larger than its original size. These methods are discussed in detail in Unit 5.

Once the printing paper has been exposed to the negative image it is ready for processing. Generally the steps in paper processing are the same as those in film processing. The paper is passed successively through the following steps:

1. *Developing.* The latent image is transformed into visible patterns of metallic silver.
2. *Stopping.* The action of the developer is stopped.
3. *Fixing.* All remaining silver halide crystals, or other light-sensitive materials, are dissolved.
4. *Clearing and washing.* All traces of processing chemicals are removed.
5. *Drying.* The wet print is dried to the desired finish.

The resulting print is, of course, a reverse image of the negative. The light areas of the negative transmit the most light to the paper. These light areas are dark in the final print, whereas the dark areas of the negative appear light in the final print. Thus a reverse print of the negative is actually a *positive print* that corresponds to the original scene.

Usually prints are made in a printing darkroom. The darkroom is organized into two areas — a *dry area* where printing paper is exposed to the negative images and where dry materials can be handled without *contamination* with processing chemicals, and a *wet area* where the processing chemicals, water taps, and sink are located. For processing prints, usually three trays are set up in the wet area. They contain the principal processing chemicals — the developer, the shortstop, and the fixer. Because most printing paper is orthochromatic (insensitive to the red-amber portion of the spectrum) printing processes usually occur under visible *safelights.* The most common printing safelights are light amber or yellow-green, and usually a printing darkroom is bathed in safelight at an intensity that will not affect the paper emulsion.

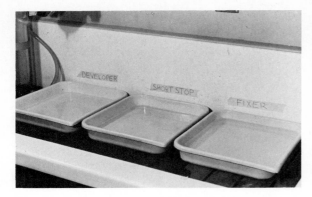

Fig. 4–12 Three-tray setup for print processing. As for film processing, first three solutions are developer, stop bath, and fixer.

The step-by-step procedure

1. Developing

Immerse the exposed printing paper — with its latent image recorded in the emulsion — in the developer. Insert it with the emulsion side down and slip it edge first into the solution as quickly as possible to immerse the entire emulsion surface under the developer in one motion. With print tongs holding the edge, agitate the paper gently so that all surface areas of the emulsion are immersed thoroughly and no bubbles are formed on the surface. When the paper is thoroughly soaked with developer, it may be turned face up in the solution to observe the developing image. Time the period of development carefully according to the developer manufacturer's recommendations. During development the photographic image appears on the paper. Like film development, however, processing should be done primarily by the clock, not by visual inspection of the print.

Throughout development, agitate by gently rocking the tray or by moving the print within the developer by means of the print tongs. When the development period has been completed, remove the print from the developer with the print tongs, allow it to drain, and then slip it edge first into the stop bath.

A

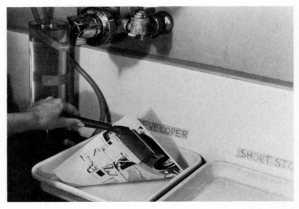

B

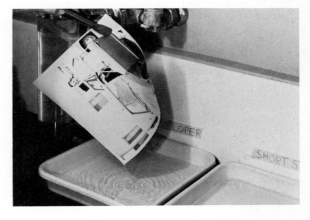

C

Fig. 4–13 Print processing. A. Immerse exposed paper evenly in developer. B. Handle wet prints with print tongs to avoid chemical contamination carried on hands. C. Drain print of excess solution between trays.

2. Stopping

The stop bath, as with film, consists of a mild (1 to 2 percent) solution of acetic acid. (See the Helpful Hint on page 111.) This bath stops the action of the developer instantly. The acid stop-bath solution must not be carried back to the developer since it can rapidly exhaust the developer solution, so take care that the tongs you use in the developer are not contaminated by the stop bath. Once the print is immersed in the stop bath, handle it with a separate set of tongs used exclusively in the stop bath. The developer tongs can be returned to the developer tray after the print has been dropped into the stop bath. Should you handle the wet prints with your hands or touch them with your fingers, be sure to wash your hands before handling other prints or unexposed paper. Many a print has been ruined by chemically contaminated hands. Follow the manufacturer's recommendations for time and procedure.

3. Fixing

After the print has been immersed for the recommended time in the stop bath, you can remove it, drain it, and slip it into the fixer tray. Again, use the stop-bath tongs to carry the wet print to the fixer, but do not immerse the tongs in the fixer — return them to the stop bath. Use a third set of tongs to handle the prints in the fixer. If you develop care in handling your tongs in the manner described, you will find that your print-processing solutions last longer and yield cleaner results than if you carelessly contaminate the printing solutions with one another. Prints should be kept immersed in the fixer with occasional agitation for the time recommended by the fixer manufacturer. (You can be exposing and developing other prints while your work accumulates in the fixer; slight overfixing will not harm your prints.)

4. Clearing and washing

When the print has been in the fixer for a few minutes, you can view it briefly under normal white light. But do not turn on white lights in the darkroom unless

Fig. 4–14 Drum-type print washer.

you are sure you have secured all light-sensitive materials in light-tight containers. Be sure your unexposed printing paper has been put away properly before you turn on any white lights. A small white light mounted directly over the fixing tray may be useful for these brief visual inspections.

Following the full fixing cycle, then, the print is ready for washing. As with film, all traces of processing chemicals must be washed from the print before drying. If any chemical remains in the print, discoloration may occur later. To ensure complete removal of processing chemicals and faster washing time, a chemical clearing agent often is introduced just prior to the final wash. Most other washing techniques take longer. Follow the washer manufacturer's recommendations for time and procedure. If you use the "bathtub" technique — soaking the prints in a tub full of water — be sure that you continually replace the wash

water with fresh water to remove all traces of processing chemical. Never let a direct flow of tap water fall directly on the surface of your prints because the force can damage the emulsion. Let the water flow into a tumbler or a pan and overflow onto your prints. Or you can use any one of a number of commercial devices that attach to your tray, converting it into an effective washer. Note that use of resin-coated (RC) papers, discussed later, substantially reduces washing time.

5. Drying

After the prints have been washed, place them on a smooth, clean surface to dry. You can use the bottom of a tray or a plastic laminated counter top. Place the prints face up and remove excess water with a soft, viscous sponge. Another way to dry the prints is to use a blotter roll, available at most photo stores. Or you can stack the prints alternately with sheets of photographic blotter paper and place a weight on top. These methods are suitable for any type of paper and will produce a matte or semigloss finish depending on the paper used.

Fig. 4–15 Commercial rotary dryer with heated ferrotype drum.

Drying fiber-base and resin-coated papers

While all papers may be dried by simple exposure to air at room temperatures or warmer, the process is often slow, especially for fiber-base papers which absorb a great deal of moisture and which tend to curl if dried this way. To speed up the drying process, various heat-generating dryers have been developed for both amateur and commercial markets. Resin-coated (RC) papers absorb much less moisture, but their drying time also can be speeded up by special drying machines. It must be kept in mind, however, that many driers suitable for fiber-base papers will damage resin-coated papers.

Contact drying and ferrotyping

Use of any contact dryer, such as those equipped with a heated ferrotype plate or drum, is limited to fiber-base papers. These papers can be finished in two ways: high-gloss and non-gloss.

If you want to obtain a very high-gloss finish, use only a glossy finish paper. Then, following the wash, immerse the print in a print-conditioning solution that softens the emulsion and prepares it for a high-gloss finish. Following this treatment, place the print face down on a *ferrotype* surface of highly polished, chromium-plate or stainless steel. Squeegee out the water, and as the print dries the emulsion surface will take on the glossy finish of the polished metal to which it is affixed.

For the most consistent results and the most professional-looking finish with conventional printing paper, the use of a commercial, drum-type print dryer is recommended. Many types of smaller, home-type dryers that also will give excellent results are readily available.

Fiber-base papers are also available in a variety of other surface finishes, intended to be finished using non-gloss procedures. Following the wash, excess water is squeegeed from the surface of the print. The print is then placed on the dryer with its back in contact with the heated surface, and its emulsion in contact with the fabric apron that holds the print in place. Used with a glossy finish paper, this procedure produces a semi-gloss finish. Used with other surface textures, it produces the non-gloss finish designed into the surface of the paper.

Contact drying should not be used with resin-coated (RC) papers as the heat of the metal surface will melt its resin coatings.

Air drying

Air drying may be used with any fiber-base paper and produces a non-gloss finish. Resin-coated (RC) papers are designed for air drying and many of them will produce a high gloss finish by this method. To dry resin-coated papers, remove excess surface water with blotters, a damp sponge or cloth. The prints may be air-dried at room temperature or by circulated warm air in a drying cabinet. These papers should not be ferrotyped. Drying is generally rapid, but for additional speed a double-belt drum drier can be used at surface temperatures under 88°C (190°F). The lowest drying temperatures will produce the least curling of the finished print.

Do Exercise 4–B on page 142

Black-and-white Print Materials

> **Objective 4–C** Describe the materials used in making black-and-white prints from negatives.
>
> **Key Concepts** printing paper, print-processing chemicals, contact printing paper, chloride paper, enlarging paper, bromide paper, chloro-bromide paper, image tone, surface texture, resin-coated (RC) paper, weight, tint, contrast grades, low-contrast paper, normal-contrast paper, variable-contrast paper, variable-contrast filters, paper developer, stop bath, indicator stop bath, fixer, hardening fixer, clearing agent, print conditioner, stabilization process, stabilization processor

Basically two types of materials are needed to make prints from negatives: *printing paper* and *print-processing chemicals*.

Printing papers

Papers are manufactured for two types of printing: contact printing and projection printing, or enlarging. The active ingredients in these papers, as with films, are primarily the silver halide salts — silver chloride and silver bromide. *Contact printing papers* use a silver chloride emulsion and are slow — that is, they are relatively insensitive to light and are effective only with the high light intensities common to contact printing. These *chloride papers* are not sensitive enough to light for enlarging where very low light levels are used. *Enlarging papers* use a more sensitive silver bromide emulsion and are much faster. If these *bromide papers* are used for contact printing, however, they will be overexposed because they are too fast to be used with the high light levels common

to contact printing. Most enlarging papers use both silver chloride and silver bromide to obtain the desired characteristics of speed, tone, and contrast. Thus they commonly are called *chloro-bromide papers*.

Papers are manufactured in a wide range of tones, textures, weights, tints, and contrast grades. *Image tone* refers to the color of the actual silver image. The tone is determined by the type of emulsion and its development and may range from cold, blue-black tones through neutral-black to warm and brown-black tones. The neutral tones are most suitable for reproduction. For exhibition, select the image tone that best suits the subject of your photograph.

The *surface texture* of the paper refers to the glossiness or the roughness of the print surface. Many types of surface textures are available, ranging from the high-gloss surface that is used most commonly for reproduction to the dull, matte surface that is used more commonly for exhibition. Also available are many specialty textures, such as those designed to look like silk or tapestry. The most commonly used textures are the glossy papers, which if ferrotyped produce a hard, mirrorlike surface, and the semimatte papers, which if dried naturally produce a dull, nonreflective surface more like ordinary paper.

The paper stock is also available in several thicknesses, or *weights,* from lightweight or document stock — which is approximately the weight of ordinary typing paper — to single-weight, medium-weight, double-weight, and heavy-weight stocks, which have the heavier thickness of light cardboard. The most commonly used weights are single-weight (.18 mm) and double-weight (.38 mm).

The paper *tint* refers to the color of the paper stock itself. Papers come in a variety of tints, from brilliant snow-white to natural white, cream, ivory, and buff. Specialty papers also may be obtained in pastel tints such as blue, red, and green. In general the warm-toned emulsions are matched with the warm-tinted stocks and the cold-toned emulsions with the cold-tinted stocks.

Printing papers also are manufactured to several *contrast grades*, numbered from 0 to 6, corresponding to the inherent contrast characteristics of the emulsion. The lower-grade papers, grades 0–1, refer to the *low-contrast papers,* which will produce prints with less contrast than the negatives from which they are made. Grade 2 paper is considered *normal-contrast paper* because it will reproduce approximately the same contrast range as the negative has. The higher-grade papers, grades 3–4 and above, refer to the *high-contrast papers,* which will produce prints with more contrast than the negatives from which they are made. Thus you can reduce the contrast of a "too contrasty" negative by printing it on a low-contrast paper, which will have the effect of enhancing the middle tones. Or, you can increase the contrast of a "too flat" negative by printing it on a high-contrast paper, which will have the effect of extending the range of tones to include deeper blacks and purer whites.

Because the negative image from which black-and-white prints are typically made consists simply of patterns of lights and shadow — no colors — the printing paper needs to be sensitive only to the relative presence or absence of light. It need not be sensitive to a full range of colors. Therefore, printing papers intended for this use are basically orthochromatic — sensitive to the relative narrow blue portion of the visible light spectrum and insensitive to the red-amber-green portions. Since these papers are not sensitive to red, amber, or green light, the printing darkroom is usually well illuminated with amber or yellow-green safelights for the convenience of the photographer.

We should add, however, that some printing papers are manufactured with panchromatic emulsions. Such papers are commonly used for making black-and-white prints from color negatives and the printing paper is designed to translate the colors in the negative into a black-and-white scale of the same relative brightness. Since these papers are sensitive to all colors, they cannot be used with the same safelights

as orthochromatic papers without exposing them. When using these papers, follow the manufacturer's recommendations regarding safelights.

Another method for achieving contrast control is by using a *variable-contrast paper*. These papers combine two separate emulsion layers. One emulsion has very low inherent contrast and is usually made sensitive to yellow-green light; the other has very high inherent contrast and is made sensitive to blue-violet light. The contrast of the resulting print may therefore be controlled by using a blend of the two colors of light to produce the desired contrast grade. Thus this product combines all the contrast grades into a single emulsion. The various contrast grades possessed by the emulsion then are obtained by using *variable-contrast filters* during the exposure process. A set of variable-contrast filters typically is numbered to correspond to the various paper grades each will produce. Thus a No. 3 contrast filter used in combination with a variable-contrast paper will approximate the contrast range of a grade 3 paper. Because each manufacturer's variable-contrast paper-filter system conforms to a special design, the filters and papers of different manufacturers are not always interchangeable. Consult manufacturers' specifications before mixing brands of filters and papers.

Resin-coated (RC) papers

Resin-coated (RC) papers have been coated with a special resin that air-dries to a hard, glossy finish without ferrotyping. Their special coating protects the paper base from saturation by photo chemicals during processing. Thus these papers fix rapidly, require less washing, and air-dry rapidly. These papers must not be ferrotyped on a contact dryer because the resin coating melts at a relatively low temperature and will damage the print and crystallize on the hot ferrotype surface. Because the resin coating prevents the paper from absorbing processing chemicals or water, only a short wash period is needed to remove all residual chemicals after development and fixing. Similarly,

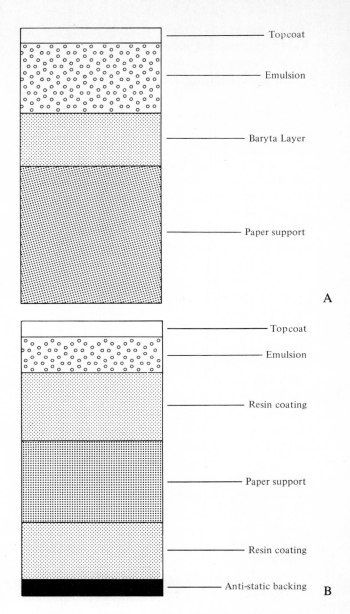

Fig. 4–16 A. Cross-section of fiber-base printing paper. B. Cross-section of resin-coated printing paper.

the paper dries very fast. While these factors provide real advantages to both amateur and commercial photographers, RC papers are not without their problems. The resins are extremely sensitive to scratches while wet and to surface heat, so special drying procedures and equipment must be used. The recommended wash time of four minutes should not be exceeded or the emulsion may separate from the support. Dry mounting, which normally requires application of heat and pressure, must also be adapted to this material, employing lower levels of heat and special mounting materials. Finally, because the resins and the emulsion expand and contract differently with changes in temperature, the emulsion separates from the support over time under normal display conditions. For this reason, RC materials have not as yet been considered suitable for archival purposes. Nevertheless, where speed of processing is more important than permanence, these materials have many useful applications.

Paper storage

Unless photographic printing papers are stored properly, both their physical and photographic properties may be affected adversely. In the darkroom, store only the paper needed for your immediate use. The balance of your stock should be stored in a cool, dry place. Observe the following recommendations for storing paper properly:

1. Avoid excessive heat. Do not store paper near a heating unit or in areas of heat buildup.
2. Avoid both very dry and very damp places. Relative humidity of 40–50 percent is recommended.
3. Avoid exposure to chemical fumes and gases such as formaldehyde, coal gas, sulfur, engine exhaust, paints, and solvents.
4. Avoid radiations. Do not store paper near x-ray or fluoroscope devices.
5. Avoid excessive weight. Do not store paper under a weight that may press the sheets of stored paper

together and cause the emulsion to fuse to the adjacent sheets.

6. Use the paper before its expiration date. Rotate your stock to use older papers first.

Table 8 lists some of the commonly available contact and enlarging papers.

Print-processing chemicals

Paper developers

The *paper developers* you use also can affect the tone of the silver image in the print. Depending on its chemical composition, a developer may produce warm-, neutral-, or cold-toned images. Table 9 describes several commonly used paper developers and the tones they tend to produce.

Stop bath

The use of a *stop bath* following development is recommended. It stops the action of the developer, helps to preserve the life of the fixer, and removes calcium scum from the print surface. A 1 to 2 percent solution of acetic acid can be used for this purpose, as can any of several products that are available in photo stores. An *indicator stop bath* is particularly useful because it will turn dark when it is exhausted signaling when replacement of the stop bath is needed. See the Helpful Hint on page 111.

Fixer

To make the print permanent, all the silver salts in the emulsion must be dissolved and removed from the print. The *fixer* dissolves these silver salts. A *hardening fixer* also will toughen the soft surface of the gelatin emulsion and render it less susceptible to damage. The useful life of the fixer depends on the amount of silver salts that have been removed from the prints that have been fixed. Light prints deposit

Table 8 Some Typical Printing Papers

Type	Manufacturer and Brand	Tone	Contract Grades	Comments
Fiber-base enlarging papers	Agfa Brovira	cold	graded	
	Agfa Porgriga Rapid	warm	graded	
	Ilford Ilfobrom	cold	graded	
	Ilford Ilfoprint YR	neutral	graded	stabilization paper
	Kodak Kodabromide	neutral	graded	
	Kodak Polycontrast	warm	variable	
	Kodak Ektalure	warm	grade 2	also for contacts
	Kodak Ektamatic SC	neutral-warm	grades 2 and 3	stabilization paper
	Kodak Panalure	warm	panchromatic	B&W prints from color negatives
	Luminos Bromide	neutral	graded	
	Unicolor Baryta Base	cold	grades 2 and 3	
	Unicolor Exhibition	neutral-warm	grades 2 and 3	excellent for display
Resin-coated (RC) enlarging papers	Agfa Brovira 310S and 312S	neutral	graded	
	Ilford Ilfospeed	neutral	graded	
	Ilford Ilfospeed Multigrade	neutral	variable	
	Kodak Kodabromide II RC	warm	graded	
	Kodak Polycontrast Rapid II RC	warm	variable	
	Kodak Panalure II RC	warm	panchromatic	B&W prints from color negatives
	Luminos Bromide RC and S-ST	neutral	graded	S-ST is self-adhesive
	Unicolor Resin Base	neutral	graded	
Contact papers	Agfa Contact-tone	neutral	graded	
	Kodak Azo	neutral	graded	
	Kodak Ad-Type	neutral	graded	lightweight; foldable

Table 9 Some Typical Paper Developers

Manufacturer and Brand	Tone
Acufine Posifine 16	neutral
Agfa Metinol	neutral
Edwal Platinum Paper Developer	neutral
Ethol LPD	warm to cold
FR Paper Developer	cold
Ilford Bromophen	cold
Kodak Dektol	cold
Kodak Selectol	warm
Unicolor B&W Print Developer	cold

more silver salts into the fixer than do dark ones. On the average, one gallon of fixer is sufficient for approximately one hundred 8-in. by 10-in. prints, or the equivalent in surface area. The strength of the fixer can be tested at any time with a fixer testing outfit, available in most photo stores. Take care to avoid using exhausted fixer because the resulting prints will not be permanent.

Clearing agent

Clearing agents aid washing because they neutralize all residual chemicals. A *clearing agent* is recommended before washing to assure freedom from residual chemicals and to reduce water consumption in the washing cycle. "Cleared" prints can be washed free of chemicals in approximately one-third the time required to wash them in water alone. RC papers do not require a clearing agent because they wash clean in four minutes unaided.

Print conditioner

A *print conditioner,* another optional bath that can be used with fiber-base papers after the wash just prior to drying, has two purposes. One is to reduce the amount of curl that affects the print as it dries, helping to produce a flat print. The solution can be used with all surface textures for this purpose. The other pur-

pose is to produce a glossy finish with glossy papers dried on a ferrotype surface.

Note that only those conventional papers specifically named "glossy" can be ferrotyped successfully. Following washing, prints to be ferrotyped are soaked in a print conditioner. This solution will help the print surface adhere properly to the ferrotype surface, producing the desired hard, mirrorlike, glassy sheen. Remember, resin-coated (RC) papers are not designed for ferrotyping and do not require the use of a print conditioner.

Stabilization process

The *stabilization process* makes possible rapid processing of prints without the usual sequential procedures. Special paper must be used, into which have been built all the chemical processing agents. After normal exposure the paper is inserted into a special machine, called a *stabilization processor*. This motor-driven machine transports the paper first through a solution that activates the developers, then through a second solution that neutralizes and stabilizes the remaining active chemicals. In about fifteen seconds, a nearly dry print emerges from the processor. It will dry completely at room temperature in about fifteen minutes. The stabilized print is not permanent because its chemical-laden emulsion eventually will oxidize as the print is exposed to light, air, and moisture. The process is useful, however, where speed is a priority. The prints can be made permanent at any time by normal fixing and washing following stabilization processing.

Do Exercise 4–C on page 143

Basic Equipment and Darkroom

Objective 4–D Describe the basic equipment and darkroom used in making black-and-white prints.

Key Concepts darkroom, fogged, safelight, enlarger, enlarging lens, enlarger optical system, contact printer

Fig. 4–17 Simple darkroom layout. U-shaped counter provides wet side for chemical processing and dry side for handling film and paper. Storage shelves above and below counter keep chemicals and equipment off counter surface. Obviously more elaborate arrangements are possible, as well as simpler ones.

The basic equipment and facilities used in printing black-and-white prints consist of the darkroom itself, safelights, an enlarger, and sometimes a contact printer.

The darkroom

The size of the *darkroom* is determined by the type of work to be done and the number of persons to be working in it at the same time. Film processing and print making can be performed in the same space, but not always conveniently at the same time. Film handling usually requires total darkness, at least while the film is being loaded into the processing tank. For a one-person darkroom this requirement poses no special problem. But if more than one person will be using the darkroom, it is useful to provide a separate

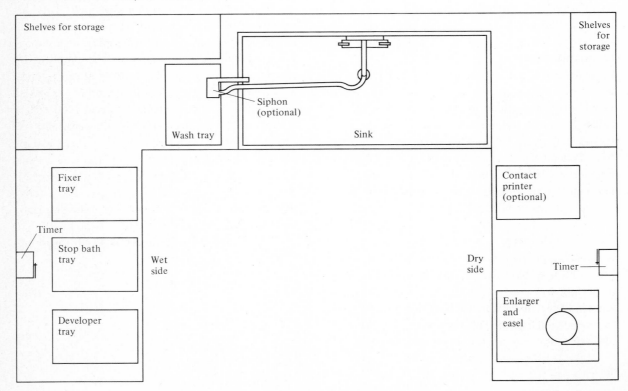

film-loading room where total darkness can be obtained without inconvenience.

An 8-ft. by 10-ft. darkroom is large enough to hold a normal amount of printing equipment and for a single operator to work in comfort. For large volume output, or for more than one operator, a larger space will be needed. The minimum requirements for a printing darkroom are: (1) at least forty square feet of space, (2) a fully grounded electrical system, (3) access to outside ventilation, and (4) a seal against the penetration of outside light. (See Figure 4–17.) In planning a printing darkroom, consider the following suggestions:

1. The enlarger and optional contact printer should be no more than 4 ft. from the developing position at the sink.
2. Electrical switches should be in easy reach.
3. Entire electrical system should be grounded to minimize electrical hazard.
4. Electrical receptacles should be plentiful and easy to reach.
5. The counter tops and the floor of the sink should be approximately 32 in. from the floor for comfortable work.
6. The floor should be dark, resilient underfoot, chemical- and water-resistant, and easily cleaned.
7. A light-trapped entry is desirable to provide free access and ventilation without opening doors or curtains.
8. Dust-collecting surfaces, such as pipes and open shelves, should be avoided. Provide plentiful shelf space in enclosed cabinets and under the sink.
9. The walls and ceiling should be light in color — ideally white or beige — and painted with a chemical-resistant paint. (Don't paint the walls and ceiling black! Your safelight should reflect off these surfaces to provide an even, diffused safelight throughout the room.)
10. Provide dust-free, filtered ventilation.

11. A counter for handling dry materials — papers, negatives, and so forth — should be provided separate from the wet sink area where liquid chemicals are used and processing occurs. This separation reduces the danger of contaminating dry materials.
12. Running water and drainage are highly desirable within the darkroom. Water taps should be within easy reach. Without running water and drainage, liquids must be prepared elsewhere and then carried into the darkroom; cast-off liquids must be carried out again.

Figure 4–18 shows movable darkroom equipment adapted for use in a relatively small space. Many amateur darkrooms have been contained on a small,

Fig. 4–18 Portable darkroom setup. With ingenuity, portable or semipermanent darkroom setup can be designed for use in small home bathroom or laundry room.

portable cart, which can be wheeled into a bathroom and set up for operation within a few minutes. With a little imagination, any similar small space can be converted into a functioning darkroom either on a permanent or portable basis.

The safelights

The darkroom should, of course, seal out all sources of ambient light that might fall upon the light-sensitive papers. Papers exposed unintentionally to such light may become *fogged* — that is, they may acquire an overall gray veil when developed.

Safelights should be provided at as high a level of illumination as possible consistent with the safety of the light-sensitive materials in use. Place safelights in several locations, reflecting their light off the walls and ceiling to provide an even field of safelight throughout the darkroom area. Additional concentrations of safelight should be provided at the work areas.

The level of safelight illumination should be tested for safety by systematic exposure of latent prints to ambient safelight. This procedure involves using a sheet of photo paper already exposed to a negative image. The exposed paper is partially covered by an opaque mask and left partially exposed to the ambient safelight illumination for several minutes before processing. If the safelights are affecting the paper, the masked and unmasked portions of the paper will appear clearly differentiated following processing. Exposed paper is used for this test because safelight fog may occur only in previously exposed portions of the print and not in the white or highlight areas.

Normal worklights also should be provided in the darkroom to aid in cleaning up when the darkroom is not in use. The switch for the worklight should be placed out of normal reach so you do not turn it on accidentally while the darkroom is in use.

The enlarger

Enlargers are designed in many varieties for many purposes. The major distinguishing features are their size, the type of light source used, and the method of distributing the source light to obtain an even field of light through the negative during exposure. Some focus manually; others focus automatically as the head is raised and lowered.

Enlargers are designed for use with specific negative formats, from 8 mm to 8-in. by 10-in. Most are designed to use tungsten photo-enlarger lamps, which are manufactured in various wattages. Other enlargers are designed to use other light sources such as fluorescent, mercury vapor, quartz-halogen, and xenon-

Fig. 4–19 Enlarger. (Omega Division of Berkey Marketing Companies)

Fig. 4–20 Enlarger timer. Terminates exposure automatically after preset time interval of from 1 to 60 seconds. (Omega Division of Berkey Marketing Companies)

arc lights. To obtain an evenly exposed print, the field of light passing through the negative to the printing paper should be distributed evenly — it should be free of "hot spots" and "cold spots." There should be no difference in intensity between the center and the edges of the focal plane. To obtain even illumination, two major methods are used: (1) diffusing the light emanating from the light source, and (2) optically condensing the source light. Diffusion is accomplished by inserting a ground glass between the light source and the negative; it tends to produce prints with less contrast. Condensing is accomplished by inserting a set of condenser lenses between the light source and the negative; it tends to produce prints with greater contrast and definition. Because of the weight of the condenser lens assembly, condenser enlargers tend to be heavier and sturdier.

The *enlarging lens* is the heart of the enlarger system. Because both the negative and the printing paper are two-dimensional, it is important that the lens possess an extremely flat field — it should produce sharp detail from the center all the way out to the edge of the print. Enlarging lenses come in a variety of focal lengths. The optimal focal length for any given purpose depends on the lens-to-easel distance and the size of the negative format. Some enlargers therefore provide for interchanging the enlarger lenses for greater flexibility of use. Interchangeable lenses are sometimes mounted on a rotating lensboard for convenience. Other enlargers are provided with a single lens and are intended for specific and limited uses.

The entire system of condenser and optical lenses, including adjustment mechanisms, is known as the *enlarger optical system.* The enlarger is used commonly with adjunct equipment, including an enlarger timer and an easel. The timer precisely times exposures to the nearest second, automatically turning off the source light after the selected interval. The easel holds the printing paper flat and in proper position during exposure.

The contact printer

The *contact printer* is a simple piece of equipment, usually a light-tight box containing a light source, built with one or more glass walls. A special clamp tightly sandwiches the negative between the contact paper and the glass wall. The typical contact printer has a built-in timer for controlled timing of the contact exposures. Its most important feature is the evenness of the illumination it provides over the entire exposure surface, eliminating hot and cold spots in the final prints. As popular negative formats have become smaller in recent years, contact printers have fallen out of common use. Today enlargement is required even to produce album-size prints from small-format negatives. Contact proof sheets and contact prints are now generally made using the enlarger as a source light. This technique will be discussed in Unit 5.

Do Exercise 4–D on page 143

Suggested references

Brooks, David. *Photographic Materials and Processes*. Tucson: HP Books, 1979, pages 68–92; 134–147.

Craven, George M. *Object and Image: An Introduction to Photography*. Englewood Cliffs, N.J.: Prentice-Hall, 1975, pages 90–105.

Davis, Phil. *Photography*. 3rd ed. Dubuque: William C. Brown, 1979. Chapters 4 and 5.

Eastman Kodak Co. *Basic Developing, Printing, Enlarging in Black-and-white*. Rochester, N.Y.: Kodak (Photo Information Book AJ–2), 1979.

Eastman Kodak Co. *Bigger and Better Enlarging*. Rochester, N.Y.: Kodak (Photo Information Book AG–19), 1974.

Jacobs, Lou, Jr. *Photography Today*. Santa Monica, Calif.: Goodyear Publishing Co., 1976, chapter 8; pages 183–201.

Rhode, Robert B. and F.H. McCall. *Introduction to Photography*. 4th ed. New York: Macmillan, 1981, Chapter 5.

Swedlund, Charles. *Photography*. 2nd ed. New York: Holt, Rinehart and Winston, 1981, Chapter 6.

Time-Life Books. *Life Library of Photography: The Print*. New York: Time, Inc., 1970, chapters 2 and 3.

Suggested field and laboratory assignments

1. Complete your acquisition and preparation of all film and print-processing supplies, including developer, shortstop, fixer, clearing agent, paper, and so forth. Complete arrangements for the use of a darkroom for film processing and printing, including processing tank, enlarger, safelights, and facilities for processing, washing, drying, and finishing.

2. Using a processing tank, reel, and roll of dummy film, practice loading the film onto the reel under normal light. Some people find it helpful to practice loading film reels while watching TV. Whatever your style, practice until the loading becomes a reflex action. When you feel confident, practice loading the film in total darkness. Use dummy film the same size as the film you plan to process and use a reel and tank designed for the same size film.

3. Develop one roll of exposed film (or more if necessary) so that you end up with a batch of usable negatives on a variety of subjects. If your first development efforts fail, shoot and process additional film until you have completed the assignment.

Do Practice Test 4 on page 145

EXERCISE 4–A

1. In any chemical process, careful control should be exercised over both _____ and

 _____ .

2. During most of the processing cycle, the film is sensitive to light. An important tool
 used to carry out processing under normal lighting conditions while protecting the film
 from exposure to light is called a _____ .

3. The first active chemical in the processing cycle is the _____ . Its function is to

 _____ .

 When it has completed its action, the film appears as follows: _____

4. The next active chemical, following a stop bath, is the _____ . Its function is to

 _____ .

 When it has completed its action, the film appears as follows: _____

5. Following which step in the processing cycle can the film be exposed to normal lighting?

6. List in order each step in the film-processing procedure.

Return to Objective 4–B, page 126

EXERCISE 4–B

1. To make black-and-white prints from negatives, you need the following:

 Place: _____

 Equipment: _____

 Dry materials: _____

 Wet materials: _____

2. In general, the steps you follow to make a black-and-white print from a negative are these:

Return to Objective 4–C, page 130

EXERCISE 4–C

1. List the rules you should follow in storing photographic papers.

 A. _____

 B. _____

 C. _____

 D. _____

 E. _____

 F. _____

2. List six important characteristics of photographic paper.

3. List four basic types of chemicals used in processing black-and-white prints.

Return to Objective 4–D, page 136

EXERCISE 4–D

1. Explain why printing darkrooms should be designed with a wet counter and a dry

 counter. _____

2. List certain precautions you should observe in using the printing darkroom to ensure against unintentional fogging of light-sensitive materials. _____

3. List the major equipment and facilities needed for print making. Describe the major functions of each.

Review References and do Suggested Field and Laboratory Assignments on page 140

8. E See "Making Black-and-white Prints," page 126, if you are uncertain about this question.

9. D Don't forget to drain! Otherwise you may contaminate solutions. Again, see "Making Black-and-white Prints," page 126.

10. E Follow the manufacturer's recommendations for storage and use.

11. B Variable-contrast paper is used with special filters for the control of contrast. See "Black-and-white Print Materials," page 130.

12. E See "Black-and-white Print Materials," page 130.

13. B See "Basic Equipment and Darkroom," page 136.

14. D Mop it up immediately to avoid spreading the solution over the floor. When dry, the fixer will crystallize and airborne particles may contaminate papers and solutions.

15. C Safelight fog may affect the exposed portions of your print, even if not the unexposed portions. Take care not to pick up your print and hold it up to the safelight. That way you'll really get fog, probably even on the white borders. See "Basic Equipment and Darkroom," page 136.

PRINTING AND FINISHING

U N I T 5

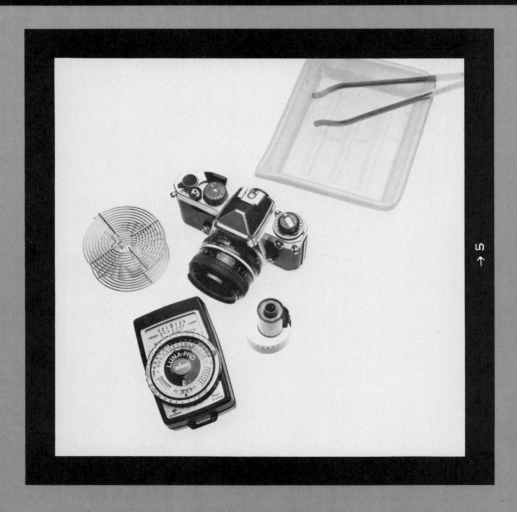

→ 5

Parts of the Enlarger

Objective 5–A Label and explain the function of the parts of a typical enlarger.

Key Concepts lamp housing, condenser housing, condenser housing lever, negative carrier, bellows, lens and lensboard, elevator control crank, elevator lock knob, focusing knob, base, timer, power plug

The typical enlarger is designed to pass an evenly distributed beam of light through a negative and a lens so that an image of the negative is focused on a sheet of light-sensitive photographic paper. The design also provides that no ambient or stray light is emitted elsewhere from the enlarger and that the enlarger can be adjusted to change the size of the projected image. Figure 5–1 shows the functional parts of a typical enlarger.

The *lamp housing* is an enclosure for the light source — usually a photo-enlarger lamp. It is fully enclosed to prevent light from leaking out except through the lens. Typically it is designed with cooling vanes to dissipate excessive heat and to keep the lamp housing as cool as possible during use.

Many *condenser housings* contain two or more condenser lenses to concentrate the light through the negative and to provide an even field of light. Usually

Fig. 5–1 Anatomy of an enlarger.

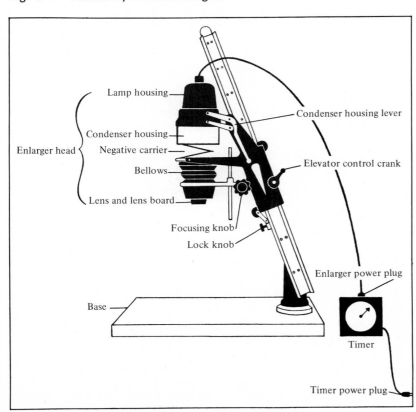

the condenser lenses are adjustable for varying sizes of negatives. The housing may also contain translucent glass to soften and flatten the field of light. Some enlargers omit the condenser lenses and use only the translucent glass to diffuse the source light.

The *condenser housing lever* allows the entire lamp and condenser housing assembly to be raised so that the negative carrier can be inserted into position. The assembly is then lowered onto the surface of the negative carrier, forming a light-proof seal. (During use, care must be taken not to operate this lever while the source light is turned on. Raising the lamp housing at this time causes source light to spill out of the enlarger in all directions and fog sensitive materials.)

The *negative carrier* is a device for holding the negative in place during enlargement and masking off the edges. It is usually a double frame that holds the negative in place with a rectangular cut-out to frame the negative format. Some enlargers use a carrier that holds the negative flat between two planes of glass. This holds the negative flatter, but increases the number of surfaces that must be dusted prior to exposure.

The *bellows* is a collapsible housing on which the lensboard is mounted. It allows the lens to be moved closer to or farther from the negative for focusing.

The enlarger lens is mounted on a board and the board is mounted on the enlarger, typically at the lower end of a bellows. *Lenses* and *lensboards* are usually interchangeable so that different lenses may be used for different negative formats. For any negative format the normal enlarger lens will have the same focal length as the normal camera lens. For example, a 50-mm enlarger lens is normal for 35-mm negatives; a 75-mm or 80-mm enlarger lens, for 6 cm by 6 cm (2¼ in. by 2¼ in.) negatives; and so forth. (See Objective 1–C, Lens Characteristics, for a discussion of normal focal length.)

The *elevator control crank* is used to raise and lower the entire enlarger head in order to change the size of the projected image.

The *elevator lock knob* is used to lock the enlarger head in position to avoid accidental slippage.

The *focusing knob* is used to focus the negative image on the printing paper.

The *base* is the board or surface on which the entire enlarger assembly is mounted and on which the paper-holding easel is usually placed.

The *timer* is technically not part of the enlarger, but an important component of the enlarger system. It allows for precise timing of exposure to the nearest second. It also provides for manual lamp turn-on during focusing.

The *power plug* provides power to the enlarger. Normally it is plugged into the timer, which in turn is plugged into the wall outlet.

Do Exercise 5–A on page 183

Making Contact Prints

Objective 5–B Explain three methods of making contact prints.

Key Concepts contact print, open-bulb method, contact-printer method, enlarger method, contact proofer

You should make *contact prints* of every negative in your file. They provide a personal record of your negatives and a convenient aid in choosing the negatives you want to enlarge. A contact print is simply a print made with the negative in contact with the photographic paper. The emulsion side of the negative is placed in contact with the emulsion side of the paper in a darkroom. The paper is exposed briefly to white light and then processed. Three methods of contact printing are in common use.

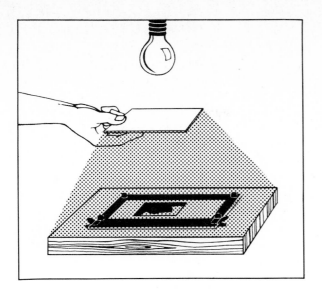

Fig. 5–2 Open-bulb method of contact printing.

Fig. 5–3 Contact-printer method of contact printing. The light-sensitive paper is positioned over the negative so that the emulsion side of the paper faces the source light.

Open-bulb method

Contact prints can be made by the *open-bulb method* on a flat table with a printing light overhead. The enlarging paper is placed in a print frame, emulsion side up, under the darkroom safelight. The negative is placed on top of the sensitive paper, emulsion side down, so that the two emulsions are in contact. The print frame is closed, sandwiching the paper and negative in close contact under the glass face of the frame. Then the source light is turned on for a few seconds to make the exposure. Test exposures will tell you the correct exposure for any particular negative and lighting condition. An opaque card, as shown in Figure 5–2, can be used to mask the light from all or part of the negative to hold back exposure of portions of the negative that need less light for correct exposure. Or you can tear a small hole in the card to give certain areas of the print more exposure than the rest.

Contact-printer method

Another method of making a contact print involves using a *contact printer*. The printer is a light-tight box containing a light and having one glass side on which the negative and paper can be placed for exposure. A movable pressure plate is used to sandwich the negative and paper into close contact during exposure. A typical contact printer is shown in Figure 5–3.

The negative and the paper are placed, emulsion to emulsion, on the glass surface of the contact printer. The negative is placed first, emulsion side up, and the paper is placed on top, emulsion side down, facing the light source. Then the pressure plate is lowered on top of them and the exposure is made. Some contact printers activate the source light as the top is clamped into place. With others, a switch is operated at the side of the box. Exposure time will vary with the contrast and density of the negatives

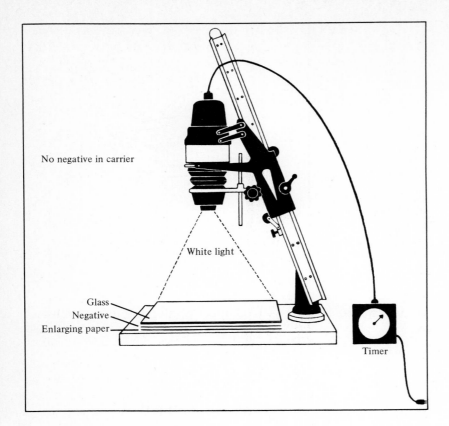

No negative in carrier

White light

Glass
Negative
Enlarging paper

Timer

Fig. 5–4 Enlarger method of contact printing.

and the intensity of the source light, but normally it will not exceed a few seconds. The darkroom timer can be used. Use contact printing paper for this method because the light source is close to the paper and enlarging paper is too sensitive to work properly.

Enlarger method

The *enlarger method* of making a contact print involves using the enlarger as a light source as shown in Figure 5–4. The negative and enlarging paper are sandwiched together under glass, emulsion to emulsion, and placed on the base of the enlarger. Then the

enlarger is switched on to make the exposure, the enlarger simply providing a light source for the exposure. A *contact proofer* can be used to hold the negative and paper. It provides a glass lid hinged to a base for convenient handling. (See Figure 5–4.)

Some general rules about contact printing:

1. Prepare your materials and set up under a safelight. Do not expose your photographic paper to white light except for the controlled exposure. Do not open the photo paper box except under safelight.

2. The emulsion side of the negative should always face the emulsion side of the paper. The emulsion

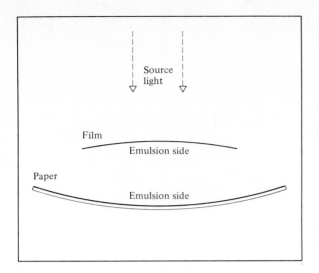

Fig. 5–5 Emulsion side of negative must face emulsion side of paper for printing.

side of the negative is the duller side; the emulsion side of the paper is usually the shinier side. Even when it is not obviously shinier, as with matte-finished RC papers, for example, the emulsion side tends to curve differently from the base side. With conventional paper, the emulsion side tends to curve slightly inward; with RC paper, outward. You must learn to identify the emulsion side of the paper you are using. The paper, of course, must be placed so that its emulsion side is facing toward the source light. Only in this way will the image of the negative be recorded. See Fig. 5–5.

3. The amount of exposure is determined by experimentation. A procedure for determining exposure is discussed on page 159. Most normal negatives should print properly with exposures between five and ten seconds. Light intensity (with a contact printer) or f/stop (with the enlarger method) are adjusted until proper exposure can be made within this time.

4. Use contact paper when using the contact printer. Use enlarging paper when using the open-bulb or enlarger method.

Do Exercise 5–B on page 184

Making a Contact Proof Sheet Using the Enlarger Method

Objective 5–C Explain and demonstrate how to make a contact proof sheet using the enlarger method.

Key Concepts contact proof sheet, proofer

A *contact proof sheet* is made by contact printing a whole roll of negatives at one time. The roll of negatives is cut into strips 18 cm to 23 cm long (7 in. to 9 in.), and the strips are placed side by side in contact with a 20-cm by 25-cm (8-in. by 10-in.) sheet of photographic enlarging paper. Thus all the negatives on the roll are contact printed in a single exposure on a single sheet of printing paper.

The negatives and paper are sandwiched into close contact under glass and the exposure is made using the open-bulb or enlarger method. Then the paper is processed in the usual manner. Figure 5–6 depicts the steps for making a contact proof sheet.

The contact proof's main value is in providing a black-and-white record of your negatives. As negatives vary in density and contrast and require different amounts of exposure, it is rare that good prints will result from every negative in a single exposure of a contact proof sheet. Because your negatives vary in density and contrast, the single exposure may be too long for some frames and too short for others. Thus some of the contact prints may appear too dark, and some may appear too light. Your single exposure

1. Cut your negatives into strips about 7"- 8" long.

2. Place strips side by side in contact with an 8" x 10" sheet of enlarging paper. Emulsion to emulsion.

3. Place a clean piece of clear glass on top of the negatives and paper. (Tape the edges of the glass to prevent cuts.)

4. Expose the paper and negatives using either the open bulb method (as above) or the enlarger method.

Fig. 5–6 Making a contact proof sheet using a print frame.

should represent an average exposure for the whole roll.

If some of the contact frames appear too dark and others too light, remember that these results usually can be corrected when you make an individual print of the negative. When making the individual print, you will select an exposure best suited to that negative. Consider your proof sheet as a record only. Before making enlargements, you can use a magnifying glass to inspect each picture on the proof sheet. Doing so often will save the time and expense of making enlargements that might be of poor quality.

A *proofer* consists of a sheet of plate glass mounted in a frame and hinged on a base. It provides a convenient means for sandwiching negatives and photopaper under glass (see Figure 5–7). To use the proofer and the enlarger method of exposure to make a contact proof sheet, follow these steps:

1. Place a negative carrier in the enlarger and adjust the enlarger lens to f/8. Stop down one or more stops to print thin negatives; open up one or more stops to print dense negatives.

2. Place an empty proofer on the base of the enlarger.

3. Turn on the enlarger. Adjust the head so that the rectangle of white light produced by the enlarger is several inches larger than the proofer. Place the proofer in the center of this rectangle. Turn off the enlarger and leave the proofer in place.

4. Place a 20-cm by 25-cm (8-in. by 10-in.) sheet of photographic paper in the proofer, emulsion side up. Arrange your negatives on the enlarging paper, emulsion side down. Close the proofer and secure the latch. Be careful not to move the proofer during this step.

5. Set the timer for five seconds. Trigger the timer for the five-second exposure.

6. Process the exposed paper according to normal procedures.

7. Examine the proof sheet after ninety seconds of development. If it is too dark overall, make another proof sheet, reducing exposure. If it is too

Fig. 5–7 Proofer.

light overall, make another proof sheet, increasing exposure. Repeat until the average prints are rendered with normal contrast. You should attempt to obtain a readable print from every negative containing an image. If necessary make more than one proof, varying exposure.

Do Exercise 5–C on page 185

Making Enlargements

> **Objective 5–D** Describe and demonstrate how to make an enlargement.
>
> **Key Concepts** image size, image focus, framing easel, lens aperture, timer

To make an enlargement, the negative is placed in the negative carrier with its emulsion side facing the enlarging paper. Its image is then projected onto the paper. Raising or lowering the enlarger head makes the projected *image size* larger or smaller. When the head is raised, the image is enlarged and its brightness is reduced. Thus larger images generally require greater exposures. By adjusting the focusing knob,

Fig. 5–8 Enlarging setup. Placing the negative carrier in the enlarger.

you can adjust the *image focus* to maximum sharpness. Placed in a special *framing easel,* the photographic paper can be held flat during exposure and the image framed within white borders that are created at the same time. The paper is placed with its emulsion side facing the light source. A typical setup for enlarging is shown in Figure 5–8.

As with the camera lens, the enlarging *lens aperture* can be adjusted to be larger or smaller. As the aperture is opened up wide, more light passes through the lens. As the aperture is stopped down, less light passes through. The effect can be seen in the projected image. The wider the aperture, the brighter the image, and vice versa.

The size of the aperture also may affect the sharpness of the projected image. The extremely large apertures, as well as the extremely small ones, may produce images that are less sharp overall than the middle apertures. You should try to make your exposures at the intermediate apertures — f/5.6 to f/11 — whenever possible.

In the initial steps of framing and focusing, however, work with the lens wide open to maximize the brightness of the projected image. Doing so makes it easier to see what you are doing. Then, just before making your exposure, stop down to your exposure aperture.

Step-by-step procedure

Follow these general steps in making a projection print, or enlargement.

Enlarger is off

1. Raise the lamp and condenser housing assembly. Remove the negative carrier and insert the negative strip into the carrier. Adjust so the desired negative is centered in the mask, emulsion side down (toward lens). Carefully clean the negative with a soft brush, bulb-blower, or can of compressed air to remove all dust from its surfaces. Film cleaner will be needed if there are oily fingerprints on the negative. (Care at this point can save touch-up time later.) Replace the carrier in the enlarger. Lower the housing assembly into place.

2. Place a sheet of plain white paper in the framing easel. (The paper should be the same weight as the paper you will use for printing.) Adjust the framing leaves to the desired enlargement size. Place the easel on the enlarger base.

3. Open the enlarger lens to its widest aperture.

Turn enlarger on

4. Raise or lower the enlarger head to obtain the desired image size. When it is obtained, lock the elevator in place.

5. Adjust the focusing knob for the sharpest focus. Special magnifiers for this purpose are available to assist in focusing. (The image can be only as sharp as it is on the negative, however; unsharp or blurred images cannot be sharpened by an enlarger.)

6. Adjust the easel for the desired position for framing the image.

7. Stop the enlarger lens down to your enlarging aperture — f/8 for negatives of normal density.

Turn enlarger off

8. Do not move the easel. Determine exposure as described in Objective 5–E.

9. Select exposure and set the *timer*. Without moving the easel, replace the blank paper with a sheet of enlarging paper, emulsion side up, toward the lens.

 Trigger the timer.

10. Process the paper. If the overall effect is too light, make another print, increasing exposure. If it is too dark, make another print, decreasing exposure. *Do not try to control the darkness of the image by under- or overdeveloping. Consistently develop prints for a fixed interval of time.* Until you have acquired experience, develop every print for the amount of time recommended by the developer manufacturer. Fig. 5–9 on pages 160–161 shows some common printing errors.

 Do Exercise 5–D on page 186

Determining Exposure

Objective 5–E Describe and demonstrate how to determine exposure using the test strip method.

Key Concepts test strip

Any photographer, regardless of experience, must estimate exposure for printing. With experience, most are able to make reasonably accurate estimates based on visual inspection of the negative. For greater precision, however, they will rely on experimental tests to determine optimal exposure. For this purpose *test strips* are widely used. Using this test procedure saves time, energy, and money; reduces waste, and takes much of the guesswork out of determining exposure.

Making a test strip

1. With the enlarger on, the aperture wide open, and blank paper in the easel, size, focus, and frame the image as desired. Stop down to f/8.

2. With the enlarger off, cut a sheet of 20-cm by 25-cm (8-in. by 10-in.) enlarging paper into five strips, approximately 5 cm by 20 cm (2 in. by 8 in.) Replace all but one of the strips into your paper safe or lightproof container. Place the other strip in the framing easel across a representative area of the image. (Of course, with the enlarger off, you must visualize where this section will be.)

3. Use an opaque sheet of stiff, dark paper as a mask to cover the test strip, holding it over the strip (see Figure 5–10A). Turn on the enlarger and expose successive sections of the strip for successively greater intervals — for example, expose a 4-cm (1½ in.) section for six seconds, the next 4-cm (1½ in.) section for an additional six seconds, and so forth. When you have exposed five sections, each for an additional increment of six seconds, you will have a strip with one section exposed for thirty seconds, the next for twenty-four seconds, the next for eighteen seconds, and so forth.

4. Develop the test strip. It will resemble Figure 5–10B.

5. Select the exposure that produces the best range of tones. Rich blacks and clean whites should be present, as well as a full range of gray tones in between. Details in highlights and shadows should be clearly visible to the full extent that they are present in the negative. If none of the sections produces an acceptable range of tone, make another test strip, increasing or decreasing the exposure increments as needed.

A B

C D

Fig. 5–9 Examples of common printing errors. A. Air bubbles, from failure to dislodge air bubbles from surface of film or paper during development. B. Dust on negative or paper yields white specs in print. C. Fix stains, from fixer contact with paper before development. D. Streaking, from improper agitation during development.

E. Tong marks, from handling print improperly with print tongs. F. Finger marks, from handling print with chemically contaminated hands. G. Agitation marks, from improper agitation during development. H. Inexact borders, from improper placement in printing easel. I. Underexposure. J. Overexposure.

E

F

G

H

I

J

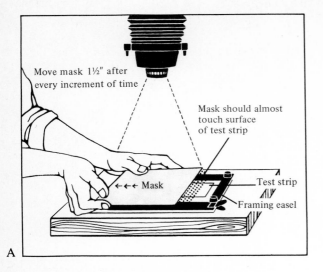

Move mask 1½" after every increment of time

Mask should almost touch surface of test strip

Mask

Test strip

Framing easel

A

Fig. 5–10 Making a test strip. A. Procedure. B. Each segment of this test strip has been exposed in fixed increments of 6 sec. C. In each segment of this test strip, exposure is doubled.

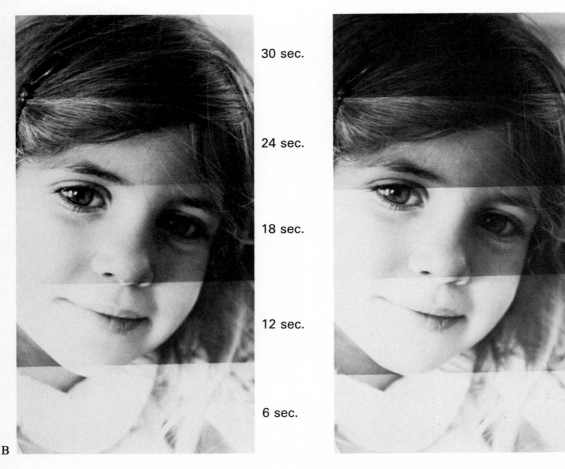

30 sec.

24 sec.

18 sec.

12 sec.

6 sec.

B

48 sec.

24 sec.

12 sec.

6 sec.

3 sec.

C

HELPFUL HINT

Using a multistation darkroom
Cooperation is essential in any multi-station darkroom — one in which more than one operator can expose and process prints simultaneously.

Remember, the dry area counters are for dry materials and operations exclusively. Only the sink should be used as a wet area for wet operations. Keep bottles of liquid chemicals in or under the sink. Keep dry papers and negatives in or on the dry area counters. If your hands should become chemically contaminated with processing chemicals, you can ruin your prints. If hands contaminated with fixer, for example, come in contact with printing paper, they will produce white smudges and fingerprints in the final print. If hands contaminated with developer come in contact with printing paper, they may produce dark smudges and fingerprints. *Wash your hands thoroughly and frequently when printing and processing.*

Be sure your enlarger source light is switched off before you raise its condenser and lamp housing to insert negatives or to remove the negative carrier. Stray light from your enlarger may strike and ruin your neighbor's work and supplies. Use print tongs to handle prints and drain them between solutions. Allow sufficient time following processing to wash and dry your prints.

Fixed versus proportional increments

The procedure just outlined describes a sequence of fixed exposure increments; the first segment was exposed for six seconds, the next for six seconds more, and so on. Note in Figure 5–10B that the exposure in the twelve-second segment is 100 percent more than in the six-second segment, but exposure in the thirty-second segment is only 25 percent more than in the twenty-four-second segment — the exposure increments in each segment represent decreasing proportions.

Another approach to incremental exposure is to increase exposure in each segment by a constant proportion, for example, to double exposure in each successive segment. Expose the first segment for twenty-four seconds, the next for twelve seconds, the next for six seconds, the next for three seconds, and the last segment also for three seconds. The result will be a test strip such as that shown in Figure 5–10C, with a much wider range of exposures and with the additional advantage that each successive increment represents one stop greater exposure.

Do Exercise 5–E on page 187

Control of Print Contrast

Objective 5–F Describe and demonstrate how print contrast can be controlled and how to produce relatively normal prints with flat, contrasty, and normal negatives.

Key Concepts density, contrast, contrasty print, flat print, normal print, contrasty negative, flat negative, normal negative, contrast grades, normal paper, flat paper, contrasty paper, variable-contrast paper, contrast filters

Tonal qualities of finished prints

Already you have learned that film does not record all the tones that the eye can perceive. The eye has greater sensitivity to minute tonal differences than

does film. One of the challenges of photography is to record on the film as much of the visible tonal range that is important to your image as your materials and procedures permit.

Printing paper is even less sensitive than film. Just as film loses many tones from the scene, printing paper loses many tones from the negative. To maximize tonal reproduction, you must learn to manipulate printing materials and techniques, primarily by controlling *density* and *contrast*.

Density refers to the overall lightness or darkness of the print — the amount of image-forming silver that it possesses. To control density, you manipulate the exposure of the print. The longer the exposure, the darker the print; the shorter, the lighter.

Contrast refers to the range of densities present in the print between deep black (maximum density) and base white (minimum density). High contrast refers to the presence of maximum and minimum densities within the same print and relatively little presence of intermediate densities. A high-contrast print tends to possess deep blacks and base whites, with few intermediate shades of gray. Low contrast refers to the presence only of a narrow range of densities — the darkest and lightest shades tend to be close together. Deep blacks and base whites do not appear simultaneously in a low-contrast image.

To control contrast, you can select printing papers with appropriate contrast properties and manipulate exposure and processing to achieve the desired contrast effects. Are the blacks as deep and pure as desired? Are details in the highlights and in the shadows visible? The materials and procedures for manipulating these qualities are introduced below.

Faithful reproduction of the original scene with clarity, definition, and sharpness is only one criterion for print evaluation. Also important is your use of these controls to express your impressions of the scene, to communicate a feeling or idea that you experienced when viewing the original scene. Thus density and contrast also may be manipulated to set a mood for the scene, to emphasize important details, and to express certain relationships you perceive to

A

B

Fig. 5–11 Contrast and density. Tone and mood can be varied by altering print contrast and density. A. Low contrast and high density create a dark, brooding atmosphere. B. Higher contrast and reduced density make the mood considerably brighter.

be important. The use of these controls and others for effective composition will be discussed more fully in Units 6 and 10.

Figure 5–11 shows two different interpretations of the same negative, in each case printed for different density and contrast. Note the different feeling and idea communicated by each print.

Negative and print contrast

Print contrast refers generally to the range between the darkest and lightest tones present in the print, as well as the number of distinct gray tones in between. Black-and-white negatives vary in contrast because of several factors, including the brightness range of the original subject, exposure, the type of film and developer used, the method of processing, and the lens quality. Prints also vary in contrast as a result of factors such as negative contrast, exposure, the type of enlarger used, the type of paper and developer, the processing method, and the type of enlarger lens.

A *contrasty print* has a wide density range, but lacks the middle gray values. Because only dark and light values are present, details in the highlight areas of the print, or in the shadow areas, or both, are lost. A silhouette is an extreme example of a high-contrast print. A *flat print* possesses few density values and a relatively narrow density range. Because only a few values are present, the image appears soft or gray. Details may be present, but they do not stand out markedly from their surroundings. A print showing a barely discernible scene through a mist or fog would be an extreme example of a low-contrast print. A *normal print* has both a wide density range and a complete scale of middle gray values. We can see details in both the high density and low density areas of the image that stand out distinctly from their surroundings. Examples of contrasty, normal, and flat images are illustrated in Figure 5–12.

The negatives used to make prints possess these same contrast characteristics. *Contrasty negatives*

A

B

C

Fig. 5–12 **Contrast.** A. Low contrast. Picture is flat, with little contrast between darkest and lightest tones. B. Normal contrast. Picture shows full range of dark, middle, and light tones. C. High contrast. Picture shows only darkest and lightest tones; middle tones are weak and undeveloped.

have a wide tonal range, but weak and underdeveloped middle tone areas. Pictures taken outside on a bright, sunny day at noon may tend to produce *contrasty negatives* because the light falling on the subject will consist of bright highlights and deep shadows. Some negatives are flat, that is, they have a relatively narrow tonal range; the difference between the lightest and darkest portions of the negative is slight. Pictures taken outside on an overcast or misty day tend to produce *flat negatives* because the light falling on the subject is even — there are no extreme highlights or deep shadows. *Normal negatives* have well-developed highlights, shadows, and middle tones. Details are clearly visible in the clearest and darkest portions of the negative.

By using contrast controls in printing, you can obtain relatively normal prints from a wide range of contrasty, flat, and normal negatives. Or, you can manipulate contrast to emphasize the print qualities that best express your idea of the scene.

Paper grades

Photographic printing papers are manufactured in a variety of *contrast grades*. Some grades, the *normal papers,* are designed to produce a tonal range — from black to white and a variety of distinct gray tones in between — that matches the tone and contrast of the negative. Some grades are designed to produce a somewhat narrower range of tones, rendering adjacent tonal areas more alike in density than they appear in the negative. They are called *flat papers* because they "flatten out" the extreme contrasts in the negative. When flat paper is used, the resulting print will have less contrast than the original negative. Other papers are designed to produce a somewhat greater range of tones, rendering adjacent tonal areas more unlike in density than they appear in the negative. They are called *contrasty papers* because they increase the contrasts present in the negative. When a contrasty paper is used, the resulting print will have greater contrast than the original negative.

Paper grades are identified by number, such as no. 0, 1, 2, 3, and 4. The lower numbers identify the flat papers; the higher numbers, the contrasty papers. A no. 2 paper is a normal paper, no. 1 is a flat paper, and no. 4 is a contrasty paper.

If you wish to obtain a normal print from a normal negative, use a no. 2 paper. If you wish to obtain a relatively normal print from a contrasty negative, you might use a no. 1 paper to flatten out the contrast in the negative. If you wish to obtain a relatively normal print from a flat negative, you might use a no. 3 paper to increase the contrast in the negative.

Variable-contrast papers and filters

Some papers (such as Kodak Polycontrast and Ilford Multigrade) are designed to give flat, normal, or contrasty results by the use of special filters during exposure. These *variable-contrast papers* are not graded by number because you can use any sheet of the paper to produce flat, normal, or contrasty results simply by selecting an appropriate *contrast filter*. Filters are coded with numbers such as 1, 2, 3, and 4 to identify the contrast grade that will result from their use. As with paper grades, the lower numbers identify filters that produce flat results; the higher numbers, those that produce contrasty results. Thus a no. 1 filter used with a variable contrast paper will produce flat results, a no. 4 filter with a variable contrast paper, contrasty results. Most contrast filter systems come in half-step intervals and thus provide seven or more selections of contrast grades. The use of contrast filters is shown in Figure 5–13.

Various manufacturers have produced variable-contrast systems; be sure you use the filters suitable for use with your selected variable-contrast paper. Check the manufacturer's specifications to assure the compatibility of your paper-filter combination. Table 10 may help you choose the appropriate grade of paper or contrast filter.

Do Exercise 5–F on page 187

Table 10 Selecting a Contrast Grade (or Filter)

With a	Use a
very flat negative	very contrasty grade of paper or filter (no. 4, 5, or 6)*
flat negative	contrasty grade of paper or filter (no. 3 or 4)
normal negative	normal grade of paper or filter (no. 2 or 3)
contrasty negative	flat grade of paper or filter (no. 1 or 2)
very contrasty negative	very flat grade of paper or filter (no. 0 or 1)

*A graded paper of contrast grade no. 5 or no. 6 will generally produce a higher contrast result than the highest grade filter with variable contrast paper.

Fig. 5–13 Using variable-contrast filters. A. Variable-contrast printing filter set. B. Filter holder (below enlarger lens).

A

B

Printing Controls

> **Objective 5–G** Describe and demonstrate several printing control techniques.
>
> **Key Concepts** cropping, burning in, dodging, vignetting, texture screening, convergence control, diffusion, flashing, combination printing

In addition to the normal printing techniques, there are several more specialized controls that can enhance the effectiveness of the final print. Some of the more important and commonly used of these controls are cropping, burning in, dodging, vignetting, texture screening, convergence control, diffusion, flashing, and combination printing.

Cropping

Often your negatives will contain more area than you wish to appear in your final print. By *cropping* your print during enlargement, you can print only that portion of your negative image that makes the best picture.

Fig. 5-14 Marking proof sheet with felt-tip pen or grease pencil for cropping.

Your first plans for cropping a print should be made before you begin making the enlargement. Examination of the print on the proof sheet should suggest the cropping you will perform. Using a felt-tipped pen or grease pencil, draw the desired cropping directly on the proof sheet. Then, during enlargement your proof sheet will remind you of the cropping you want to perform for each print, and you will save darkroom time by not having to puzzle out your cropping plans while in the darkroom. (See Figure 5-14.)

During enlargement, after placing the negative in its carrier, place the printing easel on the base with a blank sheet of ordinary paper within the frame. Turn on the enlarger and examine the image projected into the easel's picture frame. Referring to your crop marks on the proof sheet, raise or lower the enlarger head, adjust the focusing knob, and maneuver the placement of the easel until the desired image is in focus within the printing frame of the easel. Then turn off the enlarger and proceed with printing.

The technique of cropping should not be relied upon to create effective prints from poorly planned negatives. Keep in mind that the more extreme the enlargement of any portion of a negative, the more the print quality will be diminished by graininess and loss of definition. As discussed in Unit 6, the arrangement of details in your photograph that best expresses your idea starts in the shooting, using the viewfinder of the camera as the primary tool of composition. The technique of cropping may be helpful in making minor compositional corrections, but not usually in performing major surgery. From the start, try to compose your pictures in the viewfinder of your camera, not on the enlarging easel in the darkroom.

Burning in and dodging

Often the range of brightness in your negative may exceed the range of tones that your printing paper can produce effectively. The result can be seen in the brightest and darkest areas of the print. In the bright areas (dark on the negative), details are lost and may appear simply as blank white areas on the print. In the dark areas (light on the negative), details are lost similarly. These dark areas may appear as almost solid masses in which details cannot easily be distinguished. Two techniques are available for partially overcoming this difficulty: (1) *burning in,* by which additional exposure is given only to areas of the print that would otherwise print too light, and (2) *dodging,* by which exposure is held back only in areas that would otherwise print too dark. See Figure 5-15.

For burning in small areas of the print, the typical tool is an opaque mask of light cardboard or plastic with a small hole in it. To burn in, the print first is given its normal exposure. Then the mask is inserted by hand under the enlarger lens about midway between the lens and the printing paper. The projected image is masked from the printing paper, except the portion that passes through the hole. Then the mask is moved so that only those areas that need additional exposure are projected through the hole. During burning in it is important to keep the mask in continuous motion so that the edge of the burned-in area will not appear in the final print.

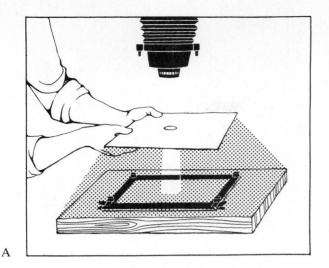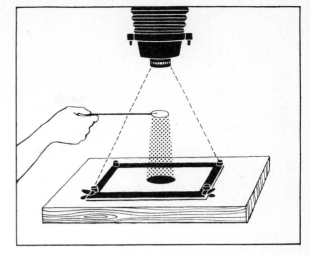

A

B

Fig. 5–15 Burning in and dodging. A. Technique for burning in. B. Technique for dodging.

For dodging, the typical tool is a sheet of opaque cardboard or plastic, or a small piece of opaque material attached to the end of a thin wire handle. Dodging is performed during the basic exposure so that the printing paper receives less than the normal exposure in the areas that might appear too dark in the normal print. During exposure, move the dodging tool over the area to be dodged, keeping it in motion so that its edges do not appear in the final print. Remember that you must allow sufficient exposure to reach the dodged area to produce an image. Dodging is performed only to reduce the exposure in that area so that it receives less exposure than the rest of the print.

Either of these techniques can help control exposure at selected local areas within the print, but only if the detail you are trying to preserve exists in the negative. No amount of dodging can restore details that were never recorded on the negative; no amount of burning in can restore details that have been lost in the dense highlights of the negative. These techniques can only work to preserve details that exist in the negative.

Vignetting

Vignetting is a control used to eliminate unwanted backgrounds and to isolate the subject against a white space. Often it is used in portraits, and works best when the portrait is composed mostly of light tones. (See Figure 5–16.)

The vignetting tool is an opaque piece of cardboard or plastic with a hole cut in it in the shape of the area you want to print. The edges of the hole are feathered so that the image will fade gradually into the white paper without its edges being clearly visible. As with dodging and burning in, the vignetter is kept in continuous motion during use so that its edges do not appear in the final print.

The vignetter is used during the basic exposure. It is inserted by hand below the lens about midway between the lens and the printing paper so that only the portion of the image to be printed is projected to the paper below and the unwanted portions are masked off.

Fig. 5–16 Vignette. Technique works best with subjects set against light backgrounds.

A

Fig. 5–17 Texture screening. Different texture screen effects are shown in A and B.

Texture screening

You can add a dimension to your print by printing through a *texture screen,* a device that gives the print a textured appearance. (See Figure 5–17.) The texture itself can be of cloth, wire, glass, or plastic. Some texture screens are introduced into the optical system at the negative stage and are used together with the negative. The texture pattern in this case will vary with the degree of enlargement. Other texture screens can be used in contact with the printing paper. You can make a texture screen of this type by stretching a sheer cloth — or any other type of thin material

that has a structural pattern of interest — over the printing paper.

You can make your own texture screens by photographing textured surfaces. Light the textured surface with a strong side light to bring out the texture of the material and then take a closeup photograph of the textured material. You can use the resulting negative as a texture screen that can be used together with another negative. Printing both negatives at the same time will impart the texture to the printed image.

B

Convergence control

When you take a picture with your camera pointed upward or downward, the vertical lines in the picture will appear to converge toward each other. This tendency is evident in pictures taken of tall buildings from ground level with the camera pointed upward to take in the top of the building. Whereas the converging verticals often may add to the feeling of height in the picture, sometimes you may find them distracting. You can correct these converging verticals during enlargement by exercising *convergence control*.

With the negative image projected on a blank sheet of paper in the easel, tilt the easel by lifting up the edge closest to the point where the converging verticals are at their widest. You will find that doing so tends to straighten out the convergence. Lift until the verticals appear to be parallel and then place an object under the easel to hold it in this position. Then, with the focusing knob, focus the image to a point about one-third of the way down from the high edge of the easel. If the needed correction is only slight, you may be able to keep the image in focus over the entire picture area by stopping the enlarging lens down to f/11 or f/16 to increase the depth of field. However, if the needed correction is great and you must tilt the easel to a considerable incline, you also must tilt the negative carrier in the enlarger. Tilt the negative car-

A

B

Fig. 5–18 Convergence control. Parallel vertical lines that tend to converge in A have been corrected in B by the technique shown in Fig. 5-19.

rier until the complete image on the easel is in focus. With many simpler enlargers, tilting the negative carrier in the enlarger is impossible, and you will not be able to correct for severely converging lines. See Figures 5–18 and 5–19.

Diffusion

By using the *diffusion* technique, you can obtain a hazy or soft-focus effect during printing. This effect may be used to subdue blemishes and wrinkles in portraiture, or to create a hazy, misty effect.

This effect is obtained by introducing a diffusing device between the enlarger lens and the printing paper during exposure. This device may be a diffusion screen, a transparent acetate sheet (such as a negative sleeve), or a thin piece of nylon or similar fabric (dark colors work best) stretched across the path of the light. You can use any transparent material that will pass the image projected from the enlarger and scatter the light rays only slightly. The amount of diffusion increases as the diffusing device is placed nearer the enlarger lens; thus you can control the amount of diffusion that will appear in the final print.

Usually best results are obtained if a slightly higher-than-normal contrast paper is used and if the diffusion technique is applied for only part of the print exposure, while the balance of the exposure is made in the normal way. Figure 5–20 shows the effect of diffusion.

Flashing

To subdue distracting highlight areas in a print, the *flashing* technique may be useful. Flashing is simply a method of locally fogging small areas within a print

A

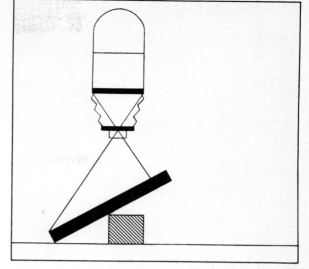

B

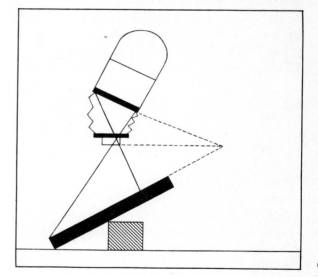

C

Fig. 5–19 Correcting converging parallel lines. A. Normal enlargement shows converging verticals in the negative. B. Slight correction can be made by tipping easel slightly and stopping down enlarger lens to increase depth of field. C. Extreme correction may require additional tilting of negative carrier.

to add density to — to darken — unwanted highlights.

Typically a small penlight is used. The penlight is rolled in heavy paper forming a long tube, 6 inches or so, through which a small circle of raw, white light can be projected by hand onto the print. For best results, the intensity of this light should be quite dim, producing a medium gray from working distance with six to eight seconds of continuous exposure.

After exposing the print normally, place a red filter over the enlarging lens and turn on the enlarger. You will be able to see the image without exposing the print further. Then, using the modified penlight, expose the offensive highlights by "painting in" these areas with raw, white light, taking care to feather out the edges of the flashed areas. Keep the tool moving. Avoid flashing in any of the desired highlights or you may degrade the contrast in these areas. Figure 5–21 shows the results of the flashing technique.

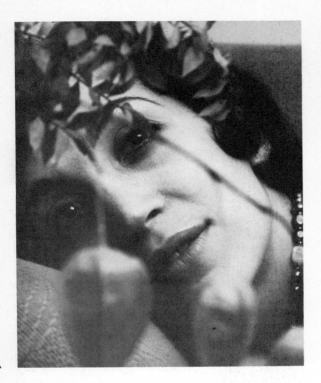

A

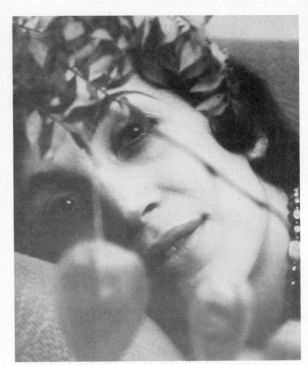

B

Fig. 5–20 Diffusion. Harsh complexion details (A) softened by using technique of diffusion (B).

Combination printing

Using more than one negative to make a single print is termed *combination printing*. One of the common uses of this technique is to add clouds to a clear sky. Basically the technique consists of printing a portion of the print, such as the clouds, with one negative and the remaining portion, such as a building or landscape, with a second negative. Both the subjects and the relative densities of the two printed portions should appear logically consistent and the joining of the two images should be concealed artfully.

In selecting two negatives for combination printing, be sure that the two subjects have been shot from the same point of view. When adding clouds, for example, be sure that the clouds and the subject are seen from the same camera angle. Similarly the lighting of the two subjects should appear to derive from the same source — if the subject is lit from the right side, the clouds also should be lit from the right. The relative size of the two images should be consistent with experience. Clouds that are supposed to be a great distance away should appear relatively small in the scale of the photograph. Violations of these logical concerns are likely to produce photographs that appear strange, artificial, and unreal.

The steps involved in combination printing a background, such as clouds, are as follows:

1. Determine the correct exposure for each negative independently to assure that the print densities of the two images are consistent.

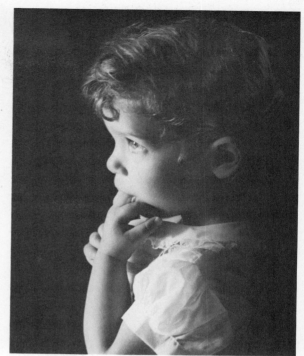

A

B

Fig. 5–21 Flashing. Distracting highlights on left ear and back of head (A) muted by flashing during exposure (B).

2. Expose the foreground subject, masking off the original sky image to within an inch of the subject. If necessary, cut a mask to conform to the general contour of the subject. Move the mask slightly during exposure to build a slightly gray margin of density around the subject image. This margin will help you join the two images without revealing the joint between them.

3. Insert a red filter below the enlarger lens. Place tape markers on the easel to remind you of the position of the margin adjoining the subject image. Next replace the subject negative with the cloud negative in the enlarger. With the red filter still in place, and without moving the position of the easel, arrange the cloud image to a suitable location and size. (You must use the markers at this point because the subject image is no longer visible.) Turn off the enlarger, remove the red filter, and proceed to expose the cloud image.

4. While masking off the previously exposed subject area, expose the clouds. Cut the mask to conform to the subject's contour if necessary. Keep the mask moving within the marginal area to blend the second image into the first.

Figure 5–22 provides an example of combination printing using two negatives. Combination prints may be made using many negatives if desired. The basic principles are the same.

Do Exercise 5–G on page 189

Fig. 5–22 Combination printing. Clouds added to a cloudless sky by double printing — using more than one negative to make a single print.

Finishing Controls

Objective 5–H Describe and demonstrate the processes of print washing, drying, spotting, mounting, and describe toning and bleaching.

Key Concepts print conditioner, glossy finish, matte finish, semigloss finish, toning, dry mounting, wet mounting, spray mounting, cold mounting, spotting, bleaching

Steps in finishing

Fiber-base paper

1. To avoid staining, you must remove all traces of photochemicals from your print following processing. This can be accomplished by washing alone. To speed the process and to assure perfect results, you can use a clearing agent before washing.

2. Following the wash, treat your prints in a *print conditioner* to preserve the emulsion, to keep it flexible, and to improve the high-gloss effect on glossy prints.

ordinary laundry bleach. Practice the technique on scrap materials before trying it with your good prints. Using a small, tightly twisted cotton swab, apply the bleaching agent delicately and gently to the precise area of the black spot. Try to avoid bleaching any of the surrounding area; the larger the bleached area, the more visible it will be in the final print. When the black spot has been bleached away, the remaining whitened area can be spotted, as just described, to restore its tone to that of the surrounding area.

Both spotting and bleaching are difficult, time-consuming tasks that should not be relied on to rescue carelessly made prints. Proper care in printing can save hours of laborious and often unsatisfying retouching.

Do Exercise 5–H on page 190

Fig. 5–25 **Spotting.** Spot the finished print to conceal blemishes (cannot be done on high-gloss finish).

To spot your print, dampen your brush slightly and pick up a little of the spotting dye that will best match the area around the spot. You can mix dye colors to obtain the right shade. Using a fine point, apply the dye to the spot using a dotting or stippling motion. Continue until the spot disappears into the surrounding area. (See Figure 5–25.)

Occasionally your print may acquire black spots as a result of pinholes or other negative blemishes that pass light. Eliminating these spots from the print is a somewhat complex operation that, if not meticulously executed, easily can ruin the print. The process involves *bleaching* the black spot from the print with a concentrated solution of potassium ferricyanide or

Suggested references

Craven, George M. *Object and Image: An Introduction to Photography*. Englewood Cliffs, N.J.: Prentice-Hall, 1975, pages 106–121.

Davis, Phil. *Photography*. 3rd ed. Dubuque: William C. Brown, 1979. Chapter 5.

Eastman Kodak Co. *Basic Developing, Printing, Enlarging in Black-and-white*. Rochester, N.Y.: Kodak (Photo Information Book AJ–2), 1979.

Eastman Kodak Co. *Bigger and Better Enlarging*. Rochester, N.Y.: Kodak (Photo Information Book AG–19), 1974.

Jacobs, Lou, Jr. *Photography Today*. Santa Monica, Calif.: Goodyear Publishing, 1976, chapter 9.

Rhode, Robert B. and F.H. McCall. *Introduction to Photography*. 4th ed. New York: Macmillan, 1981, Chapter 6.

Swedlund, Charles. *Photography*. 2nd ed. New York: Holt, Rinehart and Winston, 1981, Chapters 7, 8.

Time-Life Books. *Life Library of Photography: The Print*. Time, Inc., New York, 1970. Chapter 3.

Suggested field and laboratory assignments

1. Using the negatives you produced in Unit 4, make a contact proof sheet that shows the detail in every negative on the roll.

2. Select a negative from your first roll for enlargement. Set up for enlarging. Determine exposure using the test strip method.

3. Using fiber-base paper, make a 20-cm by 25-cm (8-in. by 10-in.) enlargement of the negative selected. Make additional prints to achieve optimal density and contrast (blacks, grays, and whites).

4. Make at least one print on glossy paper and finish it to produce a high-gloss finish. Make at least one other print using matte or semimatte paper. Finish it to produce a matte or semimatte finish.

5. Demonstrate the following techniques:
 A. Cropping
 B. Printing in
 C. Dodging
 D. Vignetting
 E. Texture screening
 F. Convergence correction
 G. Diffusion
 H. Flashing
 I. Combination printing

 On the back of each print, in soft lead pencil, describe the techniques used and the effect achieved with each.

6. Select one print for mounting. Dry mount it on mounting board.

Do Practice Test 5 on page 193

EXERCISE 5–A

1. Without referring to the reading, label the parts of the enlarger in the drawing below.

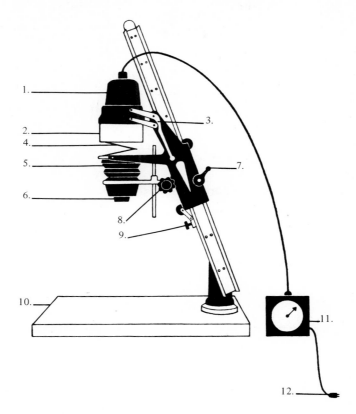

2. Briefly describe the function of each part.

(1) _____

(2) _____

(3) _____

(4) _____

(5) _____

(6) _____

(7) _____

(8) _____

(9) _____

(10) _____

(11) _____

(12) _____

Return to Objective 5–B, page 152

EXERCISE 5–B

1. Describe three methods for making contact prints.

 A. _____

 B. _____

 C. _____

2. Describe the correct relationship of the negative and paper emulsions during exposure.

3. What special photo papers are used for each of the contact-printing methods?

A. _____

B. _____

C. _____

Return to Objective 5–C, page 155

EXERCISE 5–C

1. Describe the steps necessary to produce a proof sheet using a proofer and the enlarger

method of exposure. _____

2. Describe two purposes for making a proof sheet. _____

Return to Objective 5–D, page 157

EXERCISE 5–D

1. Describe the major steps necessary to produce an enlargement from your negative.

Return to Objective 5–E, page 159

EXERCISE 5–E

1. Describe how to make a test strip to determine exposure.

Return to Objective 5–F, page 163

EXERCISE 5–F

1. Explain what is meant by "print contrast." _____

2. Explain what is meant by "negative contrast." _____

3. Explain what is meant by "contrast grades" as applied to printing papers and variable-

 contrast paper/filter systems. _____

4. To obtain a normal-contrast print with a high-contrast negative, what grade of printing paper should you use? What are the characteristics of this paper grade that are important for this purpose?

5. To obtain a normal-contrast print from a flat negative, what grade of printing paper should you use? Why? _____

6. Explain how the variable-contrast paper/filter system works. What advantages do you see in the variable-contrast system as compared to the graded paper system?

Return to Objective 5–G, page 167

EXERCISE 5–G

1. Describe the tools and procedures used for each of the following printing controls:

A. Cropping _____

B. Burning in _____

C. Dodging _____

D. Vignetting _____

E. Texture screening _____

F. Convergence control _____

G. Diffusion _____

H. Flashing _____

I. Combination printing _____

Return to Objective 5–H, page 176

EXERCISE 5–H

1. Describe the procedure used to produce a print with a high-gloss finish. What type of paper should you use? What solutions should you bathe it in? How should you dry it?

2. Describe the procedure used to produce prints with a semigloss or matte finish. What type of paper? What solutions? How should you dry them?

3. Describe the types of subjects for which you might choose glossy or matte finishes.

4. Describe each of the following optional techniques and list the equipment and materials needed for each.

A. Toning _____

B. Mounting _____

C. Spotting _____

D. Bleaching _____

Review References and do Suggested Laboratory and Field Exercises on page 182

PRACTICE TEST 5

For each of the following questions, select the one *best* answer and write its corresponding letter in the blank preceding the question. After you have completed the test, check your answers against the correct answers, which follow the test. If you miss any of the test items, review the study materials as suggested.

_____ 1. Your camera has a 6-cm by 6-cm (2¼-in. by 2¼-in.) negative format. Normally you will use a _____ focal length lens for enlargement.
 A. 135-mm
 B. 120-mm
 C. 80-mm
 D. 50-mm
 E. 35-mm

_____ 2. On a typical enlarger, the frame with a rectangular cutout the exact size of the film format is called the _____ .
 A. lensboard
 B. mounting board
 C. film holder
 D. negative carrier
 E. framing easel

_____ 3. Which of the following is *not* a functional part of the typical enlarger?
 A. lens housing
 B. focusing knob
 C. lamp housing
 D. bellows
 E. condenser housing

_____ 4. Enlarging paper is generally used for the _____ method of making contact prints.
 A. open-bulb
 B. contact-printing
 C. enlarger
 D. A and C
 E. all three methods

_____ 5. When contact printing, you prepare your setup and materials under a _____ and expose with a _____ light.
 A. safelight, amber
 B. safelight, white
 C. white light, amber
 D. white light, white
 E. none of the above

_____ 6. Making a test strip is one way to determine _____ .
 A. developing time
 B. paper selection
 C. exposure time
 D. printing controls
 E. fixing time

_____ 7. White fingerprints or marks around the edges of a print are caused by _____ .
 A. developer contamination of unexposed paper
 B. fogging
 C. fixer contamination of unexposed paper
 D. use of exhausted chemicals
 E. light leaks in camera

_____ 8. A _____ is helpful when selecting prints for enlargement from your contact proof sheet.
 A. developing computer
 B. photometer
 C. densitometer
 D. close inspection with magnifier
 E. sensitometer

_____ 9. Negatives and photographic paper may be sandwiched together under glass in a(n) _____ during contact printing.
 A. easel
 B. proofer
 C. sandwich board
 D. printing processor
 E. lensboard

_____ 10. For the enlarger method of contact printing, the enlarger is turned on while the _____ .
A. enlarger head is adjusted
B. negatives are arranged on the enlarging paper
C. exposure is made
D. A and C
E. B and C

_____ 11. Normally exposure of a print is executed with the enlarging lens _____ .
A. wide open
B. stopped down to f/8 or f/11
C. stopped down to f/16
D. stopped down as far as possible
E. none of these — the enlarging lens has no adjustments

_____ 12. As you increase the height of the enlarger head, the necessary exposure will _____ .
A. have to be decreased
B. have to be increased
C. ordinarily remain the same
D. increase or decrease depending on negative density
E. increase or decrease depending on the type of paper used

_____ 13. The _____ side of the negative faces the _____ side of the paper during enlargement.
A. emulsion, backing
B. backing, backing
C. backing, emulsion
D. emulsion, emulsion
E. depends on the type of paper used.

_____ 14. A high-contrast (contrasty) negative probably would print more normally using a _____ contrast-grade paper.
A. no. 1
B. no. 2
C. no. 2½
D. no. 3
E. no. 4

_____ 15. A negative image that has a narrow range of tones, without extreme shadows and highlights, is called _____ and would probably print more normally on a _____ grade of photographic paper.
A. contrasty, no. 4
B. contrasty, no. 1
C. flat, no. 4
D. flat, no. 1
E. none of these

_____ 16. For a high-gloss finish with fiber-base paper, use _____ paper and dry print with the emulsion facing the _____ .
A. matte, ferrotype surface
B. glossy, canvas or cloth surface
C. matte, canvas or cloth surface
D. glossy, ferrotype surface
E. none of the above

_____ 17. Using fiber-base paper with glossy surface and drying with the emulsion facing the canvas apron produces a _____ finish.
A. high-gloss
B. semigloss
C. low-contrast
D. tapestry
E. matte

_____ 18. Yellowish brown stains appearing on your print days or weeks after processing are signs that the prints were _____ .
A. overexposed
B. overfixed
C. underwashed
D. underdeveloped
E. overdeveloped

_____ 19. A technique used to give additional exposure to highlight areas that would otherwise print too light is known as _____ .
A. cropping
B. burning in
C. dodging
D. texture screening
E. vignetting

_____ 20. The picture of your subject is excellent but the background is cluttered and distracting. You may be able to rescue this print by _____ .
 A. vignetting
 B. dodging
 C. toning
 D. burning in
 E. any of the above

_____ 21. You can give a textured appearance to your print by _____ .
 A. placing a diffusion disk between the enlarger lens and printing paper
 B. placing any transparent screening over the emulsion side of the enlarging paper
 C. using crumpled cellophane below and near the enlarging lens
 D. photographing cloth, wire, plastic or other material and using the negatives as a texture screen
 E. either B or D

_____ 22. A good test for the dry mounting of your print involves _____ .
 A. flexing the mounting board
 B. using an electric iron
 C. using a dry-mounting press
 D. using a mount tester
 E. none of the above

_____ 23. Spotting is a technique used for _____ .
 A. focusing the negative image
 B. removing dark blemishes from the print
 C. attaching the dry-mount tissue to prints and mounting board
 D. removing white blemishes from the print
 E. none of the above

_____ 24. To straighten converging verticals, _____ .
 A. use stretching horizontals
 B. tilt the enlarging easel
 C. use a better point of view
 D. use a different camera
 E. convergence cannot be straightened in printing

_____ 25. In the toning process _____ .
 A. the color of the image is altered
 B. the color of the base is altered
 C. the color of the image and the base is altered
 D. the color of neither the image nor the base is altered
 E. a filter is used between the lens and enlarging paper

ANSWERS TO PRACTICE TEST 5

1. C If you missed this question, refer to "Parts of the Enlarger," page 151. If you don't remember how to figure the "normal" lens for any film format, review "Lens Characteristics," page 17.

2. D See "Parts of the Enlarger," page 151.

3. A The lens is mounted on a lensboard which is mounted to the enlarger. The lens is not contained in a housing of any kind. See "Parts of the Enlarger," page 151.

4. D Only the contact printer requires slower, contact printing paper. See "Making Contact Prints," page 152.

5. B You have read a great deal about controlled exposure of photographic paper. Photo paper always must be handled under a safelight, but exposed to white light. Therefore your setup will be under these conditions.

6. C See "Determining Exposure," page 159. The text recommends that you start out with six-second exposure increments and increase or decrease the time as necessary. Control by exposure; do not control by reducing or lengthening the developing time.

7. C Contamination of sensitive paper with processing chemicals carried on the hands is common. White fingerprints result from fixer contamination before development. Wash contaminated hands thoroughly and often. See the Helpful Hint on page 163.

8. D An illuminated magnifier is especially helpful for this purpose. See "Making a Contact Proof Sheet Using the Enlarger Method," page 155. The photometer or densitometer, by the way, is used to check _negative_ densities for selection of contrast grade and exposure in printing.

9. B See Figure 5–7 on page 157 if you missed this question.

10. D Again, as in question 5, controlled exposure is stressed. The source light is turned on while the enlarger head is adjusted so that the white light produced by the enlarger can be set to exceed the perimeter of the proofer. The enlarger must be off while you arrange the negatives on sensitive paper. Only after the setup is completed is the enlarger turned on again to expose the paper and negatives. See "Making a Contact Proof Sheet Using the Enlarger Method," page 155.

11. B Focus with the lens wide open, expose with the lens stopped down to f/8 or f/11. The size of aperture for the exposure of prints is discussed in "Making Enlargements," page 157.

12. B The exposure functions as the square of the distance between the light source and the photo paper. The higher you raise the enlarger head, the longer you will have to expose your print. Double the height of the enlarger head and you will have to quadruple the exposure. See "Making Enlargements," page 157.

13. D See "Making Enlargements," page 157.

14. A See "Control of Print Contrast," page 163, if you missed this question.

15. C See the definition of "flat" in "Control of Print Contrast," page 163.

16. D See "Finishing Controls," page 176.

17. B See "Finishing Controls," page 176.

18. C Any trace of a processing chemical remaining in the print may produce stains later on. See "Finishing Controls," page 176.

19. B See "Printing Controls," page 167.

20. A See "Printing Controls," page 167.

21. E See "Printing Controls," page 167.

22. A The print should adhere firmly when the board is flexed. See "Finishing Controls," page 176.

23. D Black, white, or gray tinting colors are used with a fine brush to remove white spots caused by dust or other particles during printing. See "Finishing Controls," page 176.

24. B See "Printing Controls," page 167.

25. A Only the color of the silver particles in the image is altered. Other products are available for tinting the paper base. No filters are used in toning; it is a chemical process. See "Finishing Controls," page 176.

INTRODUCTION TO COMPOSITION

U N I T 6

Elements of Composition

Objective 6–A Define composition and describe its elements and purposes.

Key Concepts line, tone, mass, contrast, color, selection, emphasis, subordination, central or dominant idea, center of interest

Without the power of our minds to organize it, our visual world would be complete chaos. So many things exist in the world to see that we cannot take it all in; we cannot comprehend the visual world in its entirety. It is your mind that helps you pick and choose what you see — to look now at this detail, now at another, until a pattern of meaning emerges that is significant to you.

Standing on a hillside viewing a valley below, the naturalist sees patterns of living things that suggest an ecological balance, the geologist sees patterns of earth formations that suggest a future earthquake, the industrialist sees valuable raw materials and energy sources, the developer sees a site for a future community. Each of us looks at this same scene but sees a different pattern and derives a different meaning from it.

It is your mind that selects and organizes the visual details of the world so that meaning emerges. As a photographer, you convey these meanings to others through your photographs. To convey meaning, therefore, your photograph must begin with an idea you want to share with others. Without an idea — without the mind of the photographer to invest it with meaning — a photograph is nothing more than a barren record of what stood before the camera when the shutter was released.

Composition refers to the way you select and organize the visual details of a photograph to convey meaning. The following discussion attempts to describe some principles that govern effective compo-

sition, and to suggest some guidelines that you as a beginner may find helpful.

The definition of composition

Music is composed, as is a poem or a novel. Often we may speak of "composing" ourselves when we are on the verge of losing control of our "composure." The common thread in all these meanings suggests organizing diverse elements into a unified whole. The elements of music are the characteristics of sound, such as pitch, timbre, volume, harmony, and rhythm. The elements of pictures are the characteristics of sight, such as *line, tone, mass, contrast,* and *color*. Just as the musician composes the elements of sound to communicate ideas and feelings, so the photographer composes the elements of sight. In all cases composition refers to the art of organizing effective communication — transmitting the composer's meaning with a minimum of distortion and ambiguity.

In photography, composition refers to the organization of pictorial elements. Sometimes effective photographic compositions are simple, straightforward expositions of a single subject. The beginner often enjoys earlier success by concentrating on such simple compositions. Nevertheless, effective compositions may be probing explorations of complex ideas — communicating richly varied patterns of detail and texture and subtle moods and feelings. As in any medium, the effectiveness of the communicator in dealing with complex subjects increases as his or her command of the medium increases. (See Figure 6–1.)

With few exceptions, however, the beginner is well advised to concentrate on pictures that have but one story to tell and have one central idea or center of interest. Attempts to cram too much within the borders of a picture often will result in a scattering of interest and a loss of unity. When this occurs the viewer cannot tell what idea the photographer was trying to communicate nor share the photographer's mood or feeling.

A

B

Fig. 6–1 Organization of pictorial elements. A. Simple composition. B. More complex composition, probing subtle moods and feelings.

The functions of composition

Composition guidelines are primarily concerned with ways of achieving pictorial emphasis. "Good" composition usually means that the pictorial elements have been *selected, emphasized,* and *subordinated* in such a way that the central idea of the photographer is effectively communicated to the viewer. Thus, the major function of photographic composition is to lead the viewer to perceive certain relationships among the pictorial elements — the relationships that the photographer perceives.

To accomplish this you should select various details for inclusion in the photograph and eliminate others. Then, among the details included in the photograph, you should emphasize some and subordinate others — that is, you should make some of the details appear more prominent and others less so. In this way you will call to the viewer's attention those details that you believe are especially important. Thus it is primarily through your selection, emphasis, and subordination of detail that you will communicate your *central* or *dominant idea.*

To achieve good composition, therefore, you must have clearly in mind what message, idea, feeling, or mood you want your photograph to convey. Otherwise you will have difficulty selecting and emphasizing the details of special importance. Typically this

means that the photograph will be about something, that some single object or group of objects will stand out unmistakably as the reason for the picture. In the rectangular area of the picture, therefore, one feature generally will dominate and appear especially important, significant, or interesting. Such a feature or element in a photograph is called the *center of interest*. (See Figure 6–2.)

A picture without such a center of interest risks being like a sentence without a subject. Nevertheless, just as musical compositions sometimes succeed without a dominant theme, on their tonal and rhythmic values alone, photographs too may succeed without a center of interest, on their tonal or rhythmic values alone. When a photograph succeeds through its use of textures, or through rhythmic repetitions of pictorial elements, usually these become the central or dominant idea. The picture is then "about" these textures or rhythms. (See Figure 6–3.)

As purposes vary with each photographer, so do viewpoints, because we see not only with our eyes but also with our minds. What we see is conditioned

Fig. 6–2 **Center of interest.** A. Single idea with careful selection of a few details. B. A single feature dominates picture, appearing especially important.

A

B

A

B

Fig. 6–3 Central idea without center of interest. A. Repeated features establish rhythm that becomes central idea. B. Textural and rhythmic values alone make picture succeed.

by past experience and feeling. Thus no two photographers will see the same subject in precisely the same way. Their compositions will differ as each tries to communicate his or her own unique idea. Centers of interest may vary; certain details may be included by some, eliminated by others; certain details may be emphasized by some, subordinated by others. The manner in which you as a photographer select and emphasize the pictorial elements in your photograph will affect the impressions of the viewer. Through your composition you will show the viewer the details and the relationships among them that you think are important.

There are some general principles of composition that may help you compose pictures to communicate your ideas effectively. However, many occasions

A

B

may arise when variations on some of the guidelines may lead to more effective communication. Ultimately you must rely on your own senses and instincts, and you must learn to see in your own special way and to express yourself photographically in your own special style. (See Figure 6–4.)

Fig. 6–4 **Composition principles.** A. Composition of richly varied tones and carefully selected details creates mood of timelessness. B. Careful timing captures poignant moment of human drama.

ELEMENTS OF COMPOSITION 205

The development of instinctive judgment becomes of special importance when you realize that often you will have little opportunity to plan each photograph carefully. News photographers, for example, often must take their shots as they find them — in the midst of rapidly moving events and under all sorts of physical conditions. Experience and practice in composing photographs may assist you, even under difficult circumstances, to quickly compose a photograph that will communicate your story effectively. You should expect to take much time and practice to gain competence in effective composition. The guidelines discussed next may help you in the beginning stages.

Do Exercise 6–A on page 219

Control of Detail

> **Objective 6–B** Explain and demonstrate how you can achieve emphasis by controlling detail.
>
> **Key Concepts** selecting details, busy background, sprout, relative sharpness, relative size, contrast, hue, primary hue, secondary hue, complement, saturation or chroma, value or brightness

Control of detail is one of the principal techniques of composition. Through your selection of details to include or eliminate and the manner in which you present these details, you will communicate the idea of the photograph. The following discussion tells how you can control details by selection, sharpness, size, and contrast.

Selection of detail

The first major decision you should make in composing a picture is *selecting the details* that are to be

A

Fig. 6–5 Control of background. A. Busy background. It is difficult to perceive subjects against background of similar tonal values. B. Sprout. Metal bar appears to protrude from child's head. C. Neutral background. By selecting an appropriate angle, subject may be set against neutral background, such as sky.

included and excluded from the photograph. One of the common errors of the beginner is to try to include too much detail. Try to decide what are the essentials and what are the nonessentials. You should try to eliminate nonessential details that may distract the viewer from the central idea of the picture.

A common example of too much detail is the *busy background*, against which the subject is lost. Try to select a neutral background for your subject, eliminating distracting elements and details. (See Figure 6–5.)

B

C

Another example of too much detail is the *sprout* — a background element such as a tree or pole directly behind the subject, which is so-called because in the final print it appears to be "sprouting" from the subject. Again, try to select a neutral background for your subject, eliminating such distracting background elements whenever possible.

A final example of too much detail is the picture with no center of interest or no central idea. In this case the photograph displays many details but fails to communicate the important relationships among them. None are emphasized, none subordinated. All appear equal in competing for the viewer's attention. The viewer cannot tell what is supposed to be important, what unimportant. (See Figure 6–6.)

Control of sharpness

Another method of emphasizing or subordinating details in a photograph is to control their *relative sharpness*. Once selected, details in the picture may be

Fig. 6–6 Vague center of interest. What is the central idea or subject?

presented with clarity and sharpness, or they may be presented as blurred, fuzzy impressions. By using the depth-of-field characteristics of the lens, you can allow background and foreground details to go out of focus while keeping the subject in sharp focus.

You can use this technique, for example, when you cannot present your subject against a neutral background. As an alternative you can present your subject in focus against a background of out-of-focus details. Thus the in-focus subject is emphasized in the photograph whereas the out-of-focus background detail is subordinated. (See Figure 6–7.)

Control of size

Controlling *relative size* is another way of emphasizing and subordinating detail. The eye of the viewer will give greater attention to the larger objects in a photograph and less attention to the smaller objects. A good guideline, then, is to move your camera as close as possible to the subject so that it will appear larger than other details in the picture. The smaller details will emphasize the larger subject. (See Figure 6–8.)

Control of contrast

A fourth way of emphasizing or subordinating detail is to use *contrast*. A bright object stands out against a dark background; a dark object, against a light background. You can emphasize the subject by maximizing the contrast between the subject and its background.

A common fault of beginners is to photograph a subject against a noncontrasting background. The subject in such a photograph may lack emphasis be-

A

B

C

Fig. 6–7 **Control of sharpness.** Sharpness of background detail is controlled in each picture to enhance subject.

A

B

Fig. 6–8 Control of size. Subjects emphasized by being largest details.

Control of color

cause it does not stand out readily from the background. "Light against dark; dark against light" is often a good guideline for the beginner. (See Figure 6–9.)

Control of color

In color photography you also must control the additional element of color. By itself, color does not necessarily add impact or meaning to a photograph. Improperly handled, it may introduce new sources of confusion and distraction. Properly handled, color may aid in the emphasis and subordination of details and may enhance the mood, feeling, and central idea of a photograph.

The three major attributes of color are:

1. *Hue*, which is determined by the wavelengths of the light rays that produce the specific color sensations. *Primary hues* are red, blue, and green. *Secondary hues* are cyan, yellow, and magenta. A primary and secondary hue are said to be *complements* when together they reflect all wavelengths present in white.

Fig. 6–9 Control of contrast. Strong contrast — almost a silhouette — not only isolates subject against background but also creates atmosphere.

2. *Saturation,* or *chroma,* which is the intensity or concentration of hue. When a color of a given hue is mixed with white, its saturation is reduced. The absence of saturation is no hue at all, or white.

3. *Value,* or *brightness,* which is lightness or darkness — the relative presence or absence of light rays. When a color of a given hue and saturation is mixed with black, its value is reduced. The absence of value is no light rays at all, or black.

Although hue, saturation, and value may be separately identified, they are not independent. When one is changed, the other two are often affected as well. Nevertheless, you can exercise limited control over each of these three attributes. The primary control over color detail, as with other detail, is through selection. By placing your camera and subject in carefully chosen positions, you can include or exclude existing color details from the photograph. In addi-

tion, you may have some opportunity to select details such as wearing apparel and backgrounds that have desired color qualities.

As with black-and-white photography, it is often helpful to arrange subjects against a neutral background of simple, contrasting color. Against a background of complementary color, relatively weaker in saturation and value, the subject's color may be emphasized. On the other hand, a profusion of bright and varied background colors may make the photograph too busy for effective emphasis of the subject. Similarly, any single bright-colored object in the background may distract the viewer's attention from the subject.

You are likely to enjoy earlier success by keeping your color compositions, like your black-and-white compositions, simple — by limiting the number of hues present in your photographs, by keeping backgrounds uncluttered, and by subduing the saturation and value of background colors.

See the color plates in Unit 10 for illustrations of these principles of color composition.

Do Exercise 6–B on page 219

Placement

> **Objective 6–C** Explain and demonstrate how details can be emphasized or subordinated through placement.
>
> **Key Concepts** rule of thirds, splitting the frame, movement into frame, camera angle, eye level, low angle, high angle

The placement of details within the frame of the photograph is a principal technique of composition. By placing details in certain areas of the frame, by facing them in certain directions, and by placing them against certain backgrounds, you can affect the idea of the photograph.

The rule of thirds

One useful guideline of placement to emphasize the center of interest is the *rule of thirds*. Mentally divide your picture area into thirds, both vertically and horizontally. Any of the four points at which the imaginary lines intersect within the picture space has been found to be a "natural" for emphasizing the dominant subject (see Figure 6–10). Secondary points of interest located at any of the other points of intersection also will be emphasized. Details elsewhere in the photograph will tend to be subordinated.

The rule of thirds also cautions against certain placements within the picture frame, such as *splitting the frame* equally between the foreground and the sky. Using one-third of the area for the foreground and two-thirds for the sky, or vice versa, you probably will achieve more pleasing results. The rule also cautions against splitting the frame exactly in half with a strong vertical element such as a tree or telephone pole. Finally it cautions against placing your center of interest in the exact, dead center of your picture. Such placement, being equidistant from all

Fig. 6–10 **Rule of thirds.** Any place marked X is a "natural" for the dominant subject. Dead center should be avoided.

Fig. 6–11 Placement by rule of thirds.

other points in the frame, tends to be static and un-interesting. Placement even slightly toward the "thirds" lines may do much to add emphasis. (See Figure 6–11.)

Movement into frame

The direction in which a subject faces or moves creates a space expectation on the part of the viewer, whose eye is drawn in the direction of orientation or movement. Unless space is provided in the frame to satisfy this expectation, the viewer's eye tends to move beyond the frame. To give proper emphasis to a subject, therefore, usually you should provide a space within the frame for your subject to look into, face into, or move into. A leaping horse ought to have its landing place inside the picture or it may appear to be leaping out of the picture. A portrait, too, usually will be more satisfying if space is provided for the subject to look into, or else she or he may appear to be looking out of the picture. In general, if there is action in a picture it should lead into the picture, not out of it. Thus *movement into frame* generally satisfies the space expectations of the viewers. (See Figure 6–12.)

Camera angle

The *camera angle* at which you shoot a picture affects the idea you communicate. When a picture is shot from a normal eye position with the axis of the camera parallel to the ground, it is called an *eye-level* shot. Eye-level shots tend to appear most natural because they reflect how we normally view the world.

A

B

C

D

Fig. 6–12 Movement into frame. A. Subject too close to right-hand edge of frame, appearing to move out of frame. B. Improved placement, shifting subject to left and providing space for moving into frame. C. Portrait too close to edge, appearing to look out of frame. D. Improved placement, allowing subject to look into frame.

From this position we can also look up or down at things. If you use a camera to look up at something, such as a basketball player under the backboard, you will tend to emphasize the height of the subject. This is called a *low-angle* shot because you are shooting from a position lower than the subject. Low-angle shots tend to emphasize the height or impressiveness of objects.

When you use the camera to look down on something, such as a child playing with blocks, it is called a *high-angle* shot because you are shooting from a position higher than the subject. High-angle shots tend to emphasize the smallness or insignificance of objects. (See Figure 6–13.)

Do Exercise 6–C on page 220

Fig. 6–13 **Camera angle.** A. High-angle shot, taken from above subject. B. Low-angle shot, taken from below subject. C. Eye-level shot, taken at level of subject.

Photographic Guidelines

Objective 6–D Describe and demonstrate five photographic guidelines based upon principles of composition.

Key Concepts previsualize, move in close, select or create a neutral background, emphasize lighting contrast, apply rule of thirds, croppers

Try to observe the following guidelines, which are based on principles of composition. These are intended only as aids, not as rules. In many cases you will find them helpful in composing effective photographs, but in other cases you will want to move beyond them to better express your own visual ideas.

1. *Previsualize the image you want to obtain.* Have your central idea in mind as you think about how you want the final print to appear. Are the important details included in your frame? Are distracting details excluded? Are the more significant details emphasized; the less significant, subordinated? Are the important visual relationships revealed? To gain control over the final image, photographers must manipulate many variables, including camera angle, lens type and focal length, distance, aperture, exposure, contrast, and processing. Even as a beginning photographer you can benefit your composition by training yourself to previsualize your final images.

2. *Move your camera in as close as possible to your subject.* Doing so will increase the size of the subject in relation to other objects in the picture, and will tend to force unnecessary details out of the picture.

3. *Whenever possible, select or create a neutral background for your subject.* Try to move your camera into a position so that the subject can be viewed against a neutral background. If the background contains too many unnecessary or confusing elements, try a high-angle shot against the ground or a low-angle shot against the sky. If you cannot select a neutral background, create one by making the background details out of focus. With color photographs, select backgrounds of solid colors, avoiding bright-colored background objects and profusions of colorful objects.

4. *Whenever possible, emphasize the contrast between the subject and the background.* If your subject is brightly lit, try to shoot it against a dark or shadowed area as a background. If your subject is dark, try to shoot it against a light background, such as a white area or the sky. With color, try to select a background of a contrasting hue, weaker in saturation and value.

5. *Apply the rule of thirds as a guideline or starting point for composing your photographs.* The rule of thirds may serve as a good starting point. If your idea is better expressed in other ways, however, do not hesitate to move beyond this or any other arbitrary rules. The final test is the effectiveness of the communication. To the extent possible, try to compose your pictures in the camera's viewfinder. However, you can achieve further composition control in printing through framing and cropping.

Do Exercise 6–D on page 222

HELPFUL HINT

Using croppers
You may find using a set of *croppers* useful in composing your final print. Croppers are nothing more than two L-shaped pieces of paper or cardboard that allow you to try various cropping positions on your proof before final printing. See Figure 6–14.

Fig. 6–14 Croppers.

Suggested references

Busselle, Michael. *Master Photography*. New York: Rand-McNally, 1978, chapter 1.

Craven, George M. *Object and Image: An Introduction to Photography*. Englewood Cliffs, N.J.: Prentice-Hall, 1975, chapter 8.

Davis, Phil. *Photography*. 3rd ed. Dubuque: William C. Brown, 1979.

Jacobs, Lou, Jr. *Photography Today*. Santa Monica, Calif.: Goodyear Publishing, 1976, chapter 10.

Rhode, Robert B., and F.H. McCall. *Introduction to Photography*. 4th ed. New York: Macmillan, 1981, chapter 2.

Time-Life Books. *Life Library of Photography: The Art of Photography*. New York: Time, Inc., 1970, chapters 1 and 2.

Suggested field and laboratory assignments

1. Shoot a roll of film under daylight conditions. For one series of shots select a scene involving at least three interacting objects, such as adult, child, and football; photographer, camera, and subject; angler, worm, and fishhook, and so forth. Shoot several shots of the scene, each time emphasizing a different object in the scene using the controls described in this unit. Note how each shot allows you to communicate a different interpretation of the relationship among the objects in the scene.

2. Keep a log of every shot, recording (a) f/stop and shutter speed, and (b) techniques used to select and emphasize various details in each shot.

3. Be sure there is at least one example for each of the five guidelines.

4. Develop and proof.

5. Make enlargements of the better negatives. Crop them for best composition.

6. Record on the back of the finished prints the details taken from the log.

Do Practice Test 6 on page 223

EXERCISE 6–A

1. Define composition. _____

2. Describe the purposes of composition. _____

3. Name four of the elements of photographic composition.

Return to Objective 6–B, page 206

EXERCISE 6–B

Explain five controls by which details in a photograph can be emphasized or subordinated.

1. _____

2. _____

3. _____

4. _____

5. _____

Return to Objective 6–C, page 212

EXERCISE 6–C

1. Describe the rule of thirds. _____

2. Illustrate the rule of thirds using a sketch of your own.

3. Describe what is meant by "movement into frame." _____

4. Describe each of the following and explain the emphasis obtained by each.

A. Eye-level shot: _____

B. High-angle shot: _____

C. Low-angle shot: _____

Return to Objective 6–D, page 216

ASSIGNMENT 6–D

List and describe five photographic guidelines based on principles of composition.

1. _____

2. _____

3. _____

4. _____

5. _____

Review References and do Suggested Field and Laboratory Assignments on page 217

PRACTICE TEST 6

For each of the following questions, select the one *best* answer and write its corresponding letter in the blank preceding the question. After you have completed the test, check your answers against the correct answers, which follow the test. If you miss any of the test items, review the study materials as suggested.

_____ 1. Composition is a tool that is used to _____ .
 A. achieve the right perspective in your picture
 B. communicate your idea to the viewer
 C. adhere to the rule of thirds
 D. subordinate the center of interest
 E. balance foreground detail with background detail

_____ 2. Every picture has several elements that are arranged to emphasize important details in your composition. Three of these are:
 A. appeal, center of interest, mass
 B. balance, perspective, detail
 C. subordination, angle, tone
 D. line, tone, mass
 E. framing, balance, line

_____ 3. Arranging elements in a photograph so that the important details are prominent is called _____ .
 A. balancing and cropping
 B. framing and detailing
 C. emphasizing and subordinating
 D. highlighting and contrasting
 E. high- and low-angle shooting

_____ 4. You are taking a picture of a white kitten. Which of the following backgrounds would be the best choice?
 A. concrete slab of a patio
 B. red carpet
 C. white gravel path
 D. yellow couch
 E. patterned bedspread

5. You are taking a news photo of a celebrity on a busy street. What can you do to emphasize the subject?
 A. open up and move in close
 B. stop down and move in close
 C. open up and move back
 D. stop down and move back
 E. use a very fast shutter speed

6. You are shooting a portrait in the park. The background is full of trees, playing children, and buildings. To neutralize your background you might try _____ .
 A. a low-angle shot
 B. an eye-level shot
 C. a high-angle shot
 D. a very small aperture
 E. either A or C

7. If you want your subject to appear taller, _____ .
 A. use a wide-angle lens
 B. shoot up from a low angle
 C. use a telephoto lens
 D. shoot down from a high angle
 E. tilt the enlarging easel in printing

8. In most cases your composition is likely to benefit if you avoid all except which one of the following?
 A. splitting the frame
 B. busy backgrounds
 C. subjects moving out of the frame
 D. placing the subject at dead center
 E. using the sky as a background

9. Try to catch action shots so that _____ .
 A. mass is balanced
 B. the action is in the left third
 C. the picture is framed with foreground detail
 D. the action moves into the picture
 E. no details are blurred

_____ 10. Your picture is a seascape. Probably you will want to crop the picture so that _____ .
 A. the horizon line is in the center of the picture
 B. the sea in the foreground occupies about two-thirds of the picture
 C. the sky occupies about two-thirds of the picture
 D. all the details in the negative show in the print
 E. either B or C

_____ 11. Previsualizing refers to _____ .
 A. planning how the final print will look
 B. darkroom manipulations
 C. arranging a setup so it looks right
 D. planning a day's shooting
 E. scripting a picture story

_____ 12. Generally you will add emphasis to your main subject if you _____ .
 A. place the subject as close to the exact center of the frame as possible.
 B. pose the subject against a neutral background
 C. move in as close as possible to the subject
 D. shoot a light subject against a dark background, or vice versa
 E. all except A

_____ 13. The characteristic of light that produces a specific color sensation is _____ .
 A. tone
 B. value
 C. chroma
 D. hue
 E. mass

_____ 14. In a color shot, try to select a background of contrasting _____ .
 A. hue
 B. saturation
 C. value
 D. brightness
 E. all of the above

_____ 15. In a color photo your subject most likely will gain emphasis from _____ .
 A. a plain background
 B. a bright background object of complementary color
 C. a bright array of attractive colors in the background
 D. a background similar to the subject in hue and value
 E. either C or D

ANSWERS TO PRACTICE TEST 6

1. B The main function of composition is to enhance communication between the composer and the viewer. See "Elements of Composition," page 201, if you missed this.

2. D Line, tone, and mass are three of the elements of composition described as characteristics of sight. See "Elements of Composition," page 201. Others mentioned were contrast and color. In black-and-white photography, of course, color is translated into tone and contrast, because colors are rendered as shades of gray.

3. C See "Elements of Composition," page 201, if you missed this one.

4. B The white kitten will appear light against a dark background in the final print if it is photographed against the red carpet. The other alternatives would likely be too light or busy to provide a good contrasting background for the subject. See "Control of Detail," page 206.

5. A The problem in this photo is the profusion of background detail. By opening to a wide aperture and moving in close to the subject, you will force many of these details out of the frame and you will tend to blur out those that remain. See the discussion of sharpness and size in "Control of Detail," page 206.

6. E The sky would be a good background, obtained from a low-angle shot. A plain blanket of grass also might serve well, obtained from a high-angle shot. If the background at eye level is too busy, consider high- or low-angle views. See "Placement," page 212.

7. B If you missed this, review "Placement," page 212.

8. E If you missed this, review "Photographic Guidelines," page 216.

9. D Alternatives A and C are desirable features for many shots. However, in shooting action pictures you often do not have a full opportunity to plan your shots so carefully. You can control for alternative D, however, and assure that your action is moving into frame. As for blurred details, as in alternative E, they often can add to the feeling of action and movement.

10. E Alternatives B or C are good guidelines. See "Placement," page 212. Remember, though, that they are *only* guidelines. You may find some other fraction suits you better. Usually splitting the frame exactly in half creates too static a feeling. Also, careful selection of detail will help you express your idea, whereas too many details may distract from the central idea.

11. A Composing in the camera's viewfinder, imagining how you want the final print to appear, and manipulating all variables necessary to achieve that image are part of the previsualization process. See "Photographic Guidelines," page 216.

12. E Placing your subject at dead center creates a static feeling; other placements within the frame tend to be stronger. Providing a neutral background, increasing subject size, and increasing contrast between subject and background all tend to add emphasis to the subject. See "Photographic Guidelines," page 216.

13. D Hue refers to the wavelength of the light that produces the specific sensation by which we identify a color. See "Control of Detail," page 206.

14. E Your subject will gain emphasis if it contrasts with the background in any of these respects. See "Control of Detail," page 206.

15. A Eliminate or subdue background details, including bright colors in color shots, that would tend to attract the viewer's eye. See "Control of Detail," page 206.

FILTERS

U N I T 7

5. *Neutral density (ND) filters.* Reduce amount of light admitted to camera without altering color rendition.

Conversion filters

Bluish and amberish in cast, *conversion filters* are designed to convert the color temperature of given lighting sources to match those for which given films are balanced. For example, you can use a conversion filter to obtain a normal color rendering using a tungsten film (3200 K) in daylight (5500 K). Because conversion filters reduce the amount of light reaching the film, it is necessary to increase exposure by an appropriate amount. Table 13 describes conversion filters and their associated filter factors that can be used with common film-light source combinations. Note that film manufacturers usually provide a film-speed index to be used with a conversion filter in order to simplify exposure calculations.

A special type of conversion filter is designed to eliminate the blue-green tint that results from photographing under fluorescent lights. Fluorescent lighting poses an unusual problem because, despite its white appearance, it is made up of only a few wavelengths of light, mostly from the blue-green portion of the visible light spectrum. Converting this discontinuous spectrum of light to a color temperature that matches a film's color balance is difficult at best. It is further complicated because fluorescent tubes of various types differ in this respect. Precise conversion, therefore, requires testing under the actual fluorescent lighting conditions encountered. For general photography, filters are manufactured that represent a compromise among the various commonly found fluorescent lighting conditions. Even though the correction is less than perfect, the results are more satisfying than they would be otherwise. The FLB filter is designed to convert fluorescent light to the approximate color temperature of tungsten-balanced film; the FLD filter is designed to convert fluorescent light to the approximate color temperature of daylight-balanced film.

Clearly, lighting situations that exist in the real world are infinitely greater in number than the three for which film is balanced. No end of filters could be produced to convert every possible lighting situation to match the color balances of available films. One attempt to simplify this problem was the development of the *Mired system* (pronounced my–red), which stands for *mi*cro-*re*ciprocal *de*grees. A Mired, simply described, is a standard conversion of Kelvin temperature. By using combinations of filters based on Mired units, you can obtain any amount of color temperature shift you want.

Typically a Mired filter system consists of two sets of filters, one composed of several bluish filters, the other composed of several reddish ones. To use the system, you must determine the Mired value of the light source and the Mired value the film is balanced for. The difference between these values determines

Table 13 Conversion Filters

Film Balanced for	Available Light Source			
	3200 K	*3400 K*	*5500 K*	*Fluorescent*
3200 K tungsten	none	no. 81A (1.25)	no. 85B (1.5)	FLB (2)
3400 K photolamp	no. 82A (1.25)	none	no. 85 (1.5)	FLB + 82A (2.5)
5500 K daylight	no. 80A (4)	no. 80B (3)	none	FLD (2)

Note: Filters are identified by Kodak Wratten filter numbers. Filter factors for each situation appear in parentheses. In place of filter factor, film manufacturers provide a new film-speed index for use when their film is used with a conversion filter.

the amount and direction of color temperature shift needed to match the film's color balance. Then you select a combination of filters that, used together, closely approximates this value. Thus with six or eight filters you can effect a wide range of color shifts suitable to numerous film-light source combinations. Color Plates 6, 7, and 9 in Unit 10 illustrate the use of conversion filters.

Color-compensating (CC) filters

Another approach to color control is the use of *color-compensating (CC) filters,* which are used most commonly in color printing to obtain control over color during the printing stages. But they also can be used during the shooting stage for color conversion as well as for achieving special color effects.

CC filters are manufactured in six colors—red, green, blue, cyan, magenta, and yellow—representing the primary and secondary colors in the visible light spectrum. Each color is manufactured in six or seven densities ranging from very light tints to very strong saturations. Each filter is numbered to identify both its color and its density (measured in relation to its complement). For example, a CC20M filter is a color-compensating magenta filter of 0.20 density to green light. The color-compensating filters provide the color photographer with extremely precise control over color production.

CC filters, when used for color conversion, provide greater precision for this purpose than is provided by the more common conversion filters. They can be used, for example, to obtain a relatively normal color balance under fluorescent lighting or similar conditions where available light represents a discontinuous spectrum. But their other uses are many. Color can be added to a sunset, for example, by photographing it through a yellow or red filter. Moonlight can be simulated in sunlight by using a blue filter and underexposing two or three stops. Multiple exposures

can be made on the same frame, changing filters between exposures, to obtain striking and unusual effects. Or filters can be used in combination with special purpose films to produce images never seen in nature. Color Plate 8 in Unit 10 illustrates some of these applications.

Skylight and ultraviolet filters

Daylight on overcast days, in open shade, at high altitudes and great distances, or in the snow, has a higher proportion of ultraviolet and blue light than that for which daylight film is balanced. Unfiltered under these conditions, daylight film will produce slides with an overall bluish cast.

The *skylight* or *ultraviolet filter,* by filtering out ultraviolet light, tends to eliminate this excess bluishness and restores the reddish warmth that otherwise would be lost. Slightly pink or yellow in appearance, these filters require no exposure increase and often are left on the camera all the time, both for their warming effect on the color balance and for the protection they provide to the camera lens.

Polarizing filters

The *polarizing filter* also performs the same functions in color photography as it does in black-and-white photography—controlling reflections and glare, reducing haze, and darkening blue skies—without altering color balance, color renderings, or brightness ratios within the scene. In addition, when it is used with color film, the polarizing filter also tends to increase color saturation of objects within the scene. Hence it is often used to obtain a deeper, richer blue sky. By filtering out polarized light reflecting from objects in the scene, however, the polarizing filter also tends to render all the colors in the scene with greater color saturation.

Neutral density filters

The *neutral density filters* perform the same function in color photography as they do in black-and-white photography—reducing the amount of light passing through the lens without altering the relative brightness or color balance within the scene. Suppose, under given circumstances, that your exposure should be f/5.6 at 1/250 sec. But suppose also that you wish to shoot at f/2 without increasing your shutter speed. A neutral density filter would make this possible. In this case using an ND–9 filter would reduce exposure three stops, requiring a three-stop increase in the camera setting. The ND filter accomplishes its function of reducing light intensity without altering color balance, color renderings, or brightness ratios within the scene.

The use of filters in color photography, as in black-and-white photography, is limited only by imagination and willingness to experiment.

Do Exercise 7–E on page 251

Suggested references

Craven, George M. *Object and Image: An Introduction to Photography.* Englewood Cliffs, N.J.: Prentice-Hall, 1975, pages 220–223.

Davis, Phil. *Photography.* 3rd ed. Dubuque: William C. Brown, 1979, pages 149–154.

Eastman Kodak Co. *Filters and Lens Attachments for Black-and-white and Color Pictures.* Rochester, N.Y.: Kodak (Photo Information Book AB–1), 1970.

Jacobs, Lou, Jr. *Photography Today.* Santa Monica, Calif.: Goodyear Publishing, 1976, pages 63–71.

Rhode, Robert B. and F.H. McCall. *Introduction to Photography,* 4th ed. New York: Macmillan, 1981, Chapter 11 and pages 248–249.

Swedlund, Charles. *Photography,* 2nd ed. New York: Holt, Rinehart and Winston, 1981, pages 110–117, 364.

Time-Life Books. *Life Library of Photography: Light and Film,* pages 24–25; *Photographing Nature,* pages 204–207; *Color,* pages 20–23; *Special Problems,* pages 47–53; *Photography as a Tool,* pages 152–156. New York: Time, Inc., 1970.

Suggested field and laboratory assignments

Shoot at least one roll of panchromatic film using at least three different filters. Keep a shooting log showing the filter used, the reason for the use of that filter, and the exposure data for each shot. Try to solve the following problems using filters.

1. White clouds against a blue sky. Use a filter to increase sky-cloud contrast.
2. Orange or red object against green foliage. Use a filter to increase subject-ground contrast.
3. Aerial haze. Use a filter to reduce aerial haze.
4. Wooden building or furniture. Use a filter to exaggerate natural wood grain.
5. Reflections or glare. Experiment with glare elimination from water, glass, or other nonmetallic surfaces.

Do Practice Test 7 on page 253

EXERCISE 7–A

1. Without referring to the preceding material, fill out the following table.

Type of Filter	Colors Lightened on Print	Colors Darkened on Print
yellow		
red		
green		
light pink		

2. Explain why the eye and the film may not see the relative brightness of colors in the same way.

3. What colors, perceived as dark by the eye, might appear relatively bright in a print

 photographed without a filter on panchromatic film? _____

4. What colors, perceived as light by the eye, might appear relatively dark in a print pho-

 tographed without a filter on panchromatic film? _____

5. Explain what would result if you used a red filter with orthochromatic film to photograph

 a red flower and green leaves against a blue sky. Refer to "Characteristics of Black-and-

 white Film" on page 45 to refresh your memory about orthochromatic film. _____

Return to Objective 7–B, page 232

EXERCISE 7–B

1. Photographic filters are constructed in two basic forms. Name and describe each form.

 A. _____

 B. _____

2. Discuss the relative durability and cost of each of these two forms. _____

3. Photographic filters mount to the camera in two ways. Identify and describe each of these ways. In each case list all the items of equipment needed.

 A. _____

 B. _____

Return to Objective 7–C, page 232

EXERCISE 7–C

1. Define "filter factor" and explain why its use is necessary when you use a filter.

4. You have bright yellow and blue flowers against a background of green foliage. You

 want the yellow flowers to appear light and the blue flowers to appear dark against a

 medium gray background. What filter might you use? Explain. _____

5. You are taking a picture of a face in a window and the face is severely masked by

 reflections off the window surface. What, if anything, might you do? _____

Return to Objective 7–E, page 242

EXERCISE 7–E

1. List the five main types of filters used in color photography and the primary uses of
 each.

 A. _____

 B. _____

 C. _____

 D. _____

E. _____

2. Explain how a conversion filter operates in a situation where the available light source does not match the film's rated color balance. _____

3. You are using color transparency film balanced for daylight with photolamps indoors. Your meter reading indicates basic exposure data of f/5.6 at 1/250 sec. Referring to Table 13, what conversion filter would you use to obtain normal color balance?_____. What exposure?_____. Explain:_____

4. Name the six colors in which CC filters are manufactured:_____

5. In the filter designation CC30Y, what does the 30 stand for? _____

Review References and do Suggested Field and Laboratory Assignments on page 245

PRACTICE TEST 7

For each of the following questions, select the one best answer and write its corresponding letter in the blank preceding the question. After you have completed the test, check your answers against the correct answers, which follow the test. If you miss any of the test items, review the study materials as suggested.

_____ 1. Using a _____ filter to photograph a landscape scene with masses of foliage will lighten the foliage to show greater detail.
A. blue
B. very dark blue
C. green
D. red
E. orange

_____ 2. A filter _____ light of the same color, which makes that color more dense on the negative and consequently _____ on the final print.
A. absorbs, lighter
B. transmits, lighter
C. absorbs, darker
D. transmits, darker
E. none of the above

_____ 3. You are photographing a red barn with a background of dense green foliage. You know that on black-and-white film, the colors will record nearly the same tone of gray. What filter will you select to help this picture?
A. neutral density filter
B. red filter
C. polarizing screen
D. green filter
E. B or D

_____ 4. Glass disk filters are attached to most cameras by use of a(n) _____.
A. threaded metal rim
B. adapter ring
C. retaining ring
D. A and C
E. B and C

5. Gelatin filter squares _____.
 A. are inexpensive
 B. are soft and easily damaged
 C. are inserted in a filter holder attached to the camera
 D. all of the above
 E. only A and C

6. A more durable version of the gelatin filter is the _____.
 A. plastic square filter
 B. correction filter
 C. red filter
 D. neutral density filter
 E. polarizing screen

7. If an exaggerated sky-cloud contrast is desired, a _____ filter would probably be selected.
 A. red
 B. yellow
 C. green
 D. light blue
 E. dark blue

8. The purpose of a contrast filter is to change the response of the film so that _____.
 A. all colors are recorded at a relative brightness close to the values perceived by the eye
 B. the contrast ratio between certain colors is changed
 C. blue skies are darkened
 D. haze is penetrated
 E. the amount of light passing through the camera lens is reduced without changing the rendition of colors

9. Rank the following in their ability to reduce haze, assigning the first rank to the condition that gives greatest haze reduction: (1) no filter; (2) red filter; (3) deep yellow filter; (4) yellow filter.
 A. 1, 2, 3, 4
 B. 1, 4, 3, 2
 C. 2, 3, 4, 1
 D. 4, 3, 2, 1
 E. 3, 4, 2, 1

_____ 10. How many stops should the exposure be increased to compensate for a filter factor of 4?
A. 1
B. 2
C. 2½
D. 3
E. 4

_____ 11. In a given situation you find a correct exposure is 1/125 sec. at f/5.6. Now, attaching a yellow filter with a filter factor of 2, you would set your camera to 1/125 sec. at _____.
A. f/4
B. f/2.8
C. f/11
D. f/8
E. none of these

_____ 12. A deep red filter has a filter factor of 16. Given basic data of 1/125 sec. at f/16, which one of the following is a proper setting using the filter?
A. 1/250 sec. at f/22
B. 1/60 sec. at f/11
C. 1/60 sec. at f/8
D. 1/60 sec. at f/5.6
E. 1/30 sec. at f/5.6

_____ 13. Using daylight-balanced color transparency film without a filter indoors under tungsten light, you would expect your transparencies to look _____.
A. too green
B. too blue
C. too yellow
D. too magenta
E. too red

_____ 14. Using daylight film outdoors on a heavily overcast day without a filter, you would expect your transparencies to look _____.
A. too blue
B. too green
C. too yellow
D. too red
E. normal

_____ 15. The major purpose of CC filters is _____.
 A. to filter out ultraviolet light
 B. to gain precise control over color production
 C. to add contrast
 D. to increase color saturation without altering color balance
 E. to reduce the amount of light without altering color balance

ANSWERS TO PRACTICE TEST 7

1. C The question asks you to lighten foliage. A contrast filter lightens its own color. Because foliage is green, the green filter will transmit green light and make all green objects appear lighter in the final print. A green filter absorbs red and blue light, which will make red and blue objects appear darker on the final print.

2. B See "Principles of Filters," page 229, if you missed this question.

3. E The red filter will make the barn lighter and the foliage darker. The green filter will make the foliage lighter and the barn darker. Either of these filters will increase contrast between barn and foliage. See "Principles of Filters," page 229.

4. E See "Forms of Filter Construction," page 232.

5. D See "Forms of Filter Construction," page 232.

6. A See "Forms of Filter Construction," page 232.

7. A The red filters provide the most exaggerated sky-cloud contrast. Yellow and green filters provide some contrast. The blue filters will make the sky appear lighter, thus providing even less tone separation between sky and clouds than would result from using no filter at all. See "Filters for Black-and-white Photography," page 234.

8. B Alternative A describes the purpose of the correction filter. Alternatives C and D describe two applications of the purpose stated in alternative B. And alternative E describes the purpose of a neutral density filter. See "Filters for Black-and-white Photography," page 234.

9. C See "Filters for Black-and-white Photography," page 234.

10. B In Unit 3 you learned that light doubles at every stop. You double the exposure by opening up one stop. You quadruple the exposure by opening up two stops. Three stops admits eight times as much light; four stops admits sixteen times as much, and so forth.

11. A You double the exposure by opening up one stop. Review Unit 3 if you missed this.

12. D See the explanation in no. 10 if you missed this question. To let in sixteen times as much light, you may open up four f/stops, _or_ you may admit some of that light with your shutter. You could also adjust to a slower shutter speed by four stops. Thus you need a four-stop increase in exposure, by adjusting your shutter, or aperture, or a combination of both. Alternative A allows two stops _less_ light. You need _more_ light with filters. Alternative B gives one stop with the shutter and one

with the aperture—not enough. Alternative C gives one stop with the shutter, two with the aperture—still not enough. The correct alternative, D, gives one stop with the shutter and three with the aperture. Alternative E gives two stops with the shutter, three with the aperture—too much light.

13. E Tungsten illumination has a much lower (reddish) color temperature than daylight, so film balanced to look normal in daylight will look too red if used under tungsten. See "Filters for Color Photography," page 242.

14. A Heavy overcast contains a higher-than-normal proportion of ultraviolet light, which will produce a blue shift in the color rendering. See "Filters for Color Photography," page 242.

15. B See "Filters for Color Photography," page 242.

BASIC LIGHTING
U N I T 8

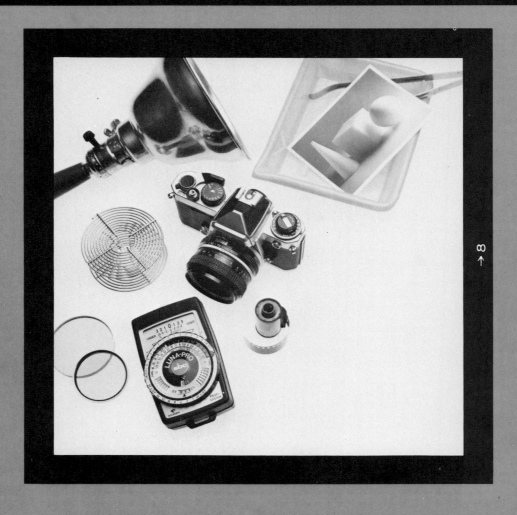

8

Principles of Artificial Lighting

Purposes

Even if it were possible to use natural outdoor illumination for every picture you wanted to take, it would not always be desirable. Outdoor lighting must be used largely as it occurs in nature. We cannot move the sun around in the sky to favor us with a perfect lighting angle. We can supplement daylight with reflectors, flashlamps, and the like, and we can move our subjects about on occasion, but we really cannot alter the quality or the source of the daylight very much.

One reason for moving indoors is to gain control over lighting and backgrounds that you may not be able to achieve outdoors. Another, of course, is to photograph your subjects in their natural indoor habitats—the company executive in his or her office, a mother and child in the nursery, a man in his workshop, for example. When you move indoors you must build an artificial lighting setup around your subject. Except for certain photographs that you may take using only light from a window or skylight, you will find it necessary to use artificial lighting to obtain a satisfactory image of your subject.

Your one overriding purpose in the artificial lighting of a subject should be to allow its essential traits to reveal themselves. That is, you want the subject to be recognized for what it is—a person, a ball, a table, a bottle of wine, whatever. But in most cases you will want to go a bit farther. Your second purpose should be to emphasize certain traits and to subordinate others to communicate an idea that you have about the subject. That is, you may wish to *idealize the subject* by exaggerating certain characteristics and suppressing others.

Leonardo Da Vinci once said of portrait painting, "You do not paint features; you paint what is in the mind." The same may be said of photographing portraits or objects. A proper lighting setup is a powerful tool for expressing what is in your mind as you photograph your subject—not just "Here is a man," but, for example, "Here is a strong, rugged, weathered, farmer."

Some basic functions of your lighting setup are these:

Modeling: The placement of lights to reveal the three-dimensional quality of the subject.

Texturing: The placement of lights to reveal the surface textures of the subject—the hard, crystal surface of a goblet, the soft skin texture of a young girl, the rough, weathered texture of an ancient tree.

Natural highlights and shadows: The placement of lights to reveal the natural planes and surfaces that are normally highlighted, and those that are normally in shadow—to produce the natural gradation of tones that might appear under natural lighting conditions.

Qualities of natural light

On an overcast day you can observe that objects and persons can be seen clearly, but that there are no hard and distinct highlights or shadows. Yet there is plenty

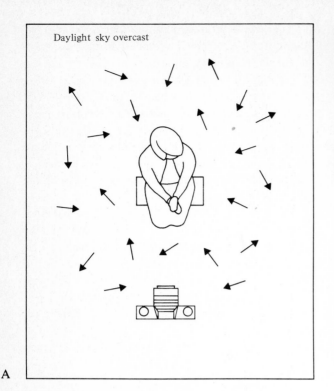

A

B

Fig. 8–1 Lighting. A. Diffuse light rays strike object from all directions, eliminating deep shadows. B. Effect of diffused light. C. Specular light rays strike object from single direction, producing deep shadows. D. Effect of specular lighting.

of strong light. Light such as this, emanating from a broad light source—in this case the entire sky—is called *diffused light*. Light rays of approximately equal strength strike the object from many directions, eliminating deep shadows, as shown in Fig. 8–1A and B. But let the clouds clear to reveal the sun—a single, concentrated light source—and immediately strong highlights and shadows appear. This type of light, produced by intense light rays emanating from a relatively small light source or reflecting from a mirror-like surface, is called *specular light*. Fig. 8–1C and D shows how specular light striking an object from one direction produces clear highlights and shadows.

Under natural lighting conditions, such as sunlight, both specular and diffused light are present. It is the presence of diffused light all around the subject that allows us to photograph details in the shadows. Were the diffused light not present, the details in the shadows would not be illuminated. The diffused light present in daylight is produced by sunlight reflecting off particles of dust and droplets of water vapor in the atmosphere as it makes its way to the earth's surface. This diffusion of part of the sunlight lights up the entire sky, making it blue, and providing a broad source of diffused skylight in addition to the direct, specular rays of sunlight that also reach the

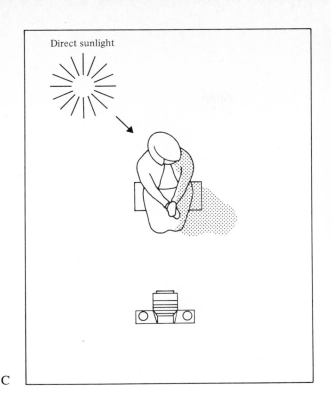

C

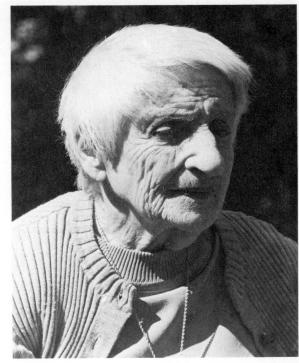

D

earth. Additional diffusion occurs as the sunlight strikes the earth and other hard surfaces—the rays are reflected in all directions, producing additional sources of diffused light. Thus, under natural daylight conditions both specular and diffused light are often present. When the sky is overcast, blocking out the direct light of the sun, only diffused light is present, producing a soft, even, relatively shadowless field of illumination.

Several methods are used to reproduce these forms of light artificially. Special lighting instruments are used to produce the highly directional, specular forms of light. These instruments are usually spotlights with

lenses and/or highly polished reflectors to focus the rays of light into a narrow beam. Highly polished reflectors, or mirrors, can be used to reflect such light without loss of its high specularity. To produce a broad source of relatively diffuse light, floodlights, or banks of fluorescent tubes, can be used. Translucent *diffusing screens* can be placed over the direct light source to scatter the direct rays emanating from the source. *Matte white reflectors* made of cloth, paper, or plastic also can be used to diffuse direct light rays as they are reflected from these surfaces. By combining direct, specular forms of light to create highlights and shadows with diffuse forms of light to

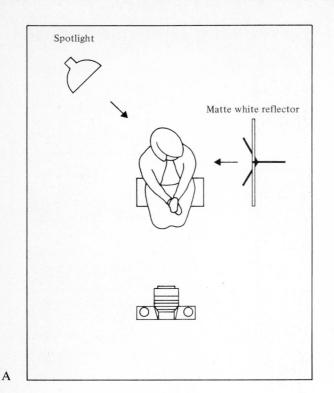

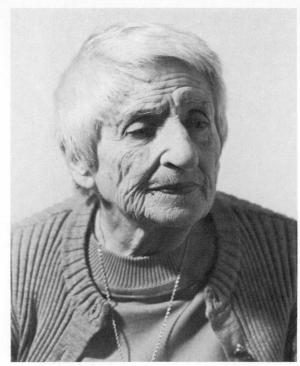

A B

Fig. 8–2 Use of reflector to fill shadows. A. Spotlight source creates highlights and shadows. Matte white reflector produces diffused light to fill shadows. B. Effect.

illuminate detail in the shadows, an ideal field of light can be created to reveal the form of the subject. See Figure 8–2.

Single dominant source

Probably the most important principle that governs the lighting of portraits as well as objects is that there should be a *single dominant light source*. To support the illusion that the subject is illuminated by a single source, all lights should be subordinated to a *main,* or *key light*. Thus the subject will appear to possess a single set of dominant highlights and shadows pro-

duced by this source. When more than one light source produces prominent highlights and shadows, the result is confusing. Shadows may cross one another and produce displeasing patterns across the subject. The subject's true form may be masked and confused by such patterns. Try to produce a single dominant set of highlights and shadows that will best reveal the shape, contour, and texture of your subject.

Except when we are seeking to create a special effect of some kind, our subject will tend to appear most natural when the main light is directed from a position above eye level. We are most accustomed to view objects illuminated by natural light that comes from overhead. Except in rare cases, such as light

2. *Place the fill lights.* Use your fill lights to flood the set with an even, shadowless field of illumination. Use your viewing screen to be sure that no shadows are visible. Take a close-up reflected-light meter reading from the position giving the maximum reading.

3. *Add the key light.* Add the key light to create the dominant set of highlights and shadows. Place it far enough away so it produces an even light, without hot spots. Place the key light so that the highlights and shadows are modeling the subject in the way that you desire. Adjust its height and position until you obtain the highlight pattern you want. Take close-up reflected-light meter readings from the position giving the maximum reading

with both key and fill lights on. Adjust the lighting positions to obtain a 3–to–1 or 4–to–1 brightness ratio between key-plus-fill and fill alone. (This is a 1½ to 2 stop difference.)

4. *Separate the subject from its background.* Do not place the subject too close to its background. Add the background light. Add the accent lights, such as hair light and/or kickers. Take care that light from these sources does not fall on the main areas of the subject—that is, be careful not to add any secondary highlights or shadows on the subject's face.

5. *Make final adjustments.* View the subject in the viewing screen with all lights turned on. Are there unwanted highlights? Shade them off with baffles

Fig. 8–9 Typical four-light setup. A. Top view. B. Frontal view.

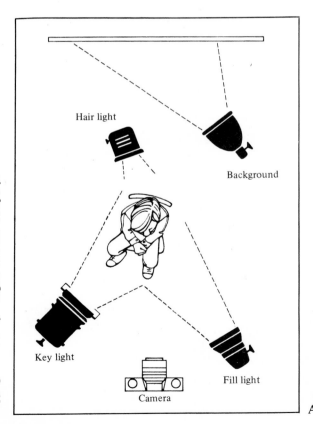

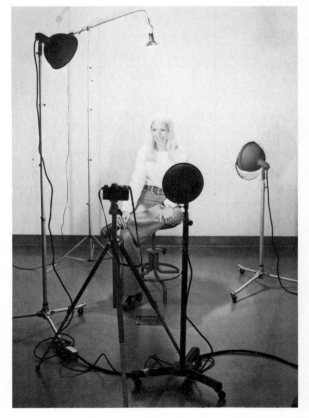

A

B

or flags. Are there deep shadow areas that need additional fill? Add reflectors or additional floodlights. Is the subject not fully separated from the background? Add accents. Are the catchlights not properly located? Adjust the key and fill. Pose your subject. Shoot.

Summary

The above describes a basic four-light setup that can be used effectively for both portraits and objects: key, fill, background, and accents. Practice in the placement and adjustment of these components will lead to proficiency in setting up artificial indoor lighting. Figure 8–9 shows a plan of this type.

Do Exercise 8–C on page 285

Basic Portrait Lighting

Objective 8–D Describe and demonstrate some basic lighting techniques for portrait photography.

Key Concepts broad lighting, short or narrow lighting, butterfly (glamour) lighting

Lighting for the portrait follows the same basic principles of lighting discussed previously. To achieve an ideal representation of the subject, the portrait photographer uses several tools—pose, camera angle, lighting, and retouching. One of the more useful and flexible tools is lighting. With proper lighting the photographer can emphasize the attractive features of the subject and subordinate the less attractive features. Features can be obscured in shadow, round faces can be narrowed, narrow faces can be rounded, long noses shortened, broad noses narrowed, and the like. Applying the principle of the single dominant light source, the placement of the key light in relation to the subject is of special importance. There are three main types of lighting commonly identified for portraits, which are based on placement of the key light. A wide variety of effects can be obtained from them.

Broad lighting

Assuming that the subject is facing slightly off camera—that is, slightly to one side or the other of the subject-camera axis—the key light fully illuminates the side of the face turned toward the camera. It also illuminates the cheek on the shadowed side of the face. This type of lighting, termed *broad lighting,* tends to wash out skin textures but helps round out thin or narrow faces. To obtain a broad-lighting setup, fully light the side of the face facing the camera with the key light. About three-fourths of the face will be in key light while one-fourth is in fill. Figure 8–10 depicts the basic key and fill positions for broad lighting.

Short or narrow lighting

Again assuming that the subject is facing slightly off camera, the key light fully illuminates the side of the face turned away from the camera and produces a triangular highlight on the cheek on the shadowed side of the face. This type of lighting, termed *narrow lighting,* may be used effectively with average oval or round faces. It tends to narrow the face and emphasizes facial contours and textures more than broad lighting. With this setup about one-fourth of the face is in highlight while three-fourths is in fill. Figure 8–11 depicts the basic key and fill positions for short lighting.

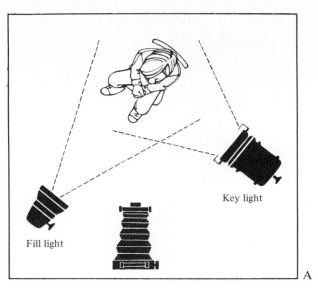

Fig. 8–10 **Broad lighting.** A. Normal key-light and fill-light placements. B. Effect.

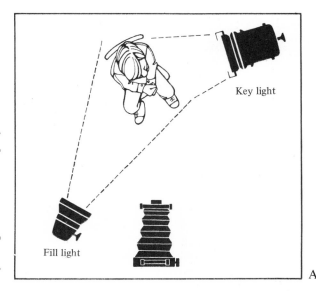
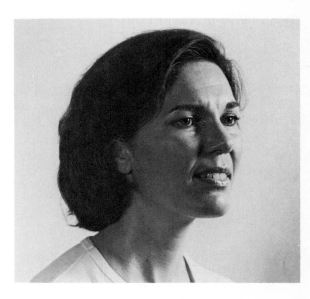

Fig. 8–11 **Short lighting.** A. Normal key-light and fill-light placements. B. Effect.

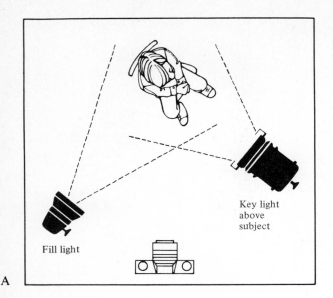

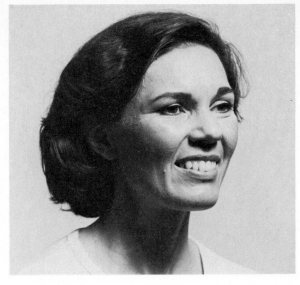

A B

In the diagram: Fill light, Key light above subject

Fig. 8–12 Butterfly (glamour) lighting. A. Normal key-light and fill-light placements. B. Effect.

Butterfly or glamour lighting

In *butterfly* or *glamour lighting*, the key light is placed directly in front of the subject and slightly above the head so that the nose shadow appears directly under the nose and in line with it. It may be used successfully with the normal oval face. It is not usually recommended for photographing people with short hair because it tends to highlight the ears, making them undesirably prominent.

Physical features

By appropriate arrangements of lighting and poses, certain physical features can be emphasized and subordinated in your portraits. Table 15 provides some suggestions for dealing with various physical features you may observe about your subject.

Do Exercise 8–D on page 286

Lighting Small Objects

Objective 8–E Describe and demonstrate some common problems and techniques for lighting small objects in product photography.

Key Concepts shape, surface texture, key backlighting, edge accents, texture accents, transillumination, tenting, spraying, dulling

As with other forms of lighting, small-object lighting challenges you to create a natural, attractive arrangement of highlight and shadow that will reveal the characteristic shape, contours, and textures of the object in a simulated outdoor lighting environment. The same natural outdoor lighting standard we discussed in "Principles of Artificial Lighting" will apply to

Table 15 Lighting Physical Features

Features	Lighting
nose	Avoid profiles if nose uneven. For short noses, shoot from slightly high angle. Raise key light to lengthen nose shadow. For long noses, vice versa.
eyes	Lower key light to reduce shadows in deep-set eye sockets. For large eyes, lower gaze, for small eyes, lift gaze.
face	For round faces, use short lighting. Increase brightness ratio. Keep sides of face in shadow. For narrow faces, use broad lighting. Lower key light. Reduce lighting ratio. For bony faces, have subject face camera; use soft, diffuse lighting; avoid shadows and highlights.
prominent features	Keep lights off prominent ears, large foreheads, large noses, etc.
wrinkles	Use flat lighting angles and diffuse light to reduce wrinkles; use oblique lighting angles and specular light to emphasize them.
glasses	Use higher key light angle and adjust fill to minimize frame shadows. Rim shadows and hot spots from lenses will need retouching. Consider glassless rims. Tip glasses slightly forward to eliminate reflection.
secondary catchlights	Arrange lights so that one and only one catchlight appears in each eye at one o'clock or eleven o'clock position. Remove secondary catchlights by etching negative or spotting print.
body	View stout persons from the side; thin persons more from the front. Have plump persons lean forward to conceal unattractive paunchiness. Narrow lighting to slim plump persons; broad lighting to fill out skinny ones.

lighting small objects for product photography. Recall these principles:

There should be one dominant source light, and one dominant set of highlights and shadows.

The key light should strike the object from an angle of incidence of approximately 40°–60°, the lighting angle that usually illuminates the objects we view outdoors.

The shadow detail should be illuminated by diffused fill light that is subordinate to the key light.

The brightness ratio should approximate 3–to–1 or 4–to–1.

The object should be separated visually from its background.

The major lighting components are the key, fill, background, and accents.

There are some differences, however. In object photography the two characteristics of the object that will determine the lighting setup most are its *shape* and its *surface texture*. The lighting setups for objects with curved surfaces will differ from those that have primarily flat surfaces. Transparent objects, shiny metallic objects, and dull, matte-surfaced objects each will require somewhat different lighting treatments to reveal surface texture in the most natural ways.

The key light

In object photography it is generally useful to establish the key light first. Unlike portrait photography,

most often the key light is placed above and behind the subject. This *key backlighting* position illuminates the top of the object with a brilliant highlight and projects the main shadow of the object toward the viewer. This main shadow helps establish the shape of the object.

Whereas it is usually more flattering to the portrait subject if the key light is a diffused light, a hard, specular light is used most often for small objects. This may be varied, of course, depending on the surface texture of the object. Matte- or coarse-surfaced objects generally will fare better with a hard, specular key-light quality, whereas shiny-surfaced objects will fare better with a diffused key light.

The accent lights

There are two types of accents that should be established next: *edge accents* and *texture accents*.

The edge accents help to separate the various subject planes so that the viewer can perceive the subject's shape better. They also separate the subject from its background by providing rim-lighting around the outside edges of the object. Edge accents are established primarily by means of additional backlights that tend to produce brilliant edge highlights.

Texture accents are intended to reveal the surface irregularities of the object. Lighting for this purpose generally originates at the extreme sides, from above or from below the object in such a way that the light beam "skids" across the surface of the object and across the grain of the texture to be emphasized. Hard, specular light is most useful for this purpose because it will tend to create the fine pattern of highlights and shadows that the viewer will perceive as texture. Lighting for texture also requires that the fill lighting be a bit weaker than normal so that the texture shadows are not washed out.

When establishing the accent highlights, take care to create no new major shadow patterns. The key light has established a single dominant shadow of the object. Thus additional accent lights should be placed

at relatively low angles, shooting upwards, to avoid producing new and competing shadows of the object.

The fill light

As with the accent lights, it is important that the fill light cast no identifiable shadows of its own. Fill light can be provided by a diffuse flood lamp or by a reflector, placed close to the camera-subject axis. The lighting ratio between key and fill areas should approximate 3–to–1 or 4–to–1. (See "Principles of Artificial Lighting.")

The background light

The background light is directed toward the background rather than to the object itself. One purpose of the background light is to provide a light background against which a dark object can be emphasized. Another purpose is to lighten a background that otherwise might appear too dark in the final print. Take care in setting up the background light so that no ambient light from this source is cast onto the object—it might wash out the dominant shadows or create a new set of conflicting highlights.

Lighting glass objects and shiny objects

Certain types of objects pose special problems in object photography. Transparent objects, such as glassware, and highly polished, metallic objects require certain special treatments that are worthy of some consideration here.

Glass objects
Avoid frontal illumination of glass objects. The reflective surface of the glass produces a profusion of distracting reflections from your light sources. One common method of photographing a glass object is

A

B

C

D

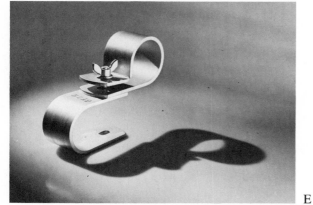

E

Fig. 8–13 Lighting objects. A. Key backlighting. Light placed high and behind object to one side. B. Edge-light accent. Light placed low and to other side. C. Fill lighting. Light placed close to camera, lens high. D. Background lighting. Light directed to background only and masked from object itself. E. Effect of combined key, fill, accent, and background lights on object.

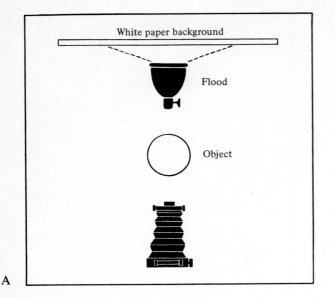

A

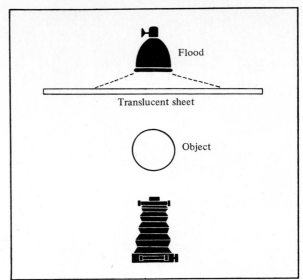

B

Fig. 8–14 Background lighting for glass objects. A. Frontally illuminated background. B. Transillumination. C. Glasses with liquid photographed against transilluminated background; no other light source used.

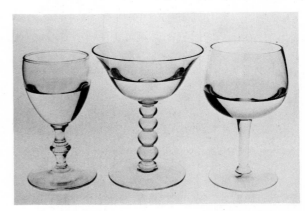

C

to place it against an illuminated background, such as a white paper background illuminated frontally by a floodlight. Another method is *transillumination,* using a background of translucent material illuminated from behind by a floodlight.

To add accents to the glass object, the careful addition of limited frontal lights may be helpful. Remember that the surface of the glass is highly polished and that it produces highly specular reflections of any light sources visible from the object's position. By placing one or two light sources in front of the object

and by shaping the light source by means of baffles, you can produce very precise highlights.

Shiny objects

The problem in photographing shiny objects, such as metalware or shiny plastic, is that they are highly reflective and will reflect images of their surroundings. Because most shiny objects have curved surfaces, the patterns of light reflected from them often are confusing and tend to mask the true surface textures of the objects themselves. The trick in photo-

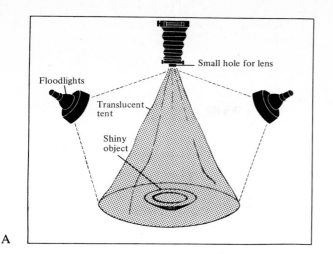

A

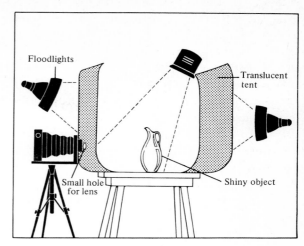

B

Fig. 8–15 Tenting arrangements. A. Photographing object from above. B. Photographing object from side.

Fig. 8–16 Effect of tenting. Silverware photographed in tent to eliminate confusing reflections from surroundings.

graphing shiny objects is to eliminate from the surroundings all objects that might be reflected by the object. If the shiny surface of the object can reflect only plain white light, then the contours and texture of the object will be revealed without confusion. Thus the object should be surrounded with only white surfaces.

To accomplish this, a technique known as *tenting* is commonly used. White paper or other translucent material can be used to erect a tent, which then is transilluminated as evenly as possible with diffused light. Then the object is photographed through a hole in the tent.

Occasionally a shiny object may appear in an arrangement that also includes other objects that may require stronger, more directional lighting treatments. When the lighting setup has been established, you may find that the shiny object is picking up and reflecting many undesirable, specular highlights from the light sources and reflections of other objects in the scene. *Spraying* the objectionable object with a matting spray will diffuse the reflections from its surface. Spraying is often the best solution when both

matte and shiny objects are in a scene. Care should be taken, however, that the spray is not used indiscriminately on all types of objects—it may damage certain plastics.

Other materials can be used to dull or matte shiny surfaces. *Dulling* can be accomplished also by brushing a white cosmetic eyeliner onto the offending surface with a broad, soft brush. This technique is especially useful for dulling small specular highlights from shiny surfaces where a matting spray is too difficult to control.

Do Exercise 8–E on page 287

Suggested references

Craven, George M. *Object and Image: An Introduction to Photography*. Englewood Cliffs, N.J.: Prentice-Hall, 1975, pages 224–230.

Davis, Phil. *Photography*. 3rd ed. Dubuque: William C. Brown, 1979, pages 161–173.

Eastman Kodak Co. *Professional Portrait Techniques*. Rochester, N.Y.: Kodak (Kodak Publication No. 0–4), 1980.

Eastman Kodak Co. *Professional Photographic Illustration Techniques*. Rochester, N.Y.: Kodak (Professional Data Book 0–16), 1978.

Jacobs, Lou, Jr. *Photography Today*. Santa Monica, Calif.: Goodyear Publishing, 1976, chapter 13 and pages 143–146.

Petzold, Paul. *Focal Book of Practical Photography*. London: Pitman House, 1980, pages 108–109.

Rhode, Robert B., and F.H. McCall. *Introduction to Photography*. 4th ed. New York: Macmillan, 1981, Chapters 9, 10.

Swedlund, Charles. *Photography*. 2nd ed. New York: Holt, Rinehart and Winston, 1981, Chapter 9.

Time-Life Books. *Life Library of Photography: The Studio; Light and Film*. New York: Time, Inc., 1970, pages 182–199.

Suggested field and laboratory assignments

1. Arrange for the use of a studio or set up a temporary one. Shoot a number of portraits, including at least one example of each of the following:
 A. Broad lighting
 B. Short lighting
 C. Butterfly lighting
 D. A portrait using key, fill, background, and accent lights

2. Set up lighting and shoot a number of objects. Include at least one example of each of the following:
 A. Round object
 B. Rectangular object
 C. Glass object
 D. Shiny object
 E. Matte object
 F. Arrangement of objects that includes a transparent, a shiny, and a matte object in a single scene

Do Practice Test 8 on page 289

EXERCISE 8–A

1. Define two major purposes of artificial lighting.

 A. _____

 B. _____

2. To accomplish these purposes, what are three basic functions of the lighting setup?

 A. _____

 B. _____

 C. _____

3. Describe the differences between specular and diffused light. _____

4. Describe the principle of the single dominant light source. _____

5. What is meant by the brightness ratio? Explain how to establish a recommended bright-

 ness ratio._____

6. List five lighting controls available to help the photographer obtain a desired field of

light._____

Return to Objective 8–B, page 265

EXERCISE 8–B

Describe each of the following basic lighting tools and its purpose in an artificial lighting setup.

1. Floodlights: _____

2. Spotlights: _____

3. Reflectors: _____

4. Baffles and flags: _____

5. Diffusion and pattern screens: _____

PRACTICE TEST 8

For each of the following questions, select the one best answer and write its corresponding letter in the blank preceding the question. After you have completed the test, check your answers against the correct answers, which follow the test. If you miss any of the test items, review the study materials as suggested.

_____ 1. When the main light illuminates fully the side of the face turned toward the camera, it is called _____ lighting.
A. narrow
B. diffused
C. short
D. broad
E. glamour

_____ 2. Short lighting is used _____.
A. for average oval faces
B. to compensate for thin or narrow faces
C. to compensate for round or plump faces
D. A and B
E. A and C

_____ 3. Which of the following light positions is the most common placement for a key light in normal portrait work?
A. at eye level and in front of subject
B. below the subject's head and to the side of the subject
C. above the subject's head and to the side of the subject
D. at eye level and to the side of the subject
E. above the subject's head and slightly behind the subject

_____ 4. Your subject's brown hair is merging with the background. How might you correct for this?
A. raise the key light
B. add a front light
C. add an accent light
D. add a light to the side of the subject
E. move the key light closer to the subject

5. In a short lighting setup, the key light generally is placed so that _____.
 A. it lights the side of the face away from the camera
 B. there is a butterfly shadow beneath the nose
 C. the subject's hair is bathed in light
 D. a highlight appears on the subject's nose
 E. the eyes pick up a reflection of the light

6. In establishing the lighting ratio for portraits, which of the following is a useful tool?
 A. an extension tube
 B. a barn-door baffle
 C. a vignetter
 D. an exposure meter
 E. a head screen

7. The two characteristics of a small object that most determine an appropriate lighting setup are its _____.
 A. length and height
 B. color and shape
 C. transparency and construction
 D. shape and surface texture
 E. surface texture and color

8. A suggested treatment to fill out the narrow face is to use _____.
 A. broad lighting
 B. short lighting
 C. diffused lighting
 D. a lower lighting ratio
 E. no hair light

9. You can sharpen your portrait-lighting ability by _____.
 A. mentally analyzing lighting used in other photographers' work
 B. practice
 C. analyzing your own work for potential improvement
 D. all of the above
 E. only B and C

10. The light produced by the direct rays of the sun is _____.
 A. broad lighting
 B. specular
 C. short light
 D. diffused
 E. both B and C

_____ 11. The light produced by incident light reflecting off a matte white surface is
_____ .
 A. broad lighting
 B. specular
 C. short lighting
 D. diffused
 E. both A and D

_____ 12. The principle of the single dominant source leads one to _____ .
 A. use the key light to produce a set of highlights and shadows
 B. use the fill light to produce a set of highlights and shadows
 C. use the background light to produce a set of highlights and shadows
 D. use the accent lights to produce a set of highlights and shadows
 E. all of the above

_____ 13. To shade undesirable highlights produced by the key light, use _____ .
 A. a diffusion screen
 B. a reflector
 C. a light standard
 D. a baffle
 E. a boom

_____ 14. The key light in object photography most often is placed _____ .
 A. at camera level and to one side of the object
 B. above and to one side of the object
 C. above and behind the object
 D. above and directly in front of the object
 E. at camera level and in front of the object

_____ 15. Tenting is a technique used for photographing _____ objects to _____ .
 A. transparent; eliminate specular highlights
 B. transparent; provide a white background
 C. shiny; eliminate specular highlights
 D. shiny; surround the object with white reflecting surfaces
 E. matte; to provide fill lighting for the shadows

ANSWERS TO PRACTICE TEST 8

1. D See "Basic Portrait Lighting," page 274.
2. E See "Basic Portrait Lighting," page 274.
3. C See "A Basic Four-Light Setup," page 270.
4. C See "A Basic Four-Light Setup," page 270. A hair light is the common solution for this problem.
5. A See "A Basic Four-Light Setup," page 270, and "Basic Portrait Lighting," page 274. Alternative E is also partially correct, although the term "catchlight" is to be preferred over "reflection." The catchlights should be located at about one o'clock or eleven o'clock, depending on whether broad or short lighting is used. A is the *better* response.
6. D See "Principles of Artificial Lighting," page 259. Without a light meter, the brightness ratio can be established by placing the lights at appropriate distances from the subject.
7. D See "Lighting Small Objects," page 276.
8. A See "Basic Portrait Lighting," page 274.
9. D You should learn to be a critic of your own work and a student of others' work. And practice!
10. B See "Principles of Artificial Lighting," page 259.
11. D See "Principles of Artificial Lighting," page 259.
12. A See "Principles of Artificial Lighting," page 259.
13. D See "Basic Lighting Tools and Their Functions," page 265.
14. C See "Lighting Small Objects," page 276.
15. D See "Lighting Small Objects," page 276.

Electronic flash

Over one hundred years ago an English photography pioneer, William Henry Fox Talbot, discovered that a high-speed electrical spark could be used as a photographic light source. The spark was so brief and so intense that its effect could stop the action of rapidly moving objects. It was not until the 1930s, however, that this principle was developed into a practical system suitable for photography. A modern *electronic flash* unit consists of (1) a power supply for the electrical energy, usually a battery or a household AC circuit; (2) a set of capacitors that store the electrical energy to a high potential; (3) a triggering circuit to release the stored electrical energy; (4) a glass tube filled with an inert gas, usually xenon, to convert the electrical energy into light; and (5) a reflector.

Because the light-producing gas in the tube is chemically inactive, the gas is not consumed during its flash. There is no burning and no oxidation. Therefore, the gas-filled tube is reusable time after time and can be fired thousands of times before replacement is necessary. The batteries that power these units also may be rechargeable, allowing them to be reused often indefinitely, barring damage. The light produced by these units is approximately 5500 K, the color temperature of daylight, and is extremely bright. It is also of extremely short duration, making its flashes easier on the eyes of the subjects.

After each firing, the flash cannot be fired again until the capacitors rebuild their electrical charge. The necessary *recycling time* varies considerably among units. The most popular units are designed to recycle in four to twelve seconds. Most units also are equipped with an indicator light to inform the photographer when the unit has completed its recycling and is charged up ready to fire again. The more useful units also may be adjusted to operate at one-half or one-fourth power, providing an additional control over the amount of light generated at each firing and the recycling time required. The *light output* of electronic flash units usually is rated in terms of beam candle-power seconds (BCPS).

Flash peak

To understand how the burst of light from these various flash units can be synchronized to the exact instant of the shutter's opening, try to visualize in slow motion how the flash unit operates. As you know, a flashbulb depends on the burning of flammable metal foils. As with any fire, there is a period when the flammable materials begin to burn, another period when the materials burn furiously at their maximum intensity, and another period when the fire dies down and goes out. The same three stages occur in a flashbulb. We can represent this process graphically as in Figure 9–2. Note that the intensity of the flash is represented on the vertical axis, and time is represented on the horizontal axis. Brightness increases during ignition, reaches its maximum at *flash peak,* and decreases during extinction.

Flash units are designed to flash at different speeds and intensities. Figure 9–3 graphs the characteristic burn patterns of several flashbulb types and the electronic flash. Figure 9–3A depicts a *fast-peak (F)* flashbulb. Its ignition time is very short, it reaches peak output rapidly, and it extinguishes rapidly thereafter. Figure 9–3B depicts a *medium-peak (M)* flashbulb. Its ignition is slower, it takes longer to reach its peak output, and its extinction thereafter occurs

Fig. 9–2 Stages of flash brightness.

Fig. 9–3 Peak patterns of various flash units. A. Fast peak (F). B. Medium peak (M). C. Flat peak (FP). D. Strobe (X).

more slowly. It may burn less brightly than the fast-peak flashbulb, but it burns longer. Figure 9–3C depicts a *flat-peak (FP)* flashbulb. Used primarily with focal plane shutters, this type of flashbulb has a medium-fast ignition period, but it holds its peak output at a relatively constant brightness for a longer period of time before extinction. Figure 9–3D depicts the characteristic "burn" pattern of *electronic (X) peak*. Remember that no materials actually burn in this unit; therefore the flash requires almost no ignition buildup at all. It approaches what is called a *zero-delay to peak* output. Note also that its flash has virtually no afterburn during extinction. Its full intensity is achieved and vanishes in an instant without an aftertrace.

Because all these flash units have different burn characteristics, their peak output must be synchronized with the operation of the shutter. To assure proper synchronization, you must select correct shutter speed and synchronization settings for your flash unit and camera.

Synchronization

The method provided to assure that the shutter of the camera is open fully while the flash is at its peak output is called *synchronization*. Not all adjustable cameras are designed to make flash pictures with all types of flash units at all shutter speeds. The timing of the synchronization depends on the type of shutter designed into the camera and the type of flash unit in use.

For cameras with leaf shutters

As you have seen, different flash units reach their peak output during different time intervals. The *leaf shutter* of your camera also operates within a time frame. The typical leaf shutter may take 2–4 milliseconds to open to its full aperture. (A millisecond is 1/1000 sec.) When set at 1/100 sec., the shutter may then stand fully open for about 8 milliseconds. Then it will take another 2–4 milliseconds to close completely. Thus the shutter will go through its complete cycle in 12–16 milliseconds when set at 1/100 sec. However, the typical medium-peak (M) flashbulb needs 20 milliseconds to reach its peak output. If the flashbulb and shutter start their cycles at the exact same moment, the shutter will have opened and closed before the flashbulb has reached its peak output.

To compensate for this discrepancy, cameras are designed to ignite the flashbulb *before* the shutter is activated. This slight delay allows the flashbulb to

ignite first and then releases the shutter. It is timed so that the flashbulb will reach its peak output just as the shutter reaches its maximum aperture.

There are several types of synchronization, each designed for use with a particular type of flash unit. The *M-synchronization* is designed especially for the medium-peak (M) flashbulb we have just discussed. By connecting a flash unit to the M-synchronization, the flashbulb is ignited first and a 20-millisecond delay is introduced between ignition and the subsequent release of the shutter. With medium-peak (M) flashbulbs and M-synchronization, you can use shutter speeds up to 1/500 sec. Some older cameras may use *F-synchronization,* which is designed for use with fast-peak (F) flashbulbs and provides for only a 5-millisecond delay between flashbulb ignition and shutter release. This type of synchronization is no longer provided in modern cameras.

Electronic flash must be synchronized differently. As we have seen, electronic flash approaches a zero-delay to peak output. Upon ignition, it reaches peak output in less than one millisecond. The flash duration is only 1–2 milliseconds. In this case igniting the flash *before* releasing the shutter would result in the shutter opening and closing *after* the flash had already completed its entire cycle. To use electronic flash you need to delay firing the flash until the leaves of the shutter have just about reached their maximum aperture. This type of synchronization is called *X-synchronization* and is timed to fire the flash just as the shutter reaches its fully open position, some 2–4 milliseconds *after* the shutter has started its cycle. Electronic flash with X-synchronization can be used at all shutter speeds with leaf shutters.

For cameras with focal plane shutters

Synchronizing the flash unit with a *focal plane shutter* poses an entirely different type of problem. The focal plane shutter typically consists of two fabric or metal curtains, stretched across the film gate and resembling two miniature window shades. When the shutter is released, the first curtain rushes across the film gate, opening it to light entering through the camera lens. Then, after the designated interval, the second curtain rushes across in the same direction, closing the film gate and terminating the exposure. At slow speeds, usually up to 1/60 sec., the entire film gate stands fully open for a brief instant.

At the faster shutter speeds, however, the two curtains follow so closely upon one another that the entire film gate is never fully open at any given instant. Upon release, the first curtain begins its rush across the film gate. But before it reaches the other side, the second curtain is released to terminate the exposure. At very high speeds, the distance between the two curtains is no more than a thin slit dashing across the surface of the film to make the exposure. Thus, any given point on the surface of the film may receive as little as one millisecond exposure while the slit may take a full 20 milliseconds to travel its full path across the surface of the film.

Although a medium-peak (M) flashbulb would produce light during this entire 20-millisecond interval, it would be uneven. Less intense at the start, it would peak while the slit was in transit, and then would start to die out before the slit completed its passage. To compensate for this problem, the flat-peak (FP) flashbulb was designed. It produces an even output of light throughout the time that the shutter is in transit. Designed to reach its peak in 20 milliseconds, it then gives off a constant level of peak output for an additional 20–25 milliseconds, giving the focal plane slit time to move across the film plane. Cameras with focal plane shutters may identify this synchronization as *FP-synchronization*. It is identical mechanically to M-synchronization because it provides a 20-millisecond delay between flash ignition and shutter release. The FP designation, however, should serve to remind the photographer that the flat-peak (FP) type of flashbulb is needed to assure even exposure. The FP flashbulb with FP-synchronization can be used at all shutter speeds.

The design of the focal plane shutter creates a special problem for the use of electronic flash units. Because of the extremely short burst of light produced, the electronic flash cannot be used with the higher focal plane shutter speeds. Remember that the film gate at these speeds does not stand fully open at any instant. Instead a narrow slit rushes across the face of the film. A 1-millisecond burst of light occurring during the transit of this slit merely would stop the movement of the slit. You would be catching this slit at some point in its transit, and your picture would show what could be seen through this slit at the exact moment of the flash. Such thin pictures are not usually what you have had in mind.

For this reason, with electronic flash you must select a shutter speed that allows the film gate to stand fully open for at least a brief instant. During this instant, the flash can be fired so that its light will reach all areas of the film simultaneously. As with a leaf shutter, X-synchronization is used to delay the flash 1-2 milliseconds until the film gate stands fully open. Then the flash is released before the second apron begins closing to terminate the exposure.

As X-synchronization with a focal plane shutter is possible only at the slower shutter speeds, electronic flash usually may be used only at focal plane shutter speeds up to 1/60 sec.; however, some focal plane cameras permit the use of electronic flash with speeds up to 1/125 sec. The owner's manual that comes with your camera specifies the maximum shutter speed that may be used with electronic flash. This maximum shutter speed is usually indicated on the shutter speed dial by a color code. It should be noted, however, that only electronic flash is limited to the slower shutter speeds. FP flashbulbs and certain midget flashbulbs designated medium peak (M) may work effectively at all focal plane shutter speeds. Follow the flashbulb manufacturer's recommendations in these cases.

Variables affecting exposure with flash

The intensity of light reflected from the subject and its duration determine exposure. Because you cannot measure the intensity of a brief burst of light without special metering equipment, you must estimate the amount of light that will be reflected from the subject. The known facts that will affect your exposure settings are:

flash-to-subject distance
reflectance of surrounding surfaces
output of flash unit
type of reflector used with flash unit
film speed
shutter speeds allowed by flash synchronization

In practice many of these variables are fairly constant during any picture-taking excursion. After all, you are not likely to change film between shots or change flash units or reflectors. Probably you will not change shutter speeds very much during any one outing, so the variables most subject to change are flash-to-subject distance as you move closer and farther from your subject, and environmental reflectance as you move to different locales.

Flash-to-subject distance

The most critical factor in determining flash exposure is the *flash-to-subject distance,* which may vary considerably from shot to shot and which may affect exposure profoundly. The amount of light falling on a subject varies inversely as the square of the distance between the flash and the subject. This is known as the *inverse square law.* It means that as you double the flash-to-subject distance—from eleven to twenty-two feet, for example—you reduce the intensity of light falling on the subject from the same flash unit to one-fourth. You would need a two-stop increase in exposure to compensate. Moving the flash closer to your subject—from eleven to eight feet, for example—requires a corresponding reduction in expo-

sure. In this case the difference would require a one-stop reduction.

Reflectance

The *reflectance* of the surrounding area and objects affects the amount of illumination reflected from the scene. A room with white walls and ceiling will reflect more of the light from the flash unit onto the subject and back to the camera than will a room with dark-colored walls and ceiling. Light objects will also reflect more light back to the camera than dark objects.

Flash unit output

Another important but relatively constant factor that affects exposure is the flash unit output. Various flashbulbs and electronic flash units produce different intensities of light for longer or shorter periods of time. The output of your flash unit will affect the amount of light reflected from your subject and, consequently, the amount of needed exposure.

Reflector

The reflectors used with flashbulbs affect the amount of the flash output that is actually directed to the subject. Some reflectors are highly polished, reflecting an intense, specular light to the subject. Others are satin-finished, reflecting a softer, more diffused light to the subject. Reflectors are manufactured in various shapes as well. Some have a shallow, cylindrical shape; others a shallow bowl shape; others a deep bowl shape. They have wide, medium, and narrow beam spreads, respectively, placing less or more light upon the subject. Flashcubes, flashbars, and electronic flash units have built-in reflectors.

Film speed

Of course, the speed of the film will affect exposure as it does in any kind of lighting situation. Faster film will require less exposure than slower film for any given intensity of illumination.

Shutter speed

If shutter speed is fixed by synchronization requirements, it will affect the manner in which an adequate exposure is obtained. If, for example, you can use a shutter no faster than 1/60 sec.—as in the case of an electronic flash unit used with a focal plane camera—then you will need to control exposure by manipulating the other camera controls—aperture, film speed, reflector, and flash-to-subject distance.

Automatic electronic flash

Managing so many variables to determine proper flash exposure may seem complicated, especially because you often must estimate factors such as flash-to-subject distance, reflector efficiency, and the reflectance of the subject and the area. To determine exposure, most manual electronic flash units have a calculator dial into which you enter (1) the power level you wish to use, (2) the ASA film speed, and (3) the flash-to-subject distance. The calculator indicates the appropriate exposure.

Automatic electronic flash units, however, have built-in automatic controls over the amount of light that reaches the film to make the flash exposure. Two general types of automatic electronic flash units are in common use: 1) those that hold light output constant and vary the camera's f/stop to control exposure, and 2) those that hold f/stop constant and vary the unit's light output to control exposure. The first of these usually employs a dedicated flash unit designed for use with a particular camera to which it is electronically linked. Given the flash unit of known output, the camera automatically adjusts the f/stop to conform to the flash-to-subject distance as the camera's focusing mechanism is operated.

With the second type of unit, you set the ASA film speed and the f/stop you are using; the unit does the rest. Whether your subject is close or far away, the flash unit will determine correct exposure by controlling its light output. A built-in sensor, similar to the photo-sensitive cell in your light meter, measures the light reflected from the subject. A built-in, integrated, solid-state computer interprets this informa-

tion and, when the reflected light is sufficient for proper exposure, a quenching circuit terminates the flash. All this happens in less than a millisecond. Once set, the exposure controls need not be reset as you move closer to your subject or farther away within the range limits of the flash unit. The automatic quenching circuit adjusts exposure for you.

One ingenious automatic electronic flash system, known as a *Thyristor circuit,* even preserves the energy remaining in the capacitors following the flash discharge and uses it during the recharging cycle. The effect of this is to conserve energy and to shorten recycling time. Thus, at shorter distances flash durations will be shorter (often as brief as 1/50,000 sec.), less energy will be spent from the capacitors, and less time will be required to recycle the capacitors to full charge.

Multiple flash

As we have seen, basic principles often call for more than one source of light to be used to create the kind of lighting we need. A single flash used off camera to improve modeling can create harsh shadows, for example, and while we can fill these shadows by using a reflector, sometimes we may wish to obtain added control by using additional lighting units instead. Similarly, we may wish to use additional lighting units to light a background, to provide edge accents, or to accomplish any of the other purposes we discussed earlier in Unit 8, Basic Lighting.

In commercial studios, large electronic flash units powered by alternating current (AC) are commonly used. Two or more of these units may be linked to a common flash generator for synchronization, for rapid recycling, and for consistent lighting quality. Many have built-in tungsten lights of low wattage that are used for modeling before the flash exposure—to aid the photographer in positioning the lights to achieve an intended effect. Electronic flash is generally replacing incandescent lighting in commercial

studios because it consumes less power, is less costly to operate, and operates at much lower temperatures.

Using two or more battery-powered portable electronic flash units simultaneously is relatively simple. The units need not even be connected by wires either to the camera or to each other. Separate *slave units* that include a flash head and power source are available. These are designed to be used with a *photo eye,* a device that triggers the slave unit instantaneously with the primary flash unit that is connected to the camera's synchronization circuit. The slave units together with their photo eyes are generally mounted on light standards or clamped in the position of fill, background, or accent lights. When light from the primary flash unit strikes the photo eyes, they in turn trigger the slave units to flash instantaneously. Thus, a portable, multiple-flash lighting system is hardly more complicated or costly to assemble and operate than a comparable incandescent lighting system.

Do Exercise 9–A on page 315

Using Guide Numbers to Determine Exposure Settings

Objective 9–B Given a table of guide numbers, select the appropriate guide number for a specific shutter speed, synchronization, flash unit, and film speed; and given a guide number, calculate appropriate f/stop settings for subjects at various flash-to-subject distances.

Key Concepts guide number, guide number table

Because many photographers cannot afford an automatic electronic flash, a knowledge of *guide numbers* will provide an alternative method for determining

flash exposure. To take into account all the variables that affect the amount of light your flash unit will throw on the subject, a system of guide numbers has been developed to simplify calculating exposure settings. The guide number takes into account the speed of the film you are using, the amount of light from the flash unit, the effectiveness of the flash reflector in concentrating the light on the subject, and the effect of shutter speed. Packed with most films as well as with most flashbulb packages are tables of guide numbers for your combination of flash source, reflector, and film speed. Such tables also are published in photographic data books.

How guide numbers work

How does the guide number simplify exposure settings with your flash unit? It helps you calculate your aperture setting for any given flash-to-subject distance. This is most useful because it is the flash-to-subject distance that is most likely to vary from shot to shot. Guide numbers are designed for calculating a correct aperture for any given shutter speed and flash-to-subject distance.

To determine the aperture, divide the guide number by the flash-to-subject distance (in feet). The quotient is your correct f/stop. The general formula is

$$\frac{Guide\ number}{Distance} = f/stop$$

Suppose your guide number is 56, and the distance between your subject and the flash unit is ten feet. A little mental arithmetic shows you that $56/10 = 5.6$, so you would set your camera aperture at f/5.6. Sometimes, of course, the quotient does not turn out to be a full f/stop. In the case just mentioned, for example, the flash-to-subject distance might be thirteen feet. Our arithmetic in this case would be $56/13 = 4.3$, which is not a full f/stop. In that case you would set the aperture at the nearest f/stop, or f/4. With a manual setting you will need to recalculate

the f/stop every time your flash-to-subject distance changes.

It is not always convenient to do this mental calculating if you are on a photo excursion. Three things will make this part easier. The first and most important is experience. As you gain experience in calculating f/stops from guide numbers, you will begin to get a feel for it. A second is the photoguide. Like a small paper slide rule, the photoguide is designed to do your calculating for you. Just enter the information about your film speed, flash unit, reflector type, and flash-to-subject distance and your f/stop is calculated for you. Photoguides are available in most camera shops. Third, one can usually standardize on two or three distances—eight feet for close-ups, eleven feet for small groups, sixteen feet for larger groups—and note the correct aperture for each distance.

How to find your guide number

Table 16 on page 304 is a *guide number table* packed with a film rated ASA 125 and based on use of blue flashbulbs and electronic flash. For clear flashbulbs, of course, and for films with different ASA ratings, the guide numbers would be different.

Use with flashbulbs

Suppose you have a leaf-shuttered camera with which you are using type AG–1B blue-coated flashbulbs, a film rated ASA 125, and an intermediate shallow bowl reflector. The surrounding light is quite dim, so you are not worried about secondary images and you want the highest possible guide number. The table shows that you can use X-synchronization with a shutter speed of 1/30 sec. to obtain a guide number of 110. At a flash-to-subject distance of 10 feet, you would then set your aperture at f/11. If the surrounding light were bright, however, and you *were* concerned with secondary images being recorded at a slow shutter of 1/30 sec., you could choose an alternative with faster shutter speed. The table shows that with the same equipment and materials you can use

M-synchronization at 1/250 sec. Under these conditions your guide number would be 55. At the same flash-to-subject distance you then would set your aperture at f/5.6.

With a focal plane shutter, of course, you have a different set of rules, as discussed in ''Principles of Flash Photography.'' For the faster shutter speeds you will need to use the FP-type flashbulbs. Suppose that with your focal plane camera you are using type 6B blue-coated flashbulbs, a film rated ASA 125, and a large, shallow bowl reflector. You can use M-synchronization (or FP-synchronization) and a shutter speed of 1/250 sec. to obtain a guide number of 50. At a flash-to-subject distance of 9 feet, you then would set your aperture at f/5.6.

Use with electronic flash

With most electronic flash units, guide numbers may also be used for setting exposure. Because the flash of light is so brief, however, the guide numbers are based on the flash interval rather than on the shutter speed. Whereas altering the shutter speed in the case of leaf shutters alters the guide number to be used with a flashbulb, altering the shutter speed will not alter the guide number with an electronic flash unit. In the case of focal plane shutters, as we discussed in ''Principles of Flash Photography,'' you must select a shutter speed that will allow the film gate to be fully open at the moment of the flash. For most focal plane shutters, this occurs at speeds up to 1/60 sec. although some may stand fully open at 1/125 sec.

Table 16 Typical Flash Guide Number Tables

Typical Guide Numbers for Blue Flashbulbs for ASA 125 Film

Flash Unit		Shutter Speed				
		X-sync	M (or FP)-Sync			
Reflector Type	Flashbulb Type	1/30	1/30	1/60	1/125	1/250
	flashcube	110	80	80	60	50
shallow cylindrical	AG–1B	80	55	55	50	40
intermediate shallow bowl	AG–1B	110	80	80	65	55
	M2B	110	NR	NR	NR	NR
intermediate polished bowl	AG–1B	160	110	110	95	80
	M2B	150	NR	NR	NR	NR
large shallow bowl	M3B, 5B, 25B	160	150	140	120	100
	6B,* 26B*	NR	150	110	75	50
large polished bowl	M3B, 5B, 25B	220	220	200	170	130
	6B,* 26B*	NR	210	160	110	80

*FP-type flashbulbs
NR—not recommended

Typical Guide Numbers for Electronic Flash for ASA 125

output of unit in BCPS	350	500	700	1000	1400	2000	2800	4000	5600	8000
guide number	45	55	65	80	95	110	130	160	190	220

Follow the camera manufacturer's recommendations for the use of electronic flash.

Beyond these considerations, the guide number is a function of the unit's light output. The guide number table shows guide numbers for electronic flash units with various light outputs rated in BCPS (beam candle power seconds). The BCPS rating of an electronic flash unit may be inscribed on the unit or included in the manufacturer's printed instructions. For example, using an electronic flash unit rated at 2000 BCPS and a film rated at ASA 125, the table shows a guide number of 110. Using X-synchronization, at a flash-to-subject distance of 10 feet, the correct aperture setting would be f/11. Although it is useful to be able to use guide numbers to determine flash exposure, they are rarely used today with electronic flash. These units generally have a built-in exposure calculator that may be adjusted for different film speeds and distances to provide a correct aperture setting. Automatic electronic flash units, of course, set exposure electronically. Today, exposure guide numbers are used primarily with flashbulbs.

Guide number tables are just what they state they are—guides. They should be used to help you determine an appropriate exposure setting under any given conditions. However, circumstances may lead you to adjust the guide numbers to suit your particular needs. If your pictures are consistently overexposed, use a higher guide number than that shown; if underexposed, a lower one. In small rooms with light-colored walls, reduce the exposure one stop; in large, dark rooms, increase the exposure one stop. If the guide numbers provided by your camera or flash unit manufacturer don't agree with those of the film or flashbulb manufacturer, follow the film and flashbulb guide numbers. These materials are being improved and updated constantly.

Do Exercise 9–B on page 316

Single-Unit Flash Technique

Objective 9–C Explain and demonstrate several techniques for using a single flash unit for lighting a subject and explain their several purposes. Calculate flash-to-subject distance for fill-in flash.

Key Concepts flash-on-camera, red-eye, flash-off-camera, bounce flash, bare-bulb flash, open flash, fill-in flash, fill-in flash table

The general principles of photographic lighting discussed in Unit 8 also apply to flash photography. The principle of the single dominant light source applies as well as the principle of filling in the shadows with some form of diffuse lighting to record shadow details. Accents to rim the edges of the subject, to help reveal its shape and contour, and to separate it from the background are also desirable, as is background lighting. To achieve these with flash may be a bit more difficult only because you are not always able to observe directly the effects of lighting placements. For that reason practice and experience with floodlights and spotlights provides invaluable knowledge when it comes to anticipating the effects you will achieve with flash.

Most flash photography is carried out with a single flash unit. Let us first consider some of the techniques for using a single flash unit to provide the key, fill, background, and accent lighting that we consider desirable.

Flash-on-camera

In most situations a single flash unit mounted on the camera close to the camera-subject axis will be the simplest, most straightforward approach. (See Figure 9–4.) This *flash-on-camera* technique is convenient

Fig. 9–4 Electronic flash-on-camera.

and adequate for most subjects. With flash-on-camera, the flash-to-subject distance is the same as the camera-to-subject distance and can be estimated from your picture-taking position. If your camera has a rangefinder, the camera (flash)-to-subject distance can be read directly off the focusing scale. It has several disadvantages, however. As a key-lighting position it produces a flat, shadowless illumination, devoid of modeling shadows. It tends to produce bounce-back reflections from shiny walls and furniture and, if the subject is close to the background, it may also produce an unsightly shadow just behind the subject. With color film, flash-on-camera sometimes produces an undesirable effect called *red-eye,* in which the pupil of the eye of the subject appears luminous and red.

These difficulties usually can be overcome by following some simple procedures. Bounce-back reflections can be avoided by facing blank walls or flat surfaces at an angle, rather than head-on. Mirrors especially should be avoided—if you can see your flash unit in the mirror, you will be taking a picture of it as it fires. The correction is simple. Change your

position so that your flash will strike such surfaces at an angle—45° if possible. Then the bounce-reflection will be thrown off in another direction and will not bounce back into the taking lens. To avoid a shadow on the background, place your subject at least several feet from the background. The subject's shadow will fall out of the camera's view and the background will be close enough so it will not be underexposed.

Flash-on-camera also tends to bounce back reflections from eyeglasses. Subjects wearing eyeglasses should turn slightly so that the glasses are turned away from the camera. Or their glasses may be tipped slightly downward so that reflections are directed away from the camera. Red-eye too usually can be avoided by having your subjects turn slightly off-camera so they are not looking directly into the camera lens and flash. Or the flash unit may be mounted on an extender so that the light source is separated from the lens by at least 5 in. (See Figure 9–5.)

Flash-off-camera

Flash-on-camera, although it is often convenient, is not the most effective flash position. To place the flash unit in a more desirable key light position, remove the flash from its bracket on the camera and use it in an off-camera position. As we discussed in Unit 8, key lighting from above and to the side of the subject tends to produce the most natural set of highlights and shadows. Using a *flash-off-camera* technique, you can hold the flash unit in one hand, high and to one side of the camera, while holding the camera in the other hand. A tripod to hold the camera is often useful for the flash-off-camera technique because it allows you to move farther to the side with the flash unit. By using the flash in this position, you improve the modeling of the subject and reveal textures that add to the three-dimensional effect of the photograph. With a special clamp, the flash unit can be placed on the edge of a door, chair, or other handy edge. Figure 9–6 shows two ways to place the flash unit in a flash-off-camera position.

A

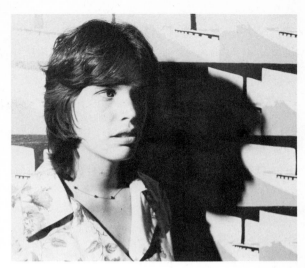

B

Fig. 9–5 Single-unit flash techniques. A. Use of flash-on-camera. Shot directly at reflective surfaces. Slight angle would have directed flash away from lens. B. Use of flash-off-camera. Subject is too close to background. Note distracting shadow.

Flash-off-camera, although it produces a dominant set of highlights and shadows that help to model the subject, does not by itself produce the additional fill light needed to illuminate detail in the shadows. The flash-off-camera technique tends to produce high-contrast prints with deep shadows, but you can use several procedures that enable your single flash unit to produce both key and fill lighting.

One common method is the use of *bounce flash,* in which your off-camera flash unit is directed to the ceiling or a wall, from where it is reflected to your subject. By aiming your flash toward the ceiling or wall of a light-colored room, the light may be bounced toward your subject to provide a soft key light effect. Some of the light also is reflected to the other flat room surfaces before it reaches the subject. This light travels farther and is diffused even more, thus providing fill light from many other directions. To calculate correct bounce flash exposure, figure your flash-to-subject distance as the total distance the key light travels from the flash to the wall or ceiling and then to the subject. Use your guide number in the usual way. Then increase exposure two or more stops beyond that indicated from the guide number. Further increases should be made for darker walls and larger rooms.

Some flash units have removable reflectors. With these units, another method may be used known as *bare-bulb flash,* in which the reflector is removed from the unit so that light from the flash will travel in all directions. To use this method, locate the reflector-less flash unit in a good key light position. Direct rays from the unit will provide the key light effect. All the other light produced by the unit will bounce around among the flat surfaces of the room and provide an even field of fill light. The highlights will be soft and the fill areas will be well illuminated and show fine detail. Calculate the flash-to-subject

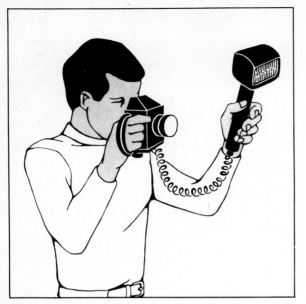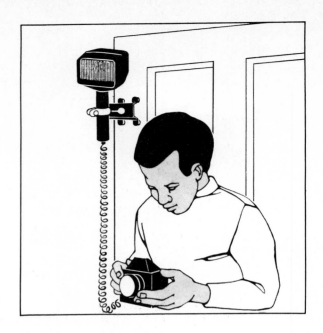

Fig. 9–6 Electronic flash-off-camera. A. Flash held high and to one side. B. Flash clamped high on edge of door.

distance as the direct distance between the flash unit and the subject. Use guide numbers in the usual way as with an intermediate, shallow bowl reflector. Then add about two stops exposure to compensate for the loss of efficiency. (See Figure 9–8C).

Another way to obtain both key and fill light from your off-camera flash is by means of subject reflectors. In this case the flash unit is used with its own reflector in a good key-light position. A matte reflector, such as a piece of light cardboard, is placed on the fill side of the subject to reflect light from the unit into the shadow areas. The same effect can be obtained by placing your subject close to a wall on the fill side. Figure 9–7 depicts the use of the subject reflector.

To obtain a soft, diffused key light with your flash, throw a clean, white handkerchief over it as a hood. Use it in a good key-light position off-camera. Calculate exposure in the usual way and then increase

your obtained exposure one or two stops. A few trial exposures will show you how much exposure increase is needed for a single thickness of handkerchief.

One way of making your single flash unit perform as many units is to use the *open flash* method. This technique is useful when ambient light is very dim or absent and your subject is absolutely stationary. At night, or in a darkened room, open your shutter and allow it to stand open while you carry your off-camera flash unit to several positions in succession, firing it in each location. With this technique you may fire your flash once from the key-light position, then again from a fill-light position, and a third time from behind to create rim accents. Then go back and close your shutter. It is clear that very little if any ambient lighting can be present while you are going about this procedure and your subject must be stationary. The open flash technique can be used for night scenes with the help of an associate if the distance between the

flash unit and the camera is too great for a flash extension cord. Set up your camera and have your associate stand with the flash unit where the flash source is needed. Open your shutter and let it stand open as you tell your associate to fire the flash. When the flash has been fired, close your shutter.

Just as with studio spotlights and floodlights, flash units can be used to simulate natural lighting sources. Placing a flash unit outside a window directed toward the interior of a room can simulate sunlight or moonlight. In a fireplace, it can simulate the light from a fire. The manner in which a single flash unit can be used to enhance your subject and to simulate natural lighting conditions is limited only by the imagination.

Fill-in flash

Aside from its obvious uses for providing a main source of illumination, your flash unit has another important use strictly as a fill light. From your experience you already know that pictures taken in bright sunlight have high contrast. The highlights are brilliant and the shadows are often deep. The range of brightness from these highlights to deep shadows often exceeds the latitude of the film so that the shadow detail actually may be obscured if you expose the film for the highlight values. In the studio we work carefully to achieve a brightness ratio of 3–to–1 or 4–to–1 because this ratio produces the most pleasing results in most black-and-white photo situations. Nature is not so cooperative. In bright sunlight, unless you take additional steps, the brightness ratio may far exceed these limits.

One way to fill in the shadow areas in a sunlit scene is to use subject reflectors—matte white pieces of cardboard or rough-textured metallic boards to reflect and diffuse the sunlight into the shadow side of the subject. By properly placing these reflectors, you can achieve a more favorable brightness ratio between the highlights and the shadows.

Another way to fill in these shadows is to use flash. In this case you use your flash unit as a fill light outdoors in the bright sunlight. This technique is called *fill-in flash*. The trick is to place the flash at an appropriate distance from the subject to obtain the desired brightness ratio between the sunlit highlights and the flash-filled shadows.

One way to calculate this placement of your fill-in flash is to use one of many published *fill-in flash tables*. These tables are found in photo data books and sometimes the manual that accompanies your flash unit may contain one. If you don't have a fill-in flash table, you may calculate flash-to-subject distance as follows:

Calculating fill-in flash

1. Start by setting your exposure for the sunlit scene. Suppose you are using ASA 125 film and an electronic flash rated at 1000 BCPS. Use your light meter to determine an exposure that is correct for the sunlit highlights in your scene. Suppose that should be f/16 at 1/60 sec.

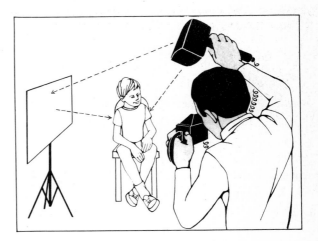

Fig. 9–7 Using subject reflector to fill with electronic flash.

2. Refer to your flash guide number table. (See Table 16 on page 304.) Locate the guide number associated with your flash rating. The guide number associated with this rating is 80.

3. Divide your guide number by the f/stop setting. Because your selected f/stop is f/16, you divide

$$\frac{Guide\ number}{f/stop} = \frac{80}{16} = 5$$

The quotient, 5 in this case, tells you the number of feet from the subject that you must place your flash unit to balance the sunlit highlights. By placing your flash unit on the shadow side of the subject 5 feet away from the subject, all the shadows will be balanced with the highlights and you will achieve nearly flat lighting. Flat lighting may be desirable in some cases; however, you will usually want a brightness ratio greater than 1–to–1.

4. To obtain a brightness ratio of 2–to–1, multiply the quotient by 1.4.
 To obtain a brightness ratio of 3–to–1, multiply the quotient by 1.7.
 To obtain a brightness ratio of 4–to–1, multiply the quotient by 2.

 In the above case, for example, if you wanted a brightness ratio of 2–to–1, you would multiply 5 × 1.4 = 7—you would place the flash unit 7 feet from the subject. If you wanted a brightness ratio of 3–to–1, you would multiply 5 × 1.7 = 8.5—you would place the flash unit 8½ feet from the subject. If you wanted a brightness ratio of 4–to–1 you would multiply 5 × 2 = 10—you would place the flash unit 10 feet from the subject.

You can use other procedures to reduce the intensity of the flash unit, as described earlier. All of these techniques assume a constant output of light from the flash unit. Automatic, variable output flash units must be used in a manual, constant output mode for fill-in flash. Practice with the fill-in flash technique will soon provide you with the experience necessary to estimate with some degree of accuracy just how to achieve the brightness ratio you desire. (See Figure

A

B

C

Fig. 9–8 Achieving desired brightness ratio. A. Bright sunlight from side or behind produces excessively great brightness ratio, obscuring details in shadow areas. B. Fill-in flash opens up shadow areas and keeps brightness ratio within film's latitude. C. Bare-bulb flash creates soft highlights and eliminates distracting shadows.

9–8.) It should be pointed out that it is difficult to use electronic flash with a focal plane shutter for fill-in flash because the slow shutter required for X-synchronization is usually too slow for use in sunlight with medium or faster speed films.

Do Exercise 9–C on page 317

Using Flash for Action

> **Objective 9–D** Explain and demonstrate how flash can be used to stop fast action.
>
> **Key Concepts** secondary image

You will recall from Unit 3 that stopping fast action requires a very short exposure—usually a very fast shutter that will open and close before the image of the subject can move perceptibly across the film. The requirement for fast shutter speeds normally leads to large aperture settings to maintain proper equivalent exposure. Often, however, even with a large aperture the existing light may be insufficient to obtain the required shutter speed.

Using a flash on these occasions may be especially useful because by supplementing existing light, ordinary flashbulbs usually will permit the use of faster shutter speeds than would be possible otherwise. Table 16 on page 304 shows the wide range of shutter speeds you can use with flashbulbs.

Another approach to stopping action, however, is by the use of the high-speed electronic flash. Recall that the electronic flash unit is capable of producing a 1/1000-sec. burst of intense light. Under very low lighting conditions, this burst of light alone may be sufficient to provide an adequate 1/1000-sec. exposure of a rapidly moving object.

In his original experiments with the electronic discharge lamp, Dr. Harold E. Edgerton and his associates at the Massachusetts Institute of Technology demonstrated that previously "unstoppable" action could be stopped by an extremely short burst of intense light. With bursts of light as short as 1/1,000,000 sec., he was able to freeze successfully the movement of a newspaper whirling as a pinwheel, the wings of a flying hummingbird, and the shattering glass of a milk bottle struck with a hammer.

With an electronic flash, the shutter speed itself does not determine exposure; instead, it is the brief,

Fig. 9–9 Stopping fast action with flash.

intense flash of the unit. As long as the shutter is fully open at the moment of the flash, the burst of light will be able to do its job. With a leaf shutter and X-synchronization, the flash will peak as the shutter reaches its fully open position. Thus electronic flash can be used with all leaf-shutter speeds. With a focal plane shutter and X-synchronization, however, remember that the shutter stands fully open only at the slower shutter speeds. These cameras are synchronized at a maximum of 1/60 or 1/125 sec. because of the design of the focal plane shutter.

Under bright lighting conditions, care must be taken with any type of shutter that the shutter setting is not too slow. Were you to use an electronic flash with a 1/30-sec. shutter speed to shoot a basketball player leaping into the air for a shot, the results might be surprising. You would get a clear image of the player, frozen as the flash caught him in his flight. But you also might get a blurry *secondary image* produced by the available lighting while the shutter was opening and closing at 1/30 sec. To avoid these blurry secondary images of moving subjects, set your leaf shutter for a very high speed. The setting should be fast enough to stop the action on its own, or to assure that the available light will not expose the film. Then the brief, intense burst of electronic flash will be the only source of exposure.

With a focal plane shutter, using electronic flash under bright illumination runs a greater risk of secondary images because the fastest shutter you can use (1/60 sec. or 1/125 sec. with electronic flash) may not be short enough to prevent some exposure from the ambient light.

The use of flash to stop action has a fringe benefit, too. Because of the rapid falloff of light intensity over distance, the subject is lighted more intensely than its background. The farther away the background, the darker it will appear. Thus when you use a flash as your main light source and expose an action shot indoors, you will increase the subject-ground contrast in your print, which will show the subject against a dark background.

Do Exercise 9–D on page 319

Fig. 9–10 Secondary images with moving subject shot with flash under bright available light and slow shutter.

Flash Maintenance and Safety Recommendations

Objective 9–E List several maintenance and safety recommendations for handling flash equipment.

Key Concepts alkaline batteries, zinc-carbon batteries, lamp ejector, flashguard

Flashbulbs use electricity and explosive materials. Any equipment of this sort requires reasonable care and maintenance to assure proper operation and to protect you and your photographic subjects from possible injury. The following list of recommendations describes some of these reasonable procedures. You should remember and practice them.

1. Keep the electrical contacts on the flash batteries and in the camera and flash unit clean. Use rough cloth or a pencil eraser to clean them before each new roll of film.

2. Be sure your photoflash batteries are fresh. *Alkaline batteries* are recommended for long life and short recovery time. However, units that have unplated brass or copper electrical contacts should use *zinc-carbon batteries* instead.

3. Use a *lamp ejector* to eject spent bulbs. Do not pull bulbs out by hand. They may break in your hand or foul your fittings.

4. Handle flashbulbs gently. Slight cracks may cause the bulb to shatter when it is fired.

5. Insert the first bulb in a series with the cord or the flash unit disconnected from the camera. If you insert the flashbulb into a live socket it may go off in your hand.

6. Always have the flash unit aimed away from you when you are connecting it. Several conditions may cause the unit to fire as it is connected.

7. Always used a *flashguard* over your flash unit. Occasionally flashbulbs shatter; a flashguard will protect you and your subjects.

8. Never flash the flashlamps in an explosive atmosphere. Never use flash equipment where there are volatile fumes such as natural gas or gasoline.

9. Do not handle flashbulbs immediately after firing. They are extremely hot and can burn you. Use the ejector to eject spent bulbs into a waste container that can be discarded later.

10. Never drop freshly fired bulbs into a container with new bulbs. The new bulbs may ignite.

11. Fire flashbulbs only at the recommended voltage. Do not fire flashbulbs with household current unless they are designed for such use.

12. Do not carry loose bulbs in a pocket or bag. Friction may break or ignite them.

Do Exercise 9–E on page 320

Suggested references

Davis, Phil. *Photography*. 3rd ed. Dubuque: William C. Brown, 1979, pages 155–158.

Jacobs, Lou, Jr. *Photography Today*. Santa Monica, Calif.: Goodyear Publishing, 1976, pages 146–155.

Kerns, R.L. *Photojournalism: Photography with a Purpose*. Englewood Cliffs, N.J.: Prentice-Hall, 1980, pages 189–202.

Kobre, K. *Photojournalism: The Professional's Approach*. Somerville, Mass.: Curtin and London, 1980, pages 180–195.

Rhode, R.B. and F.H. McCall. *Introduction to Photography*, 4th ed. New York: Macmillan, 1981, Chapter 9.

Swedlund, Charles. *Photography*. 2nd ed. New York: Holt, Rinehart and Winston, 1981, Chapter 9.

Time-Life Books. *Life Library of Photography: Light and Film*. New York: Time, Inc., 1970, chapter 6.

Suggested field and laboratory assignments

1. Arrange for the use of a flash attachment—preferably an electronic flash—for your camera. Mount the unit to the camera. Practice setting the shutter and the aperture for subjects at various distances from the flash.

2. Shoot a roll of film using your flash unit. Include at least one example of each of the following. Keep a shooting log describing the technique used, why, type of flash, exposure data, etc.

 A. Flash-on-camera

 B. Flash-off-camera: flash held in good key light position

 C. Flash-off-camera: bounce flash

 D. Stop rapid action indoors

 E. Stop rapid action in sunlight

 F. Fill-in flash with strong sidelight

 G. Fill-in flash with strong backlight

Do Practice Test 9 on page 321

EXERCISE 9–A

1. Explain the different principles by which flashbulbs and electronic flash units operate.

2. What is meant by flash peak? _____

3. Explain how the flash peaks differ for M, FP, and X flash units. _____

4. Explain the shutter and ignition sequence for each of the following synchronizations

 with a leaf-shutter camera.

 M: _____

 X: _____

5. Why can't a high-speed focal plane shutter be used with an electronic flash unit and X-synchronization? _____

6. If a high-speed focal plane shutter is needed, what is the recommended flash unit and synchronization?_____

7. List six variables that will affect your choice of exposure settings with flash.

A. _____ D. _____

B. _____ E. _____

C. _____ F. _____

Return to Objective 9–B, page 302

EXERCISE 9–B

Use the guide number table provided on page 304 to calculate the correct exposures in the problems below. Assume your camera is loaded with a film rated at ASA 125.

1. You are using flashcubes at a basketball game. Sitting under the basket, you want to stop the action of a player driving under the basket about six feet away from you. The ambient light level is high, so you want to use a fast shutter to stop action and avoid secondary images.

Synchronization: _____

Shutter speed: _____

Aperture: _____

2. You are using electronic flash rated at 4000 BCPS with your focal plane camera twenty feet from your subject.

Synchronization: _____

Shutter speed: _____

Aperture: _____

3. You are using electronic flash rated at 1000 BCPS with your leaf-shutter camera fifteen feet from your subject.

Synchronization: _____

Shutter speed: _____

Aperture: _____

Return to Objective 9–C, page 305

EXERCISE 9–C

1. Describe flash-on-camera technique and its major advantages and disadvantages.

2. Describe flash-off-camera technique. _____

3. Describe two ways you can use a single flash unit off-camera to obtain both key and fill illumination of your subject.

A. _____

B. _____

4. Describe open-flash technique. What functions can it perform? _____

5. Describe fill-in flash. _____

6. You are using ASA 125 film in your leaf-shutter camera on a bright, sunny day. Your subject is backlit by the sun. Your exposure for the highlights f/16 at 1/250 sec. You are using an M3B flashbulb in a large, polished bowl reflector as a fill-in flash. At what distance should the flash unit be placed to obtain a 3–to–1 brightness ratio between the sunlit highlights and the flash-filled shadows? Explain and show your calculations.

Return to Objective 9–D, page 311

EXERCISE 9–D

1. Explain the major differences between using ordinary flashbulbs and electronic flash for stopping fast action. _____

2. Explain why you will be able to stop fast action with electronic flash even though your shutter is a relatively slow 1/30 sec. _____

3. What undesirable result might occur if you are using electronic flash with a relatively slow shutter where existing light is bright? _____ Explain: _____

4. Explain how to use your flash unit to stop fast action and increase subject-background contrast. _____

Why does the background go dark in the final print? _____

Return to Objective 9–E, page 313

EXERCISE 9–E

1. List three important maintenance recommendations you should follow to make sure your flash equipment is in top working order.

 A. _____

 B. _____

 C. _____

2. List five important safety recommendations you should follow to be sure that you minimize the danger of injury to yourself and your photographic subjects.

 A. _____

 B. _____

 C. _____

 D. _____

 E. _____

Review References and do Suggested Field and Laboratory Assignments on page 314

PRACTICE TEST 9

For each of the following questions, select the one best answer and write its corresponding letter in the blank preceding the question. After you have completed the test, check your answers against the correct answers, which follow the test. If you miss any of the test items, review the study materials as suggested.

_____ 1. For proper synchronization, most electronic flash units require the camera shutter to be set at _____.
A. X
B. T
C. M
D. F
E. B

_____ 2. Which of the following safety habits should be practiced when using a flash?
A. Use a flashguard over the reflector.
B. Never drop a freshly fired bulb into a pocket or bag containing new bulbs.
C. Have the flash holder aimed away from you when you connect the cord.
D. Do not flash lamps in an explosive atmosphere.
E. All of the above.

_____ 3. Which of the following statements about electronic flash is *not* generally true?
A. The cost per flash is relatively low.
B. Electronic flash guide numbers are the same at any shutter speed.
C. With the X setting, electronic flash can be synchronized with between-the-lens shutters at any shutter speed.
D. Electronic flash is ideal for rapid sequence shooting.
E. Electronic flash is ideal as fill-in for outdoor shots.

_____ 4. Your shutter has been set correctly and your guide number is 160. The flash-to-subject distance is ten feet. Your aperture should be set at _____.
A. f/32
B. f/22
C. f/16
D. f/11
E. f/8

5. You are using an AG–1B flashbulb with a shallow bowl reflector. Your film speed is ASA 160. Your guide number for M-synchronization is 90 at 1/60 second. For a subject-to-camera distance of eleven feet, the proper aperture is _____.
 A. f/16
 B. f/11
 C. f/8
 D. f/5.6
 E. f/4

6. The guide number for your electronic flash-film combination is 200. Your camera has a between-the-lens shutter. Your flash-to-subject distance is nine feet and you have set your shutter at 1/125 second. What is the proper aperture setting?
 A. f/22
 B. f/16
 C. f/11
 D. f/8
 E. f/5.6

7. Fill-in flash is used _____.
 A. to light up harsh shadows created by intense backlighting and sidelighting
 B. to diffuse light that hits the ceiling or wall and is reflected back to your subject
 C. to simulate other kinds of lights
 D. to produce soft, glare-free, almost shadowless light
 E. none of the above

8. Which of the following is normally used to provide fill light in sunlight?
 A. spotlight
 B. reflector
 C. texture light
 D. flash unit
 E. B and D

9. You are taking an indoor shot of a group of people in a modern home with wide expanses of windows, and you want to keep your subjects from becoming silhouettes against the windows. Which of the following techniques would you use in this situation?
 A. open flash
 B. multiple flash
 C. bounce flash
 D. fill-in flash
 E. flash-off-camera

_____ 10. You have placed your off-camera flash high and to the right of the subject. You want to use a reflector to the left of the subject to fill in shadow areas. Which of the following might you use as a reflector?
A. a mirror
B. a floodlamp
C. a large piece of white cardboard
D. a flashlight
E. a sheet of aluminum foil

_____ 11. Exposure for flash-off-camera should be based on the distance from _____.
A. camera to flash
B. camera to subject
C. camera to reflector
D. flash to subject
E. flash to reflector

_____ 12. You aim your flash unit at the ceiling, or a wall, or a corner of the room to achieve a soft, diffused light to illuminate your subject. This flash technique is called _____.
A. bounce flash
B. fill-in flash
C. modeling flash
D. flat lighting
E. bare-bulb flash

_____ 13. You are using electronic flash to stop fast action. What factor is primarily responsible for the duration of the exposure?
A. the shutter speed
B. the aperture
C. the existing light levels
D. the speed of the action
E. the flash duration

_____ 14. You are using ordinary flashbulbs to stop fast action. What factor is primarily responsible for the duration of the exposure?
A. the shutter speed
B. the aperture
C. the existing light levels
D. the speed of the action
E. the flash duration

_____ 15. With electronic flash, you may get secondary images if _____.
A. you forget to advance the film
B. you shoot before the unit is fully charged
C. you use a slow shutter in bright surroundings
D. the subject moves too fast
E. you are not in precise focus

ANSWERS TO PRACTICE TEST 9

1. A See "Principles of Flash Photography," page 295, if you missed this question.
2. E Read the safety habits in "Flash Maintenance and Safety Recommendations," page 313, if you missed this question.
3. D Electronic flash does not always lend itself to rapid sequence shooting because the required recycling time is a limitation. However, the other alternatives, all true, are benefits of electronic flash.
4. C Remember, always divide the guide number by the distance from the flash to the subject to determine the proper f/number to use. See "Using Guide Numbers to Determine Exposure Setting," page 302.
5. C Again, divide the guide number by distance. All the other information given in the question enables you to find the proper guide number in a guide number table. In this case, 90 divided by 11 does not give an even f/stop, but you are instructed to set the aperture at the *closest* f/stop. See "Using Guide Numbers to Determine Exposure Setting," page 302.
6. A If you were fooled by this question, read the explanation in no. 5. Remember, with between-the-lens shutters and electronic flash, the shutter speed does not affect the guide number. The aperture remains the same if the subject remains at the same distance, regardless of the shutter speed.
7. A See "Single-Unit Flash Technique" page 305, if you missed this question.
8. E Either a reflector or a flash unit can be used for fill in bright sunlight. See "Single-Unit Flash Technique," page 305.
9. D Any of these techniques can be used, as long as they are used to fill in the shadows created by the window side and backlighting. Thus fill-in flash best describes what this situation requires. See "Single-Unit Flash Technique," page 305.
10. C The white cardboard will reflect a soft, diffused light that is ideal for fill. The mirror and the foil would reflect highly specular light that might produce undesirable highlights and shadows. See "Single-Unit Flash Technique," page 305.
11. D Exposure always is based on the distance from flash to subject, even if the flash travels an indirect path, such as with bounce light. See "Principles of Flash Photography," page 295.
12. A See "Single-Unit Flash Technique," page 305.

13. E The extremely brief flash—one millisecond or less—is responsible for the exposure duration. The shutter may be open before and after the flash, but low existing light levels will record no image at these times. See "Using Flash for Action," page 311.

14. A The flash is designed to provide illumination throughout the opening and closing of the shutter. Thus the shutter determines the duration of the exposure. See "Using Flash for Action," page 311.

15. C See "Using Flash for Action," page 311.

A

B

Fig. 10–12 Compositional arrangements. A. Opposing lines of composition produce a sense of resistance and conflict. B. Converging lines of composition lead the eye toward point of convergence.

Use of Tone and Contrast

Objective 10–C Describe and demonstrate how tone and contrast can be used to reveal essential details, emphasize the central idea, and contribute to the mood of a photograph.

Key Concepts full-scale print, figure-ground contrast, silhouette, low-key photo, high-key photo, zone system, previsualization

The fine print

The technical quality of a print depends to a great extent on the range of tones represented in it and the clarity with which different tones are separated from one another. A *full-scale print* is one in which all tonal values are present. In a full-scale print of good quality, specular highlights alone are reproduced as pure white, many middle gray tones may be clearly differentiated, and shadow tones are reproduced as deepest black in the darkest areas while still revealing details. Figure 10–13 shows a full-scale print and identifies the major tone values present in it.

Many factors affect the tonal qualities of the final print. In fact, every step in the photographic process contributes to the final result. Film selection, lighting, exposure, and processing, and paper selection, exposure, processing, and finishing all work together to determine the technical quality of the resulting print.

The tonal quality of a print depends primarily on the negative, so achieving good print quality requires that good negative quality be achieved at the outset. Although tone and contrast can be enhanced during printing, the characteristics of the negative limit the range of enhancement that is possible. Some major factors affecting densities and contrast are these:

Film selection. Some films possess more inherent contrast than others. Generally, slower speed films

Fig. 10–13 Example of a full-scale print. A. Zone system scale. B. Full-scale print showing all tonal values.

have higher inherent contrast than faster speed films.

Lighting. Exposures made in bright sunlight produce higher contrast negatives than exposures made in diffused light.

Exposure. Density in the thinnest areas of the negative (the shadows) is controlled primarily by exposure. Underexposure results in certain shadow details not being recorded on the film. Unrecorded details can never be made to appear in the final print. Details in the densest areas of the negative (the highlights) are controlled by exposure plus development. Overexposure may result in highlights so dense that they are difficult to print.

Processing. Increasing development time tends to increase negative contrast, while decreasing it reduces negative contrast. Altering development time affects the highlights more than the shadows. Also, some developers tend to increase contrast; others tend to decrease it.

Just as many factors affect negative quality, many factors also affect print quality. Within the limits imposed by the negative, final print quality will be affected by such factors as these:

Paper selection. Print contrast is controlled primarily by choice of paper grade (or contrast filter, in the case of multigrade papers). Some papers have more inherent contrast than others and tend to increase print contrast. Surface texture also affects contrast, with more glossy surfaces tending to produce a wider range of tones and greater separation than less glossy surfaces.

Exposure. Print density is controlled primarily by exposure. The objective is to expose prints so that they will reach their optimal density in the full, normal developing time. Overexposed prints suffer loss of tonal separations in the darkest areas. Underexposed prints fail to achieve needed tonal separations in the lightest areas.

Enlarger system. The quality, cleanliness, and condition of the enlarger lens affects both sharpness and contrast. Condenser lighting systems also tend to increase contrast and sharpness and diffuser lighting systems tend to decrease contrast and to soften sharpness.

Processing. Many processing factors can affect print quality. Papers and chemicals should be stored and used to maintain proper temperatures, freshness, and purity. Failures at this stage may result in loss of contrast, poor image tone, and stains. Optimal contrast and density are best achieved using full, normal development time. Underdevelopment of prints causes muddy-looking, often uneven, brownish image tones. Overdevelopment of prints and improper fixing can cause the loss of tonal separations in the highlight areas, fog, and chemical stains. Developer selection also affects contrast. Some developers increase contrast while others decrease it.

When all the factors affecting technical quality in the negative and in the print are under control and working together, we can expect optimal technical quality in the final print. The desirable characteristics of a high quality, full-scale print are these:

1. Specular highlights print as white (base white). The presence of any image density in these highlights reduces image brilliance.
2. Darkest subject tones print as deepest black (maximum density). The lack of deepest black also reduces image brilliance.
3. Light objects in the shadows are visible as dark gray tones. Shadow details can be seen.
4. Light objects in the highlights are visible as light gray tones. Highlight details can also be seen.
5. Different tonal values are separate and distinguishable throughout the mid-tone range.
6. Grain is not visible unless used for special effect.
7. Image is clear and sharp except where selective focusing or blurring is used for special effect.

8. Print is totally free of imperfections such as dust specks, stains, scratches, fingerprints, uneven borders, retouching marks, or other, unintended, non-image blemishes.

Figure 10–13 shows a high quality, full-scale print as well as the printing process permits it to be shown. Ink reproductions such as appear in this book can only approximate the tones and contrast of original photographs, but the qualities of a good print should become clear. A review of Figure 5–9, page 160, will remind you of the characteristics of poor prints.

Emphasis

In addition to revealing details clearly, contrast can be used for emphasis. The arrangement of black, white, and gray tones in a print should create *figure-ground contrast,* by which objects stand out clearly from their backgrounds. Light objects seen against light backgrounds afford little contrast, but against dark backgrounds they stand out. The eye follows light, moving from shadows to highlights and from highlights to shadows. The greater the contrast, the greater the attraction to the eye. See Figure 10–14.

One central object of interest against a plain background poses no problem of emphasis. But when there are two or more objects in the same photo and you wish to emphasize one, remember that the eye is attracted toward the lighter tones. See Figure 10–15.

An extreme example of figure-ground contrast may be found in the *silhouette*. Silhouette technique works well where details are easily recognized by their shapes. Unless objects can be recognized by their shapes, however, the silhouette may obscure the subject, essential details, and thus the entire idea of the photograph. See Figure 10–16.

A

B

Fig. 10–14 **Figure-ground contrast.** A. Light objects stand out against contrasting darker background. B. Dark objects stand out against contrasting lighter background.

Fig. 10–15 **Emphasizing objects.** Eye tends to move from darker toward lighter tones.

Fig. 10–16 **Silhouette.** Subjects are easily interpreted by their shapes.

1B

Plate 1 Poor organization of color elements. A. Busy, disorganized color composition fails to direct attention to any central subject. B. Brightly colored object in foreground competes with central subject for viewer's attention.

Plate 2 Background color. A. Subject and background are of complementary colors, enhancing brilliance of subject. B. Subjects stand out against background of contrasting hue and value.

2B

3A

Plate 4 Contrasting color composition. A. Contrasting colors and blurred action enhance feeling of vibrant activity. B. Colored lights create a mood of cheerfulness against the evening sky. C. Contrasting colors emphasize the intersecting lines and planes of this architectural composition.

4A

Plate 3 **Monochromatic color composition.** A. Feeling of stillness and harmony is conveyed. B. Curved lines and haze create illusion of distance, which, combined with monochromatic composition, generates sense of tranquility. C. Diagonal element adds sense of movement to otherwise static scene.

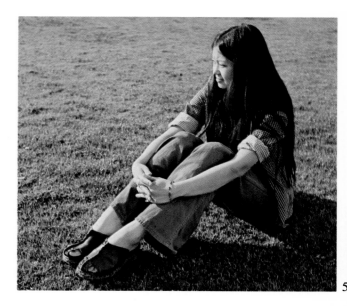

5B

Plate 5 **Using tungsten-balanced film in daylight.** A. Uncorrected. B. Corrected by use of conversion filter.

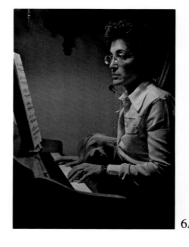

6A

6B

Plate 6 **Using daylight-balanced film in tungsten light.** A. Uncorrected. B. Corrected by use of conversion filter.

7A

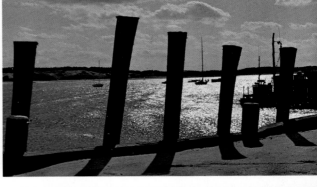

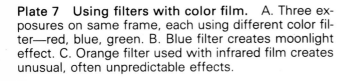

Plate 7 Using filters with color film. A. Three exposures on same frame, each using different color filter—red, blue, green. B. Blue filter creates moonlight effect. C. Orange filter used with infrared film creates unusual, often unpredictable effects.

Plate 8 Photographing stage productions. A. Colored gels on stage lighting instruments shift color balance far into red portion of spectrum. B. Correction with considerable blue shift.

Plate 9 Toning. Use of sepia tone enhances feeling of warmth and supports natural coloring of wood, earth, and flesh.

8A

8B

A

B

Fig. 10–17 Tonality. A. High-key photograph. Majority of tones are light. B. Low-key photograph. Majority of tones are dark.

Mood

Contrast can also contribute to the mood of a photograph. A *low-key photo,* for example, one in which the majority of tones fall in the darkest areas of the tonal range, tend to support a somber, serious mood, or one of mystery. A *high-key photo,* on the other hand, one in which the majority of tones fall in the lightest areas of the tonal range, tend to support a light, bright mood, or one of gaiety and happiness. Photos that have little contrast tend to create a mood of stillness, peace, and quiet. Those with a wide range of contrasts, create a mood of activity, vitality, and energy. See Figures 10–17 and 10–18.

The zone system

A more comprehensive approach to precise control of tone and contrast is the *zone system,* developed originally by Ansel Adams and Fred Archer.

The zone system is based on the concept of *previsualization,* a process by which the photographer analyzes the tonal values present in the subject and

B

A

Fig. 10–18 Tonal contrast. A. Flat contrast conveys feeling of stillness. B. High contrast generates feeling of activity, even with stationary subjects.

plans, before exposing the film, how to represent these values in the final print. In other words, one tries to visualize just how the final print will appear. Then using a light meter to measure the relative brightness of various parts of the scene, an exposure is determined that will, with proper development, render the various tonal values in the scene to the desired levels of density in the negative.

The system is based on a printed gray scale, such as that shown in Figure 10–13. Ten distinct shades, or zones of gray are represented. The deepest black (maximum density) of Zone 0 results from no exposure on the negative; the maximum white (minimum density) of Zone IX results from maximum exposure on the negative. Each successive zone represents double the exposure of the preceding zone — a one f/stop increase. The average shade in a full-scale print is the medium gray of Zone V. For all practical pur-

poses, clear, visible details may be expected only in Zones III–VII.

With careful testing of each film/developer combination, photographers can learn to place various subject light values in the zones they desire. By manipulating exposure, they may shift the entire tonal range of the image upward or downward in the scale, altering the tonal rendering of various details. By manipulating development time, the range of tonal values may be expanded or contracted to better represent the relative light values present in the scene. See Figure 10–19 for examples of zone system applications. The books by Ansel Adams and Minor White that are listed in the Suggested References on page 347 provide extensive explanations of the zone system.

Do Exercise 10–C on page 350

Fig. 10–19 Zone system applications. A. For soft light the range of densities was limited to only a few middle tones. B. Zone system scale. C. For stark contrast the middle densities were omitted and only the extremes were included.

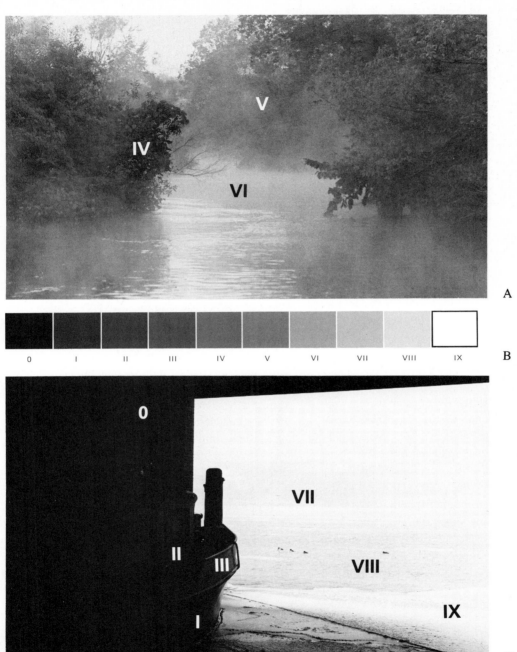

Color Composition

Objective 10–D Describe and demonstrate principles of color composition related to color harmony, psychological effects of color, and effects of reflected light.

Key Concepts color harmony, contrasting colors, complementarity, monochromatic, cast

Color provides the photographer with an additional dimension of control in organizing pictorial elements to communicate an idea, mood, or feeling. Emphasis and subordination of selected details can be achieved not only through control of perspective, lines of composition, tone, and contrast but also, in the case of color photography, by the arrangement of color details. Understanding some principles of color composition should help you achieve effective communication in color photography.

Color harmony

Color harmony refers to the relationship among various color details within the photograph. As with contrast in black-and-white photography, color details may be emphasized or subordinated by setting them next to objects or against backgrounds of *contrasting colors*. Similarly, certain hues and values tend to appear brighter than others and thereby attract attention to themselves, providing emphasis. By color harmony we mean an organization of color elements within a photograph that supports its central idea and avoids distracting color elements. See Color Plates 1 and 4.

To achieve a harmonious arrangement, you should be aware of the principle of *complementarity* of colors. Because white light is made up of all wavelengths in the visible light spectrum, any given hue is made up of only some of these wavelengths. The combination of wavelengths omitted from this hue make up its complementary hue — that color of light that would produce white light when combined with the given hue. The color wheel shown in Fig. 10–20 arranges a sample of twelve colors from the visible light spectrum into a circle. The primary colors — red, blue, and green — are connected in the figure by the solid triangle. The combination of light of these three pure hues would produce white light. The secondary colors — cyan, yellow, and magenta — are connected in the figure by the dotted triangle. Note that each secondary color is a combination of two primary colors. Note also that each color appears exactly opposite its own complement.

When any color appears against a complementary background color of lower saturation and value, its own hue is enhanced. It appears more brilliant and therefore is emphasized. Against a background of equal saturation and value, however, complementary colors compete for attention, often appearing to clash and vibrate in disharmony. See Plate 2.

Color contrasts can be developed in other ways besides using color complements. Even objects of the same hue may contrast if one is more highly saturated than the other. A scarlet rose may be set off nicely against a background of its pink cousins — a pink that may be identical in hue but of less saturation than the scarlet. Similarly the dull blue of a predawn sky may provide a fitting contrast to a bright blue electric sign — a color of the same hue, perhaps, but differing in value. Thus appropriate contrast can be developed even in *monochromatic* compositions — those based on one hue or several closely related ones — by controlling their relative saturations and values. The greatest contrasts can be developed, however, between complementary colors or between colors farther apart in the visible light spectrum. See Plate 3.

Psychological effects of color

It is difficult to generalize about the psychological effects of color. Under one set of circumstances, green and yellow hues may convey the general idea of new life, sunshine, and springtime; under another, the feeling of jealousy, sickness, or death. Red, the traditional color of hate and anger, may suggest the feeling of love and contentment in a cozy, firelit scene. Whereas blue is usually the color of cold, ice, and darkness, a photograph of an azure sky over a sandy shore may give a sense of warmth and summertime. In these matters there are far more exceptions than rules and you should rely on your own taste and judgment in communicating your ideas about a scene.

If we were to generalize about color, we would advance the following few principles:

1. The red-orange-yellow hues tend to appear brighter to the eye than the blue-green-violet hues of similar value. (These are often called warm tones in contrast to cold tones, though this may be confusing if you think in Kelvin terms, in which reds are cooler and blues warmer.) Nevertheless the apparent brightness of the red-orange-yellow wavelengths may draw attention to objects of those hues in a color photograph. Similarly, these red-orange-yellow hues tend to convey a greater sense of activity than the blue-green-violet hues.

2. The greater the color contrasts within a photograph, the more active and dynamic a feeling the photo will tend to convey. The photograph that contains a profusion of highly contrasting colors will tend to generate a sense of activity and energy.

3. Monochromatic compositions or compositions developed around a few closely related hues will tend to convey a sense of restfulness, tranquility, and stillness.

The effects of reflected light

Already you are aware that the color temperature of the source light can affect the color rendering of objects in a color photograph. As long as the light reaching the film is matched to the color temperature for which the film is balanced, the image will be rendered in hues that appear as they were perceived in the original scene. When the light source and film are not matched, the image will be rendered with an overall *cast* reflecting this mismatch. These effects and their filter corrections are shown in Plates 5 and 6.

The source light is not the only determinant of light hues that illuminate objects in a scene, however. Within the scene, color is reflected from object to object. Light rays reflected from an object tend to assume the hues of the object and to lend those hues to other objects upon which they fall. Thus light reflected from the green leaves of a tree would consist primarily of the green-blue wavelengths (the red wavelengths having been absorbed by the leaves). A nearby white object would reflect these predominantly green wavelengths as well as those of the source light. As we view the object, we are not aware of this phenomenon, and we perceive the object as white. Our color film, however, is more faithful; the influence of this green, reflected light is recorded as a greenish cast on the white object. Any object of strong color value can be expected to influence the cast of other, nearby objects. This effect may be useful if the cast is desirable in the color composition, or it may be a distraction. To eliminate the effect, separate strongly colored objects from other objects in the scene.

Some guidelines

Many of these principles can be applied by a simple extension of guidelines you have already learned from black-and-white photography. For example:

1. Try to photograph your subject against a background of weaker color. Look for neutral backgrounds of relatively low color saturation and

value. Out-of-focus backgrounds tend toward neutrality; the colors tend to merge as focus is diminished.

2. To emphasize the color of your subject and/or to heighten the sense of activity in the scene, try to shoot against a background of contrasting or complementary hue, weaker in saturation and value.

3. If you wish to emphasize the color of the overall scene and/or to heighten the sense of restfulness in the scene, try to shoot against a background of

similar hues, somewhat weaker in saturation and value.

4. To reduce the sense of busy-ness and confusion, avoid using a wide variety of colors in any single scene. Limit your colors to a few that are carefully chosen to express your idea and well organized to lead the attention of the viewer to the important details and relationships in the scene.

Do Exercise 10–D on page 351

Fig. 10–20 **Color wheel.** Twelve arbitrary hues from visible light spectrum, including primary colors — red, blue, green — and their complements — cyan, yellow, magenta, respectively. Complements appear opposite primaries. (From Kodak Publication No. E–66, *Printing Color Negatives,* Major Revision, 1978: p. 72, Color circle. © Eastman Kodak Company, 1978.)

Suggested references

Adams, Ansel. *The Negative*. Hastings-on-Hudson, N.Y.: Morgan and Morgan, 1968.

Craven, George M. *Object and Image: An Introduction to Photography*. Englewood Cliffs, N.J.: Prentice-Hall, 1975, chapters 4, 9, and 10.

Davis, Phil. *Photography*. 3rd ed. Dubuque: William C. Brown, 1979, chapter 10.

Jacobs, Lou, Jr. *Photography Today*. Santa Monica, Calif.: Goodyear Publishing, 1976, chapters 10 and 12.

Rhode, Robert B. and F.H. McCall. *Introduction to Photography*. 4th ed. New York: Macmillan, 1981, chapters 2 and 17.

Swedlund, Charles. *Photography*. 2nd ed. New York: Holt, Rinehart and Winston, 1981, chapters 3 and 10.

Time-Life Books. *Life Library of Photography: Color*. New York: Time, Inc., 1970, chapter 4.

White, Minor. *The Zone System Manual*. Hastings-on-Hudson, New York: Morgan and Morgan, 1968.

Suggested field and laboratory assignments

In black-and-white, shoot several pictures in which you use each of the following techniques. You may include more than one technique in each picture. Keep a shooting log and identify the techniques used in each picture.

1. A long shot, including the horizon, using one or more linear perspective controls to enhance the illusion of depth.

2. A long shot, including the horizon, using one or more aerial perspective controls to enhance the illusion of depth.

3. A shot using a natural frame to enhance the illusion of depth.

4. A shot using vertical composition lines to increase the feeling of strength or dignity.

5. A shot using horizontal composition lines to increase the feeling of rest, repose, or peacefulness.

6. A shot using diagonal composition lines to increase the feeling of violence or action.

7. A shot using curved composition lines to increase the feeling of graceful movement.

8. A shot using tone and contrast to emphasize the center of interest.

9. A shot using converging lines of composition to emphasize the subject or opposing lines to create a sense of conflict.

10. A low-key photograph, dominated by dark tones, to create a somber mood.

11. A high-key photograph, dominated by light tones, to create a bright mood.

12. A full-scale print containing deepest blacks, pure whites, and many differentiated grays throughout the tonal range.

Do Practice Test 10 on page 353

EXERCISE 10–A

1. Describe three ways to create the illusion of depth through control of linear perspective.

 A. _____

 B. _____

 C. _____

2. Describe three ways to create the illusion of depth through control of aerial perspective.

 A. _____

 B. _____

 C. _____

3. Describe how scale can be established in a photograph. _____

Return to Objective 10–B, page 333

EXERCISE 10–B

1. Describe six different types of compositional lines and the mood or feeling each tends

 to convey. _____

2. State three principles regarding the use of compositional lines.

 A. _____

B. _____

C. _____

Return to Objective 10–C, page 336

EXERCISE 10–C

1. Describe the tone and contrast characteristics of a full-scale print._____

2. Describe how tone and contrast can be used to emphasize a center of interest.

3. Describe how tone and contrast can be used to create or support the mood of a photograph._____

4. What are some subjects that are suitable for silhouettes? _____

5. What is meant by the term "previsualization" as it is used in the zone system?

Return to Objective 10–D, page 344

EXERCISE 10–D

1. Describe a principle of color composition that generally emphasizes the color of the

 subject and generates a sense of activity in a photograph. _____

2. Describe a principle of color composition that generally emphasizes the color of an

 entire scene and generates a sense of restfulness or tranquility. _____

3. Comment on the validity of the idea that "green is the color of envy." _____

4. If your subject, a man in a white suit, is photographed standing next to his blue car, what effect are you likely to observe in his suit? _____

In his face? _____

How might you deal with this effect? _____

Review References and do Suggested Field and Laboratory Assignments on page 347

PRACTICE TEST 10

For each of the following questions, select the one *best* answer and write its corresponding letter in the blank preceding the question. After you have completed the test, check your answers against the correct answers, which follow the test. If you miss any of the test items, review the study materials as suggested.

_____ 1. In photography, framing refers to _____.
A. using your hands to define the picture
B. using a natural foreground element to establish a frame for background elements
C. mounting the print after finishing
D. using dark objects in the foreground
E. all of the above

_____ 2. You're taking a picture in Death Valley. Which of the following might you use for perspective control?
A. a burro
B. a hiker
C. a desert plant
D. a horse and rider
E. any of the above

_____ 3. The illusion of depth is increased by _____.
A. horizontal lines
B. converging lines
C. vertical lines
D. parallel lines
E. zigzag lines

_____ 4. A feeling of speed and activity is generated in a picture by emphasis of the _____ and _____ lines.
A. horizontal, curved
B. vertical, horizontal
C. curved, diagonal
D. zigzag, vertical
E. diagonal, zigzag

_____ 5. In general, the feelings of softness and repose are best served by _____.
A. diffused lighting
B. horizontal composition
C. level camera angle
D. emphasis of the diagonal line
E. all except D

_____ 6. The _____ line is the slowest, least active line of composition.
A. horizontal
B. vertical
C. curved
D. zigzag
E. interrupted

7. Tone and contrast can be used in composition to create _____.
 A. emphasis
 B. detail
 C. mood
 D. A and B
 E. all of the above

8. Photos with a wide range of contrasts, with light and dark tones close together, will tend to create a feeling of _____.
 A. serenity
 B. mystery
 C. activity
 D. gaiety
 E. stillness

9. A picture in which a majority of tones falls in the highlight area of the tonal range is known as a _____ photograph.
 A. silhouette
 B. high-key
 C. low-key
 D. highlight
 E. A and C

10. A full scale print has _____.
 A. a majority of light tones
 B. a majority of dark tones
 C. white, black, and gray tones
 D. only white and black tones
 E. only gray tones

11. Previsualization in the zone system refers to _____.
 A. planning how tones will appear in final print
 B. placing your subject in a proper light
 C. framing your subject in the viewfinder
 D. planning what objects will appear in focus
 E. selecting a proper color correction filter

12. A subject shot against a background of complementary color equal in saturation and value is likely to _____.
 A. harmonize with its background
 B. appear as the center of interest
 C. generate a sense of restfulness
 D. clash with its background
 E. appear as a silhouette

13. An object of strong color is likely to _____.
 A. distract the viewer's attention
 B. reflect a cast on nearby objects
 C. confuse the viewer
 D. require the use of a filter
 E. lead to reciprocity failure

14. Red is the color of _____.
 A. anger
 B. violence
 C. treachery
 D. death
 E. any of the above

ANSWERS TO PRACTICE TEST 10

1. B See Figure 10–3, page 330.
2. E Any of these objects are of generally known size and will help you give an idea of the scale of the desert.
3. B See Figure 10–1, page 328.
4. E See Figures 10–7 and 10–8, page 334.
5. E Diffused lighting and the level camera angle add to the feeling of softness. The horizontal line is the least active.
6. A See Figure 10–6, page 333.
7. E Visibility of detail depends on adequate contrast between highlights and shadows. "Use of Tone and Contrast," page 336, discusses how tone and contrast also can contribute to mood and emphasis.
8. C See "Use of Tone and Contrast," page 336.
9. B See "Use of Tone and Contrast," page 336.
10. C See "Use of Tone and Contrast" on page 336 and Figure 10–13.
11. A See "Use of Tone and Contrast," page 336.
12. D If the subject and background are of complementary color, clash or vibration will result unless one is subdued in saturation and/or value. See "Color Composition," page 344.
13. B Color is reflected from object to object. See "Color Composition," page 344.
14. E These phenomena have no color, except as the photographer interprets them — it is a matter of judgment. See "Color Composition," page 344.

APPLIED PHOTOGRAPHY

U N I T 11

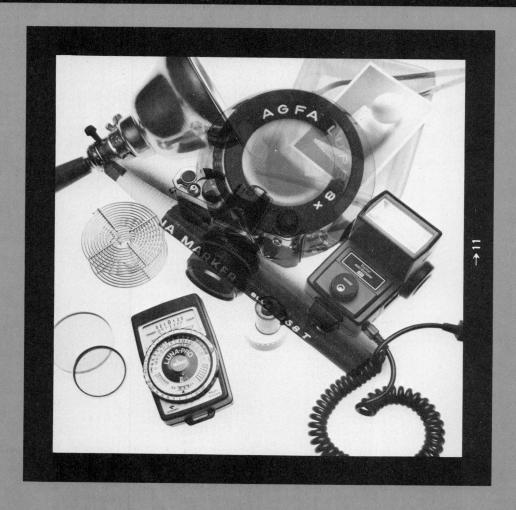

Scenery

Objective 11–A Describe some of the principles and techniques of scenic photography.

Key Concepts grand view, intimate view, haze, contrast, actinic light, foreground detail, flat lighting, cross-lighting, backlighting

Visit a national park, beach, desert, or mountains and you will see some spectacular scenery that you may want to capture on film. Your first efforts to photograph such vast scenic grandeur may not quite measure up to the glorious scenes that inspired you. The endless, breathtaking space has been shrunk into the small borders of a print. A magnifying glass is needed even to see the once great distant mountain ranges. The fields of brilliant flowers have merged with the surrounding foliage into a pallid gray mass. It is easy to see why scenic photography poses such a challenge to photographers and provides a lifetime of study for many.

Many variables enter into the making of a scenic photograph. As the sun moves across the sky or passes behind a cloud, the lighting of a scene continually changes character. In spring, summer, winter, or fall, in rain, snow, or sun, each change of season or weather alters the landscape. Add to these the myriad of possible viewpoints, lenses, filters, and more, and you can see that the picture possibilities in even a single landscape are virtually limitless.

As with other types of photography, scenic photography requires first that one learn to see — to study the subject and to visualize the final result. It requires next that one learn to execute — to perform the operations necessary to achieve what has been visualized. One of the more important factors in visualizing the final result is to compose for the format of the final print. Unlike the actual scenery that has no borders and extends off into space in all directions, the scenic photograph has precise borders at the top, bottom, and sides. Because of this limiting feature, successful scenic photography involves deciding carefully what features will appear in the final image, what features will not appear, and what features will be emphasized. To make these decisions, the photographer needs to become consciously aware of the impressive characteristics of the scene. Is it the way the sunlight filters through the trees that is most moving? Or is it the towering height of the cliff face nearby? Decisions follow naturally from awareness. Many a scenic photograph has failed because the photographer failed to visualize the final result and tried to include too much within the limiting borders of the image.

Your scenic photographs will be more interesting if you select a principal feature in the scene to emphasize. Use your camera's viewfinder and apply basic guidelines of composition to compose your shots. It takes experience to compose successfully with the naked eye and, until you have gained it, you should use your viewfinder as a basic compositional tool. With your viewfinder you can readily see the top, bottom, and side limits of the frame and the relationships among the various features in the scene. You can see if your intended center of interest is obscured or dominated by other elements in the frame. By moving the camera to different positions and by changing focal length or depth of field, you can alter composition in the viewfinder until the image best communicates your idea about the scene.

A vast landscape encompassing miles of space is sometimes termed a *grand view;* a narrower scene measured in yards, an *intimate view*. Whatever view you seek to capture, remember that your purpose is to convey the character, the mood, and the feeling of the place as you experience it, rather than to make a simple record. Try to communicate whatever stirred your own interest and excitement. Your scenic photograph should not be a simple picture of a place, but should tell a story about a place.

Fig. 11–1 Grand scenic view. Pictures convey sense of great distance and magnitude.

The grand view

To communicate the expanse of a grand view, you will often want to emphasize visual elements associated with distance, such as atmospheric haze, tone and contrast, foreground detail, lighting, and depth of field.

Often a grand view contains natural *haze* because of the distance involved. To eliminate haze in black-and-white photographs so that distant details appear

clearer, you may use a haze-penetrating filter such as yellow, red, or a polarizing filter. Many times, however, a photographer wishes to include natural haze to enhance aerial perspective. To include haze you might elect to use no filter or, to exaggerate haze, a blue filter.

Scenic photographs may also benefit from control of *contrast.* Even though we can see white clouds against a blue sky, the panchromatic film we use may not separate those tones. Similarly, as we have seen earlier, the film may record certain colors, such as red and green, in similar tones of gray even though we may see them as distinctly different values. Further, if you are shooting at high altitudes, at the seashore, or in the snow, you may wish to compensate for the intense ultraviolet light, called *actinic light,* that is present in these places. Thus, to better represent tonal contrast in scenic photographs, filters are often used. (See Unit 7 for a more complete discussion of filters for black-and-white as well as color photography.)

Foreground detail also adds to the sense of distance. A rock, tree, shrub, or person in the scenic foreground provides a visual reference by which the viewer may judge the scale of distance in the photograph.

Lighting also is important to the grand view. The adage ''keep the sun at your back'' rarely provides the best lighting for grand scenic views. In that position, the sun produces relatively shadowless *flat lighting* that reveals little texture. Similarly, noon sunlight from directly overhead seldom produces the shadow patterns that best reveal landscape features. *Cross-lighting,* on the other hand, cutting across the landscape from a relatively low angle, improves image contrast and reveals the contours, textures, and shapes of scenic features. *Backlighting,* striking the scenic features from behind, reveals their shapes and outlines and often produces spectacular rim highlights, although the frontal details may be lost in shadow. Often the features of most interest are enhanced when their shapes and textures are emphasized by appropriate lighting. Natural lighting of this

sort is most often available during the early morning and late afternoon when the sun is relatively low on the horizon, a time favored by many landscape photographers.

For the grand view, it is usually desirable that features in the near foreground as well as those in the distant background appear in sharp focus. To obtain maximum depth of field, the landscape photographer often uses small apertures and hyperfocal focusing.

The intimate view

The intimate view may picture sailboats at a lakeside dock, a rural church, or mailboxes along a country road. Whereas the grand view seeks to picture great scale and distance, the intimate view focuses on particular features closer at hand. Once again, significant foreground detail may provide a useful frame of reference, a feeling of depth, and a means to direct the viewer's attention to the details of particular interest.

As with a grand view, you may find filters useful with an intimate view. The yellow filter, for example, helps preserve sky-cloud contrast, yet it keeps foliage from appearing too dark. If the sky is the main interest, however, a red or orange filter will produce a dramatically dark sky with chalky white clouds. These filters also tend to reduce haze which, in an intimate view, may give an unwanted feeling of distance.

Great scenic photographs do not need miles of space; many focus on only a few square yards of natural scenery and close-ups of such features as a bough of leaves, a few rocks in a stream, or the gnarled roots of an old tree. Many potentially exciting photographs may lie just at your feet as well as in the distance as you gaze across miles of grand scenic landscape. Train yourself to pay attention to the close-up details that may capture your imagination and convey a sense of the region that produced them.

Fig. 11–2 Intimate scenic view. Pictures draw attention to close details.

Scenes with water

Water may be a part of either a grand or an intimate scenic view and sometimes poses problems for the photographer. For example, if your picture of a quiet pond includes a reflection of the shore, the viewer may have to rotate the picture to figure out which side is up. For such scenes, breaking the smooth reflecting surface of the water with a stone or including a strong, unreflected foreground feature often helps to distinguish up from down and to add interest to the water detail.

Marine scenes, too, may be grand or intimate views, usually dominated by sea and sky. Large foreground waves or rocks may appear as a center of interest; boats, birds, or interesting cloud formations may establish the mood or idea of the scene. Sometimes a marine scene would benefit from the presence of living creatures, creatures that are often camera-shy. You might try carrying some food along to attract them.

Backlighting and silhouettes can often be used to excellent effect in marine scenes. Light reflecting over the water and toward the camera reflects a myriad of glints, dapples, and sparkles from the surface of the water that enlivens the picture and provides a brilliant background against which foreground objects may be silhouetted.

Fig. 11–3 Scene with water. Yellow filter used to darken water reflecting expanse of blue sky.

To darken the surface of water under blue skies, proceed as you would to darken the blue sky itself. Use a yellow, red, or polarizing filter, for the surface of the water only reflects the light of the sky. A red and polarizing filter combined will produce spectacular night effects with back- or side-lighted surf.

Do Exercise 11–A on page 393

Architecture

Objective 11–B Describe some of the principles and techniques of architectural photography.

Key Concepts record shot, interpretive shot, keystone effect, perspective control (P-C) lens

Photographs of buildings or other architectural structures may be classified as either record or interpretive. A *record shot* is one that shows a structure in its entirety and attempts to represent all its essential details from a relatively neutral point of view and with a minimum of distortion. An *interpretive shot* may show all or only a portion of a structure. It attempts to convey an impression of its character and its meaning beyond the simple fact of its existence.

Interpretive architectural photography is closely related to outdoor portraiture. The photographer must study the subject and come to know it quite well — its character, its personality, its moods at different times, in different seasons, and in different weather — and ultimately develop a statement about it through a photograph. Only then may the photographer select an appropriate point of view from which to picture the structure, appropriate lighting angles, and time of day. Only then may the photographer decide which features of the structure to emphasize and which tonal qualities to seek.

Architectural photography may call for special equipment. For example, you may have to picture a tall building from across a narrow street or a long bridge from a position near one end of it. Under these conditions you may find a wide-angle lens useful to encompass the entire structure from such short range. At other times you may want to capture a feature far up the facade of a building or far out along the span of a bridge. Under these conditions, you may find a telephoto lens useful to obtain a close-up image of some distant detail.

Because architectural subjects are typically large and deep, small apertures are commonly used to assure maximum depth of field. As a consequence, exposure times are typically long and the use of a tripod or other camera support is usually necessary.

Architectural subjects often benefit from the use of contrast filters that increase figure-ground contrast and create a dark sky background against which the structure will stand out in bold relief or appear to be separated from its background.

Ordinarily the pictured structure will gain impact if it does not appear isolated in space. The presence of other objects of known size, such as trees or people, will convey a sense of scale to the viewer. The presence of nearby features, such as other buildings or nearby lakes or mountains, will convey a sense of locale. These additional features provide the viewer with a frame of reference that contributes to a more complete understanding of the subject.

To photograph an architectural subject, one often cannot avoid shooting from ground level and pointing the camera upward toward the top of the structure. At close range this produces a *keystone effect*. Because the top of the structure is farther away from the camera than the base of the structure, the top appears smaller than the base and the parallel vertical sides of the structure tend to converge as they rise to the top of the picture. To deal with this and other problems of perspective, the serious architectural photographer often prefers to use a view camera with a full complement of swings and tilts to control perspective. Ground-glass focusing and composing also are considered essential for this kind of work.

To accomplish similar purposes with a 35-mm SLR camera, a *perspective-control (P-C) lens* may be used. This wide-angle lens is designed so that its optical elements may be shifted off center and the entire lens rotated on its axis. With these adjustments it is possible to obtain some control over perspective similar to that provided by a view camera, although not to the same degree.

Perspective should be controlled at the time the exposure is made in order to obtain optimal image

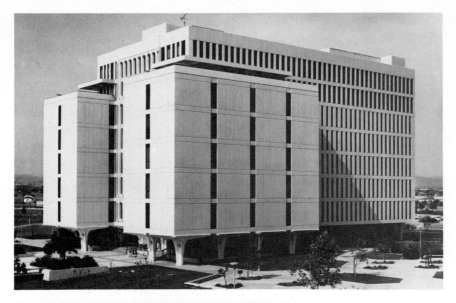

Fig. 11–4 Architectural record shot. Above. Seeks to represent entire structure without interpretive comment.

Fig. 11–5 Interpretive architectural shot. Left. Seeks to capture character of structure and to convey photographer's feeling about it.

quality, but that is not always possible when working with a standard camera and lens. If you are unable to control perspective at the time the exposure is made, remember that perspective can be corrected partially, sometimes even completely, during enlargement. When composing the image for enlarging, simply tilt the easel so that the projected image reverses the perspective distortions present in the negative. Some enlargers provide for tilting the negative stage as well. With proper adjustments of this sort during enlargement, the combination of the negative's distortion and the enlarger's distortion in a reverse direction will make the print appear normal. See "Convergence Control" on page 171.

Do Exercise 11–B on page 394

A

B

Fig. 11–6 **Techniques for interpretive architectural photography.** A. Character revealed by selection and emphasis of detail. B. Precise timing. C. Cross-lighting to reveal significant texture and detail.

C

Still Life

> **Objective 11–C** Describe some of the principles and techniques that can be used in photographing still-life subjects.
>
> **Key Concepts** close-up lens, extension tubes

The function of still-life photography is to generate meaning or to communicate an idea from an arrangement of inanimate details and objects. Still-life photography often poses a special challenge for the photographer. The arrangement of the objects to be photographed and the manner in which they are photographed should communicate to the viewer in a way that transcends the objects themselves. The unsuc- cessful still life is simply a record shot of several objects. The viewer is likely to be left wondering, ''I see these objects, but so what?'' The successful still life achieves meaning beyond the mere record. The viewer of a successful still life is left with ideas and feelings called up by the objects arranged in the picture. Without an idea as a basis, a still life lacks vitality and interest.

The necessary equipment need not be elaborate. A camera, a camera support, and a few lights are all that are necessary. However, it is preferable to use a camera that permits accurate viewing and focusing on a ground-glass screen to eliminate the problems of framing and focusing. SLR and view cameras work well for this purpose. For close-up work, an acces- sory *close-up lens*, a bellows unit, or a set of *exten- sion tubes* will be useful for focusing at closer-than- normal distances. (See Objective 11–G.)

A

B

Fig. 11–7 Still life. A. Achieves thought or feeling beyond mere record. B. Selection and arrangement of detail to create mood and tell a story.

Effective pictures can be made with just one photoflood light (with reflector) and a piece of white cardboard. The best lighting positions conform to the principles of object photography. See "Lighting Small Objects," page 276.

Ordinary household tungsten lamps can be used in still-life photography when the subject is small. The inanimate nature of still life means that you seldom need short exposures, so brilliant lighting is not required. Larger subjects may require more than one light source. A tripod is recommended as a camera support to aid in composition and to hold the camera steady during painstaking framing and focusing as well as for slow exposures.

Do Exercise 11–C on page 395

People

Objective 11–D Describe and demonstrate some common sense guidelines for photographing people.

Key Concepts characteristic activity

People like to look at pictures of people. If you are learning about photography for your own pleasure, you'll find that people — your family, friends, children, and others you meet going about their daily activities — will be among your most important sub-

jects. If you are learning about photography for professional reasons, you'll soon learn that the ability to capture the feelings and personalities of people in both natural and planned settings is an invaluable asset. There are several common sense guidelines that apply to most pictures of people.

1. Avoid distracting backgrounds.

A photograph of people will benefit from simplicity. The photograph should draw the viewer's attention to the people who are the center of interest. Avoid any kind of background that might confuse or distract the viewer's attention from the center of interest.

To simplify your shots of people, consider using the sky as a background. The sky, with or without clouds, usually provides a flattering background for people, especially with a yellow or light green filter and panchromatic film to darken the sky tones. If outdoors, try posing your subject on a hill or sitting on a wall or similar object that will allow you to shoot a low-angle shot against the sky.

The ground too may provide a plain background while you stand on a chair, wall, or other object for a high-angle shot. Or try posing your subject seated on the ground.

The side of a plain building may provide a suitable background for your picture, but avoid such busy patterns as brick and stone. Indoors, a plain wall or drape may provide an uncluttered background. If you are using flash, however, be sure to pose your subject several feet away from the wall to avoid distracting shadows. If background objects will appear in the picture, try to arrange them in such a way that they contribute to the overall composition rather than distract from it.

2. Use close-ups.

Get your camera in as close as possible to your subject. A simple guideline is to shoot at a conversational distance. You'll want a large image on your negative. A negative with a small image outline must be enlarged considerably and thus may result in a grainy print.

Fig. 11–8 Background. Background creates environment for subject's activity.

3. Give your subject something to do.

Sometimes the only activity you can provide your subject is conversation, but even that is better than simply smiling self-consciously for the camera. Give your subject something to hold — a book, a hoe, a bouquet of flowers — something characteristic of the individual that will tell us something about that particular person. Try to photograph people engaged in or looking up from an activity, whether it be brushing a horse or arranging a stamp collection. The most

Fig. 11–9 Activity. Subject engaged in characteristic activity reveals more of self than one who simply smiles into camera.

revealing pictures of people, like portraits, depict the central figures engaged in a *characteristic activity,* something they do regularly and may be known for among their friends.

4. Eliminate distracting objects.

Remove the picture in the background, or other inappropriate background objects. Remove lights that might form white glares in the background, as well as mirrors and other reflective objects. The fewer objects there are in the background of the photograph, the greater will be the emphasis on the center of interest. Make sure that those objects that do appear in the background are related to the subject or the sub-

ject's activity in the photograph. For example, if your subject is shown painting a picture, brushes or paints or similar objects may serve to enhance the overall impression. Moving in closer to your subject, by the way, is one good way to eliminate extraneous background objects that might distract from the subject or that might have to be cropped out of the final print.

5. Use lighting to help portray your subject.

Diffused, flat lighting is soft and tends to be appropriate for subjects in a quiet, reflective mood or situation. Specular lighting is hard and tends to reveal textures when it is used to cross-light your subject.

A

B

Fig. 11–10 Lighting. A. Soft lighting for soft, gentle idea. B. Contrasty lighting appropriate to strong subject.

This type of lighting is usually appropriate for subjects in an aggressive, active mood or situation. Try to avoid the midday sun for it produces deep and harsh shadows. Try never to force your subjects to look directly into the sun for it generally makes them squint and produces unnatural expressions. Refresh your memory on "Principles of Artificial Lighting," on page 259 to enhance your subject with lighting.

Do Exercise 11–D on page 396

Action

> **Objective 11–E** Describe real action, simulated action, and peak action and demonstrate a technique used for photographing each.
>
> **Key Concepts** real action, peak action, simulated action, blurred movement, time exposures, photo sequence

Action may be classified into three types: real, peak, and simulated. Each requires a different approach to shutter speed.

Real action

Real action is what the name implies: movement that is occurring as you take the picture. Real action is a halfback's run in a football game, a speeding car, a baseball player in the middle of a swing, a runner in the midst of a 100-yard dash. Because your subject is in movement at the moment your shutter snaps, faster shutter speeds are required to stop the action.

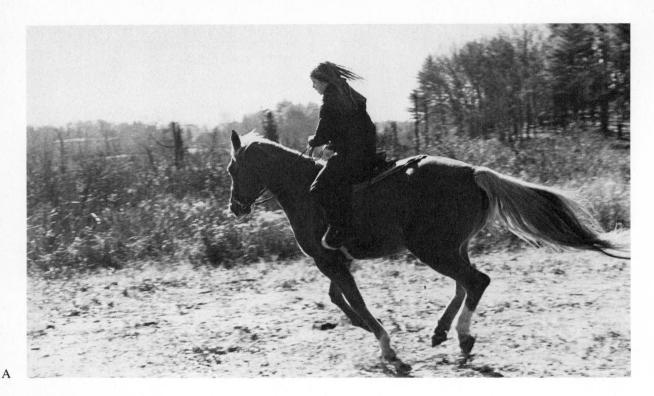

A

Fig. 11–11 A. Real action. B. Peak action. C. Simulated action.

Peak action

Peak action is the split second when real action slows or even stops. In most action situations there is a moment when the action reaches a peak. This moment provides an opportunity for a picture in which action can be stopped with a slower shutter than that required for real action. At the very top of a pole vault, for example, as the vaulter's body reaches the top of its upward flight, movement momentarily slows. Yet this moment provides an excellent picture opportunity in this field event. The peak instant in a pole vault can be stopped with a much slower shutter speed than the vaulter's approach, ascent, or descent.

Baseball has a number of moments that are full of peak action. The pitcher winds up and then unwinds to throw the ball. In that instant between winding and unwinding the action is suspended. The same is true of the follow-through. In swimming and diving, the diver touches the toes in the jack-knife and is poised. The punter in football at the top of the follow-through is another example. The tennis player follows through after each serve and shot.

The photographer who snaps the shutter when action pauses during its peak is able to use a slower shutter speed and therefore a smaller f/stop, which permits greater depth of field. In low light, the ability to record action with a slower shutter speed at peak

B

C

moments of action may mean the difference between success or failure.

Simulated action

Simulated action is found in a situation where the subject makes no swift movements yet appears to be occupied by a task. A person talking on a telephone is an example of simulated action. The president may appear to be signing new legislation. New officers of an organization appear to be examining a record book. A picture of a person drinking something or lighting a pipe will suggest more action to the viewer than a snapshot of a subject standing motionless and looking into the camera with a grin. A recommended practice for photographing people is to have them doing something to introduce simulated action. Pictures that simulate action reveal more of the personality of the subject than those that merely record the subject's presence before the camera.

Depicting action

A good action picture does not always require that movement be frozen. Sometimes an effective photo results when the photographer purposely uses a slower shutter speed to obtain the effect of *blurred*

A

B

Fig. 11–12 Blurred vs. stop action. A. Intentional blurs enhance feeling of action. B. Idea of motion expressed by stopping or freezing action at an instant in time.

Fig. 11–13 **Implied action.** Diagonal composition adds to feeling of dynamic movement.

Fig. 11–14 **Time exposure.** Movement expressed by allowing moving subject to create trace across film.

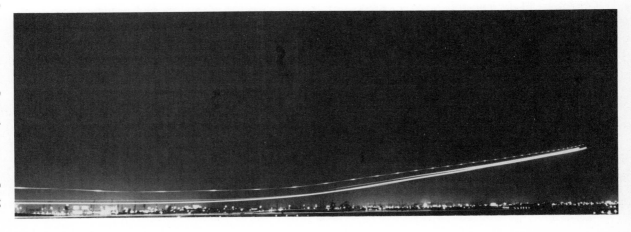

movement. The resulting picture, slightly blurred, may add emphasis to the sense of movement. When the subject's action is obvious, as it is from the straining muscles of the high hurdler, freezing the action may promote more interest than blurring the action. In this case a stop action shot would tend to reveal the straining muscle and sinew and the runner's concentration, whereas the blurred shot would tend to conceal this detail.

Whatever the type of action, the sense of movement can be enhanced by appropriate timing. For example, action may be implied if the subject of the picture is off-balance or suspended in midair. Use of compositional lines — especially the zigzag and diagonal — also enhances the illusion of movement and action. At night, *time exposures* can be used to capture the action patterns of moving lights or the tracings of exploding fireworks.

Finally, action can be depicted by means of the *photo sequence*. As the viewer's eyes move from picture to picture in a well-designed sequence, they will transmit a sense of action and movement.

Do Exercise 11–E on page 397

Emotion

Objective 11–F Describe how successful pictures of people appeal to basic human emotions.

Key Concepts emotion, conflict appeal, sex appeal, ambition appeal, escape appeal

Photographs that appeal to basic human *emotions* have a special kind of impact. The viewer does not simply observe the subject, but reacts emotionally to it. The viewer may laugh, feel sad, or simply em-

pathize with the emotions of the subjects. Some of the subjects that appeal to basic human emotions are related to conflict, sex, ambition, and escape.

Conflict exists when people compete against others or against the forces of nature or society. It may be seen in photographs of firefighters battling a blaze, residents sandbagging to fight a flood, ordinary people struggling against disasters. The human competitive spirit is seen also in sports, in elections, in business, and in a grimmer way, in war. Accidents are another context in which we can observe basic human conflict against the forces of nature and society.

Sex appeal has become a standard phrase in our language and it describes another appeal to basic human emotions. Photographs of attractive men and women, singly, in couples, and in groups, usually appeal to human beings of both sexes: they attract the eye and trigger emotional responses. Sex appeal may be observed in action in newspaper and magazine advertisements and in human interest stories and articles.

The *appeal to ambition* can be seen in pictures of people who have achieved success in any area of business, science, athletics, cultural activities, industry, or in other human pursuits. People are interested in others who have achieved success, who have overcome odds, or who by the workings of chance have attained a measure of fame or a notable position.

Finally, photos of people in recreational activities possess *escape appeal*. Escape is represented when the subjects portrayed are shown attempting to escape the monotony of everyday life by having fun, in the pursuit of pleasure and adventure. The person with an interesting hobby, the surfer, or the mountain climber, appeals to the viewer's desire for escape. For a moment the viewer can empathize with the subject and escape the routine of life.

Seeing picture possibilities that appeal to basic human emotions is a skill that can be developed. Look at your photographic subjects. Ask youself what feeling or emotion the subject generates in you. Then consider how best to convey that same feeling or

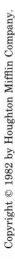

Fig. 11–15 Conflict appeal. Emotion is evident in competitive sports.

emotion to your viewer. Ask yourself not only what the idea of your photograph is to be, but also what the emotion of the photograph is to be. Your own emotional sensitivity to the scenes you perceive can be developed.

Do Exercise 11–F on page 397

Fig. 11–16 Escape appeal. Desire to escape
is conveyed in photographs of adventure, sport,
and faraway places.

Close-up and Copy Photography

Close-up photography

With most cameras equipped with a normal lens, you can take pictures from as close as 2 to 3 feet (.6 to 1 meter). However, this is not usually close enough to get extreme close-ups of small objects such as flowers, small animals, or insects. To obtain really dramatic close-ups of small objects, you must be able to move the camera much closer to the subject. In order to focus this close to the subject, special lenses or accessories are needed.

Not all cameras are well suited for close-up work. At close distances, focusing and framing are critical. The slightest misdirection of the camera axis may shift the field of view far off the subject. Depth of field is extremely shallow at close distance, often no more than a small fraction of an inch. Consequently, extremely precise framing and focusing are necessary to assure that essential details are recorded in sharp focus.

The cameras best suited for close-up work are those that permit framing and focusing directly through the camera's picture-taking lens — the single-lens reflex and view cameras. Only these cameras permit one to view precisely the frame and focus of the image as they appear at the focal plane prior to making the exposure. Close-ups can be made, of course, with viewfinder and twin-lens reflex cameras, but the process requires precise measurement to correct parallax and to obtain correct frame and focus.

Techniques

The techniques of photographing objects at close range have been classified in several categories. The term *close-up photography* is used to describe photography between a camera's minimum focusing distance (with normal lens) and a distance of about two focal lengths from the subject. At the normal minimum focusing distance, the image of an object is recorded at about 1/10 lifesize, or at a 1:10 *image-to-object ratio*. When the camera is brought to a distance of two focal lengths from the object, the object is recorded at about lifesize, or at a 1:1 image-to-object ratio.

The term *photomacrography* is used to describe the photographing of objects to produce an image larger than lifesize. The image-to-object ratio produced by these techniques ranges from 1:1 to as much as 50:1, or 50 times larger than life. The term *photomicrography* is used to describe the photographing of objects through a microscope to produce an even larger image-to-object ratio. Using an electron microscope, for example, it is possible to record an image-to-object ratio as great as 200,000:1, and to make visible images of details that are far beyond the range of the unaided eye. Figure 11–17 distinguishes among the several classes of close-up photography. All of these procedures for photographing objects closer than the minimum focusing distance of a normal lens require the use of special techniques and equipment.

Two other techniques are often confused with these. The term *microphotography* is used to describe techniques for producing extremely small images, such as those used in micro-electronic circuits. The term *macrophotography* is used to describe techniques for producing extremely large images, such as photomurals and posters.

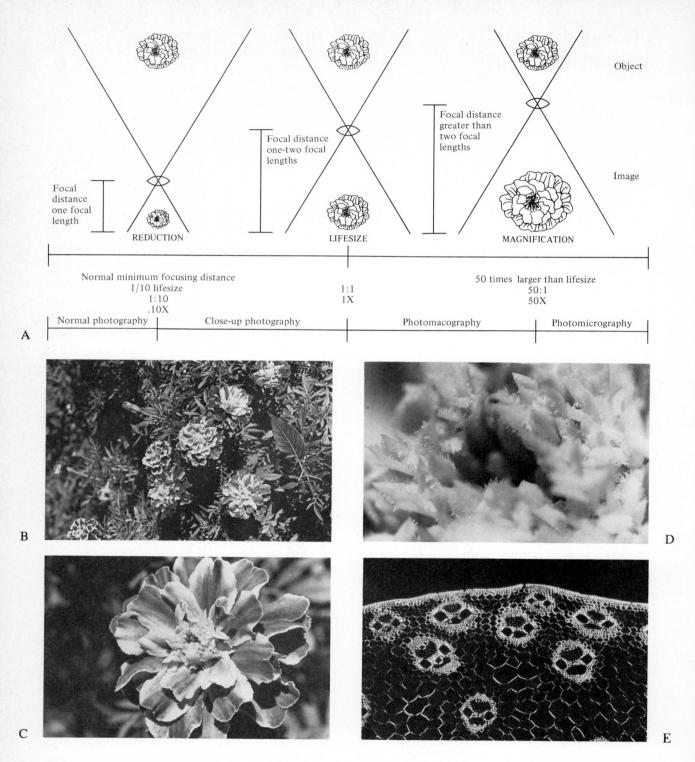

Object

Focal distance
greater than
two focal
lengths

Focal distance
one-two focal
lengths

Image

Focal
distance
one focal
length

REDUCTION

LIFESIZE

MAGNIFICATION

Normal minimum focusing distance
1/10 lifesize
1:10
.10X

1:1
1X

50 times larger than lifesize
50:1
50X

| Normal photography | Close-up photography | Photomacography | Photomicrography |

A

B

C

D

E

◀ **Fig. 11–17 Close-up photography.** A. Reduced, lifesize, and magnified focusing distances. B. Normal focusing distance. C. Close-up photography. D. Photomacrography (center of flower). E. Photomicrography (stem cross-section).

Equipment

In normal operation, a camera's lens is positioned so that, at infinity, the distance between the lens and the focal plane, known as the *focal distance,* is approximately equal to one focal length. Within the normal focusing range, some minor extension of the focal distance is needed to focus at closer distances. To focus on objects closer than the minimum focusing distance, the focal distance must be extended significantly beyond one focal length.

HELPFUL HINT

The focal frame
A device for precisely framing and focusing subjects using close-up lenses with a viewfinder camera is the *focal frame.* A focal frame may be made from a block of wood and some heavy metal wire, such as from a wire clothes hanger. Figure 11–18 shows how the wire, formed into a frame, is attached with the camera to the block to measure an exact focusing distance and to frame the area included in the field of view. A different focal frame is needed for each close-up lens and focusing distance you wish to use because each focal frame is good for only one situation.

To determine the dimensions of a focal frame you may use a published table to determine focusing distance and field size for various close-up lenses and focus settings. Table 17 is an example for a 35-mm camera with a normal 50-mm lens focused at infinity.

Several types of equipment are used to increase the ratio between the focal distance and the focal length of the lens. One of these is the *close-up lens,* a simple magnifying lens fitted in front of the normal lens to shorten its effective focal length. Most modern close-up lenses attach by means of a threaded mount or an adapter ring, just as filters attach. Close-up lenses are available in various strengths commonly designated as +1, +2, +3, etc., that relate to their focal length — the stronger the lens, the greater the degree of magnification. Close-up lenses also may be used in tandem. Combining a +2 and a +3 lens, for example, will produce the effect of a +5 closeup lens. By shortening the effective focal length, a close-up lens increases the ratio between the focal distance and the focal length. One advantage of using close-up lenses over other alternatives is that no exposure compensation is required. Another advantage is that they can be used with fixed lenses as well as with interchangeable lenses. A disadvantage, however, is that image quality is somewhat degraded by introducing these additional lens elements into the optical system.

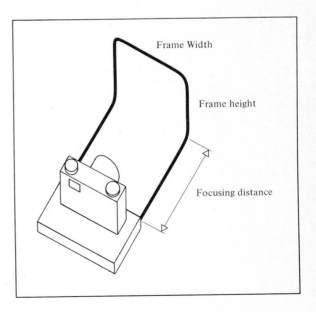

Fig. 11–18 Focal frame.

Table 17 Close-up Lens Data for 35-mm Camera with 50-mm Lens Focused at Infinity

Close-up Lens	Focusing Distance* (cm)	Approximate Field Size (cm)
+1	100	46 × 68
+2	50	23 × 34
+3	33	15 × 23
+3 plus +1	25	11 × 17
+3 plus +2	20	9 × 14
+3 plus +3	17	8 × 11

*Focusing distance is measured from the front rim of the close-up lens.

Other types of equipment are the *bellows unit* and *extension tubes,* used to increase the focal distance. These devices can be used only on cameras with interchangeable lens systems because they are attached between the camera body and the lens. The bellows unit provides for continuous extension of the focal distance by racking the bellows between its minimum and maximum limits. A bellows unit is useful for extreme close-ups requiring exact framing and focusing. Extension tubes, a less costly alternative to the bellows unit, are manufactured in sets consisting of several interconnecting hollow tubes that can be used singly or in combination to extend the focal distance by fixed increments up to two focal lengths.

Another type of equipment is the *macrolens* designed especially for close-up photography in place of a camera's normal lens. This alternative is generally better for close-up photography than using a camera's normal lens with a close-up attachment. The normal lens is designed to give optimal performance between the normal minimum focusing distance and infinity. Using attachments to focus closer than that introduces optical aberrations that degrade image quality as the focusing distance is reduced, although the image is generally acceptable up to a 1:1 or lifesize image-to-object ratio. Macrolenses are designed to give optimal performance in the close-up

focusing range and beyond, although they may not operate as well in the normal focusing range, especially toward infinity. A macrolens can only be used, of course, if your camera provides for interchanging lenses.

Another type of equipment used for close-up photography is the *reverse adapter*. A normal lens may focus satisfactorily up to a 1:1 ratio — with the focal distance extended to about two focal lengths. At greater focal distance (and greater magnification), image quality may be improved by reversing the normal lens in its mount. Reverse adapters are manufactured for various lens-mounting systems and permit the interchangeable lens to be mounted front-to-back for improved performance in photomacrography. Figure 11–19 shows several types of close-up equipment.

Determining exposure

Determining exposure for close-up photography is sometimes awkward. Obtaining a reading with a conventional light meter at the object position is difficult because of shadows created by working so close to the camera and the subject. Furthermore, a conventional meter is ill-equipped to distinguish important highlight and shadow differences within the extremely narrow fields of view characteristic of close-up photography. For these reasons, a built-in, through-the-lens (TTL) light-metering system is generally more accurate and convenient. If it is necessary to use a conventional light meter, exposure may be determined more easily by using an 18 percent gray card (see page 95). When using close-up lenses or a reverse adapter, exposure is determined in the normal way. Using a bellows unit, extension tubes, or a macrolens, however, may require an exposure increase. When the focal distance exceeds one focal length, the f/numbers on the aperture scale cease to function in the normal way. This is because the f/numbers are calibrated to assume a focal distance of approximately one focal length. When the focal distance is increased beyond that, the image brightness at the film plane is decreased. Thus the f/numbers on the aperture scale

A

B

C

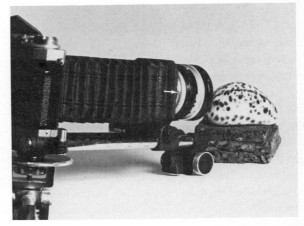

D

Fig. 11–19 Close-up accessories in use. A. Close-up lens attachment. B. Extension tubes. C. Bellows unit. D. Reverse adapter (note arrow).

overestimate the actual image brightness. Exposure would need to be increased over that indicated to obtain proper exposure.

If you use a TTL light-metering system, the problem is overcome automatically because the system reads the actual image brightness, not the f/numbers on the aperture scale. If you use a macrolens, an exposure compensating scale inscribed onto the focusing scale permits you to make simple exposure adjustments at various focal distances.

If you use a bellows unit or extension tubes and conventional metering, however, you must determine an *exposure factor* by which to increase exposure at any given focal distance. To do so, you may use the following formula:

$$\text{Exposure factor (EF)} = \frac{(\text{focal length} + \text{extension})^2}{\text{focal length}^2}$$

For example, if you are using a 50-mm lens and a

CLOSE-UP AND COPY PHOTOGRAPHY 381

20-mm extension, making a total focal distance of 70 mm, then

$$EF = \frac{(50 + 20)^2}{50^2} = \frac{70^2}{50^2} = \frac{4900}{2500}$$

$$= 1.96, \text{ or about } 2$$

Thus, in this case, the exposure indicated on your conventional meter would have to be multiplied by 2 to obtain proper exposure.

Because close-up focusing distances produce shallow depth of field, it is usually desirable to use small apertures to maximize the field of focus. Furthermore, if close-up lenses are used, their performance is generally improved using apertures of f/8 or smaller. Small apertures, in turn, mean slower shutter speeds are needed to obtain proper exposure. Thus, extreme close-ups may require exposures longer than 1 sec. and some compensation for reciprocity failure may also be necessary. (See page 81.)

If excellent close-up results are desired, you can see that you must use a lens of fine quality that will operate well at the focal distance required, focus and frame precisely, account for sometimes extremely shallow depth of field, avoid movement of camera or subject, and obtain precise exposure by compensating for lens extension and reciprocity failure as may be required.

Lighting

The principles of lighting objects for close-up photography are the same as for lighting in other situations, although special techniques are required to work at close distances.

To obtain a balanced light effect, sunlight or a single spotlight may be used for key light with a reflector of white paper or aluminum foil used to bounce fill light into the shadows. For many subjects, the soft, even, diffused light of an overcast day may be appropriate when no distinct highlights or shadows are desired. Flash also may be used in close-up photography, but the intensity of flash on or near the camera must be muted to avoid overexposure. You may use a layer of white handkerchief over the flash to diffuse

Table 18 Close-up Flash Exposure Table

Type of Flash (with One Layer of Handkerchief	Subject Distance	
	10–20 in. (25–50 cm)	20–30 in. (50–75 cm)
flashcube	f/16	f/11
electronic flash 700–1000 BCPS	f/16	f/8
1000–2000 BCPS	f/16	f/11
2000–4000 BCPS	f/22	f/16
4000–8000 BCPS	f/22 with 2 layers of handkerchief	f/22

the light and reduce its intensity at close distances. Flash-off-camera may be used in the usual way to improve the modeling of close-up subjects.

A special type of flash unit is especially useful for close-up work called *ringflash*. The unit is a circular electronic flash tube that fits around the front element of the lens to illuminate close-up subjects. These units provide an even field of relatively shadowless flash illumination at close-up focal distances.

Copy photography

In most cases, *copying* is a form of close-up photography in which the subjects are two-dimensional, such as drawings, paintings, photographs, or other documents, and the products are exact recordings of the originals in each and every detail of line, tone, and/or color. Because the original subject, termed *the copy*, is two-dimensional, copy photography is not concerned with depth of field; rather, it is concerned with obtaining a sharp, undistorted image over the entire flat surface of the original. Sometimes it is necessary to produce a *copy negative* — a negative obtained by photographing the original copy — from which to make a positive print. Sometimes, as in the case of producing a positive transparency, no intermediate negative is necessary. Whatever procedure

is used, the final product — an exact positive print or transparency of the original — is termed a *reproduction*.

As with other close-up photography, accurate framing and focusing is best accomplished with an SLR or view camera. To achieve stability during exposures, a camera support such as a *copy stand* or tripod is necessary. Unlike other forms of photography, copy photography is usually accomplished best with flat, even, shadowless illumination.

Basically, all copy setups consist of 1) a camera, 2) a camera support to hold the camera in a fixed, stable position during focusing, framing and exposing, 3) a *copy board* for holding the copy in place, 4) an arrangement of lights to illuminate the copy, and 5) a cable release to operate the shutter without shaking the camera. In its simplest form, copying may be accomplished by affixing the original to a wall, illuminating it with a pair of floodlights, and photographing it with a camera mounted on a tripod. However, not all copying needs are met best in this way. As the volume, size, and variety of originals varies, as the required negative formats vary, more elaborate copying setups may be necessary. In its more complex forms, such as in the graphic arts industry, copying is performed using commercial process cameras which permit copying large and small originals using roll or sheet films or large or small formats. See Figure 11–20.

Except for large volume, commercial copying, however, relatively simple copying setups will satisfy the needs of most photographers.

A simple horizontal copying setup

Figure 11–21 shows a simple horizontal copying setup you can make yourself using either a view or SLR camera. Its dimensions can be adapted to the available space and the maximum size of the originals to be copied.

The camera is mounted to a sturdy box that slides between two runners so that the camera axis remains aligned with the center of the copy board as the camera-to-subject distance is adjusted. The floodlights are

Fig. 11–20 Commercial process camera for copying. (NuArc Company, Inc.)

on adjustable standards so that they can be adjusted easily to illuminate different sizes of copy. The original can be kept flat during copying by pinning it to the copy board, by using double-sided tape or magnets, or by placing it in a glass *printing frame* which is then hung on the copy board. The table is attached to the wall with loose pin hinges that can be removed easily to store the setup. The legs are also hinged to simplify storage.

Copying with an enlarger

Some enlargers are designed to be converted to copy cameras by attaching a camera-back adapter in place of the negative carrier. By placing the original on the easel and illuminating it, the enlarger then works as a copy camera. Enlarging lenses are well suited to copy work because they have an exceptionally flat field; however, this method is satisfactory only for small and medium size originals, when space is at a

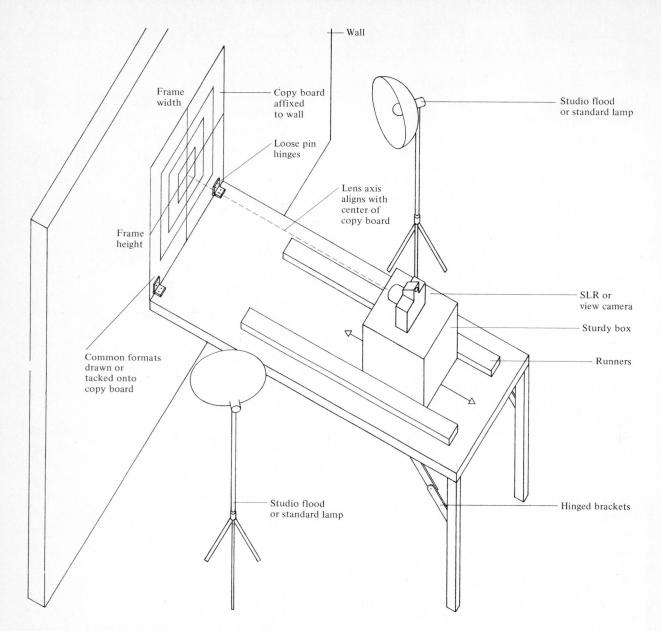

Fig. 11–21 A simple horizontal copying setup.

premium, when the frequency of copying is very low, and when the enlarger will not be needed for other purposes during the copying operations.

A vertical copying setup for 35-mm cameras

Vertical copy stands designed for 35-mm cameras are generally available from photo stores. A vertical, tubular post is mounted to a copy board. The camera is mounted to a collar assembly that slides up and down the post and can be locked in any desired position. Flood lamps are mounted to the post or to the copy board for illuminating the original. See Figure 11–22.

A 35-mm SLR camera fitted with a waist level ground-glass focusing screen or angle viewfinder is most suitable for use in a vertical copying setup. The image can be framed and focused by the photographer standing in a relatively normal position.

As we have seen, a 35-mm camera with normal lens has a minimum focusing distance of about two or three feet (.6 to 1 meter), too far away to obtain a frame-filling image of small- to medium-size copy. Under these conditions, it is necessary to apply the principles of close-up photography to obtain an image of satisfactory size. For copying, the use of a close-up lens is not recommended for critical work because of its curvilinear aberrations. The use of extension tubes, a bellows unit, or a macrolens is to be preferred.

Lighting for copy photography

For copying, it is essential to illuminate the original uniformly over its whole surface. Uneven lighting will produce a reproduction of uneven density.

Small originals, 8 in. by 10 in. (20 cm by 25 cm) or smaller, can be illuminated with two flood lamps placed about 30 in. (75 cm) from the center of the copy board and at an angle of 45 degrees to it. See Figure 11–23.

Even when the copy is evenly illuminated, the image at the focal plane may not be uniformly exposed.

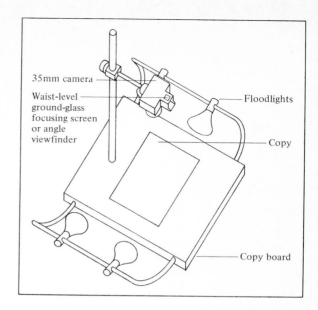

Fig. 11–22 A simple vertical copying setup.

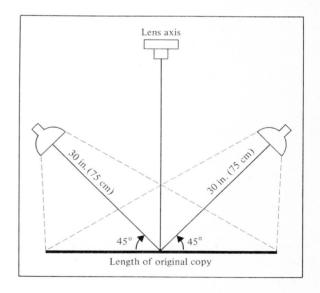

Fig. 11–23 A lighting setup for copy photography.

by repositioning the lamps until an even field of light is obtained.

The exposure indicated by the light meter must be adjusted to compensate for lens extension, as described above, and also for the overall tonal value of the copy. If the overall tone of the copy is dark, exposure should be reduced; if light, increased (see "Exposure for Shadows or Highlights," page 94).

Copying different types of originals

The original may consist solely of *line art,* such as drawings, woodcuts, printed documents, and the like. In these cases, the objective of copying is to obtain maximum contrast so that the lines or lettering appear strong and black against a white background. Best for this purpose are the high contrast films and developers that will drop out any hint of intermediate gray tones. Precise exposure and processing are necessary for high-contrast copy work to obtain perfect results. Filters are useful in high-contrast copying to exaggerate the contrast between the lines and the background if either or both are colored. A general approach is to use a filter that transmits the paper color easily but that absorbs the ink color.

The original may consist of a *continuous-tone* image, such as a black-and-white photograph. In this case the objective is to reproduce the full range of tones present in the original. Best for this purpose are the normal contrast, fine-grain films and soft-working developers that will record a full range of tones between the extremes of black and white. The color sensitivity of the film is of no concern when the original is in black-and-white.

The original may consist of colored images, such as a painting, color drawing, or color photograph. To obtain a black-and-white reproduction of a colored original, a fine-grain, high resolution, panchromatic film should be used to obtain a copy negative from which black-and-white reproduction prints can then be made. To obtain a color reproduction, any of several color films may be used. For the highest quality color reproduction prints, a color negative film may be used to obtain a copy negative from which color

reproduction prints can then be made. However, a color transparency film may also be used to obtain a positive transparency from which color reproduction prints can then be made using direct positive color print materials. Ordinary color film, balanced for the light source, may be used for these purposes, but it is better to use the specially formulated copying films because they have the low inherent contrast necessary for optimal reproduction of flat copy originals.

Instant color print films also have proved to be excellent media for making positive color prints from color transparencies. Several devices are presently available to adapt 35-mm cameras and enlargers for this purpose.

Table 19 describes some of the films commonly used for copying.

Slide duplicating

Making *duplicates* of 35-mm slides is basically a procedure of close-up copy photography. Its objective is to produce an exact recording of an original slide at life size or larger on positive transparency film. To accomplish this objective, one of several approaches may be used.

If your camera is equipped to interchange lenses, a slide-copying attachment with its own lens, available at most photo stores, may be attached to it in place of your normal lens (see Figure 11–25A). Many copying attachments of this type are designed to zoom between $1\times$ and $2\times$ magnification, permitting some cropping of the original image at the time the exposure is made. Similarly, a bellows unit may be fitted with a slide copier and your own normal lens and operated in a similar way (see Figure 11–25B).

If your camera is not equipped for interchanging lenses, you may use a special rear-projection screen to enlarge the slide image and then photograph the enlarged image using a close-up lens if necessary. This approach is not ideal, but will yield useful results when other methods are not convenient. Another approach is to use one of the many special slide-copying cameras designed solely for this purpose.

Table 19 Films for Copying

Film	Sizes Available	Uses
Black-and-white		
Kodak Pan-X/Pan-X Professional	35- and 120-mm	to make copy negatives or positive transparencies of continuous tone originals
Kodak High Contrast Copy Film (5069)	35-mm	to make copy negatives of printed materials, drawings, maps, etc. — with extended range developer, to make copy negatives of continuous tone originals
Eastman Direct MP Film (5360)	35-mm long rolls	to make 35-mm positive transparencies of continuous tone prints or transparencies
Kodak Rapid Processing Copy Film SO-185 (RP/C)	35-mm special order	to make 35-mm positive transparencies from both line and continuous tone originals
Kodak Commercial Film (4127 and 6127)	sheets	to make copy negatives and positive transparencies from continuous tone, black-and-white originals
Kodak Contrast Process Ortho (4154)	sheets	to make copy negatives of high contrast black-and-white printed originals and line art
Kodak Contrast Process Pan (4155)	sheets	to make copy negatives of high contrast printed originals and line art when print, line, and/or stock are colored
Kodak Professional Copy Film (4125)	sheets	to make copy negatives of photographs or other black-and-white continuous tone and line art
Polaroid Polapan 552	sheets	to make black-and-white prints from continuous-tone, line, or color originals; P/N types also produce a negative for making enlarged reproduction prints.
Polaroid Landfilm	packs and sheets	same as Polapan 552
Color		
Kodak Vericolor II Type S	120	to make color negatives from color originals; balanced for daylight
Kodak Vericolor II Professional (4108)	120 and sheets	to make color negatives from color originals; balanced for tungsten
Kodak Vericolor Internegative film (6011 and 4112)	long rolls and sheets	to make color negatives from color transparencies, prints, and line art
Kodak Ektachrome Slide Duplicating Film (5071)	35-mm	to make slide duplicates from color transparency originals; balanced for tungsten
Kodak Ektachrome Duplicating Film (6121)	sheets	to make color transparency duplicates from slide and transparency originals of all types
Kodak Ektachrome SE Duplicating Film SO-366	35-mm special order	to make slide duplicates from color transparency originals; balanced for tungsten; compensates for short-exposure reciprocity failure
Kodak Instant Print Film PR-10	packs	to make direct positive prints from slides
Polaroid SX-70	packs	to make direct positive prints from slides
Polaroid Polacolor 2 Landfilm	packs and sheets	to make direct positive prints from slides
Polaroid Time-Zero Color Print Film	packs	to make direct positive prints from slides

A

B

Fig. 11–25 Slide duplicating accessories. A. 35-mm camera with zoom slide copier attachment. B. Bellows unit copier attachment.

Although duplicate slides can be made using any color transparency film that is correctly balanced for the light source, it is preferable to use film specially formulated for slide duplicating. (See Table 19.) Whenever you copy color slides with ordinary color slide film, the resulting reproduction has higher contrast than the original. Furthermore, using electronic flash as a light source in slide duplicating, the extremely short exposure results in a blue shift caused by reciprocity failure. Slide duplicating films have been formulated to overcome these effects. Proper film and conversion filtration are essential to obtain color reproductions that closely match the originals.

For large volume slide copying, a number of special-purpose devices are manufactured that use electronic flash and precise exposure and filtration controls (see Figure 11–26). For less frequent slide copying, however, any of the above procedures will meet the needs of most photographers at moderate cost.

Fig. 11–26 Commercial slide copier. (Bogen Photo Corporation)

Suggested references

Busselle, Michael. *Master Photography*. New York: Rand-McNally, 1978, pages 64–65, 98–167, 195.

Davis, Phil. *Photography*. 3rd ed. Dubuque: William C. Brown, 1979, pages 228–238.

Eastman Kodak Co. *Copying*. Rochester, N.Y.: Kodak (Publication M–1H), 1974.

Jacobs, Lou, Jr. *Photography Today*. Santa Monica, Calif.: Goodyear Publishing, 1976, pages 257–262.

McGarry, Jerome T. ''Slide Duplicating Techniques.'' In *The Fourth Here's How, Techniques for Outstanding Pictures*. Rochester, N.Y.: Kodak (Publication AE–85), 1967.

Petzold, Paul. *The Focal Book of Practical Photography*. London: Focal Press/Pitman House, 1980, pages 58–61, 84–108, 124–125.

Rhode, Robert B. and F.H. McCall. *Introduction to Photography*. 4th ed. New York: Macmillan, 1981, chapter 12.

Swedlund, Charles. *Photography*. 2nd ed. New York: Holt, Rinehart, and Winston, 1981, pages 261–265.

Time-Life Books. *Life Library of Photography: Caring for Photographs,* 1972, pages 112–115; *The Great Themes,* 1970; *Photographing Nature,* 1971. New York: Time, Inc.

Suggested field and laboratory assignments

1. Shoot, process, and print a roll of film that includes at least the following subjects:

 a. one shot each of the following:
 1) a grand view scenic photograph
 2) an intimate view scenic photograph
 3) a record architectural photograph
 4) an interpretive architectural photograph

 b. two shots each of the following:
 1) still life
 2) people engaged in characteristic activity
 3) people in action (real, peak, simulated)
 4) emotional appeal subjects

2. Shoot, process, and print a roll of black-and-white panchromatic film that includes at least one example of each of the following:

 a. closeups of small objects such as flowers, insects, or coins, to produce a 1:1 or lifesize negative image

 b. photomacrographs of similar objects to produce a 2:1 (double lifesize) or larger negative image

 c. copy photographs to produce a reproduction of a photograph or other continuous-tone, black-and-white original

Do Practice Test 11 on page 401

EXERCISE 11–A

1. Describe the basic differences in approach that are appropriate for grand and intimate scenic photographs. _____

2. How may filters be useful in scenic photography? _____

3. Name three ways that could be used to establish a mood and idea in a sea-and-sky shot.

 A. _____

 B. _____

 C. _____

4. In what situations might backlighting be desirable? _____

5. In what situations might cross-lighting be desirable? _____

Return to Objective 11–B, page 362

EXERCISE 11–B

1. Describe the architectural record shot. _____

2. Describe the architectural interpretive shot. _____

3. State how converging parallel lines in a building can be corrected.

A. During exposure: _____

B. During enlargement: _____

4. Suggest several ways to provide a frame of reference against which to view your architectural shot._____

5. How might filters be used to enhance your architectural shots? _____

Return to Objective 11–C, page 365

EXERCISE 11–C

1. Describe the differences between a mere record shot of objects and a good still-life

 photograph._____

2. Describe the lighting principles that apply to still-life photography. _____

3. List the accessory equipment that may be of particular use in still-life photography.

Return to Objective 11–D, page 366

EXERCISE 11–D

List the five principles for photographing people and briefly explain each.

1. _____

2. _____

3. _____

4. _____

5. _____

Return to Objective 11–E, page 369

EXERCISE 11–E

1. Define and explain three types of action that were discussed in Objective 11–E.

 A. _____

 B. _____

 C. _____

2. Describe three ways in which the sense of movement and action can be enhanced in your action photographs.

 A. _____

 B. _____

 C. _____

Return to Objective 11–F, page 374

EXERCISE 11–F

1. List four human emotions commonly communicated in photographs and give an example of each.

 A. _____

B. _____

C. _____

D. _____

2. Explain why it is important to explore your own feelings and emotions about a scene before you plan your picture. How might your feelings affect the decisions you make about how to take the picture? _____

Return to Objective 11–G, page 377

EXERCISE 11–G

1. Distinguish among normal photography, close-up photography, photomacrography, and photomicrography in terms of image-to-object ratio and focal distance:

A. normal _____

B. close-up _____

C. photomacrography _____

D. photomicrography _____

2. Define the function of each of the following types of equipment:

A. close-up lens attachment _____

B. a set of extension tubes _____

C. a bellows unit _____

D. a macrolens _____

E. a reverse adapter _____

Review References and do Suggested Field and Laboratory Assignments on page 391

PRACTICE TEST 11

For each of the following questions, select the one *best* answer and write its corresponding letter in the blank preceding the question. After you have completed the test, check your answers against the correct answers, which follow the test. If you miss any of the test items, review the study materials as suggested.

_____ 1. For most intimate scenic views, you may want to use a _____ filter.
A. light yellow
B. blue
C. ultraviolet
D. neutral density
E. deep blue

_____ 2. Which of the following adds to a feeling of distance in a photograph?
A. composing to include foreground detail
B. making sure lighting is under actinic conditions
C. letting haze show as part of the view
D. A and C
E. all of the above

_____ 3. Which of the following may be used to add a sense of mood and idea to a marine scene?
A. large foreground rocks or waves
B. boats
C. birds
D. unusual cloud formations
E. any of the above

_____ 4. Which of the following statements about architectural photography is false?
A. Converging parallel lines can be corrected during enlargement.
B. The structure should be isolated in space.
C. A view camera with a complement of swings and tilts is helpful.
D. Small apertures are needed for maximum depth of field.
E. A tripod camera support is important.

_____ 5. Architectural pictures generally are taken so that _____.
A. the most flattering angles of the structure are pictured
B. the sun provides flat lighting
C. maximum depth of field is achieved
D. cross-lighting provides shadows and adds to illusion of depth
E. all except B

6. You have taken a picture of the Lincoln Memorial in the near distance against a dark sky, framed by a tree in the foreground. The picture is a(n) _____.
 A. interpretive shot
 B. architectural scenic
 C. record shot
 D. A and B
 E. B and C

7. For photography too close for the normal lens, the still-life photographer will find _____ useful.
 A. filters
 B. extension tubes
 C. close-up lenses
 D. flash
 E. B and C

8. Still-life photography is closely related to _____ photography.
 A. action
 B. portrait
 C. scenic
 D. photomicrographic
 E. time exposure

9. Among the following, which is probably the best general background for pictures of people?
 A. sky
 B. brick wall
 C. grained wood paneling
 D. trees
 E. a milling crowd

10. Generally, aggressive, active shots are improved by _____.
 A. front lighting
 B. cross-lighting
 C. backlighting
 D. diffused lighting
 E. none of the above

_____ 11. Which of the following is an example of real action?
 A. a man lighting a pipe
 B. fireworks exploding at night
 C. a girl eating a hamburger
 D. the president signing new legislation
 E. a receptionist on the telephone

_____ 12. Good action pictures of objects in motion are possible at slower shutter speeds with greater depth of field if the exposure is made during _____ action.
 A. peak
 B. real
 C. fast
 D. simulated
 E. all of these

_____ 13. Slightly blurred action is produced by _____.
 A. using a slower shutter speed
 B. using a smaller aperture
 C. using a faster shutter speed
 D. using a larger aperture
 E. throwing the subject out of focus

_____ 14. The picture shows a couple on the roof of their house while flood waters rise. To which basic emotion does the picture appeal?
 A. conflict
 B. violence
 C. sex
 D. escape
 E. curiosity

_____ 15. Generally, pictures on the sports page appeal to which basic emotion?
 A. ambition
 B. fear
 C. escape
 D. survival
 E. sex

_____ 16. Pictures of wealthy, jet-setting movie stars might appeal to which basic emotion?
 A. survival
 B. sex
 C. ambition
 D. fear
 E. curiosity

_____ 17. The term _close-up photography_ refers to photographing objects that are
 A. closer than the normal minimum focusing distance from the camera
 B. two focal lengths distant from the camera
 C. smaller than normal
 D. visible only through a magnifying glass
 E. reproduced as larger than lifesize negative images

_____ 18. When using a 50-mm lens with a 50-mm extension, you must increase the indicated exposure by a factor of
 A. 1
 B. 2
 C. 4
 D. 8
 E. none of these

_____ 19. To copy black-and-white line art, it is usually best to select the following film/processing combination:
 A. normal contrast/low contrast
 B. normal contrast/high contrast
 C. high contrast/high contrast
 D. high contrast/low contrast
 E. normal contrast/normal contrast

_____ 20. Slide duplicating requires _____.
 A. special duplicating films
 B. a tungsten light source
 C. special-order film processing
 D. a slide-duplicating camera
 E. close-up photography equipment

ANSWERS TO PRACTICE TEST 11

1. A See "Scenery," page 357.

2. D Actinic lighting conditions are found at high altitudes where light is extremely strong and powerful. It may tend to overexpose your negatives, but it will not add to the feeling of distance. See "Scenery," page 357.

3. E See "Scenery," page 357.

4. B Your structure should not be isolated in space, especially if the picture is a record shot. See Unit 10 for suggestions on how to portray the size of an unknown object by using known features in a photograph.

5. E Flat lighting is ordinarily dull and uninteresting lighting. See "Architecture," page 362.

6. C You are taking a picture of the entire building. The tree in the foreground provides a frame of reference for the viewer to estimate the size of the building. We do not use the term *architectural scenic* for architectural shots, for if you are interested in a building the scenery surrounding the building is of secondary interest. See "Architecture," page 362.

7. E See "Still Life," page 365.

8. B See "Still Life," page 365.

9. A The sky is the best choice here. Of course, it is not appropriate when you are shooting indoors, but a plain wall would be better than wood paneling indoors. Keep the background simple. See "People," page 366.

10. B See principle 5 in "People," page 366.

11. B See "Action," page 369.

12. A An object in motion, as it is poised to change direction, is suspended motionless for an instant. In this instant, action can be stopped with a slow shutter speed. See "Action," page 369.

13. A Stopping or blurring action is controlled by the shutter. The aperture is manipulated to maintain correct exposure, just as the shutter is manipulated to maintain correct exposure when the aperture is adjusted for depth of field. When you use a slow shutter, the object moves somewhat while the shutter is open. This movement blurs the image of the object. See "Action," page 369.

14. A See "Emotion," page 374.

15. D Conflict is the emotion generally underlying sports pictures because of the competitive nature of sports. Usually, the more real action in a sports picture, the more emotional appeal the picture will have. See "Emotion," page 374.

16. C (Perhaps also B.) See "Emotion," page 374. There may be some argument here, but usually such personalities generate more emotion based on ambition than sex. Their wealth and lifestyle are widely reported in the press for mass consumption because the general public is interested in how they spend their money.

central idea the subject of a composition; the key meaning or impression of a composition; the major cognitive or affective representation intended to be communicated by a composition; often associated with a center of interest — a dominant feature or detail within the composition that serves as its main integrating element.

characteristic curve See *H & D curve*.

chloride See *halide*.

chloride paper a printing paper, used primarily for contact printing, whose principal active ingredient is silver chloride.

chloro-bromide paper a printing paper sensitized with a combination of silver bromide and silver chloride.

chroma See *saturation*.

clearing agent a chemical agent designed to transform fixing compounds into more readily soluble salts to aid in cleansing them from film and prints during washing. Also called *hypo neutralizer, hypo eliminator,* or *hypo clearing bath*.

close-up a photograph characterized by focus on an object at an apparent distance of no more than a few feet from the camera. It may be achieved by placing the camera within a few feet of the object or optically by the use of appropriate lenses. It also refers to light-meter readings taken at similar apparent distances from the object being read.

close-up lens a type of magnifying lens designed to be fitted in front of the normal lens to foreshorten focal length and increase focal distance, thereby resulting in close-up focusing distances and image magnification.

close-up reading See *close-up*.

coarse grain a grain pattern characterized by the grouping of silver grains in the image into relatively large clumps.

coating a transparent film applied to lens elements and designed to absorb extraneous, nonimage-forming light and to increase contrast.

cocking the shutter loading tension onto the shutter spring mechanism to store the energy needed for its operation.

cold tones bluish hues associated with the metallic silver image of a print, often emphasized by the use of certain emulsion-developer combinations.

color a visual sensation that permits differential perception of various wavelengths of light generated by the interaction of light and the qualities of the objects perceived.

color balance the capability of a film to reproduce colors as they are perceived, notwithstanding differences in light sources; a property of color film that specifies under what lighting conditions the film will reproduce colors as perceived.

color-compensating (CC) filters optically corrected filters, available in various saturations of the six primary and secondary hues, used principally in color photography to modify the overall color balance of the transmitted image.

color composition the relationships among color details within a photograph; the organization of color elements to support a central idea in a color photograph.

color contrast the relationship among color values by which colors of complementary hue and varying brightness are composed to achieve emphasis.

color harmony the pleasing arrangement of color details in a photograph. See *color composition*.

color negative a color image, reversed as to brightness and color, supported on a transparent base for the purpose of making positive prints and transparencies. See *negative*.

color negative film a film designed to produce, after processing, a color negative. Compare with *color reversal film* and *color slide film*.

color print a positive color image supported on an opaque base of paper or other sheet material; a positive color image designed for unassisted viewing. See *print*.

color reversal film a film designed to produce, after processing, a positive color transparency; color slide film; film that, after processing, reproduces the colors originally present in the scene. Also called *color slide film*.

film advance a mechanism for advancing roll film a prescribed distance within a camera to obtain a succession of evenly spaced exposures; the knob or lever used to advance such film.

film holder a frame designed for handling sheet film. It holds two sheets of film in a light-tight compartment, is inserted into the camera to hold the film in a precise relationship to the lens, and is withdrawn from the camera following exposure.

film pack a frame designed to hold sheet film. It is loaded with several film sheets that can be used sequentially by manipulating a series of paper tabs without removing the pack from the camera.

film plane the locus of the film within the camera, usually placed to intersect the focal point of the camera's normal lens.

film processing tank a light-tight container, used for developing and fixing film, that provides for the entry and egress of fluids through a light trap; also the container used for processing sheet film.

film speed the relative sensitivity of film to light, as indicated by its film speed index. See *speed, film speed rating*.

film speed rating a number indicating the sensitivity to light of a given film. The most common film speed rating systems are *ASA, DIN, BSI,* and *ANSI*.

film speed setting the mechanism on a photographic device, such as a light meter or camera, by which the film speed index is programmed into the device.

filter a transparent medium, usually plastic or glass, that absorbs and transmits precisely selected wavelengths or other components of incident light.

filter factor the number by which exposure must be multiplied to compensate for the absorption of light by a filter used during exposure.

filter holder a device that attaches to the front of a lens designed to hold filters in place.

fine grain a grain pattern characterized by the grouping together of silver grains in the photographic image into relatively small clumps.

finishing See *print finishing*.

fix to dissolve light-sensitive materials from a photographic emulsion in order to render it chemically stable; the chemical agents employed in the process.

fixed exposure an exposure-setting system using a single, nonadjustable aperture and shutter-speed combination.

fixed focus a focusing system without adjustments that is preset to focus within a given distance range.

fixer See *fix*.

fixing bath See *fix*.

flag a small baffle used to create shadow in a photographic lighting setup.

flare nonimage-forming light produced by interreflections between lens surfaces; a fogged or dense area produced on the negative as a result of such light on the film in the camera.

flash in photography, any artificial light source that produces a brief, intense pulse of light, usually synchronized with the opening and closing of a camera's shutter.

flash bar a type of flash unit consisting of ten individual flashbulbs, each with its own reflector and shield, designed to fire one at a time as successive shots are taken.

flashbulb a consumable lamp containing combustible materials and designed to produce a measured quantity of intense illumination for photographic purposes upon electrical ignition synchronized with a camera's shutter.

flash contacts the electrical connections that complete the ignition circuit and allow flash equipment to be synchronized to a shutter's action; the metallic connectors by means of which flash units are linked to a camera's circuitry.

flash cube a cube-shaped unit consisting of four small flashbulbs and their reflectors, designed for shooting four flash pictures in succession without replacing spent flashbulbs.

flashguard a transparent plastic cover fitted to a flash reflector in order to contain spent flashbulbs, which occasionally shatter.

flashing a technique for increasing density in certain portions of a print by means of controlled exposure of the printing paper to raw, white light.

flash-off-camera a flash technique in which the flash unit is placed or held at a distance from the lens axis.

flash-on-camera a flash technique in which the flash unit is mounted on the camera, close to the lens axis.

flash peak the moment in the flash cycle when the flash reaches its maximum intensity; see *F, M, FP, X.*

flash synchronization the mechanical coordination of flash ignition and shutter release so that flash peak is timed to occur at a precise moment during the shutter's action; see *F-synchronization, M-synchronization,* and *X-synchronization.*

flash-to-subject distance the distance light travels from the flash unit to the subject; the distance between the unit and the subject if aimed directly; the total distance traveled if bounced off reflecting surfaces.

flash unit generic term referring to any one of many devices used as flash lighting sources.

flat See *low contrast.*

flat peak (FP) a flashbulb burn pattern in which maximum output is reached approximately 20 milliseconds after ignition and is maintained at a relatively constant level for the next 20–25 milliseconds before extinction. Designed for use with focal plane shutters.

floodlight an artificial light source designed to illuminate a wide area with relatively uniform intensity.

f/number a standardized numerical expression describing the light-admitting characteristics of a lens at a given aperture setting; the ratio of a given aperture diameter to the focal length of a lens. Also *f/stop.*

focal distance the distance between the optical center of a lens and the plane of the focused image it produces.

focal frame the device used for precise focusing and framing of close-ups with a viewfinder camera.

focal length the distance between the optical center of a lens and the plane in which the image of an object at infinity is resolved into sharpest focus; the symbol for focal length is F.

focal plane the plane in which a lens forms a sharp image of an object at infinity. Within a camera, the film is located in the focal plane.

focal plane shutter a mechanism for controlling exposure that is located slightly forward of and parallel to the camera's focal plane; a camera component designed to initiate, time, and terminate exposure by means of the opening and closing of two overlapping panels.

focal point the point, characteristic of a given lens, at which the lens resolves parallel light rays to a point of sharp focus.

focus the adjustment of a lens system to resolve the transmitted light rays in a given plane; to adjust a camera to achieve a clear, sharply defined image of the subject.

focus setting the mechanism by which a lens is adjusted so that a clear, sharply defined image of the subject is formed on the photosensitive material.

fog negative or print density produced by nonimage-forming light or chemical action.

folding camera a type of camera characterized by a bellows that collapses the lens and shutter assembly into the camera body for ease in carrying and storing.

forced development a technique for developing photographic materials for a longer-than-normal time span, usually to compensate for underexposure.

foreground that portion of a visual composition perceived to be nearest the viewer.

format print or negative dimensions; aspect ratio; the length and width of a photographic product.

FP See *flat peak.*

FP-synchronization See *M-synchronization.*

framing easel See *easel.*

low contrast characterized by minimal differences in density between adjacent tonal areas; without contrast; dominated by middle tones to the exclusion of clearly defined highlights and shadows; also said of lighting situations and photographic materials that tend to produce such images. Also *flat, soft*.

low-key dominated by dark or black tones to the exclusion of white or light tones. Compare *high-key*.

M See *medium peak*.

macro lens a type of lens used in place of a camera's normal lens for close-up photography.

macrophotography techniques used to produce extremely large images such as for photomurals.

magazine See *cartridge*.

main light the principal light source in a studio setup, which establishes the dominant pattern of highlights and shadows. Also *key light, modeling light*.

manual exposure an exposure-setting system requiring the photographer to determine proper exposure and to set both aperture and shutter speed by hand.

manual focus a focusing system by which the lens is hand-set to an inscribed scale based on photographer's estimate of camera-to-subject distance.

mass an element of visual composition; an aggregate of relatively homogeneous tonal densities cohering together such that they to appear to be one body within a composition.

match needle a type of automatic exposure-setting system that requires photographer to adjust the aperture and/or shutter speed so that an indicator needle seen in the viewfinder is properly aligned.

matte a dull, nonreflective surface texture.

matte white reflector a reflector with a dull, white surface of relatively high reflectance and diffusing qualities.

maximum aperture the rated aperture of a lens; its largest useful opening; its aperture when wide open.

maximum depth of field See *depth of field*.

medium format See *format*.

medium grain a grain pattern characterized by the grouping together of silver grains in the photographic image into clumps of moderate size.

medium peak (M) a type of flashbulb that reaches peak output 15–20 milliseconds after ignition.

medium speed moderate sensitivity to light of a photographic film or paper; moderate light-transmitting capability of a lens.

medium-speed film See *medium speed*.

metallic silver See *silver*.

microphotography techniques used to produce extremely small images, such as for microelectronics.

mired a unit of measurement, derived from Kelvin, used to measure the color temperature of light; contraction of *micro-reciprocal-degrees*. The mired system simplifies the selection of filters to achieve a desired color balance in color photography.

modeling revealing by means of lighting the three-dimensional qualities of an object.

modeling light See *main light*.

monobath a single solution for rapidly developing and fixing photographic materials.

monochromatic based entirely upon a single or several closely related hues.

monochrome a single hue. See *monochromatic*.

motor drive a device that automatically advances film under force at a rate of about five frames per second.

mounting adapter a device that enables a given lens to mount to a given camera body.

M-synchronization the mechanical synchronization used with medium-peak (M) flashbulbs; provides a 20-millisecond delay between flash ignition and subsequent shutter release. Similar to the FP-synchronization designed for use with flat peak (FP) flashbulbs and a focal plane shutter.

multicontrast filter See *variable-contrast filter*.

multicontrast paper See *variable-contrast paper*.

multigrade paper See *variable-contrast paper*.

narrow lighting See *short lighting*.

ND filter See *neutral density filter*.

negative a photographic image in black-and-white (or color) in which subject tonalities (and colors) have been reversed from light to dark (and from primaries to complements) and vice versa *vis à vis* the original scene. Usually the negative is used to make finished positives that possess tonalities (and colors) corresponding to the original scene.

negative carrier a frame-like device used to hold a negative in position in an enlarger during printing.

negative format See *format*.

neutral background the absence of distracting peripheral details and contrasts in a photographic composition.

neutral density (ND) filter a filter toned to a specific density of gray and used over a camera's lens to reduce the intensity of image-forming light without altering its color balance.

normal contrast a photographic image characterized by the presence of a wide range of tonal densities, including whites, blacks, and a variety of middle gray tones; lighting situations and photographic materials that tend to produce such images.

normal lens any lens possessing a focal length approximately equivalent to the diagonal measurement of the film format of the camera on which it is used. See *long lens, short lens*.

object something visible and/or tangible; a photographic detail. See *subject*.

object-at-infinity an object that is at least 50 feet (15 m) from the camera.

one-shot developer a developing solution intended to be used once and discarded.

110 camera a camera designed to use 110-film cartridges.

126 camera a camera designed to use 126-film cartridges.

opaque resistant to the passage of light.

open bulb a method of contact print making in which exposure is made with a bare electric light bulb.

open flash a flash technique in which the flash unit is fired manually, often more than once, while the shutter stands open.

open up to increase the size of the lens aperture.

optimal exposure the exposure that yields the maximum contrast with minimum density under given developing conditions.

orthochromatic a type of emulsion characterized by sensitivity to all wavelengths in the visible light spectrum except red.

outdated film film unprocessed and/or unexposed after its published expiration date. Outdated film is not guaranteed by the manufacturer to perform to its rated specifications; however, if properly stored, film may perform effectively long after its expiration date.

outdoor lighting standard an arrangement of highlights and shadows that reproduces the appearance of natural outdoor light sources, which typically originate from above and to the side of the subject.

out-of-focus indistinctness of image caused by lack of image resolution and sharpness. Also see *blur*.

overall reading a reflected-light meter reading obtained by placing the meter at the camera position and pointing it in the general direction of the scene to be photographed. It records the average light intensity of the entire scene.

overexposure the action of too much light upon a photographic emulsion. Overexposed negatives, developed normally, are characterized by overall excessive density, loss of detail in highlight areas, overall loss of contrast, and graininess in the final print.

pan (1) contraction of *panchromatic;* (2) to swing the camera during exposure to follow a moving subject. Also *panning, panoramming*.

panchromatic a type of emulsion characterized by sensitivity to all wavelengths in the visible light spectrum, although only minimally sensitive to green.

panning See *pan.*

panoramming See *pan.*

paper tint See *base tint, tint.*

parallax the discrepancy between the image seen through a camera's viewfinder and that recorded on the film.

pattern screen a type of baffle that, introduced into a light beam, produces a shadow pattern. It is used for background interest.

PC contact a flash synchronization socket by means of which the camera and flash unit are connected using a short cable.

P-C lens See *perspective control lens.*

peak action a moment when a moving subject is changing the direction of movement and thus temporarily either stationary or moving slowly; e.g., a pole vaulter at the top of his arc, when upward movement has ceased and downward movement has not yet begun. Compare *real action* and *simulated action.*

perspective the representation of three dimensions within a two-dimensional image by means of variations of line, image size, tonality, and focus. See *linear perspective, aerial perspective, selective focus.*

perspective control lens type of wide-angle lens providing for rotation and shifting of its optical elements to control convergence and depth of field.

photo eye a photoelectric triggering device used to operate slave flash units.

photoflood an artificial lighting instrument that produces an even, relatively diffused field of light over a broad area.

photographic paper paper coated with a photosensitive emulsion and used for making photographic prints.

photomacrography techniques used to produce negative images that are lifesize or larger.

photomicrography techniques used to photograph objects through a microscope.

photosensitive subject to chemical change in response to exposure to light.

pinhole camera a camera characterized by a tiny hole rather than a lens to resolve admitted light into an image in the film plane.

pocket camera a camera of small size and shape suitable for carrying in a pocket.

point of view the position from which a scene is viewed; the position from which a photograph is taken; the relationship between the subject and its viewer.

poised action See *peak action.*

pola filter See *polarizing filter.*

polarized light light composed of electromagnetic waves vibrating predominantly in, or parallel to, a single plane. It is commonly produced by source light reflecting off nonmetallic surfaces, or passing through a polarizing screen.

polarizing filter a filter designed to block or pass polarized light by positioning its axis to oppose or conform to the axis of polarization; a filter designed to block the passage of any light except that which is vibrating in the plane of its axis. Thus, only polarized light is transmitted by such a screen.

positive a photographic image in black-and-white (or color) in which subject tonalities (and colors) correspond to those in the original scene; the reverse of a negative.

positive print See *print.*

positive transparency See *transparency.*

press camera historically, a large-format camera, such as a Graflex or Speed Graphic, commonly used by press photographers; currently, any camera used by a press photographer.

previsualization the process of visualizing the final photographic print prior to exposure. In the zone system, a method of analyzing brightness values before exposure to plan a desired range of densities in the final print.

primary colors a set of hues from which all other hues may be derived. The additive light primary colors — red, green, and blue — can, when added together in varying proportions, produce a maximum number of hues, including white (all

color). The subtractive light primary colors — magenta, yellow, and cyan — can, when added together in varying proportions, absorb all hues from white light to pass any specific hue, including black (no color).

print a photographic image, usually understood to be positive, reproduced in final form on an opaque photographic paper; to make a print.

print conditioning solution a photoprocessing agent that functions to soften the gelatin emulsion, thereby reducing curling and generally improving the effect of ferrotyping.

print finishing those procedures subsequent to washing — including drying, ferrotyping, spotting, bleaching, mounting, and similar techniques — intended to produce photographic prints suitable for their intended purposes.

printing the procedures for making prints; making prints.

printing frame a flat, rectangular holder equipped with removable or hinged front glass or back, designed to sandwich copy, negative, and/or printing paper tightly in place for exposure or copying.

printing in See *burning in*.

printing paper See *photographic paper*.

process the sequence of steps, usually including developing, stopping, fixing, and washing, necessary to transform a latent photographic image into a permanent image; to subject photographic materials to such a sequence of steps.

programmed automatic exposure a type of automatic exposure-setting system that sets both aperture and shutter speed automatically to obtain proper exposure.

projection the act of causing an image of an original to fall upon a surface by directing and controlling the passage of light onto and/or through the original; the act of reproducing on a surface the image of a transparency, negative or positive, by directing and controlling the passage of light through the transparency.

projection print a print produced by projecting the master image onto the surface of photosensitive material; usually understood to be and often called an enlargement.

projection printing the process of making projection prints.

projection printing paper relatively fast photosensitive paper used primarily for projection printing. Also see *printing paper*.

proofer a device used to hold a set of negatives in contact with printing paper while making contact proofs or proof sheets.

proof sheet See *contact sheet*.

push to expose film at a higher-than-normal ASA rating and then to prolong development to compensate for resulting underexposure. See *forced development*.

quartz light an extremely intense incandescent lamp designed with a filament bathed in bromine or iodine vapor, having longer life and more constant color temperature than ordinary tungsten-filament lamps.

range (1) the distance between the camera and the objects intended to be in focus in a photograph; (2) the spectrum of tones, from lightest to darkest, in a photographic image is referred to as its *tonal* or *contrast range*.

rangefinder a mechanical-optical mechanism, usually integrated with a camera's viewfinding system, used to focus an image onto the camera's film plane.

rangefinder camera a camera with a built-in rangefinder.

range of brightness a method of using a light meter to measure the intensity of light in the important highlight and shadow areas of a scene.

range of density the total breadth of silver deposits in a negative produced by the total range of brightness in the scene.

RC paper See *resin-coated paper*.

real action movement of the subject at the moment it is photographed. Compare *peak action* and *simulated action*.

reciprocity failure the nonoccurrence of normally expected density changes, resulting from exposures of extremely short or long duration. See *reciprocity law*.

reciprocity failure (RF) factor the number by which exposure time must be multiplied to compensate for reciprocity failure.

reciprocity law a principle of photography stating that a constant density is obtained on a photosensitive material if the product of light intensity and exposure duration remains constant. Thus density is postulated to remain constant if, for example, light intensity is halved while exposure duration is doubled, and vice versa. Also see *reciprocity failure*.

record shot a photograph that represents a subject objectively and accurately and is devoid of interpretation by the photographer; a theoretical ideal, since any photograph requires the photographer to select, emphasize, and subordinate details in the process of composition.

recycling time the time interval necessary to recharge an electronic flash unit following discharge.

red eye the appearance of red pupils in color photographs when flash illumination is reflected off the retina of the subject's eyes back toward the camera. It is avoided by placing the flash unit off the camera axis and/or by directing the subject's gaze off the camera axis.

reducer a chemical agent capable of dissolving metallic silver, and thereby of reducing the density of photographic images. See *bleach*.

reflectance the light-reflecting characteristic of an object or surface. Surfaces of high reflectance reflect much of the light incident upon them; subjects of low reflectance absorb much of such light.

reflected-light light rays that are deflected or bounced from a surface or subject after striking it.

reflected-light meter a light-measuring device designed to respond to the intensity of light reflected from a surface or subject and to compute proper exposure. Also see *incident light meter*.

reflection the partial or complete deflection of light rays from an encountered surface; the production of an image composed of reflected light, as if by a mirror.

reflector a polished and/or light-colored surface for reflecting light.

reflector floodlight a lightbulb with a built-in reflector designed to function as a floodlight.

reflector spotlight a lightbulb with a built-in reflector designed to function as a spotlight.

reflex camera a camera whose viewfinding mechanism utilizes an inclined mirror to reflect an image onto a ground-glass screen. See *single lens reflex* and *twin lens reflex*.

refraction the deflection of a light ray in passing obliquely from one transparent medium to another in which its velocity is altered.

relative brightness comparative light reflectances among various elements of a scene to be photographed.

replenisher a chemical agent added to developer to restore its strength following use.

reproduction a print made from a copy negative; an exact positive print or transparency of the original; the end-product of copying.

resin-coated (RC) paper a photosensitive printing paper characterized by a tough, smooth resin coating on the paper base below the emulsion layer.

resolution See *definition*.

resolving power the capability of a lens to form an image in fine detail; the capability of a photographic emulsion to reproduce fine detail in a recorded image.

retaining ring a device used with an adapter ring to hold a filter in place in front of a camera's taking lens.

reticulation a network of wrinkles and cracks in a photographic emulsion, brought about by exposure of the emulsion to extreme temperature changes during processing.

retina a light-sensitive membrane that lines the interior chamber of the eye and upon which the image is formed by the lens.

reversal film a film designed to produce a positive image after exposure to a positive image; a film that reproduces tonal densities corresponding to those of the image to which it is exposed. Also see *color reversal film*.

reverse adapter a device used to invert the position of a normal lens back to front to improve its performance in close-up photography.

RF factor See *reciprocity failure factor*.

rim light backlight placed to produce edge accents from the camera's viewpoint. See *edge accent*.

ringflash a circular flash unit used at the front of the lens in close-up photography.

roll film film manufactured in a strip and wound onto a spool, designed for use in a camera that advances the film in measured increments to produce separate negative frames.

rule of thirds an approach to placement of a photographic subject based upon division of the picture space into thirds, both horizontally and vertically.

safelight darkroom illumination of such limited wavelength and brightness that it does not affect the photosensitive materials being handled. Materials of different sensitivities require different safelight.

saturation concentration of hue; also *chroma*. The absence of saturation is no hue at all, or white.

scale the relative sizes of an object in a photographic image and in actuality.

second adhesive layer See *adhesive layer*.

secondary color a complement of a primary color; a hue consisting of equal proportions of any two primary colors. In light, the complements of the primary colors red, blue, and green are the secondary colors cyan, yellow, and magenta respectively.

secondary image the occurrence, when using flash under bright existing light conditions and a slow shutter speed, of two images, one from the flash and a secondary one from the existing light.

selection the choice of details to appear in a photograph.

selective focus the representation of three dimensions and distance on a two-dimensional surface by means of variations in the sharpness of foreground and background details.

semigloss finish a surface texture of a print characterized by a soft, slightly reflective sheen.

sensitivity the potential of a photographic material to be chemically altered by the action of light energy.

separation the differentiation of tonal areas within a photographic image; the process of differentiating and recording the primary color components of a photographic image as three distinct black-and-white images.

series number an adapter-ring specification designating the size of the filters the ring is designed to accept.

shadow area any mass within a photographic image corresponding to the least illuminated areas in the original scene or subject; the least dense areas of a negative, the densest areas of a print. Also see *highlights*.

shadow area reading a light-meter reading of the least illuminated areas of a scene, or those that will produce the areas of least density on the film.

shallow depth of field See *depth of field*.

sharpness the apparent clarity and definition of details in a photographic image; a function of such factors as graininess, image resolution, density, and contrast of the negative, which interact to create an impression of sharpness.

sheet film film manufactured and packaged in individual pieces; cut film.

shifts and swings See *swings and tilts*.

short lens any lens possessing a focal length shorter than is normal for the camera on which it is used. See *wide-angle lens*.

short lighting a portrait lighting setup characterized by placement of the main light to illuminate the side of the subject's face farthest from the camera.

short stop a highly diluted acetic acid used during processing to stop developing action prior to fix-

ing the image; the step in processing in which such a solution is used.

shutter the mechanical component of a camera system by means of which the time interval of exposure is controlled.

shutter priority a type of automatic exposure-setting system that requires the photographer to set the shutter speed manually while the system sets the aperture automatically for proper exposure.

shutter release a mechanical component of a shutter system by means of which the action of the shutter is activated.

shutter speed (1) the interval of time during which the activated shutter is admitting light into the camera; (2) the calibrated markings on an exposure scale indicating a shutter-speed setting.

silhouette a visual representation of an object's mass and shape, but lacking details within the mass.

silver the metallic element **Ag,** commonly compounded with halides to form the main active ingredient in most modern photosensitive materials.

silver bromide one of the silver halides.

silver chloride one of the silver halides.

silver density See *density*.

silver halide See *halide*.

silver iodide one of the silver halides.

simulated action an impression of activity in the absence of real action. Compare *real action* and *peak action*.

single-lens reflex a type of camera that has a hinged mirror device through which the viewing and picture-taking functions may be performed by the same lens: SLR.

skylight filter a filter that performs with color film a function similar to that of a haze filter with black-and-white film. It filters ultraviolet light, reduces bluishness, and restores warmth to scenes characterized by excessive ultraviolet light sources.

slave unit a secondary flash unit designed to supplement a primary flash unit through a remote, photo-triggering operation.

slide (1) a positive transparency designed for use in a projector; (2) a component of a film holder that seals the film within against light; a dark slide.

slow minimally sensitive to light; responsive only to relatively high levels of illumination (said of photosensitive paper or film); capable of transmitting relatively small amounts of light per unit of time (said of photographic lenses of relatively small diameter relative to their focal length).

slow-speed film See *slow*.

SLR See *single-lens reflex*.

small format See *format*.

soft See *low contrast*.

soft focus focus that is slightly diffused, often used to reduce the clarity and definition of details in a photograph.

spectrum an ordered series of electromagnetic wavelengths; in photography, usually the band of wavelengths to which photographic emulsions are sensitive, made up largely of those perceived as light by the human eye.

specularity See *specular light*.

specular light highly directional, nondiffused light such as that emanating from a relatively small point source or reflected off a highly polished, mirror-like surface.

speed the relative sensitivity to light of photographic materials; the light-transmitting characteristic of lenses, as expressed by the ratio of their focal length to their maximum aperture diameter; the apparent movement of an object being photographed.

split-image focusing See *split-image rangefinder*.

split-image rangefinder a type of rangefinder in which opposing halves of the image are displaced except when the device is properly focused. Such a rangefinder is commonly built into a camera and integrated with the camera's lens-focusing mechanism.

splitting frame a colloquial term for a compositional arrangement, usually undesirable, in which a strong vertical or horizontal feature splits the picture format into approximately equal halves.

spotlight a lighting instrument, usually possessing an integrated lens and/or reflector, used to pro-

duce a focused, narrow, relatively specular beam of light.

spotmeter a type of exposure meter, often built into modern cameras, characterized by its capability of measuring light intensity reflected from a very small area within the viewing format.

spotting a technique for bleaching and/or tinting out undesirable spots on a print, such as those caused by pinholes or dust particles on the negative during printing.

spotting colors tinting materials, used in spotting, that can be mixed to match print tones.

spraying a technique for dulling a shiny surface to eliminate specular reflections.

spring tension an elastic device that can be compressed to store energy and extended to activate a mechanism, such as a shutter.

sprout a colloquial term for the alignment in a photographic composition of a background detail with a foreground object such that the former appears to be appended to the latter.

square filter a type of filter, square in shape, requiring a special filter holder to mount it to the camera.

stabilization process a process for developing and fixing prints rapidly. It requires specially treated materials and a mechanical processing unit that automatically conveys the exposed paper through the processing chemicals to produce a processed print in about ten seconds. Such a print will oxidize over time unless subsequently fixed for permanence.

stabilization processor a mechanical processing unit used in stabilization processing.

stain a nonimage-related color or tone on a print, usually produced by chemical oxidation and rarely expected or desired.

standard a stand, often weighted and castered, for mounting lighting equipment.

standard average gray eighteen percent gray. See *average gray*.

stereo camera a camera designed to take a pair of photographs simultaneously, as though seen separately by each eye. When viewed through a ster-

eoscope, the photographs are perceived as a three-dimensional image.

stereoscope a device used for viewing stereoscopic photographs to produce a three-dimensional effect.

stop action an approach to photographing real action that seeks to capture an unblurred image of a rapidly moving object by means of extremely short exposure intervals. Also *freeze action*.

stop bath a processing solution of dilute acetic acid, introduced following development to neutralize the action of residual developer promptly prior to fixing.

stop down to reduce the aperture size of a lens as a control in exposing and focusing.

strobe a device that produces rapidly flashing bursts of light; derived from "stroboscope," now commonly used to refer to an electronic flash unit. See *electronic flash*.

strobe peak (X) a flash burn pattern that reaches maximum output within 1 millisecond after ignition and sustains this level up to 2 milliseconds prior to extinction. See *electronic flash, X-synchronization*.

studio camera See *view camera*.

subbing adhesive layer adhesive coating used to bind a photographic emulsion to its support. See *adhesive layer*.

subject the center of interest; the person, place, thing, or view photographed. A photograph may include many objects, but usually only one subject. Compare *object*.

subject speed See *speed*.

subordination the reduction to a subordinate status of a particular detail or feature in a photograph; minimization of the attention-attracting position, size, or clarity given to such a feature. Compare *emphasis*.

sunshade See *lens hood, lens shade*.

superimposed-image focusing See *superimposed-image rangefinder*.

superimposed-image rangefinder a type of rangefinder in which two images of the subject appear to overlap except when the device is properly

focused on the subject. Such a rangefinder is commonly built into a camera and integrated with the camera's lens-focusing mechanism.

supplementary lens a lens used in front of a primary lens to alter its performance. Often used in close-up photography or for special effects.

support a transparent, firm, chemically stable base upon which is coated the emulsion of a photographic film or plate.

surface texture See *texture*.

swings and tilts the adjustments of the front and rear standards of a studio or view camera. Also *shifts and swings*.

synchronization the mechanical-optical method of timing the ignition of a flash unit in coordination with the release of the shutter to obtain optimal exposure.

tacking iron a hand-held electrical tool used to attach dry-mounting tissue to the mounting surfaces prior to pressing in a dry-mount press.

taking lens the camera lens that resolves the photographic image on the film; the picture-taking lens (as distinct from other lenses used in viewfinding). Compare *viewing lens*.

tank See *film-processing tank*.

teleconverter a device inserted between lens and camera body to increase the effective focal length of the lens.

telephoto lens a type of long lens characterized by its production of an image on the film larger than that produced by a given camera's normal lens; a lens capable of resolving on the film a relatively large, clear image of objects relatively distant from the camera.

tenting a method of lighting through a translucent medium in order to produce an even, diffused field of light devoid of reflectable details. It is used especially with shiny objects.

test exposure See *test print, test strip*.

test print a full-size print exposed in segments for varying exposure intervals in order to determine optimal exposure for printing.

test strip a narrow piece of printing paper exposed in segments for varying exposure intervals in order to determine optimal exposure.

texture (1) image texture — an apparent surface characteristic produced by the photographic image, i.e., the image suggests the texture; (2) surface texture — a surface characteristic of photographic paper, such as glossy or matte; a surface characteristic of an object that may be exaggerated or subdued by means of lighting.

texture accents highlights that reveal the surface irregularities of an object.

texture screen a device used to produce image texture in a print. See *texture*.

texturing emphasizing or revealing surface texture, such as by the use of lighting.

thin characterized by low overall density (said of a negative or positive transparency image).

thin emulsion film a type of film characterized by an exceptionally thin photosensitive layer of high resolution and contrast, fine grain, slow to moderate speed, and narrow latitude.

35-mm camera a type of camera designed to use 35-mm sprocketed motion picture film, popularly packaged for use in such cameras.

threaded mount a lens-mounting system using screw-threads by which a lens may be aligned with the mount and screwed into place.

thyristor circuit a type of automatic electronic flash that conserves unused energy in its capacitors following each flash to reduce recycling time and extend capacitor life.

time (T) a shutter setting (T) at which the shutter remains open following depression of the shutter release until the release is depressed a second time. Also see *bulb*.

time and temperature the main variables requiring precise control during chemical processing of photographic materials, especially during development.

time exposure an exposure interval, usually longer than a few seconds, timed by the photographer while the shutter stands open rather than by the camera's automatic settings.

timer a device used in the darkroom to measure time intervals during printing and processing, often integrated into the design of photographic equipment.

tint a hue of very low saturation. Paper tint or base tint is the color of the paper stock itself.

TLR See *twin-lens reflex.*

tonality the range of values, in gray or color, present in a photographic image; the range of distinct value that can be discriminated between black and white. See *contrast, gray tone separation.*

tonal range See *tonality.*

tone white, black, or an intermediate shade of gray; the tint present in the silver image. See *tonality, tint.*

toner a chemical agent used to alter the color or tint of the silver image in a black-and-white print. Toners affect only the silver image, not the base tint.

tone separation the rendering of brightness values in a scene that appear different to the eye as distinctly different shades of gray in a black-and-white print.

toning See *toner.*

topcoat an abrasion-resistant material coated onto the surface of a photographic emulsion as a protection.

transillumination illumination produced by lighting through a translucent medium.

translucent capable of transmitting light, but not image; characteristic of a medium that transmits light only at a high level of diffusion.

transmission the passage of light through a medium. See *law of transmission and absorption.*

transparency a photographic image, positive or negative, recorded on a transparent medium and capable of projection.

transparent capable of transmitting light and image; characteristic of a medium that transmits light at a minimum level of diffusion.

tripod a three-legged, usually foldable, support commonly used for positioning and stabilizing a camera.

T setting See *time.*

tungsten-filament See *tungsten light.*

tungsten-halogen improved smaller version of tungsten-filament lamp that emits whiter, brighter light.

tungsten light conventional artificial light produced by passing an electric current through a tungsten filament in a vacuum or in inert gas. In photography, it usually refers to lamps designed to burn at specific color temperatures (3200 or 3400 K).

twin-lens reflex a reflex camera characterized by its use of separate but optically similar built-in lens systems to perform the separate functions of viewfinding and picture taking; TLR.

2¼-square camera a camera that produces a 2¼ × 2¼-inch negative format.

type A a designation identifying color film balanced for tungsten light of 3400 K.

type B a designation identifying color film balanced for tungsten light of 3200 K.

ultra-fast film film designed for use under low lighting levels; arbitrarily, film with ASA film-speed rating over 400.

ultraviolet relating to a band of electromagnetic wavelengths just shorter than those perceived as violet in the visible light spectrum; describes an invisible band of electromagnetic waves detectable by most photosensitive silver halide emulsions.

ultraviolet filter See *skylight, haze filter.*

umbrella reflector a highly reflectant metallic cloth, stretched over a foldable frame resembling an umbrella, that reflects a soft directional light beam.

underexposure an amount of exposure inadequate to produce normal density and tonal range on a photosensitive emulsion by means of standard developing procedures.

underwater camera a camera designed for use underwater.

underwater housing a container designed to provide a waterproof enclosure for underwater operation of a camera.

value brightness; the relative presence or absence of black; lightness or darkness. The absence of value is equivalent to zero electromagnetic energy, or no light at all.

variable-contrast filter a type of filter designed for use with variable-contrast printing paper to control contrast in photographic printing. Also *multicontrast filters*.

variable-contrast paper a type of printing paper coated with both high contrast and low contrast emulsions, each sensitive to a given band of electromagnetic wavelengths. It is used with variable-contrast filters to control contrast in printing. Also *multicontrast and multigrade paper*.

view camera a type of camera characterized by large-format ground-glass viewing of the image in the film plane, and considerable adjustability of the lensboard and film plane to control linear perspective and depth of field.

viewfinder a mechanism on a camera that indicates to the photographer the details the camera will record and, commonly, the details that will be in focus.

viewing lens the lens of the viewfinding system, rather than the picture-taking system. The term commonly refers to the lens that forms the viewfinder image in a twin-lens reflex camera. See *taking lens*.

vignetting (1) a dodging technique for achieving a progressive reduction of exposure toward the edges of a picture format, isolating the subject within borders that gradually fade to the value of the base; (2) the progressive reduction of exposure toward the edges of a negative, produced by using a lens or attachment optically inadequate for the camera design.

visible light spectrum See *spectrum*.

warm tones brownish hues associated with the metallic silver image of a print, often emphasized by the use of certain emulsion-developer combinations.

wash to clear active chemicals from photographic materials by rinsing in water.

washed out a colloquial term describing a print of inadequate density in which a full range of highlight detail has failed to develop, typically as a result of underexposure in printing.

wavelength a characteristic of electromagnetic energy which, within the visible light spectrum, activates differential neural sensations that are perceived as color.

weight the thickness of printing paper stock, e.g., document weight, single-weight, double-weight.

wet area a portion of a darkroom, designed especially for the handling of processing chemicals, solutions, and water so as to minimize the possibility of contaminating chemically sensitive, dry materials such as films and papers.

wet mounting a technique for affixing finished prints to a surface by means of a liquid adhesive. Compare *dry mounting*.

wetting agent a water additive that acts to break down surface tension and is used in photography to aid in spot-free drying of film.

white light light consisting of virtually all wavelengths in the visible light spectrum; standard daylight; light capable of making normal exposure of photographic emulsions.

wide-angle camera a camera with a revolving lens and shutter system or a wide-angle optical system, designed for making panoramic photographs.

wide-angle lens a lens with a shorter focal length and wider angle of coverage than is normal for the camera on which it is used. Such lenses tend to have greater-than-normal depth of field and to elongate perspective between nearby and distant objects.

X See *strobe peak*.

X-synchronization mechanical synchronization of shutter and flash for use with electronic flash units; X, zero-delay, is designed to make flash contact when the shutter stands fully open.

zero-delay to peak a flash burn pattern in which peak flash output is reached virtually instantaneously upon ignition. Electronic flash units are said to peak with zero-delay (actually less than one millisecond) and are used with cameras set for X-synchronization.

zinc-carbon battery a type of battery recommended for flash units with unplated brass or copper contacts. See *alkaline battery*.

zone system a precise method for controlling density and contrast using analysis of brightness values in a scene to plan the exposure and processing necessary to obtain a previsualized result in the final print.

zoom lens a lens with a continuously adjustable focal length within its design limits.

APPENDIX A

A Starter Kit of Equipment and Materials

This starter list of equipment, facilities, and supplies provides some recommendations for completing the suggested laboratory and field assignments in this book. Take whatever liberties you wish to satisfy your own preferences; these are offered only for your guidance.

Equipment

1. Adjustable Camera
Recommended features: Size: 120 or 35 mm
Standard lens: (for 35-mm cameras) f/1.4–2.8; 45–55 mm (for 120 cameras) f/2–3.5; 70–85 mm
Flash synchronization: M (or FP) and X
Viewing and focusing: Twin-lens or single-lens reflex is recommended. If you use a range-finder camera, it should have a lens-coupled focusing system.
Shutter: 1 sec. to 1/500 sec. + T and/or B minimum
Supplementary lenses: A line of interchangeable lenses and/or supplementary lenses should be available for use with your camera.

2. Light Meter
Recommendations: Built-in light meters with automatic exposure control may be convenient under many circumstances. If you use a built-in meter, it should be coupled to the camera's diaphragm and shutter and permit reading of the f/stop settings. It should also be possible to override the automatic coupling for manual setting of both shutter and aperture independent of one another. Whether or not your camera has a built-in light meter, the use of a separate light meter is strongly recommended. It is also recommended that your separate light meter be designed for both incident and reflected use and be sensitive to very low light levels (around EV 5 or 6).

3. Camera Case with Adjustable Strap (Optional)

4. Lens Shade

5. Filters
Recommendations: Yellow, green, red, and polarizer, together with adapter ring, if required.

6. Electronic Flash Unit

7. Tripod

8. Gadget Bag (Optional)

Facilities

To complete the work in this book you will need access to a darkroom for processing and printing, and a place where you can finish your prints. A place you can use as a studio will also be useful. These facilities are often available where a formal course is offered — in schools and colleges. If you are studying on your own, most areas now have excellent, completely equipped rental facilities that are available for a nominal hourly charge. Or you may wish to set up your

own facilities. The following references for setting up a photolab may help your planning.

Eastman Kodak Co. *Basic Developing, Printing, Enlarging in Black-and-White* (Publication AJ–2). Rochester, N.Y., 1979.

Eastman Kodak Co., *Photolab Design* (Publication K–13). Rochester, N.Y., 1978.

Supplies (a suggested starter list of expendables)

1. Film

Several rolls of medium-speed film for your camera to get started; additional film as needed

2. Photographic Paper

Fifty-sheet supply of 8-in. by 10-in. single-weight semimatte enlarging paper

Fifty-sheet supply of 8-in. by 10-in. single-weight glossy enlarging paper

(variable contrast is recommended; otherwise the supply should include paper grades 0–4)

Additional paper as needed

3. Chemicals

1 quart of a moderate grain film developer (such as Kodak D–76)

1 pint of 28 percent acetic acid for mixing short-stop

1 gallon of a hardening fixer for film and paper

1 gallon of clearing agent

1 gallon of paper developer (such as Kodak Dektol)

1 pint of photographic wetting agent

1 quart of print-conditioning solution

1 quart of developer replenisher (such as Kodak D–76–R), if replenishing type developer is used

Distilled water to mix

4. Miscellaneous

Felt-tipped pen (permanent) for marking proof prints

Copymarking pencil (no. 1, large head, very soft) for writing on back of prints

Camel hair or electrostatic brush for cleaning lenses and negatives

Negative preservers for your negative format

Rubberized laboratory apron to protect clothing

Mounting board as needed

Dry mounting tissue as needed

NOTE: Not included in the above list are the normal and usual small equipment and supply items used in the laboratory. It is assumed that the laboratory setup you arrange for will provide them, or that you will equip your own darkroom as recommended in the references.

APPENDIX B

Metric and U.S. Customary Equivalents

In this edition, wherever practical, both U.S. Customary and metric measures are provided. Where one system is the more commonly used in a particular case, that measure appears first. Its equivalent in the alternative system then follows in parentheses. Occasionally you may need to convert measures from one system to the other. The following table provides conversion information.

Units of length

meter = 39.370 inches
centimeter = .3937 inch

foot = .3048 meter (30.48 centimeters)
inch = .0254 meters (2.54 centimeters)

centimeters = inches × 2.54
inches = centimeters × .3937

Units of volume

liter = 1.056 U.S. quarts
 = .264 U.S. gallons

U.S. quart = .9463 liter
U.S. gallon = 3.785 liters

milliliters = U.S. ounces × 29.6
 = U.S. quarts × 946.3
U.S. ounces = milliliters × .034
U.S. quart = milliliters × .001

Temperatures

$$°F = 32 + (°C × 1.8)$$
$$°C = (°F − 32) × .5556$$

°C = (°F - 32) x .5556

INDEX

Aberration(s), 380, 385, 407
Absorption, 407
 law of transmission and, *see* Filter(s)
Accent lights, *see* Light and lighting
Accessories, *see* Camera
Acetic acid, 128, 133, 407
 formulas for mixing, 111
 glacial, 111, 417
 See also Stop bath(s)
Acid fixer, *see* Fix (fixer, fixing bath, hypo)
Actinic light, *see* Light and lighting
Action
 blur, 80, 83–84, 371, 374, 408
 peak (poised), 369, 370–371, 423
 real, 369, 424
 simulated, 369, 371, 427
 ''stopping,'' *see* Stop (freeze) action
Acutance, *see* Film
Adams, Ansel, 341, 342
Adapter ring, 232, 379, 407
Adhesive layer (film), 407
 second and subbing, 43, 428
Adhesives (mounting), caution in use of, 180
Advance of film, *see* Film
Aerial perspective, *see* Perspective
Age of film, *see* Expiration date
Agitation, 407
 in film processing, 110–111, 116, 119, 120
 in printing, 127, 128
Air-bells, 110, 407
Air drying, *see* Drying prints
Alkaline battery, *see* Battery(ies)
Ambition, appeal (of photograph) to, 374
Angle
 camera (high-angle, eye-level, low-angle shots), 213, 215, 409, 414, 418, 420
 of incidence (lighting), 263–264, 270, 277, 407
 of movement, 82–83, 407
ANSI (American National Standards Institute), *see* ASA
Antihalation backing, *see* Halation (halo effect)
Aperture, 70, 407
 and depth of field, 76, 79, 83, 359, 362, 370, 382, 386

determination of, by guide number, 303–305
 enlarging lens, 158
 maximum, 19, 71, 421
 regulation of, by eye and camera, 1
 and shutter speed combinations, 79–82, 83, 303, 311, 382
 size of, *see* f/number, f/stop
Aperture priority, *see* Exposure
Archer, Fred, 341
Architecture photography, 362–363
Artificial lighting, *see* Light and lighting
ASA (American Standards Association), now ANSI (American National Standards Institute), 44–45, 407.
 See also Film speed rating
At-the-back (focal plane) shutter, At-the-lens shutter, *see* Shutter(s)
Auto-focus system, *see* Focus and focusing
Automatic diaphragm, *see* Diaphragm
Automatic electronic flash, *see* Flash, electronic
Automatic exposure, *see* Exposure
Automatic winder, 22, 407
 motor drive for, 22, 421
Available light, *see* Light and lighting
Average gray, *see* Gray
Average (overall) reading, *see* Exposure meter(s)
Averaging meter, 90, 407. *See also* Exposure meter(s)

B (setting), *see* Bulb
Background
 ''busy'' or distracting, 206, 207, 212, 346, 367, 368, 409
 in color photography, 345–346
 elimination of, by vignetting, 169
 neutral, 206–207, 212, 216, 345–346, 422
 out-of-focus, 208, 216, 346
 pattern screen use and, 268
 ''sprout'' in, 207, 428
 subject separation from, 273, 277
Background light, *see* Light and lighting
Backlight (kicker), 272, 408
Baffle(s) (barn-door, flag, head screen, pattern screen), 267–268, 272, 280, 408, 415, 418, 423

Bare bulb flash, *see* Flash/flash unit
Barn door baffle, *see* Baffle(s)
Base
 enlarger, 152, 408
 film or print, 408
Base tint, *see* Tint
Basic exposure rule, *see* Exposure
Battery(ies)
 alkaline, 313, 407
 electronic flash, 297
 removal of, during storage, 24
 zinc-carbon, 313, 432
Bayonet mount (for lens), *see* Mounting equipment
Beam candlepower seconds (BCPS), 297, 305, 309, 408
Behind-the-lens shutter, *see* Shutter(s)
Bellows, 5, 14, 16, 152, 408
 extension (bellows unit), 22, 365, 380, 381, 385, 388, 414
Between-the-lens shutter, *see* Shutter(s)
Black-and-white film, 43–50
 brightness ratio and, 263, 309
 characteristics of, 44–47, 50 (table), 94
 commonly available, 48, 50 (table)
 composition of, 43–44
 copying with, 386, 388
 filters for, 234–240, 264
 flashbulbs for, 295
 printing from, *see* Printing
 processing of, 109–125
 RF factors for, 81
 shutter speed for, 80
 See also Tone(s)
Black body, 54, 408. *See also* Color temperature (Kelvin degrees)
Bleach, 408. *See also* Print finishing
Blocked up (burned out), 87, 408. *See also* Dense, density
Blue-sensitive, 46, 131, 229, 234–235, 408
Blur, 338, 408
 and blur action, 80, 83–84, 371, 374, 408
 camera shake and, 27, 80, 409
 and enlargement, 158
 See also Out-of-focus
Boom (lighting equipment), 269, 408
Bounce flash, bounce light, *see* Light and lighting

Box camera, 5, 409
Bracketing, 409. *See also* Exposure
Brightness, brightness ratio, relative
	brightness, *see* Value (brightness)
Broad lighting, *see* Light and lighting
Bromide (silver halide), *see* Silver
Bromide paper, *see* Paper(s), photo-
	graphic
B setting, *see* Bulb
BSI (British Standards Institution) sys-
	tem, 409. *See also* Film speed rating
Built-in meter, *see* Exposure meter(s)
Bulb (B setting), 70, 409
Burned out, *see* Blocked up
Burning in (printing in), 168, 169, 328,
	409. *See also* Flashing (printing
	technique)
Busy background, *see* Background
Butterfly lighting, *see* Light and lighting

Cable release, 20–21, 409
Camera
	accessories for, 20–22, 27 (*see also*
		Exposure meter[s]; Lens[es]; Tripod)
	basic settings for, 69–73
	basic types of, 3–19
	body and body types, 1, 4–5, 409
	care, inspection, and repair of, 23–24
	compared to eye, 1–3, 21
	defined, 409
	good habits in use of, 25, 27
	recommendations on, 27, 433
Camera angle (eye-level, high-angle,
	low-angle), 213, 215, 409, 414,
	418, 420
Camera shake, *see* Blur
Camera-to-subject distance, *see* Distance
Carrier, *see* Negative carrier
Cartridge (cassette, magazine), 6, 48, 49
	(fig.), 409
	how to open in darkroom, 116
Cassette, *see* Cartridge
Cast, 345, 409. *See also* Color(s)
Catchlights, *see* Light and lighting
CC (color-compensating) filters, *see* Fil-
	ter(s)
Center of interest (central idea), *see*
	Composition
Center-weighted meter, 90, 409. *See also*
	Exposure meter(s)
Characteristic curve, *see* H & D (charac-
	teristic) curve
Chemicals
	caution in using, 109, 111
	for film processing, 109–111, 120–122
	list of needed, 434

for print processing, 126, 180
	storage of, 338
Chloride, *see* Silver
Chloride paper, chloro-bromide paper,
	see Paper(s), photographic
Chroma (saturation), *see* Hue(s)
Circuits, electrical, overloading dangers,
	269
Clearing agent, 121, 128, 135, 176, 177,
	410
Clearing prints, *see* Printing
Closeup(s)
	adjusting for parallax in, 13, 377
	and closeup (exposure meter) reading,
		93, 95
	as copying technique, 385, 388
	defined, 410
	equipment for, 365, 379–382
	exposure and lighting for, 380–382
	in portrait photography, 366, 368
Closeup lens, *see* Lens(es)
Coarse grain, *see* Grain size
Coating (lens), 410
Cocking the shutter, *see* Shutter(s)
Cold mounting, 180. *See also* Print fin-
	ishing
Cold tones, *see* Tone(s)
Color(s)
	attributes of (three major), 210–211
	balance of, 54, 56–57, 81, 95, 242,
		243–244, 245, 295, 386, 410
	complementary, 51, 52, 210, 230,
		235, 328, 344, 411
	contrast in, 344, 345, 410
	control of, in composing picture, 201,
		210–212, 344–346, 410
	defined, 410
	filter use and, 229–245, 264
	guidelines in photographing, 345–346
	harmony in, 344, 410
	perception of (eye vs. film), 21, 45,
		54, 229, 234–235, 345
	primary, 51, 210, 229, 230, 244, 344,
		423–424
	psychological effects of, 345
	secondary, 210, 244, 344, 426
	sensitivity to (of film), 45–46, 131,
		229, 234–235, 264, 411
	See also Hue(s); Spectrum; Tone(s)
Color-compensating (CC) filters, *see* Fil-
	ter(s)
Color film, 51–57
	brightness ratio and, 263
	color negative, 51, 52–53, 57, 242, 410
	color reversal (color slide/
		transparency), 51–52, 242, 410

commonly available, 56 (table)
	composition of, 51
	copying with, 386, 388, 390
	exposures, 82
	filters used with, 242–245
	flash use with, 295, 306
	instant color print, 51, 53–54, 388
	integral tripack, 51, 52, 419
	latitude of, 263
	printing of, 95, 242, 244
	processing of, 51–54, 57, 242
	and RF factor, 81
	Type A, Type B, 54, 265, 430
Color negative, *see* Negative(s)
Color negative film, color reversal film,
	see Color film
Color print, *see* Print(s); Printing
Color slide or transparency, *see* Trans-
	parency(ies)
Color slide or transparency (color rever-
	sal) film, *see* Color film
Color temperature (Kelvin degrees),
	54–56, 242, 243–244, 345, 408,
	411, 419
Combination printing, *see* Printing
Complementarity, complementary colors,
	see Color(s)
Composition
	background considerations in,
		206–208, 212, 216
	central or dominant idea (center of in-
		terest) of, 202–203, 207, 212,
		333–334, 335, 346, 357, 367, 410
	color control in, 201, 210–212,
		344–346, 410
	contrast in, 201, 208, 210, 216
	cropping for, 167–168, 216, 217
	defined, 201, 411
	detail control in, 202, 206–212, 216
	detail placement in, 212–215
	dynamism in, 334, 413
	elements of, 201–206
	emphasis (vs. subordination) in, 202,
		208, 212–213, 215, 216, 259, 339,
		344, 346, 413, 428
	functions of, 202–206, 334
	guidelines for, 210, 216, 357
	line as element of, 201, 420
	lines of (real, implied), 333–335, 374,
		420
	mass as element in, 201, 421
	and movement into frame, 213
	natural frame in, 329
	perspective control and, 333–335
	rule of thirds in, 212–213, 216, 335,
		426

Timer, 430
 enlarger, 139, 152, 159
 processing, when to start, 115, 116,
 159
Tint
 base (paper), 131, 408
 defined, 430
TLR, *see* Twin-lens reflex (TLR) camera
Tone(s), 201, 430
 cold, 131, 177, 178, 345, 410
 and composition, 201, 336–342, 345
 continuous, 388, 411 (*see also* Full-
 scale print)
 high-key, 341, 418
 image, 131, 177, 178
 low-key, 341, 421
 neutral, 131
 perception of (eye vs. film), 87,
 163–164
 previsualization of, 95, 341–342
 of prints, 163–166
 separation of, 229, 235, 338, 426, 430
 of test strip, 159
 and tonality, tonal range, 85, 336,
 338, 430
 warm, 131, 177, 178, 345, 431
 See also Color(s); Contrast, contrast
 range; Gray; Tint
Toner, 430. See also Print finishing
Tone separation, *see* Tone(s)
Topcoat, *see* Emulsion
Transillumination, *see* Light and lighting
Translucent (defined), 430
Transmission, 430
 and absorption, law of, *see* Filter(s)
Transparency(ies)
 color (color slide), 51, 53, 56, 388,
 411
 defined, 430

duplicate, 51, 388, 390
positive (slide), 51, 53
Transparent (defined), 430
Tripod, 14, 20–21, 27, 306, 362, 366,
 383, 430
T setting, *see* Time
TTL (through-the-lens) meter, 380, 381,
 387. *See also* Exposure meter(s)
Tungsten film, *see* Film
Tungsten light, *see* Light and lighting
Twin-lens reflex (TLR) camera, 9,
 10–11, 12, 240, 377, 430
2 ¼-square camera, 7, 430
Type A, Type B color films, *see* Color
 film

Ultra-fast film 430. *See also* Film speed
Ultraviolet, *see* Filter(s); Light and light-
 ing
Umbrella reflector, *see* Reflector(s)
Underexposure, *see* Exposure
Underwater camera and housing, 15, 430

Value (brightness), 211, 431
 and brightness ratio/relative brightness,
 229, 234–235, 240, 245, 263, 272,
 277, 278, 309, 310, 409, 425
 color sensitivity and, 45
 range of, 86, 87, 94, 95, 168, 309,
 424
 See also Light and lighting
Variable-contrast filter and paper, *see* Fil-
 ter(s); Paper(s), photographic
Vertical lines, 335. *See also* Composition
View camera, 14, 362, 365, 377, 383,
 431
Viewfinder, 377, 431
 use of, 25, 83, 168, 216, 357 (*see
 also* Composition)

Viewing lens, *see* Lens(es)
Vignetting, 169, 431. *See also* Dodging
 (holding back)
Visible light spectrum, *see* Spectrum

Warm tones, *see* Tone(s)
Wash (defined), 431
"Washed out," 431
Washing negatives, 110, 121, 122 (fig.)
Washing prints, *see* Printing
Water scenes, *see* Scenic photography
Wavelengths, *see* Spectrum
Weight
 of accessories, 22
 avoidance of, in storing paper, 133
 of paper, 131, 158, 431
Wet area, *see* Darkroom
Wet mounting, 180, 431. *See also* Print
 finishing
Wetting agent, 110, 122, 431
White, Minor, 342
White light, *see* Light and lighting
Wide-angle camera, 15, 431
Wide-angle lens, *see* Lens(es)

X (electronic or strobe peak), 428. *See
 also* Flash, electronic
X-ray, effect of, 58, 132
X-synchronization, *see* Synchronization

Zero-delay to peak (electronic flash),
 298, 432
Zigzag lines, 335, 374. *See also* Compo-
 sition
Zinc-carbon battery, *see* Battery(ies)
Zone system, 94, 341–342, 432
Zoom lens, *see* Lens(es)